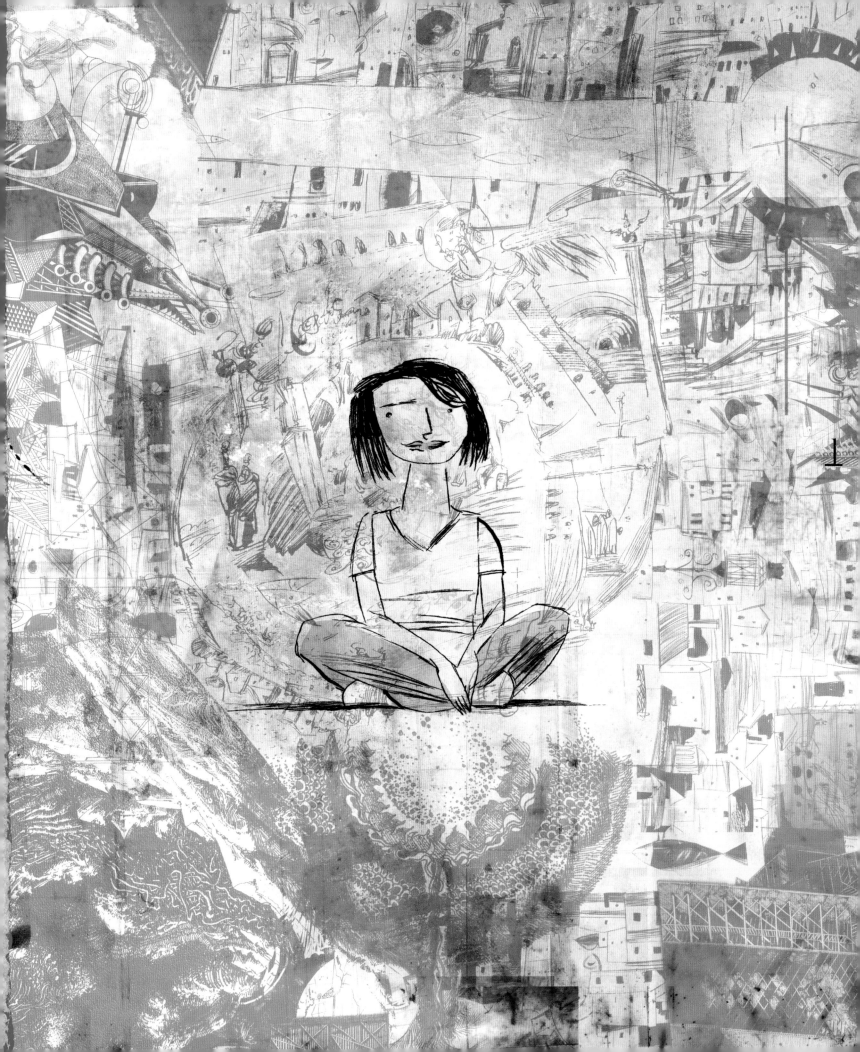

the Alchemy of MirrorMask

2

Published by Collins Design
An Imprint of Harper Collins Publishers

world. In the real world she's like every kid, sometimes kind and understanding, some
spiteful and bolshy. I like the use of mirrors etc, but I'm not sure about the 'seein
reflections of other people' stuff, I saw the trailer for THE OTHERS yesterday and th
all mirrors and ghosts reflected in them, and it's been done so many times, the great
being ORPHEE. How about she wakes up in the night. Silent and dark, wind blowing. May
hears something to get her out of bed, nobody around, her mums in hospital but her da
in bed either. She looks out the window, no-one around, the front door is open, she w
out into the street, we move gradually into a slightly changed reality, she walks int
desolate road, turns and her front door has gone. (Is this too close to Coraline fo
But we start with the audience AND OUR GIRL assuming that this is a dream, confirmed
fact that early on, she looks through a window on tip toe and sees herself asleep in
she is in one of the drawings on her bedroom wall. But later she looks out of another
and the bed is empty, she is up, it is daylight in her bedroom. She realises that she
split into the good girl, now locked in this world, while her bad side is inhabiting
real body. I don't think we should spend any time with the bad girl, but we should se
not hear) her arguing with her dad and upsetting him, spending her savings on frivolo
things (instead of bus fair to visit her mum) and about half way through, our girl se
starting to burn all the photos of her mum she can find, adding urgency to her quest
In the fantasy city, everyone has deserted apart from a few strange stragglers, it is
the world type strangeness, mad prophets and lost souls. The reason is the impending
night, tendrils of night start to drift down the streets. The reason why the queen of
is taking over is the illness of the queen of light. This is obviously a visualisatio
her mums illness. The cancer black tendrils of night warp and rot everything they tou
here she is not powerless (I like the idea that in order to gain control over the sir
with her mum, she has lost control over her real body to her bad side). in fairy tale
tradition if she follows a route, or map, or sequence of clues, she begins to loosen
grip of the tendrils (there must be logical reason to this, even it's an internal log

Introduction
by Dave McKean

It is difficult to pinpoint exactly when MIRRORMASK started, but I think it's fair to say the seed would be Jim Henson and his two personal puppet fantasies, THE DARK CRYSTAL and LABYRINTH. Although these films were expensive and financially unsuccessful when first released, they have become perennial favorites with each new generation that discovers them. Sony now owns the rights to these films, and someone there noticed this long-term success and, in the midst of various Muppet deals with The Jim Henson Company, offered the opportunity to make another film, but for a far smaller budget. This precluded the use of Creature Shop puppets and sets, so Lisa Henson decided to look elsewhere.

Seed number two would be Neil's ongoing business relationship and friendship with Lisa Henson during the development of his NEVERWHERE project, a BBC TV series that really needed a big-screen treatment to do it justice. Neil didn't want to write this new film but was happy to throw some ideas on the table.

HarperCollins books may be purchased for educational, business, or sales promotional use. For information, please write: Special Markets Department, HarperCollins Publishers, 10 East 53rd Street, New York, NY 10022.

First Edition

First published in 2005 by:
Collins Design
An Imprint of HarperCollins Publishers
10 East 53rd Street
New York, NY 10022
Tel: (212) 207-7000
Fax: (212) 207-7654
collinsdesign@harpercollins.com
www.harpercollins.com

Distributed throughout the world by:
HarperCollins International
10 East 53rd Street
New York, NY 10022
Fax: (212) 207-7654

Designed by Dave McKean @ Hourglass

Library of Congress Control Number: 2005924705

ISBN 0-06-082379-8

Jim Henson
THE JIM HENSON COMPANY

Printed in China

1 2 3 4 5 6 7 / 11 10 09 08 07 06 05

First printing, 2005

PYROTECHNIC ARTIST

I can't give you any more time. She's a lovely woman. I'd walk through fire for her. But that doesn't change the facts.

MUSICIAN

I've been busking. In the tube. ~~At my time of life.~~ *That's got to be a sharp down the career ladder by anybody's standards!*

FRED

Eric's got a point. If we knew that the circus would be back on the road in, let's say, a week, I'm sure we could all find stuff to hold us over till then.

TRAPESIST

It's a big if. We can't dangle indefinitely.

Helena catches Morris's eye.

HELENA

5

THE WEEK BEFORE is about God creating the universe. It documents the week that was supposed to be THE week of creation, but without inspiration he prevaricates, goes fishing, invites his neighbor (the Devil) around for a game of cards, and finally after a heavy night on Sunday, starts again on Monday morning with a hangover and a household accident that initiates the big bang. This story is all told without dialogue and set to a wonderful collection of vintage recordings by Django Reinhardt.

N[EON] is about a man who is escaping a failed marriage, wandering the streets of Venice, trying to make sense of it all. He encounters a naked ghost who is only visible during the second of decay as a neon tube in a shop window blinks out. At the same place and time each night, he prizes the moment wider in order to see more and more of her repeated moment of time. I think it's about the sacrifice that you make by leaving the pattern of one relationship and plunging into the unknown of another.

Books (author in brackets)

The Alchemy of MirrorMask
MirrorMask Scriptbook (Neil Gaiman)
MirrorMask Picture Book (Neil Gaiman)
Narcolepsy
London Orbital (Iain Sinclair)
Varjak Paw (SF Said)
The Wolves in the Walls (Neil Gaiman)
The Particle Tarot: Major Arcana
The Tip of My Tongue
The Day I Swapped My Dad for
 Two Goldfish (Neil Gaiman)
What's Welsh for Zen
 (John Cale and Victor Bockris)
Option: Click
A Small Book of Black and White Lies
Sandman: Dust Covers
The Dark Tower: Wizard and Glass (Stephen King)
The Vertigo Tarot
Slow Chocolate Autopsy (Iain Sinclair)
Black Cocktail (Jonathan Carroll)

Comics (author in brackets)

Bitten & Bruised
Eye
Pictures that Tick
Rolling Stones: Voodoo Lounge
Cages
Mr. Punch (Neil Gaiman)
Signal to Noise (Neil Gaiman)
Arkham Asylum (Grant Morrison)
Black Orchid (Neil Gaiman)
Violent Cases (Neil Gaiman)

Films (Director/Designer)

MirrorMask
Reason
N[eon]
William Shakespeare's Sonnet No. 138
Displacements
The Week Before

(Production Design/Digital Artist)

Harry Potter and the Prisoner of Azkaban
Harry Potter and the Philosopher's Stone
Asylum
The Falconer
Habitat

The placeholder title of the film at this point was THE CURSE OF THE GOBLIN KING, and in reverence to this inspiring legend, we set about writing a film without curses, goblins, or kings in it. There were two queens, and some characters who were referred to as goblins by Neil for a couple of days, but then after four hours of heated discussion over whether this word should be banned from the script, we decided to toss a coin. I won, but felt so bad about the arbitrariness of it all that I spent another four hours suggesting more and more baroque reasons why I was right. I think my worry was that in even suggesting that there might be goblins in the film, we were opening a can of goblins that our American producers wouldn't let go. We'd be knee-deep in goblins before Act Two.

Lisa let us stay in her family's London home in Hampstead, neutral territory for both of us, no phone calls or other distractions. We spent two solid weeks hammering it into shape. We both brought characters, plot ideas, images, music, dialogue, and soundscapes to the table, and, after a rocky start, found a workable way of getting it all down onto a single, large sheet of paper so it made sense.

The origins of each of the sequences in the film are described in the following pages, but overall, the film has a few obvious antecedents. Structurally it is ALICE'S ADVENTURES IN WONDERLAND or THE WIZARD OF OZ, or more contemporary versions, such as LABYRINTH or the wonderful TIME BANDITS, which Neil and I talked about a lot. But I recently saw Fellini's CASANOVA again at The National Film Theatre and realized there's a lot of that film in MIRRORMASK as well: the perpetually foggy streets and the feeling of drifting from place to place, the bizarre mechanical bird, and the automaton doll at the end. Also, after initially really disliking Hayao Miyazaki's SPIRITED AWAY, I watched it again with my kids and started to get past those bland manga faces, and really enjoyed it. It became a touchstone for us in dealing with dream logic and the links between fantasy and reality. Miyazaki really taps into a child's anxiety in that film, and to even greater effect in his masterpiece MY NEIGHBOR TOTORO (which I discovered only after one of our animators, Daniel Gerhardt, installed a catbus on top of his computer and strongly recommended the film).

her, filled with chalks and pens and little toys.

There's a noise behind her.
It's MORRIS. He's come through the door on
the roof, pushing it open.
We can see a few chalk drawings by HELEN
on the surfaces of the roof.
MORRIS sits down next to her.

HELENA

Mum says you should have ta
to Scotland.

MORRIS

She's not the only one

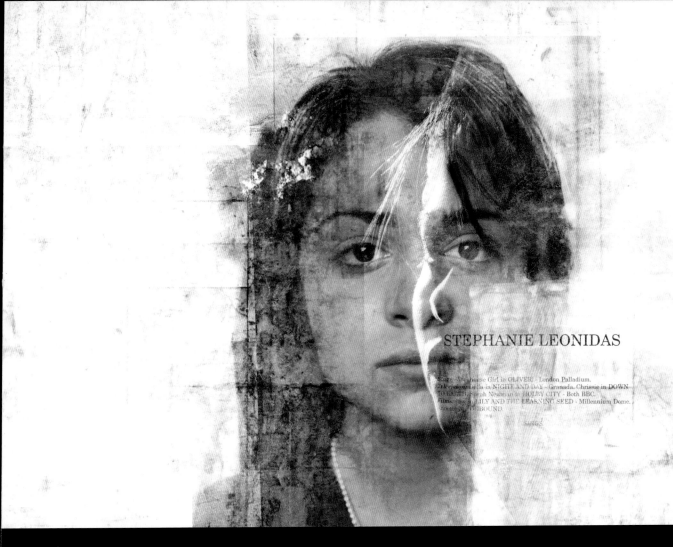

STEPHANIE LEONIDAS

Stage: Workhouse Girl in OLIVER! - London Palladium.
Television: Della in NIGHT AND DAY - Granada. Chrissie in DOWN
TO EARTH. Sarah Newman in HOLBY CITY - Both BBC.
Film: Stacey in LILY AND THE LEARNING SEED - Millennium Dome.
Jeanette in HOMEBOUND.

The shoot was hectic but went pretty much to schedule: a week in Brighton, a week in London, and then four weeks in a blue-screen studio, which was rather less soundproofed than we were led to believe. As our neighbors hammered their sets together and then trashed them two days later, we were forced to start and end later in the day. At two o'clock every afternoon an ice cream van could be heard circling the studios, and every time Gina McKee came onto the set, a crow would sit by an air vent in the roof and caw loudly at her.

The crew was a pretty crack unit from slate one. It would be unfair to single out particular thank-you's here because it was such a team effort, but I would like to be unfair and thank Jo Lea, who was my first assistant director. I've never had one of those before and I wasn't sure what she was actually going to do, but she kept the whole show moving along brilliantly and was great company; we almost perfected our Pete and Dud routine. Apparently there are two kinds of first ADs, very loud, shouty ones and the kind that believe that if you have to shout you're not doing it right. Jo was in the latter category, with an interesting twist. When we were really up against it, she (being a statuesque, red-headed Amazonian type) could offer the mostly male crew sexual favors. Obviously in jest, it nonetheless had a remarkably persuasive effect when discussing overtime.

I'd never developed a good relationship with an editor. During the making of my shorts, that had always been the missing piece in the team. So I tried to think of films I'd seen recently that had really outstanding editing, and DUST by Milcho Manchevski, edited by Nic Gaster, was one of them. A film with temporal and conceptual changes at every turn, it contains battle scenes that, although brutal, are almost balletic. Fortunately he was available and interested.

Additional picture credits:

Photographs on pages: 8,20,21,23,24,25,26,27,29,30,35,42,44,48,70,72,158,165,168,184,201
are by Mark Spencer

Photographs on pages: 23,49,99,107,180,181,191,201
are by Antony Shearn

Photographs on pages: 198,200
are by Vanessa Kellas

Images on pages: 1,16,17,38,39,109,124,126,150,151,152,155,157,159
include drawings by Ian Miller

This book is dedicated to my little team:

Simon Moorhead
Tony Shearn
Max McMullin

with big thanks.

DM

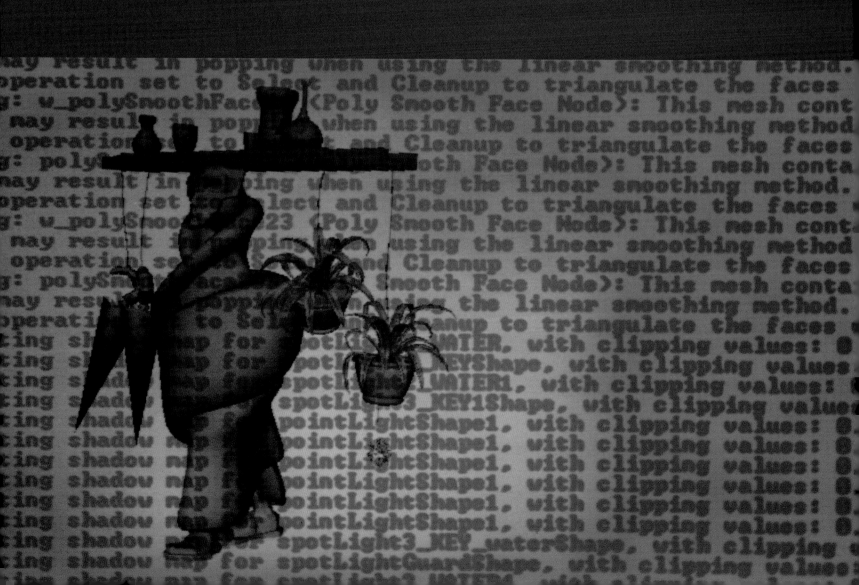

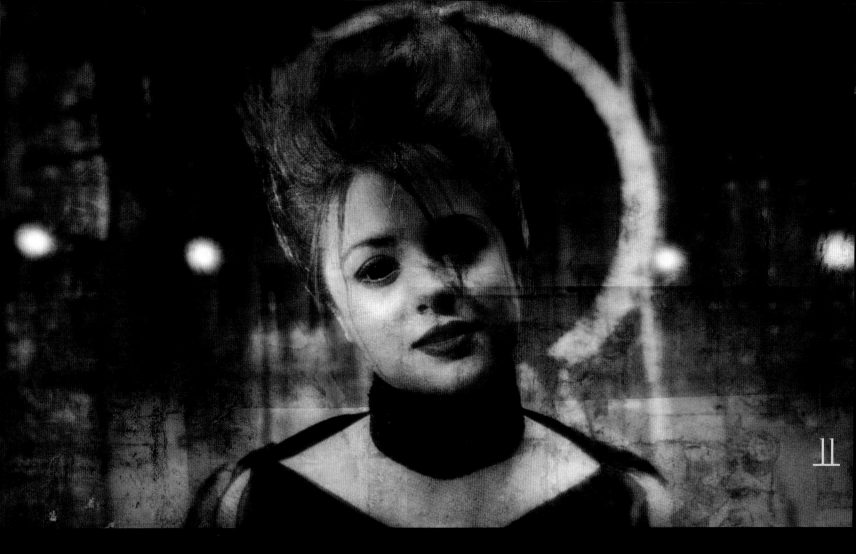

Fifteen months later we limped, bruised and beaten, over the finishing line.

A major lesson learned: Don't try to set up a studio full of computers and networking during production. They need a good four months to settle into their new home, get to know each other, and decide that they are actually going to work together before a single animator goes near them. I never realized computers are as individually temperamental as people. This wasn't really helped by our technical manager Dave Barnard's habit of naming the machines according to increasingly impenetrable systems. The four Macs that we used for editing and compositing were named after the BEATLES. I was John. Fair enough. But when we needed a fifth, he called it Yoko, and that's when they all stopped talking to each other. For some reason Paul could never seem to get permission to take files off John; Ringo couldn't get into any of them without re-asking for permission every morning; George sometimes had trouble getting permission to access himself.

Meanwhile, upstairs in the render farm, render allotment really, Dave had named the RAID arrays after the RAMONES in a vain hope that they might render really quickly. They did have encouraging bursts of speed, punctuated by crashes, burnouts, and an endless litany of gash frames that had to be "nitpicked" and deleted manually. I was never much of a RAMONES fan, so the names never meant anything to me, but my worst fears were realized when, sadly, one of the actual band members died during the minor heat wave we suffered in May. Our air-conditioning packed up, electricity supplies melted, alarms sounded, and Simon had his foot crushed by a falling faulty air-con unit while helping a hopeless hire company move them up and down stairs. We ended up using a far better company called Chilli Pepper Hire, whose main operative treated his job like a daily episode of MISSION IMPOSSIBLE.

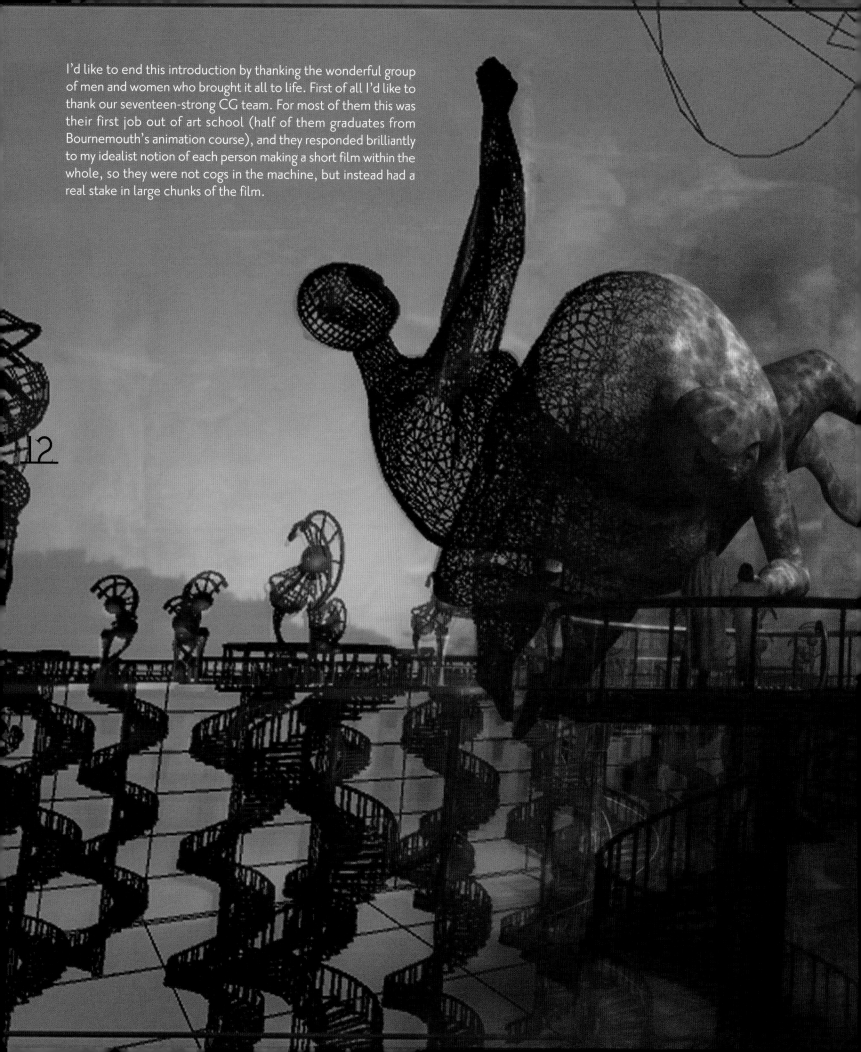

I'd like to end this introduction by thanking the wonderful group of men and women who brought it all to life. First of all I'd like to thank our seventeen-strong CG team. For most of them this was their first job out of art school (half of them graduates from Bournemouth's animation course), and they responded brilliantly to my idealist notion of each person making a short film within the whole, so they were not cogs in the machine, but instead had a real stake in large chunks of the film.

12

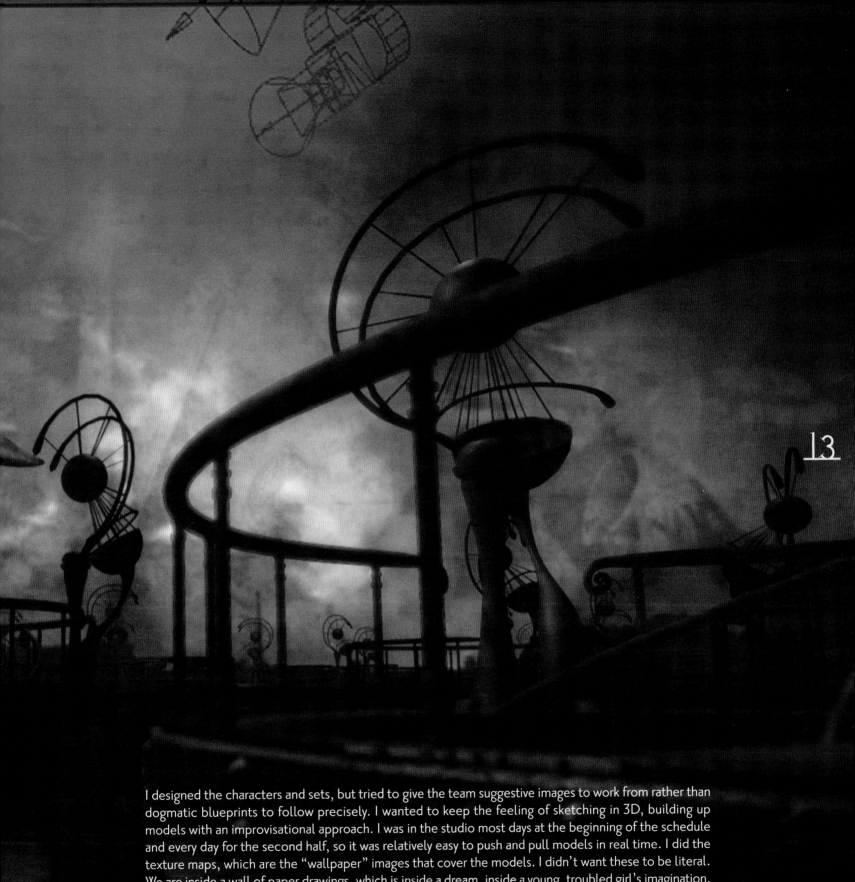

I designed the characters and sets, but tried to give the team suggestive images to work from rather than dogmatic blueprints to follow precisely. I wanted to keep the feeling of sketching in 3D, building up models with an improvisational approach. I was in the studio most days at the beginning of the schedule and every day for the second half, so it was relatively easy to push and pull models in real time. I did the texture maps, which are the "wallpaper" images that cover the models. I didn't want these to be literal. We are inside a wall of paper drawings, which is inside a dream, inside a young, troubled girl's imagination. So images are embedded in the floor and engraved onto the walls. There are paper skies and metal floors and doodles and calligraphy hanging in the air. The creatures are made of stone, bone, and wood, with cloth and string tying them together; their faces are simple, two-dots-and-a-dash faces, as if drawn as cartoons. They are sculptures made from books and rocks and bags of rubbish. The digital world can go anywhere and do anything, yet is usually called upon to re-create the real world. Although an astonishing technical achievement, this seems to me to be a narrow goal.

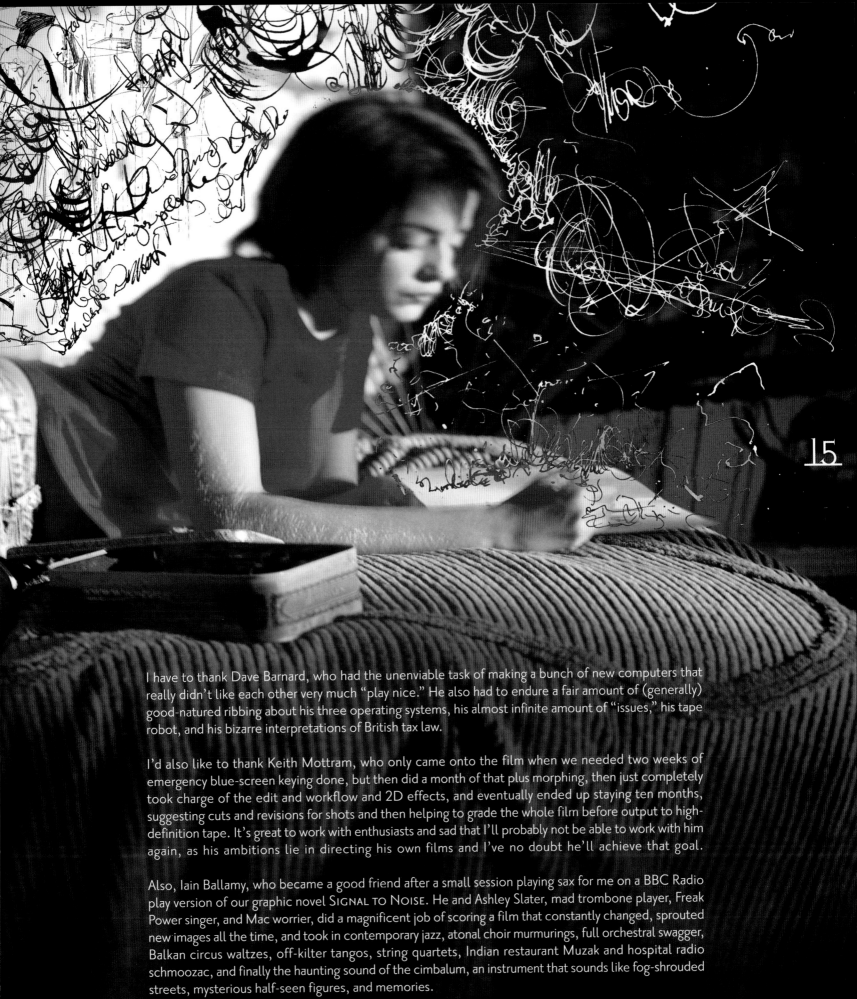

15

I have to thank Dave Barnard, who had the unenviable task of making a bunch of new computers that really didn't like each other very much "play nice." He also had to endure a fair amount of (generally) good-natured ribbing about his three operating systems, his almost infinite amount of "issues," his tape robot, and his bizarre interpretations of British tax law.

I'd also like to thank Keith Mottram, who only came onto the film when we needed two weeks of emergency blue-screen keying done, but then did a month of that plus morphing, then just completely took charge of the edit and workflow and 2D effects, and eventually ended up staying ten months, suggesting cuts and revisions for shots and then helping to grade the whole film before output to high-definition tape. It's great to work with enthusiasts and sad that I'll probably not be able to work with him again, as his ambitions lie in directing his own films and I've no doubt he'll achieve that goal.

Also, Iain Ballamy, who became a good friend after a small session playing sax for me on a BBC Radio play version of our graphic novel SIGNAL TO NOISE. He and Ashley Slater, mad trombone player, Freak Power singer, and Mac worrier, did a magnificent job of scoring a film that constantly changed, sprouted new images all the time, and took in contemporary jazz, atonal choir murmurings, full orchestral swagger, Balkan circus waltzes, off-kilter tangos, string quartets, Indian restaurant Muzak and hospital radio schmoozac, and finally the haunting sound of the cimbalum, an instrument that sounds like fog-shrouded streets, mysterious half-seen figures, and memories.

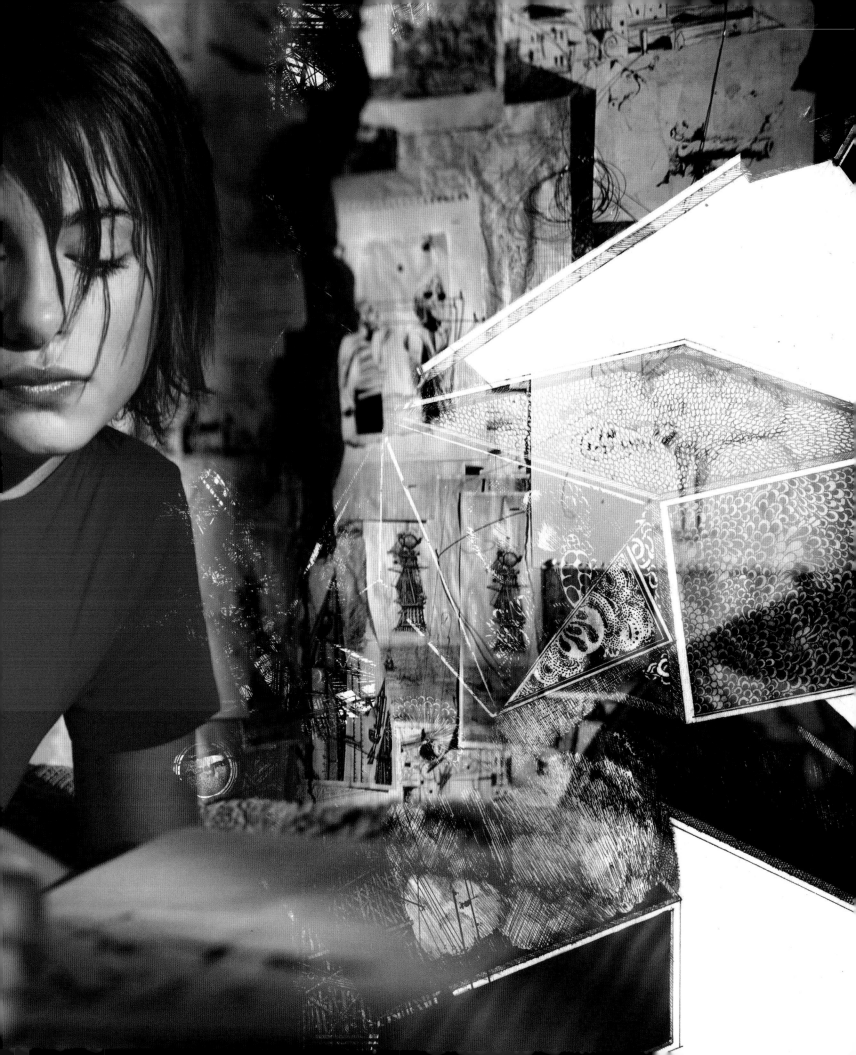

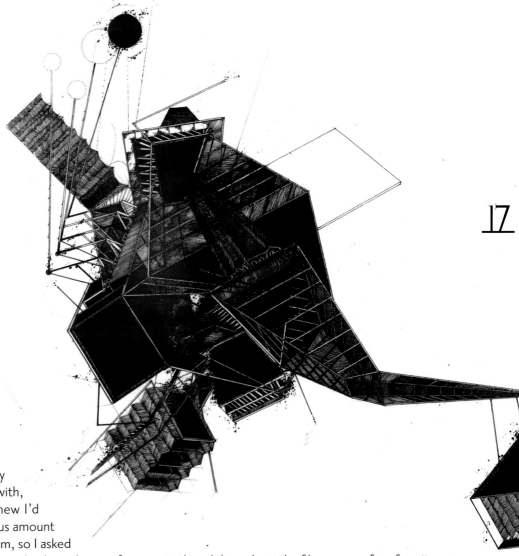

I'd like to thank Ian Miller, whom I've known for many
years, but had never had the opportunity to work with,
despite a number of promising occasions. I knew I'd
never have the time to generate the enormous amount
of drawings to wallpaper Helena's bedroom, so I asked
Ian if he would contribute some of his huge back catalogue of images to thread throughout the film, some of my favorites
are on these pages.

Finally I'd like to thank my trusty collaborators over many projects now: Neil, of course, for getting me involved
in slaying this monster in the first place; Simon, for making me feel like everything was under control, and
somehow navigating successfully between my panic attacks that related to real problems and the ones
that were just panic attacks; Tony, who saved the bottle of champagne I gave him after we finished
shooting THE WEEK BEFORE and gave it back to me on the last day's shoot of MIRRORMASK, having
kept it in his fridge for six years ("I knew this day would come," he said); and Max, for answering
my "help" phone call to Australia, where he now resides, leaving his wife and family for the
best part of a year to work with me in London, and for never mentioning the words "chew,"
"bitten," and "more than" during the whole grueling schedule.

An "Art of..." book is a curious thing, usually a document of the sketches, paintings, and other preparatory work behind the film, a record of costume designs and props and models. All of this material is usually generated before a film begins production because many different individuals need to explain to each other what they are planning to do. So much of that process was bypassed on MirrorMask because there were so few levels of approval of design, actually only one, me. So much of the designing was done ad lib on the day, doodling in 3D or acting out nonsense in the studio. So this book is a collection of images, some factual, some descriptive, but many just suggestive, a record of the feeling of making the film rather than a definitive handbook.

So welcome to a part of the art of...

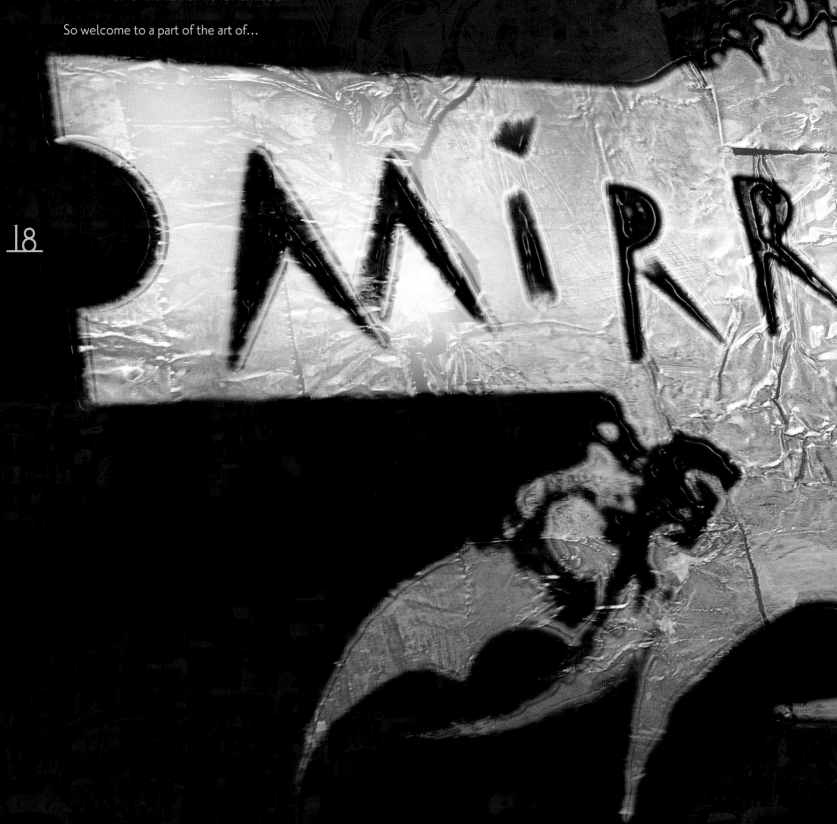

Contents

18, 19 Titles & Contents

19

Biographies and End Titles

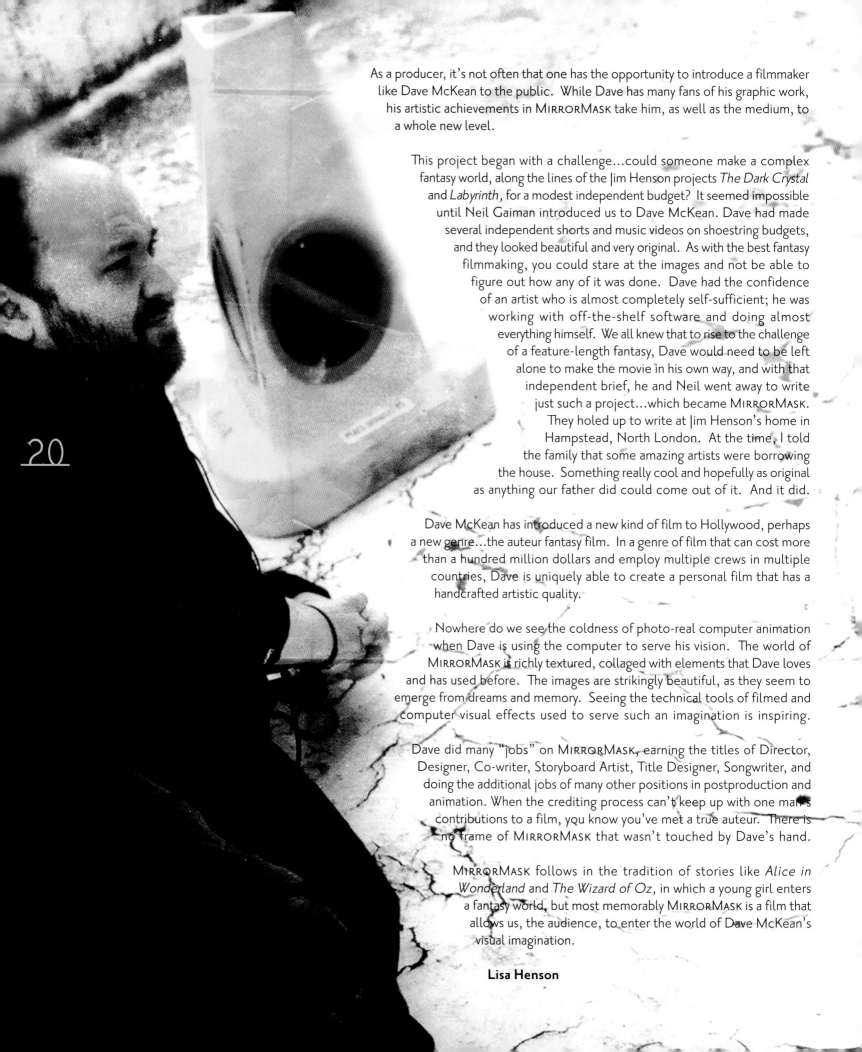

As a producer, it's not often that one has the opportunity to introduce a filmmaker like Dave McKean to the public. While Dave has many fans of his graphic work, his artistic achievements in MIRRORMASK take him, as well as the medium, to a whole new level.

This project began with a challenge…could someone make a complex fantasy world, along the lines of the Jim Henson projects *The Dark Crystal* and *Labyrinth,* for a modest independent budget? It seemed impossible until Neil Gaiman introduced us to Dave McKean. Dave had made several independent shorts and music videos on shoestring budgets, and they looked beautiful and very original. As with the best fantasy filmmaking, you could stare at the images and not be able to figure out how any of it was done. Dave had the confidence of an artist who is almost completely self-sufficient; he was working with off-the-shelf software and doing almost everything himself. We all knew that to rise to the challenge of a feature-length fantasy, Dave would need to be left alone to make the movie in his own way, and with that independent brief, he and Neil went away to write just such a project…which became MIRRORMASK. They holed up to write at Jim Henson's home in Hampstead, North London. At the time, I told the family that some amazing artists were borrowing the house. Something really cool and hopefully as original as anything our father did could come out of it. And it did.

Dave McKean has introduced a new kind of film to Hollywood, perhaps a new genre…the auteur fantasy film. In a genre of film that can cost more than a hundred million dollars and employ multiple crews in multiple countries, Dave is uniquely able to create a personal film that has a handcrafted artistic quality.

Nowhere do we see the coldness of photo-real computer animation when Dave is using the computer to serve his vision. The world of MIRRORMASK is richly textured, collaged with elements that Dave loves and has used before. The images are strikingly beautiful, as they seem to emerge from dreams and memory. Seeing the technical tools of filmed and computer visual effects used to serve such an imagination is inspiring.

Dave did many "jobs" on MIRRORMASK, earning the titles of Director, Designer, Co-writer, Storyboard Artist, Title Designer, Songwriter, and doing the additional jobs of many other positions in postproduction and animation. When the crediting process can't keep up with one man's contributions to a film, you know you've met a true auteur. There is no frame of MIRRORMASK that wasn't touched by Dave's hand.

MIRRORMASK follows in the tradition of stories like *Alice in Wonderland* and *The Wizard of Oz,* in which a young girl enters a fantasy world, but most memorably MIRRORMASK is a film that allows us, the audience, to enter the world of Dave McKean's visual imagination.

Lisa Henson

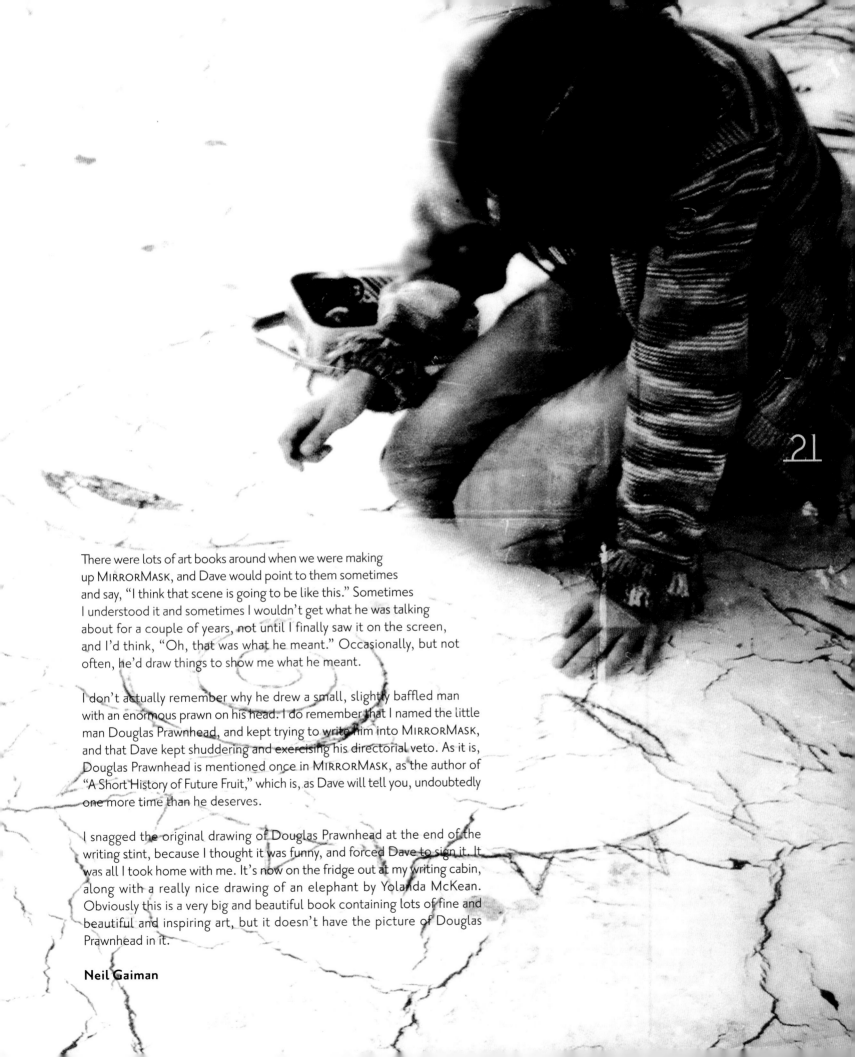

There were lots of art books around when we were making up MIRRORMASK, and Dave would point to them sometimes and say, "I think that scene is going to be like this." Sometimes I understood it and sometimes I wouldn't get what he was talking about for a couple of years, not until I finally saw it on the screen, and I'd think, "Oh, that was what he meant." Occasionally, but not often, he'd draw things to show me what he meant.

I don't actually remember why he drew a small, slightly baffled man with an enormous prawn on his head. I do remember that I named the little man Douglas Prawnhead, and kept trying to write him into MIRRORMASK, and that Dave kept shuddering and exercising his directorial veto. As it is, Douglas Prawnhead is mentioned once in MIRRORMASK, as the author of "A Short History of Future Fruit," which is, as Dave will tell you, undoubtedly one more time than he deserves.

I snagged the original drawing of Douglas Prawnhead at the end of the writing stint, because I thought it was funny, and forced Dave to sign it. It was all I took home with me. It's now on the fridge out at my writing cabin, along with a really nice drawing of an elephant by Yolanda McKean. Obviously this is a very big and beautiful book containing lots of fine and beautiful and inspiring art, but it doesn't have the picture of Douglas Prawnhead in it.

Neil Gaiman

BACKSTAGE AT
THE CIRCUS.

CircUs

I can't remember why the circus ended up at the center of the story. I remember seeing Cirque du Soleil and sending Neil an e-mail of scenes and characters suggested by some of the acts. I also remember trying to think of things in our world that could be slippage or leakage from some other world. Things that have lost their origins, things with odd rules that no one really understands, or costumes and traditions that are repeated simply because they've always been done that way. I think I imagined that the fantasy world would have similar leakage from our world, with art and entertainment and sport that reflected aspects of our everyday lives, but in strange, abstracted, evolved forms. Maybe the trapeze act could be an interpretation of flying creatures; maybe the balancing strong man act could be a reimagining of huge stone statues poised in space, gravitationally attracted against each other. Maintaining these dualities proved to be a bit convoluted in the end, but the circus imagery stayed and these two ideas in particular embedded themselves into the film. After deciding to set the film in a circus, the first call I made to Simon Moorhead concerned the practicalities of shooting in a circus. Do we build one? Can we buy a big top? In the end, we hired Arnett and Paulo's Circus in London, and their staff and performers couldn't have done enough to help us, giving us free run of their tents and equipment for the three days we were there.

DM

23

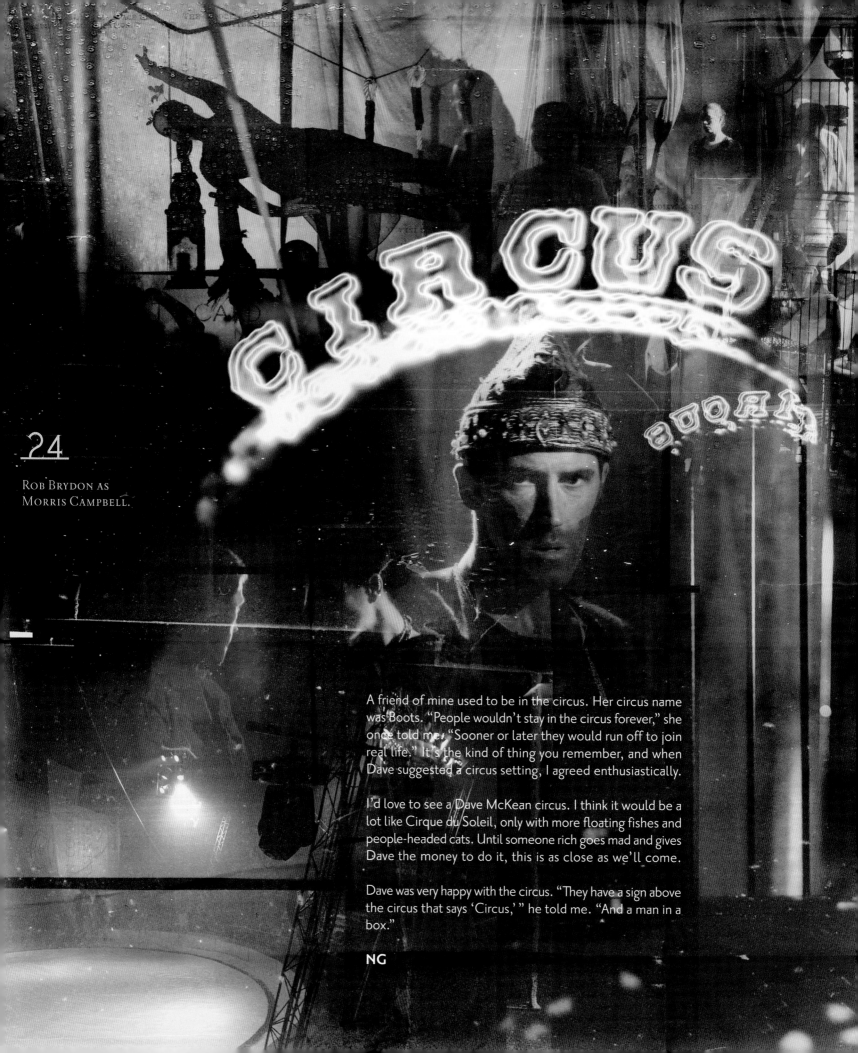

CIRCUS

ROB BRYDON AS
MORRIS CAMPBELL.

A friend of mine used to be in the circus. Her circus name
was Boots. "People wouldn't stay in the circus forever," she
once told me, "Sooner or later they would run off to join
real life." It's the kind of thing you remember, and when
Dave suggested a circus setting, I agreed enthusiastically.

I'd love to see a Dave McKean circus. I think it would be a
lot like Cirque du Soleil, only with more floating fishes and
people-headed cats. Until someone rich goes mad and gives
Dave the money to do it, this is as close as we'll come.

Dave was very happy with the circus. "They have a sign above
the circus that says 'Circus,' " he told me. "And a man in a
box."

NG

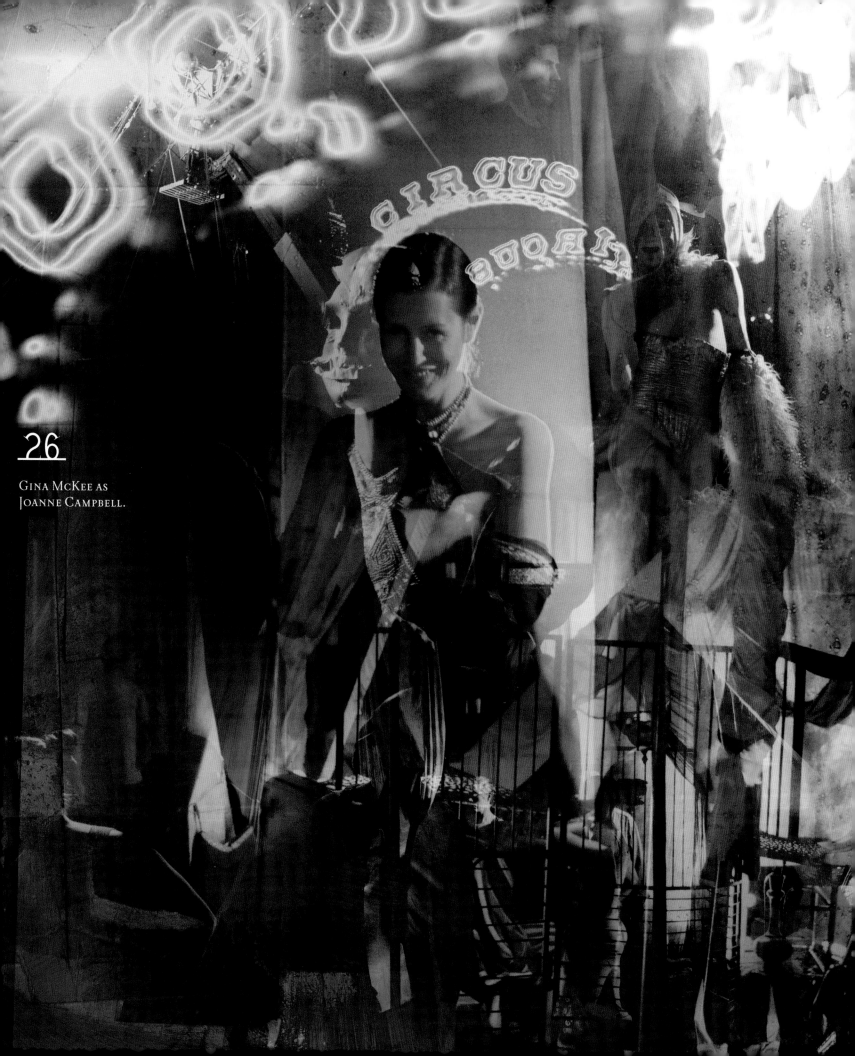

GINA MCKEE AS
JOANNE CAMPBELL.

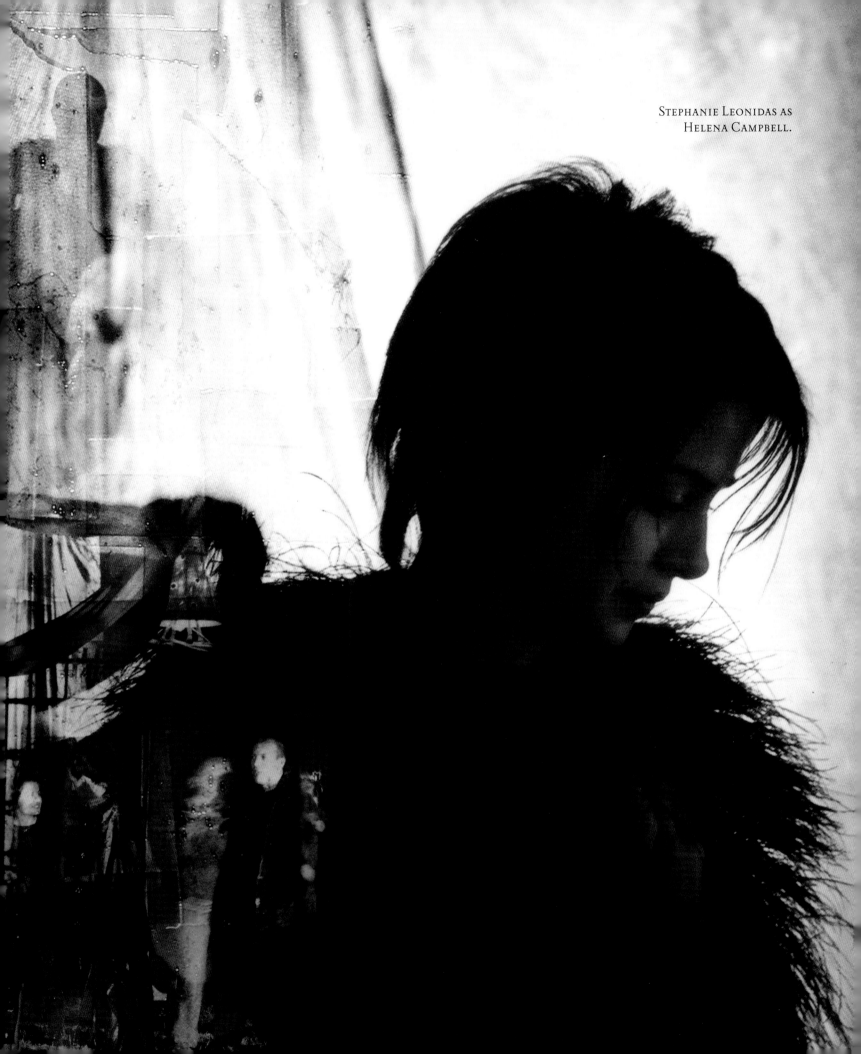

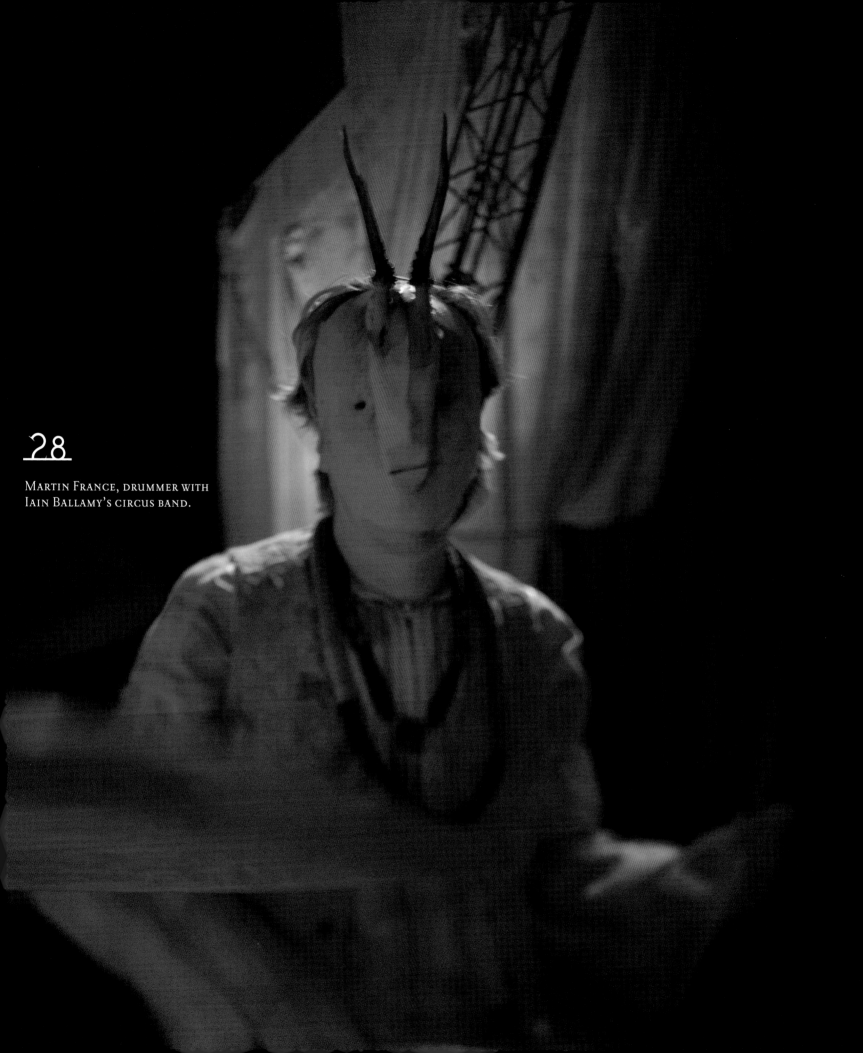

28

Martin France, drummer with
Iain Ballamy's circus band.

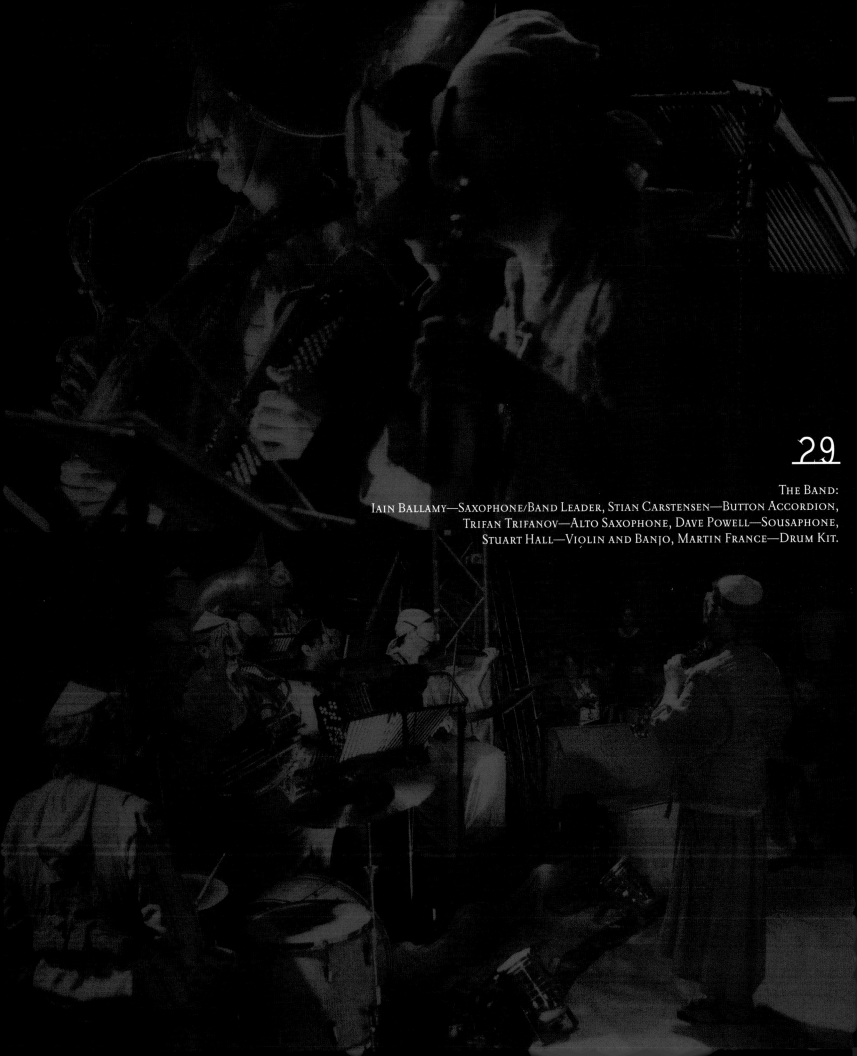

29

The Band:
Iain Ballamy—Saxophone/Band Leader, Stian Carstensen—Button Accordion,
Trifan Trifanov—Alto Saxophone, Dave Powell—Sousaphone,
Stuart Hall—Violin and Banjo, Martin France—Drum Kit.

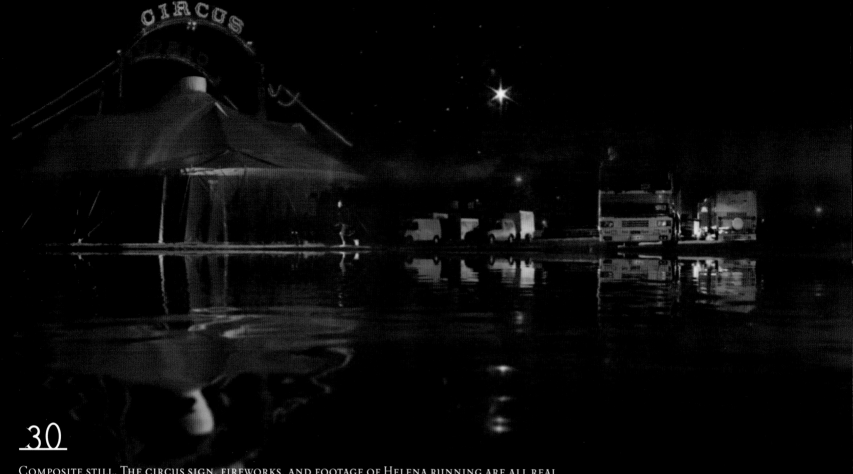

Composite still. The circus sign, fireworks, and footage of Helena running are all real. The background is a still collage. The water is computer generated.

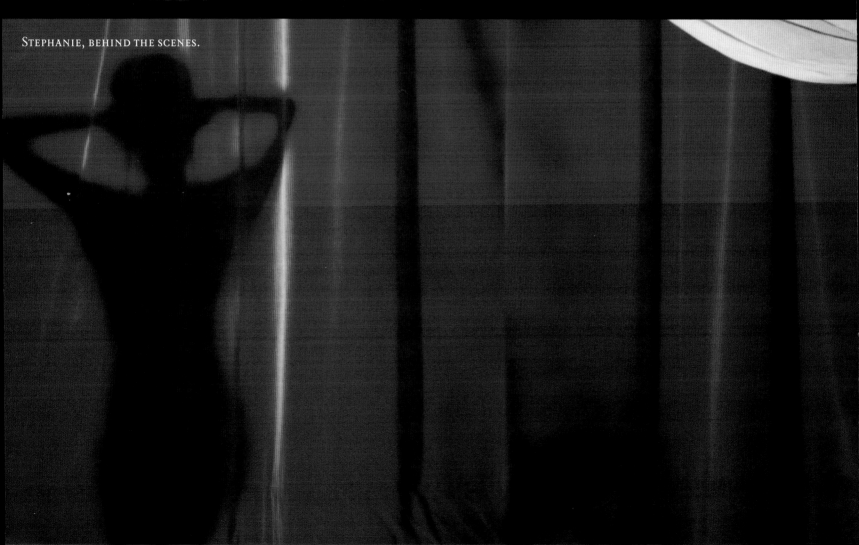

Stephanie, behind the scenes.

The CAMPBELL FAMILY

ONE OF THREE CIRCUS
POSTERS CREATED FOR
THE FILM.

the best little BIG top alive.

3pm and 7pm. Saturday 2nd. June - Sunday 10th. June,
Moorhead Park, Brighton.
Ticket prices adults: £6 - £12, children: £2 - £6

Tickets available from Bakers in the High Street, and from Hensons under the railway arches.

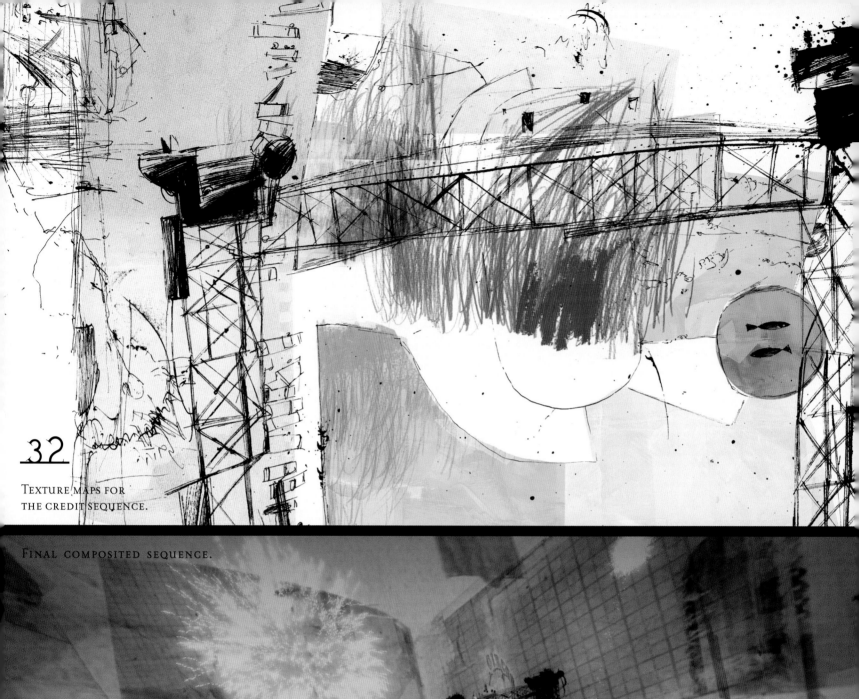

32

TEXTURE MAPS FOR
THE CREDIT SEQUENCE.

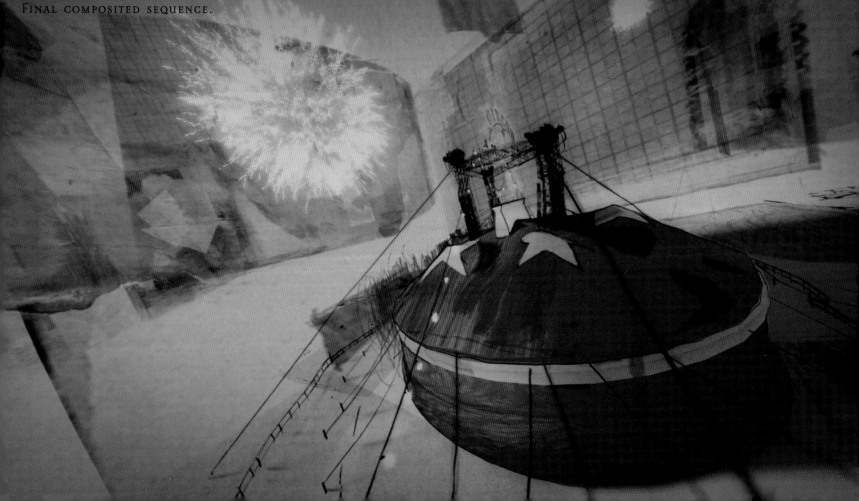

FINAL COMPOSITED SEQUENCE.

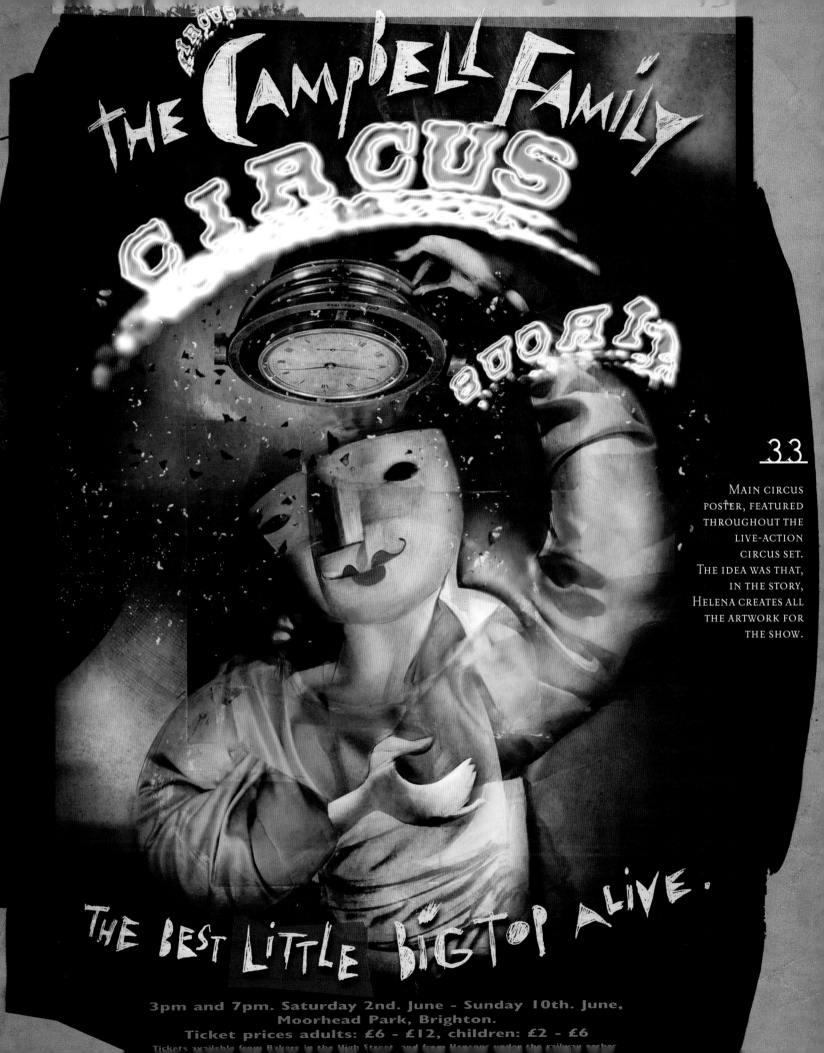

THE **Campbell Family**
CIRCUS
CIRCUS

MAIN CIRCUS
POSTER, FEATURED
THROUGHOUT THE
LIVE-ACTION
CIRCUS SET.
THE IDEA WAS THAT,
IN THE STORY,
HELENA CREATES ALL
THE ARTWORK FOR
THE SHOW.

THE BEST LITTLE BIGTOP ALIVE.

3pm and 7pm. Saturday 2nd. June - Sunday 10th. June,
Moorhead Park, Brighton.
Ticket prices adults: £6 - £12, children: £2 - £6

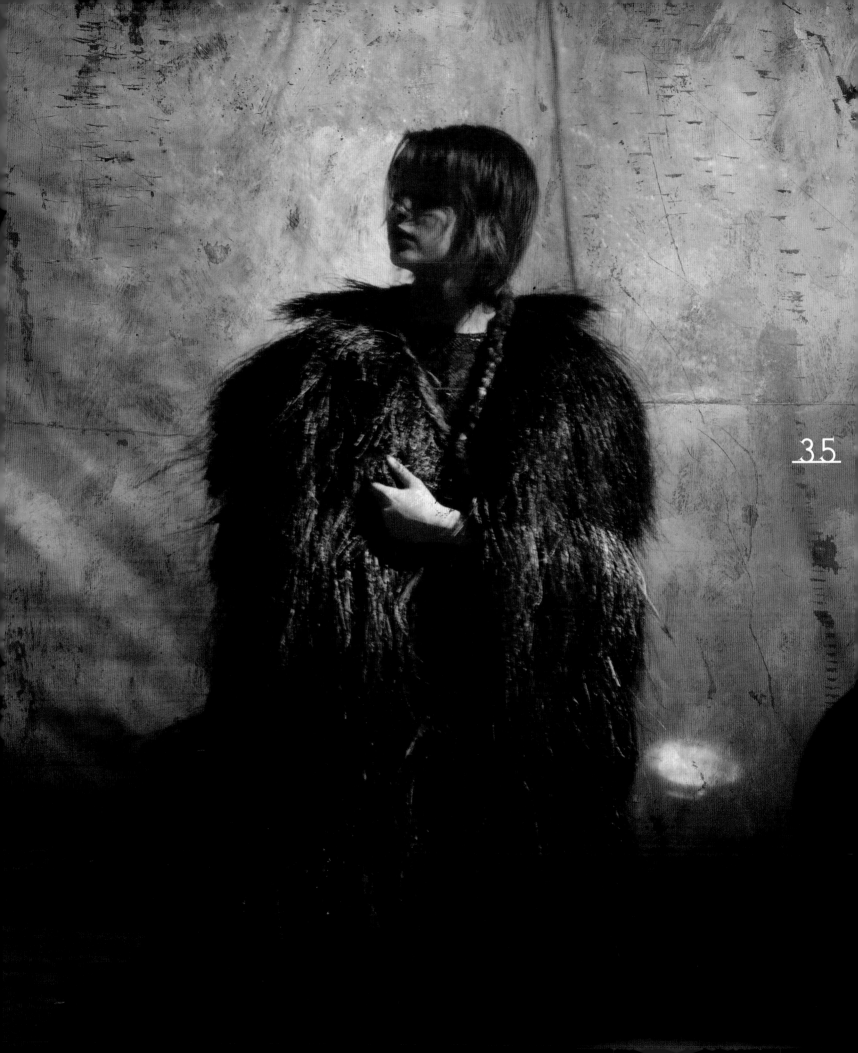

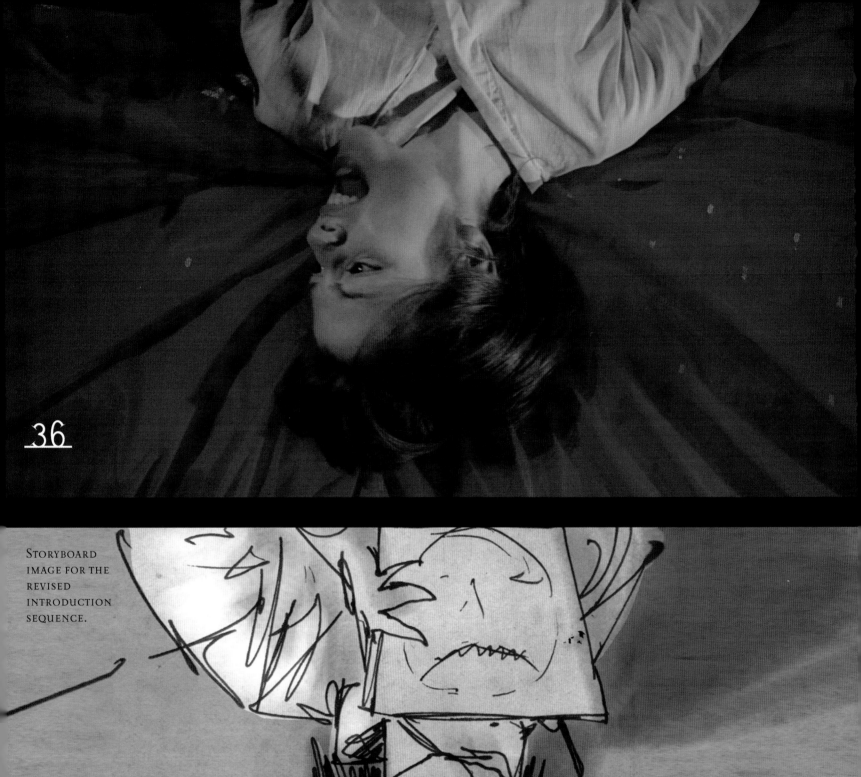

36

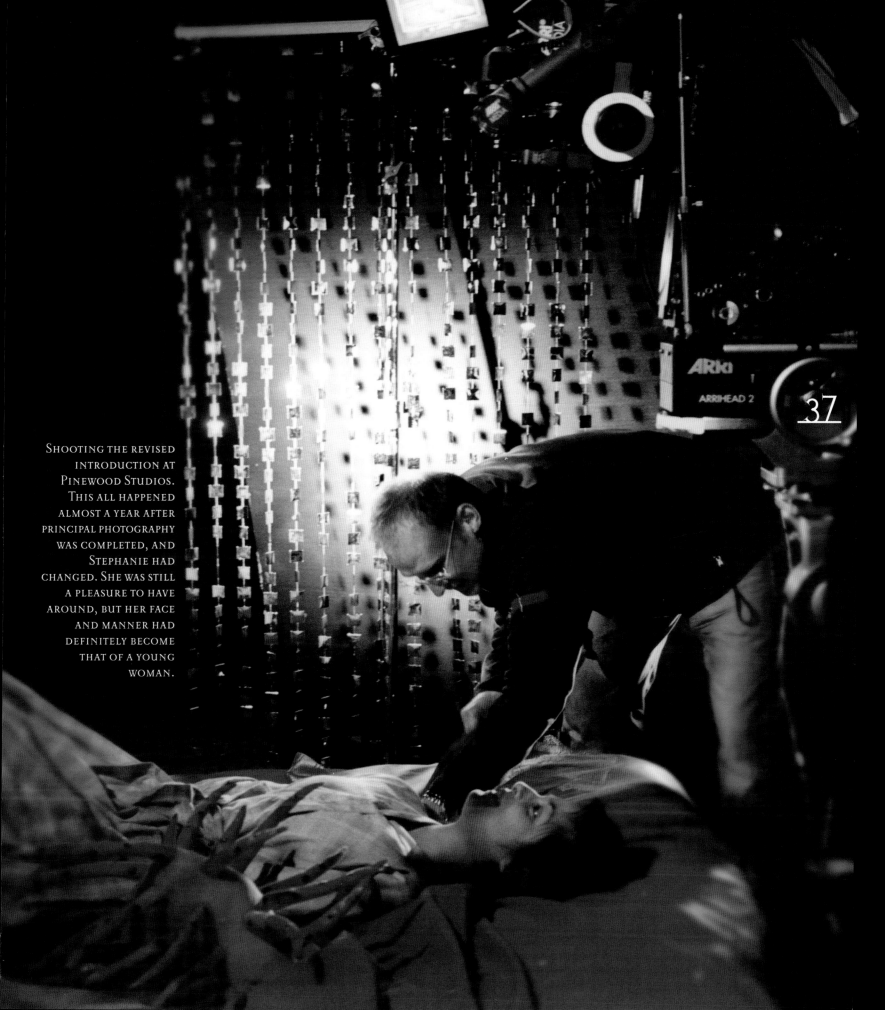

SHOOTING THE REVISED
INTRODUCTION AT
PINEWOOD STUDIOS.
THIS ALL HAPPENED
ALMOST A YEAR AFTER
PRINCIPAL PHOTOGRAPHY
WAS COMPLETED, AND
STEPHANIE HAD
CHANGED. SHE WAS STILL
A PLEASURE TO HAVE
AROUND, BUT HER FACE
AND MANNER HAD
DEFINITELY BECOME
THAT OF A YOUNG
WOMAN.

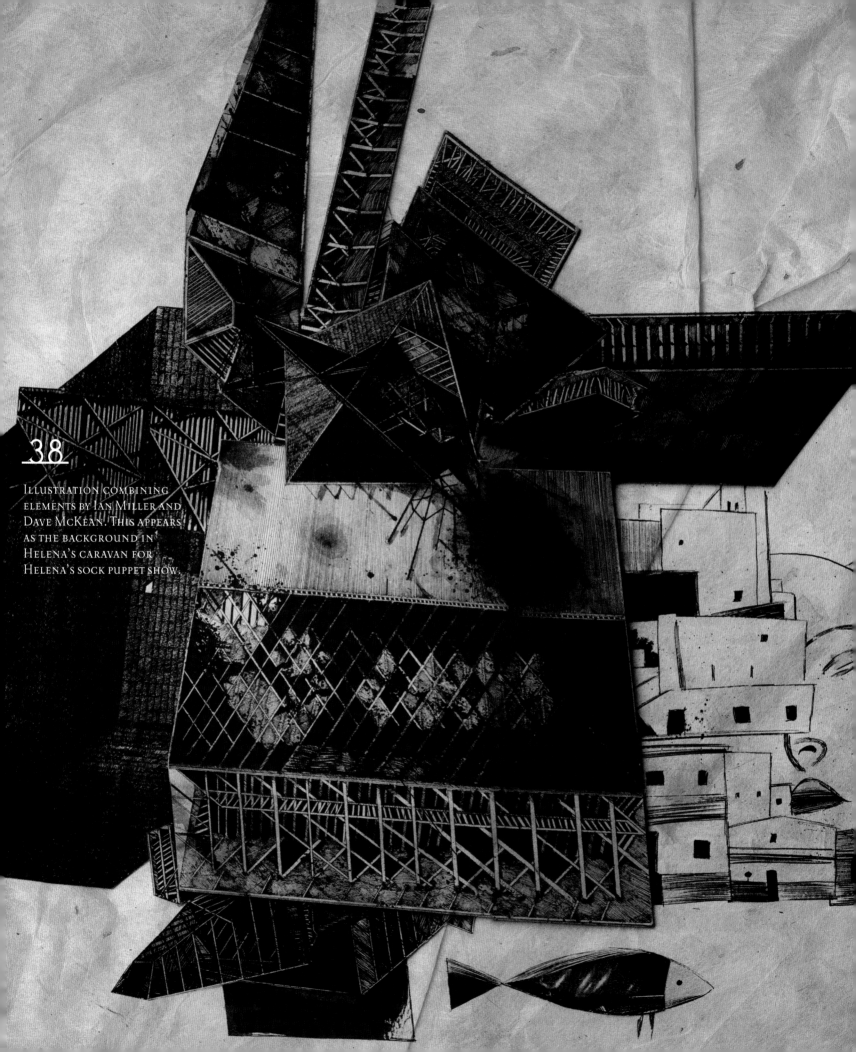

38

ILLUSTRATION COMBINING
ELEMENTS BY IAN MILLER AND
DAVE MCKEAN. THIS APPEARS
AS THE BACKGROUND IN
HELENA'S CARAVAN FOR
HELENA'S SOCK PUPPET SHOW.

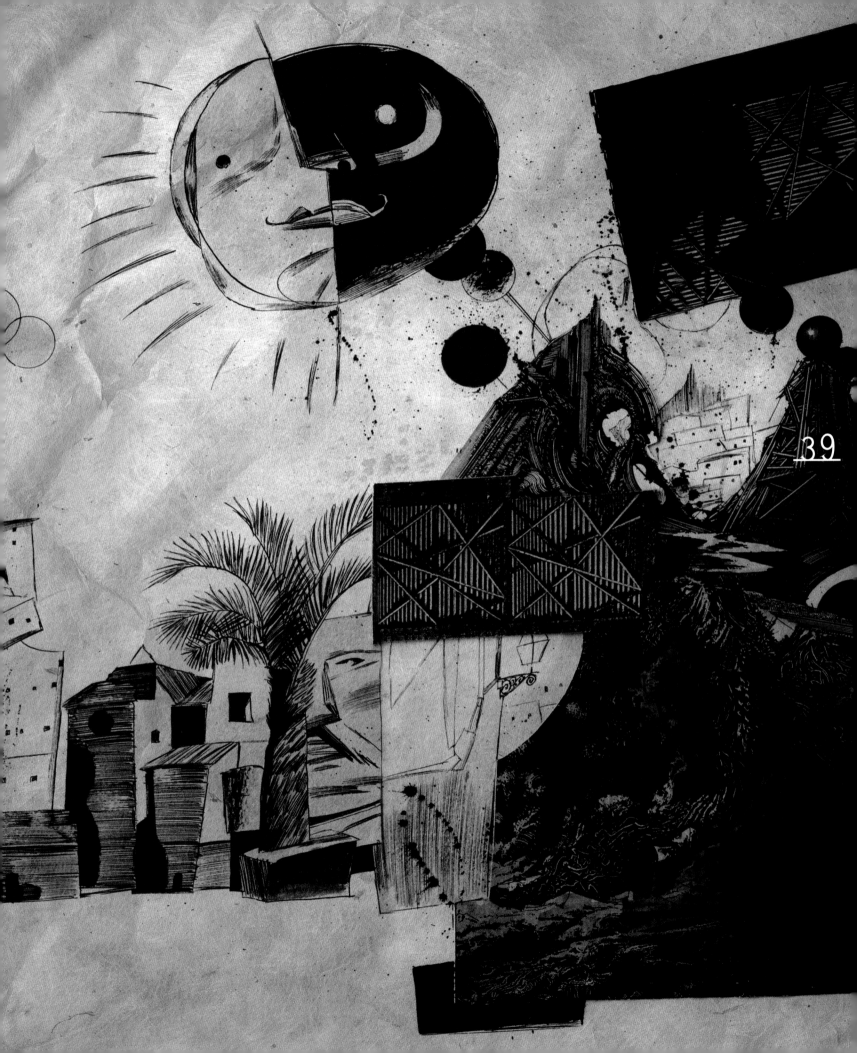

39

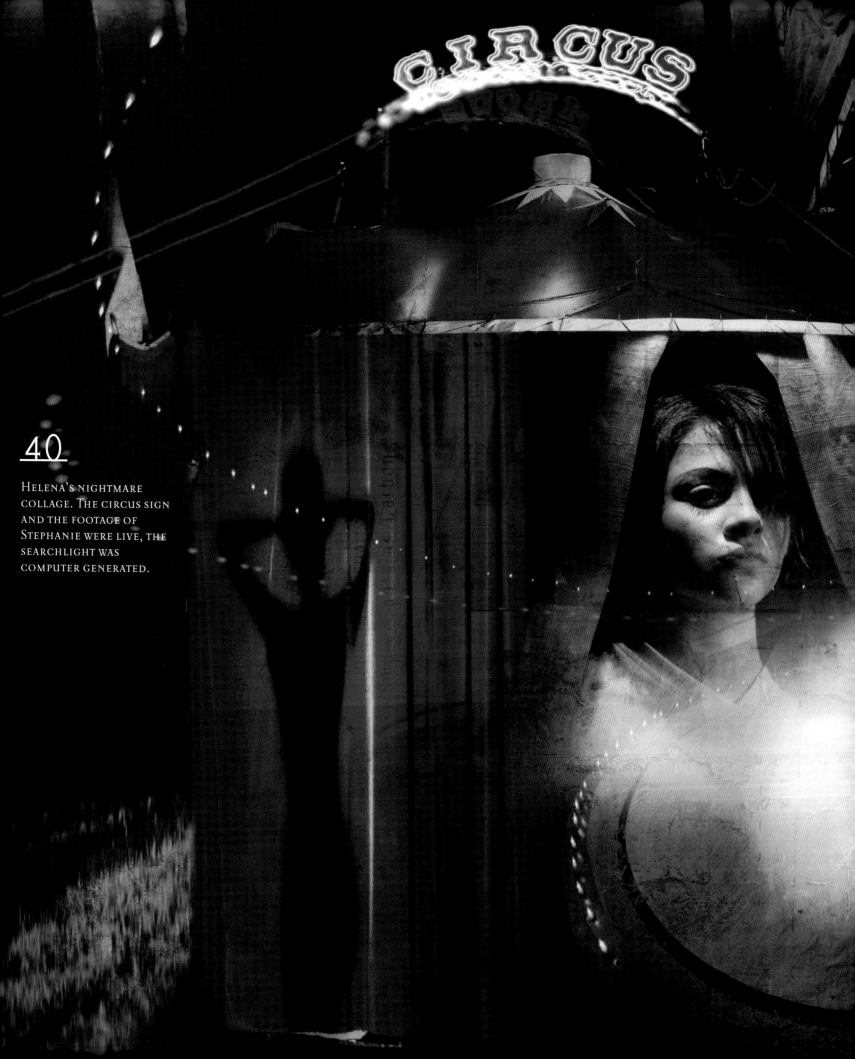

40

HELENA'S NIGHTMARE
COLLAGE. THE CIRCUS SIGN
AND THE FOOTAGE OF
STEPHANIE WERE LIVE, THE
SEARCHLIGHT WAS
COMPUTER GENERATED.

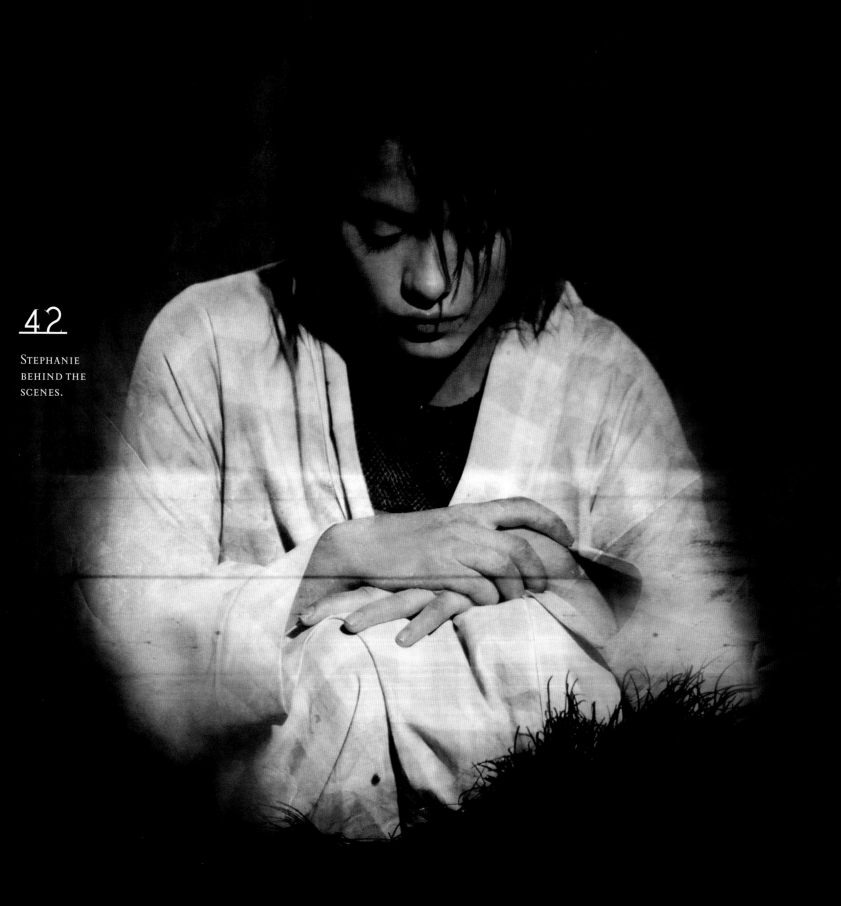

42

STEPHANIE
BEHIND THE
SCENES.

HeIena

Stephanie Leonidas

I can't praise Stephanie Leonidas enough. I've never really worked with actors before. My short films were puppeteered rather than directed, and even though the actors were wonderful, the characters I created didn't really allow for much exploration.

If I ever do this ridiculous job of directing again, I hope I get a cast full of Stephanies. A pleasure to have around every day, she is in practically every frame of the film. She made the story work by making us empathize completely with Helena's anxiety at the start of the film, and making us believe that she believed everything that was happening to her. At one point Tony Shearn, the director of photography, was taking light readings and adjusting the spots during the cops scene. He asked Stephanie what she was using for an eye line, if she was looking at one of the sky pan lights overhead. "No," she said, "I'm looking at this circle of red beetley cops looking down at me."

Helena's journey in the film is represented by the different versions of herself in her dream. She is a kid who could either roll with the events in her life and become a responsible young adult, or could let those events roll over her, becoming a resentful and self-centered adolescent. In the end, of course, she is, like most fifteen-year-olds, a mix of the two. It's one thing to pull off this tension in a realistic drama, it's another challenge altogether to make us understand these emotions while regressing to a simpler, safer world of childhood fantasy. I think Stephanie really convinced us.

DM

44

HELENA, ENTRANCED
INTO HER DOLL-LIKE
INCARNATION.

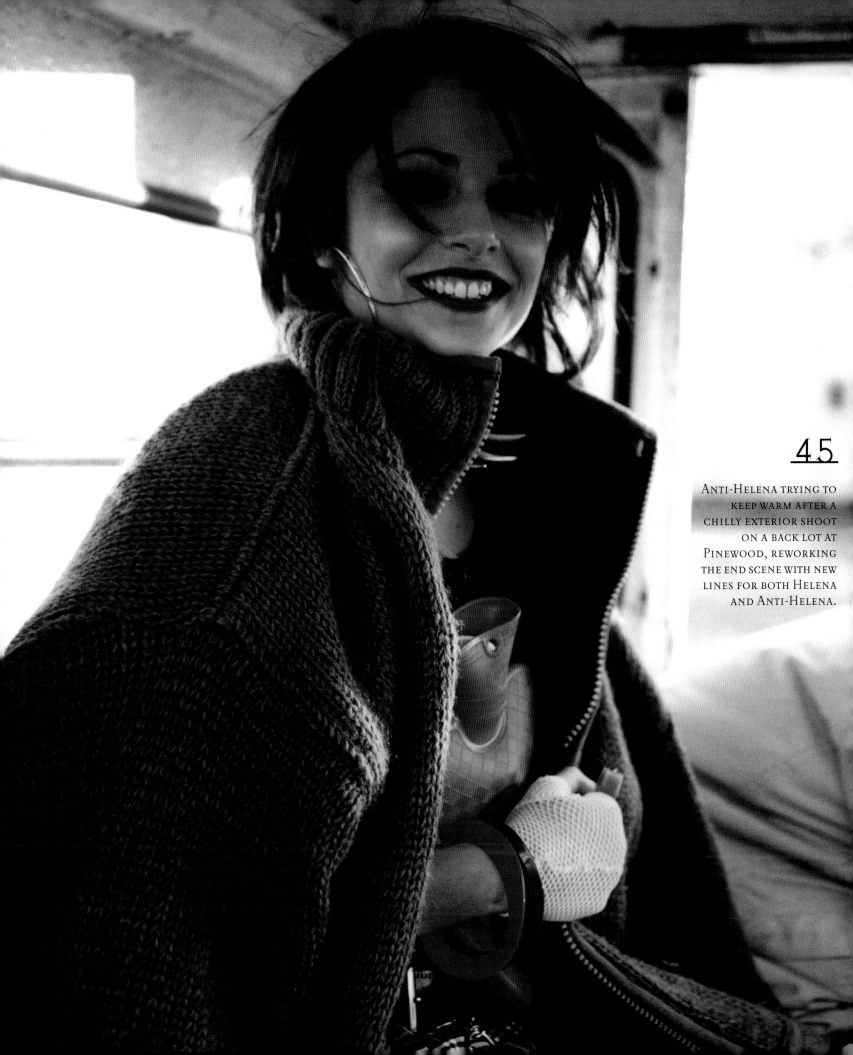

ANTI-HELENA TRYING TO
KEEP WARM AFTER A
CHILLY EXTERIOR SHOOT
ON A BACK LOT AT
PINEWOOD, REWORKING
THE END SCENE WITH NEW
LINES FOR BOTH HELENA
AND ANTI-HELENA.

46

Anti-Helena.

Film crews are mostly united by pressure, or more precisely by the conviction that every other film crew in the world is sleeping in and dining on bonbons, probably getting in a few shots between leisurely games of tennis, while this film crew is currently suffering the worst privations known to humanity. When I got to the MirrorMask set I found our film crew united on this, and on the conviction that Stephanie Leonidas was the nicest person they'd ever worked with.

The strange thing was that, while we wrote it, we were most worried about finding a Helena. We'd written the part as someone on the cusp between childhood and adulthood, and knew that finding someone good enough, someone who could be in every shot and convince you that she was really talking to monkeybirds or riddling with a gryphon would be next to impossible.

Stephanie was easy to find, in every shot, and made the film.

NG

47

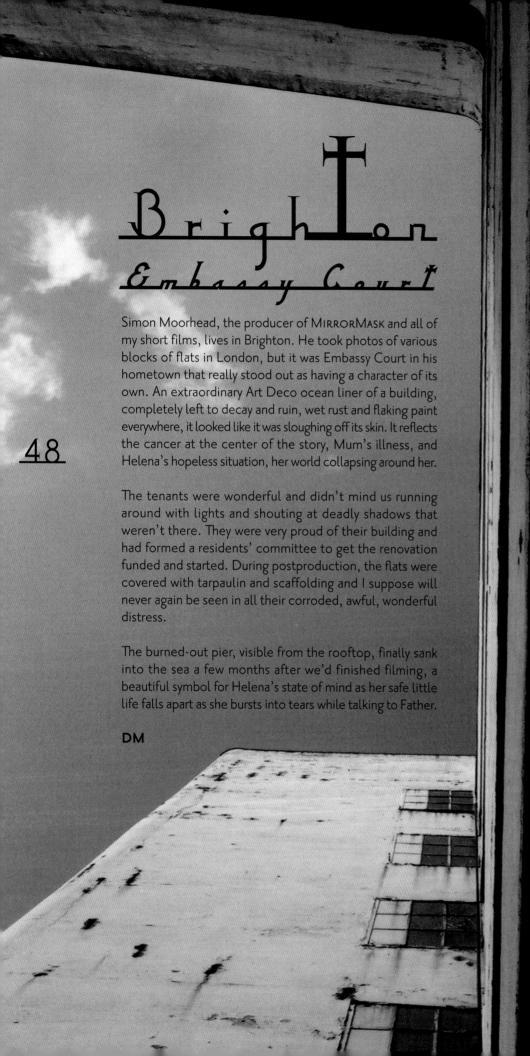

Brighton
Embassy Court

Simon Moorhead, the producer of MIRRORMASK and all of my short films, lives in Brighton. He took photos of various blocks of flats in London, but it was Embassy Court in his hometown that really stood out as having a character of its own. An extraordinary Art Deco ocean liner of a building, completely left to decay and ruin, wet rust and flaking paint everywhere, it looked like it was sloughing off its skin. It reflects the cancer at the center of the story, Mum's illness, and Helena's hopeless situation, her world collapsing around her.

The tenants were wonderful and didn't mind us running around with lights and shouting at deadly shadows that weren't there. They were very proud of their building and had formed a residents' committee to get the renovation funded and started. During postproduction, the flats were covered with tarpaulin and scaffolding and I suppose will never again be seen in all their corroded, awful, wonderful distress.

The burned-out pier, visible from the rooftop, finally sank into the sea a few months after we'd finished filming, a beautiful symbol for Helena's state of mind as her safe little life falls apart as she bursts into tears while talking to Father.

DM

48

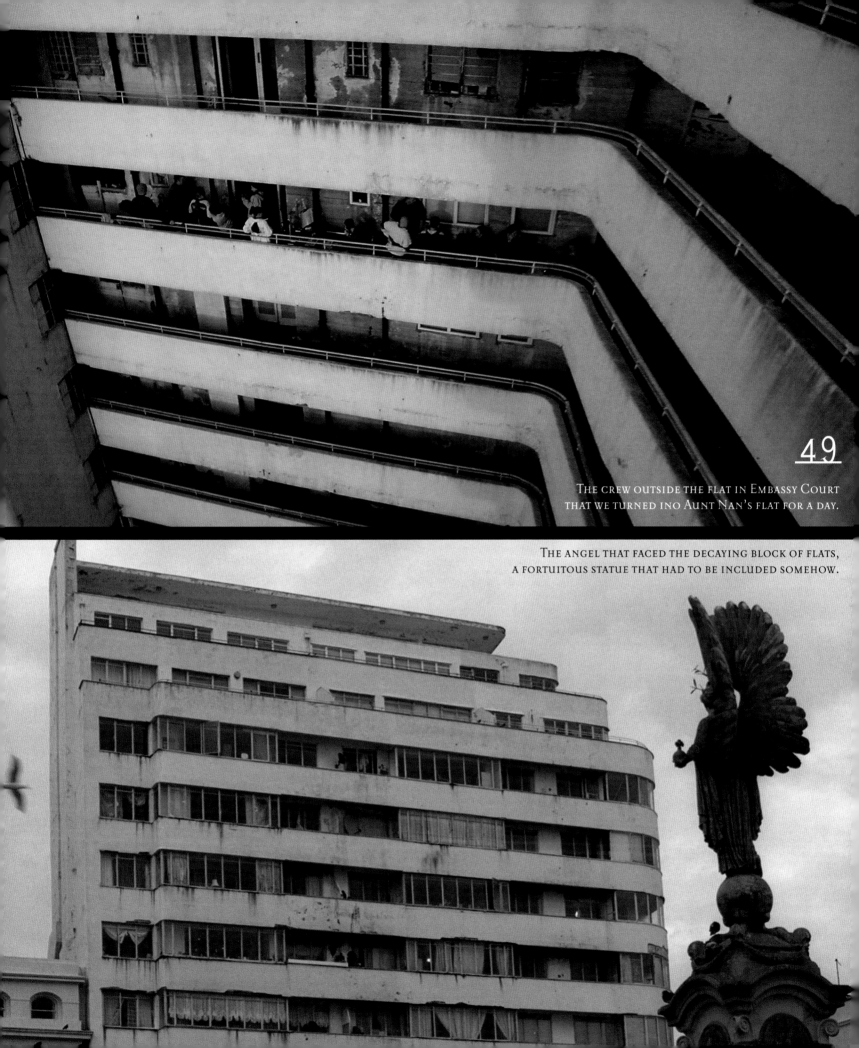

THE CREW OUTSIDE THE FLAT IN EMBASSY COURT
THAT WE TURNED INO AUNT NAN'S FLAT FOR A DAY.

THE ANGEL THAT FACED THE DECAYING BLOCK OF FLATS,
A FORTUITOUS STATUE THAT HAD TO BE INCLUDED SOMEHOW.

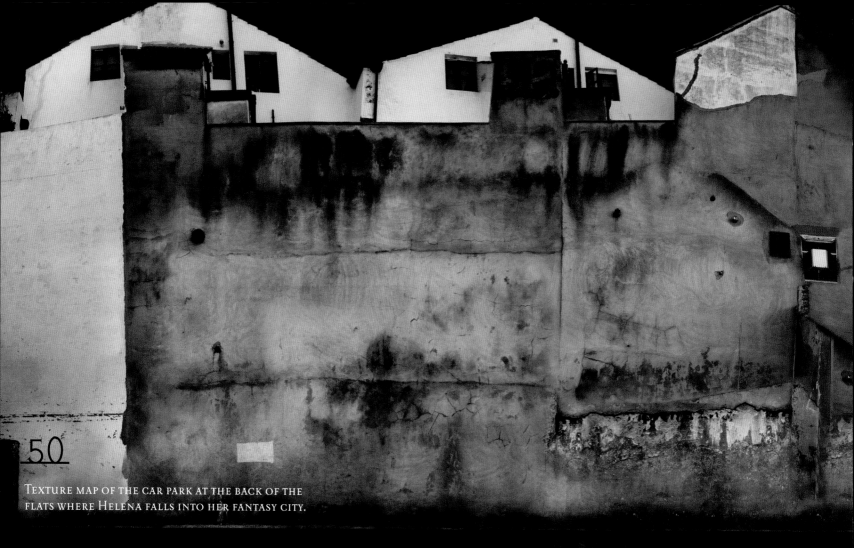

50

Texture map of the car park at the back of the
flats where Helena falls into her fantasy city.

When we wrote it, I assumed we'd be shooting in London, where there are lots of decaying tower blocks. Simon Moorhead, our producer, found Embassy Court. It, and the wrecked pier in the background, are preserved forever like this, although Embassy Court has now been restored, and the West Pier has, following a couple of subsequent arson attacks, fallen into the sea.

It also meant that it was easy to cast Dora Bryan, who lives in Brighton, as Aunt Nan, something that made me happy. She's someone who has been part of British comedy, and the British film world, for more than 50 years.

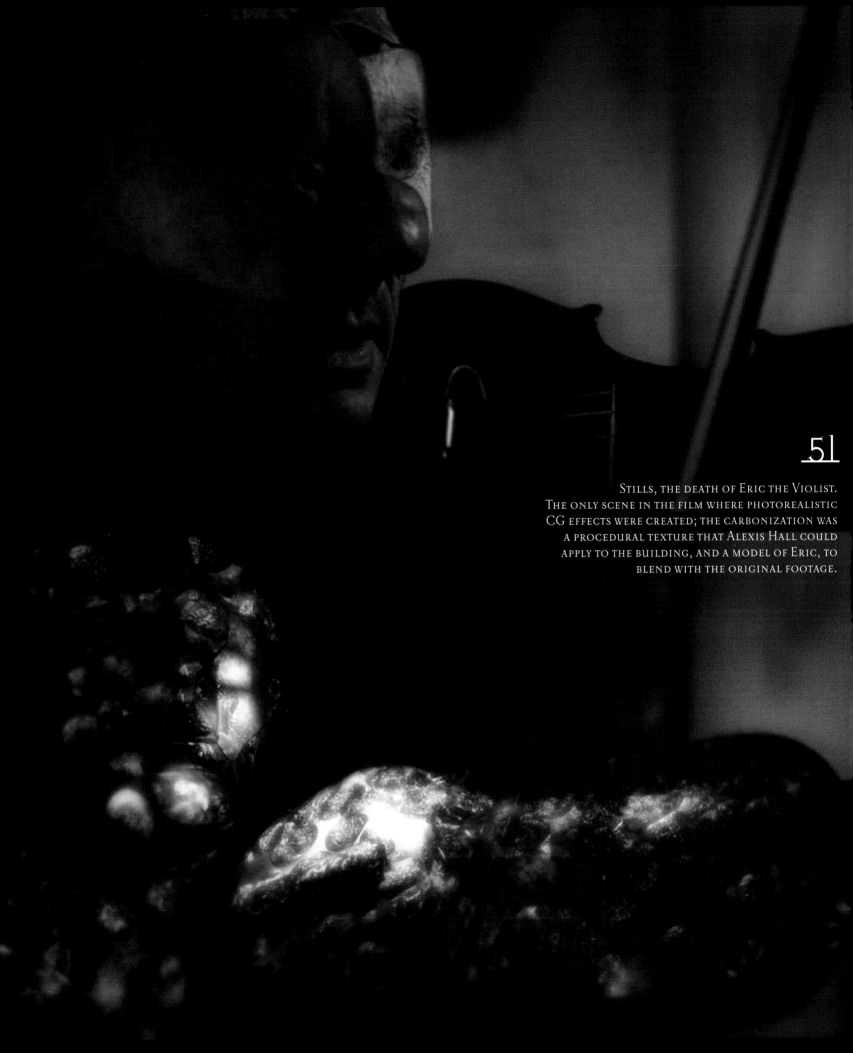

51

STILLS, THE DEATH OF ERIC THE VIOLIST.
THE ONLY SCENE IN THE FILM WHERE PHOTOREALISTIC
CG EFFECTS WERE CREATED; THE CARBONIZATION WAS
A PROCEDURAL TEXTURE THAT ALEXIS HALL COULD
APPLY TO THE BUILDING, AND A MODEL OF ERIC, TO
BLEND WITH THE ORIGINAL FOOTAGE.

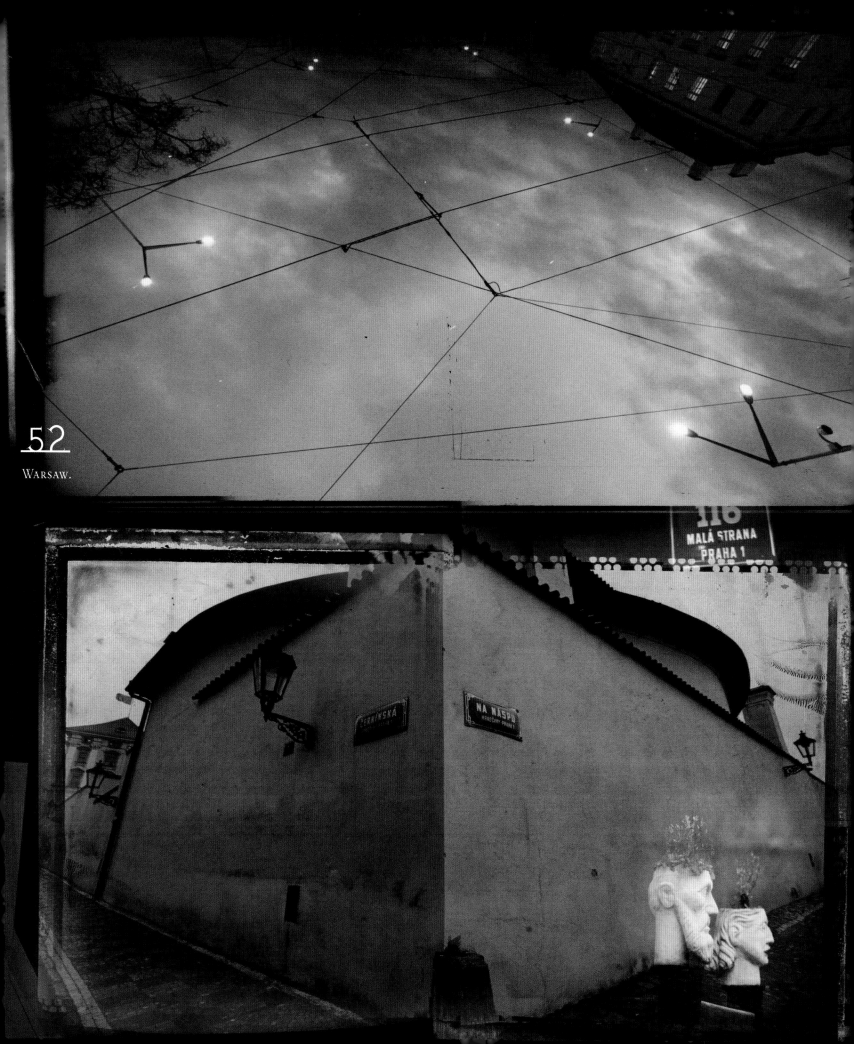

Warsaw.

City

I'm not really that interested in plot. Fortunately, Neil is, so the script always had to hit those marks from Neil's point of view. Don't get me wrong. I like a good story, and the first time I watch a film, obviously the story (especially the beginning and the end) has a huge effect on whether I feel it's worked. But the plot doesn't keep me thinking about the film, or coming back to watch it again. There has to be something unexplainable, something in the atmosphere, or the sound and music, something that makes it an abstract experience, a place to want to visit again and again.

So the thing about this film that I latched onto at a very early stage, the thing that would keep me going during the long nights and weeks and months of work, was the opportunity to create my ideal city.

I think some of my happiest times have been spent just wandering around beautiful European cities. When I was writing and collecting soundscapes for my short film N[EON], I walked around Venice until around 3 A.M., sitting in the odd bar for a quick, deadly espresso, listening to the sounds of distant voices, bells, lapping water reflected off the walls and canals, collecting as disconnected echoes in courtyard corners and under bridges. Many of my favorite cities found their way into this film: Trieste; Venice, of course; Warsaw; Angoulême; Prague.

My trip to Warsaw was particularly magical. I have always loved the Polish tradition of poster design; surreal and provocative images wallpaper the streets. We found a street with rocks embedded in the walls, floating like thought balloons. The same street, set on a sharp incline, had a walkway over to a house. The front door set into the eaves of the roof, presumably you walk down to the living rooms below. The same street again had a little gallery full of astonishing personal statues and the odd commission; a bust of the pope sat next to obsessive elaborations of angels. You entered through a little courtyard festooned with fairy lights and ivy and lanterns that looked like torture devices. I was asked on Radio Warsaw (or the equivalent) the traditional question: "Where do I get my ideas from?"

"Here," I said.

I could quite happily have spent another year and another X million dollars creating more streets and bits of city for Helena and Valentine and myself to wander through, but we had to create a bare minimum. Just as a director's camera on a physical set for a film, if the virtual camera strayed too far to the left or right on a digital set, it would reveal the edges of streets and the gray wasteland of dead space beyond the 3D model.

If it's not going to be in the picture, you don't spend time and money making it.

DM

Angoulême.

CT

Trieste.

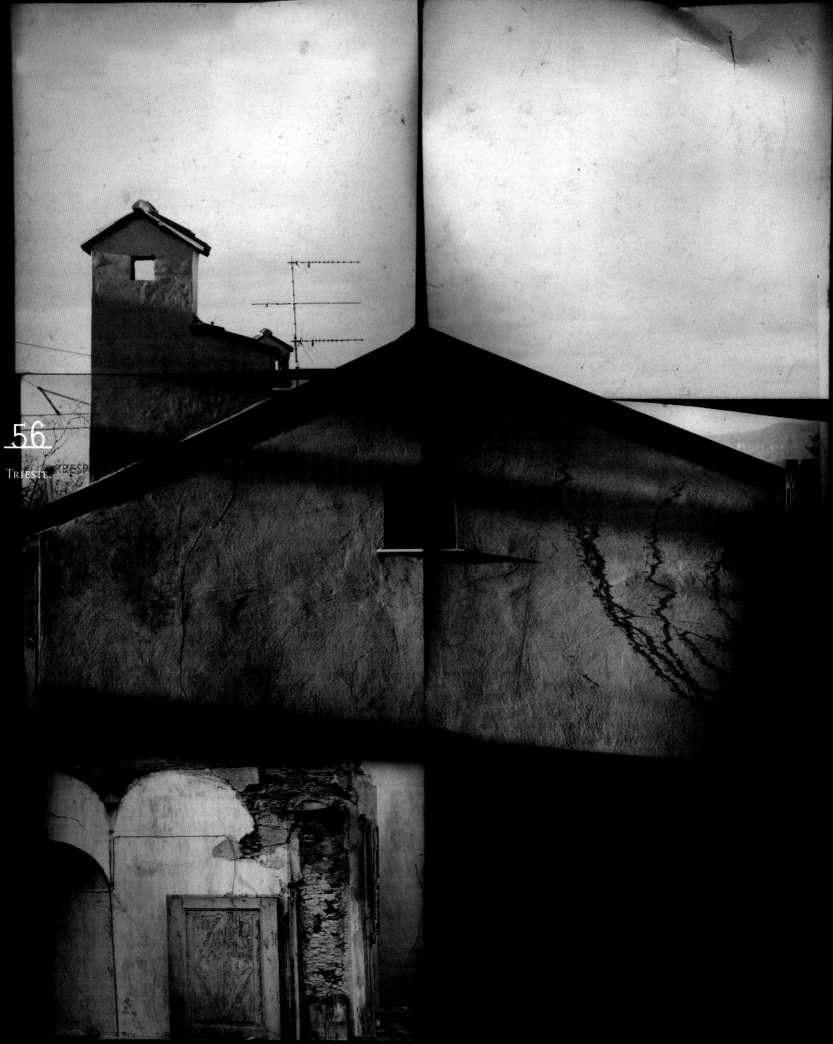

56

Trieste.

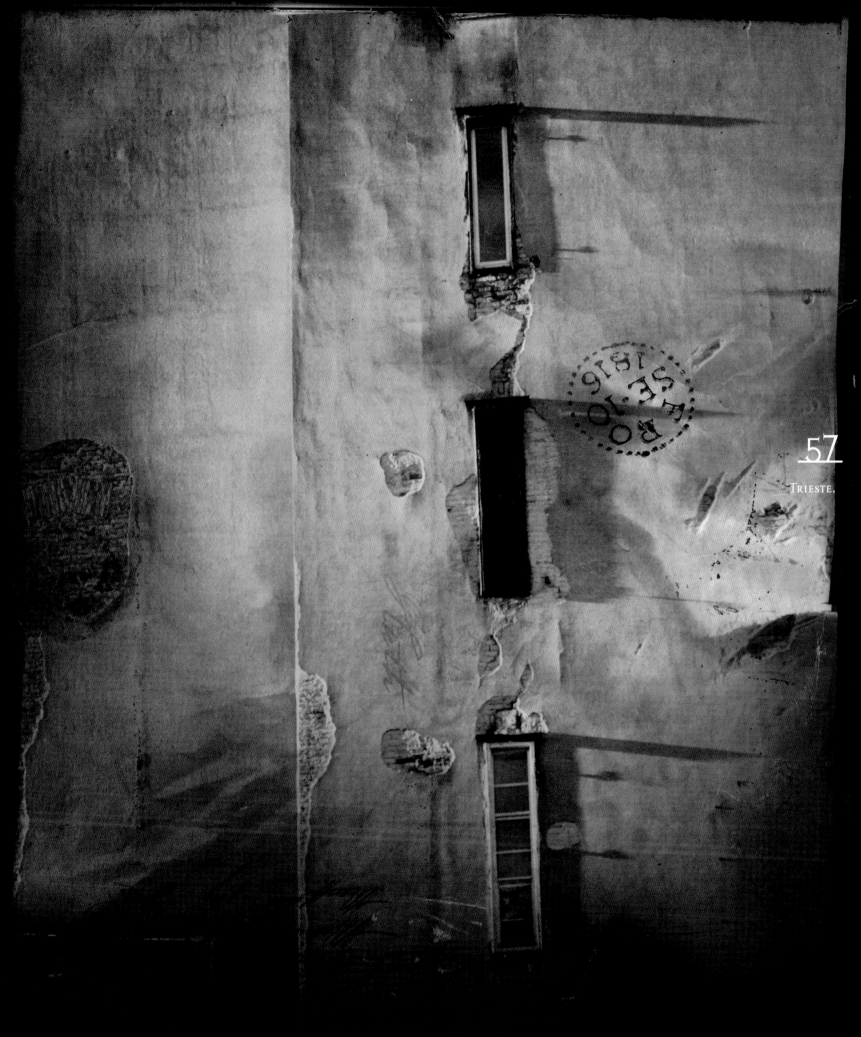

57

Trieste.

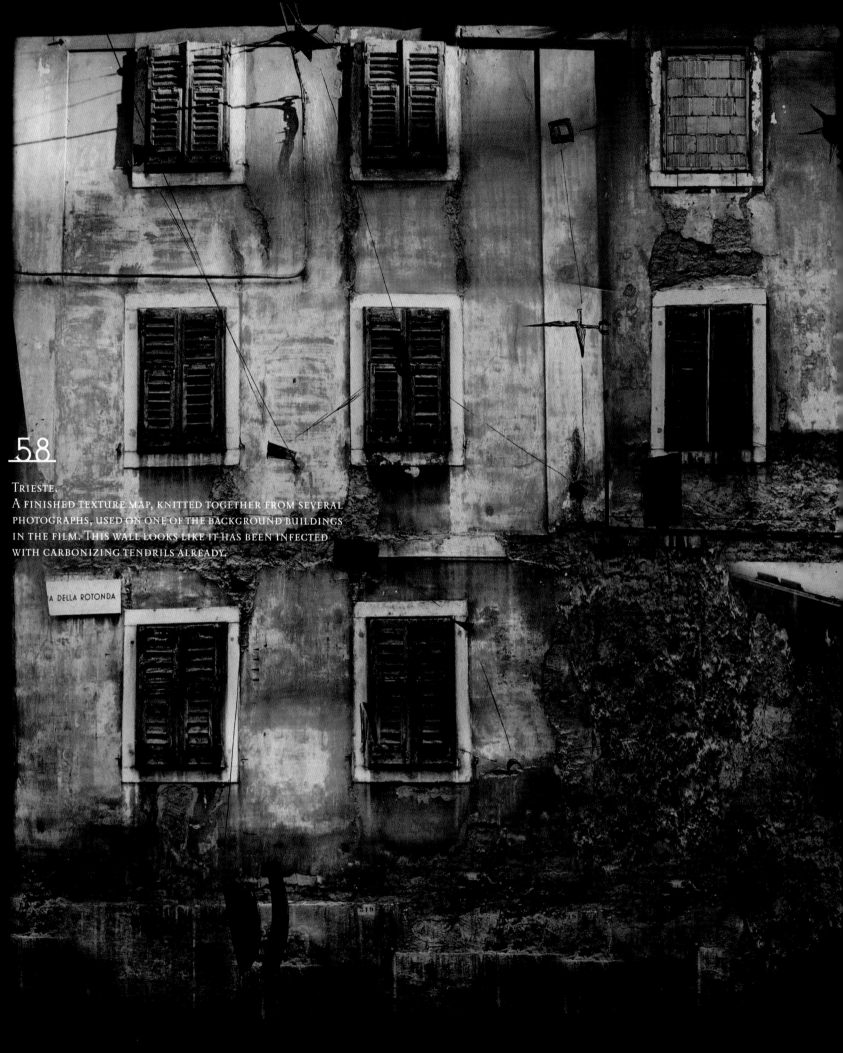

58

Trieste.
A finished texture map, knitted together from several photographs, used on one of the background buildings in the film. This wall looks like it has been infected with carbonizing tendrils already.

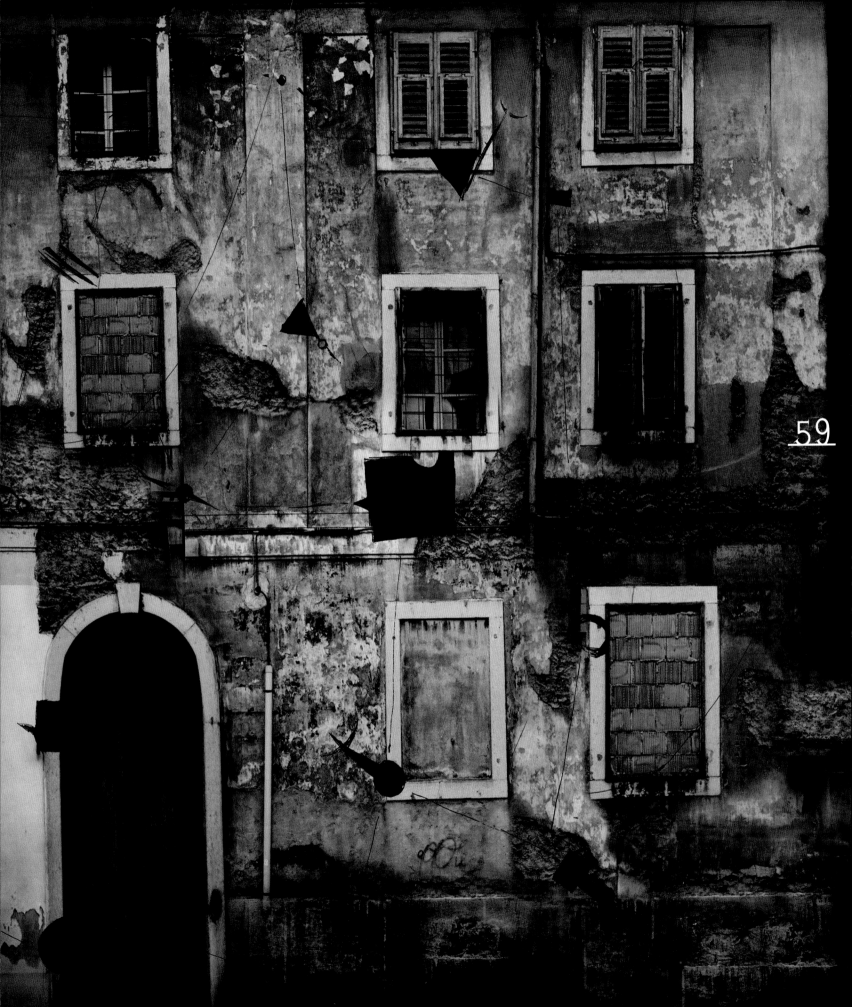

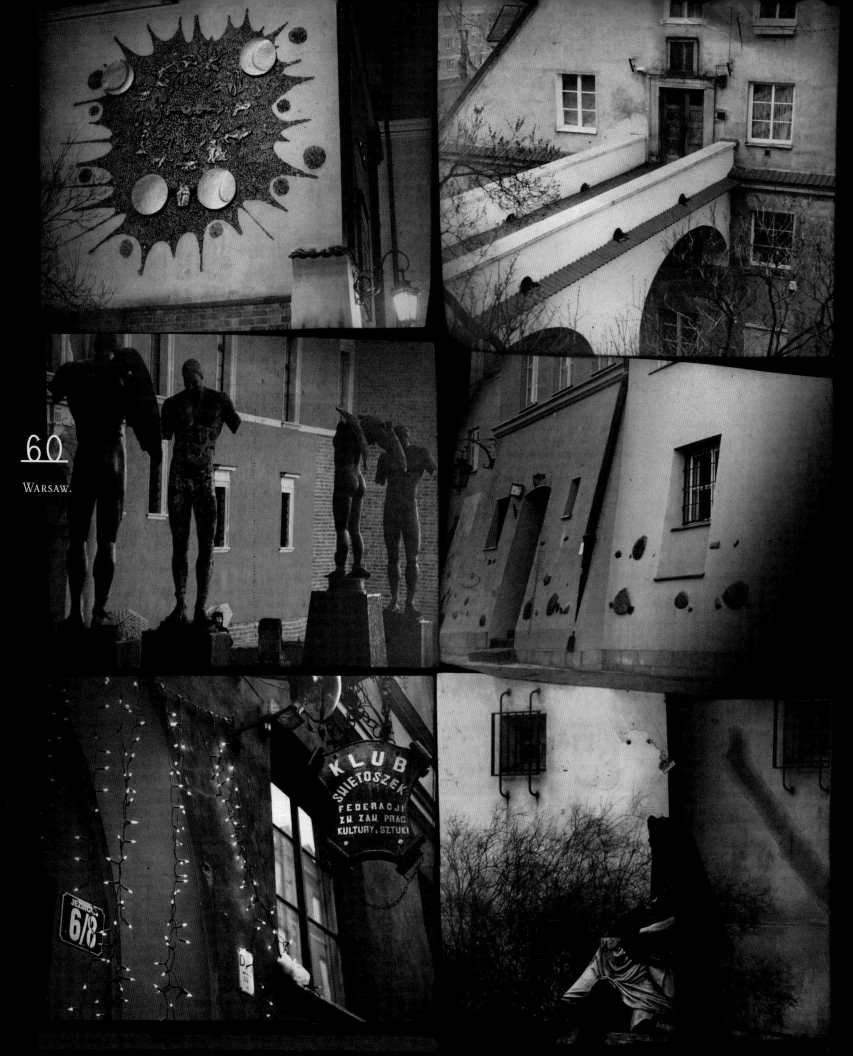

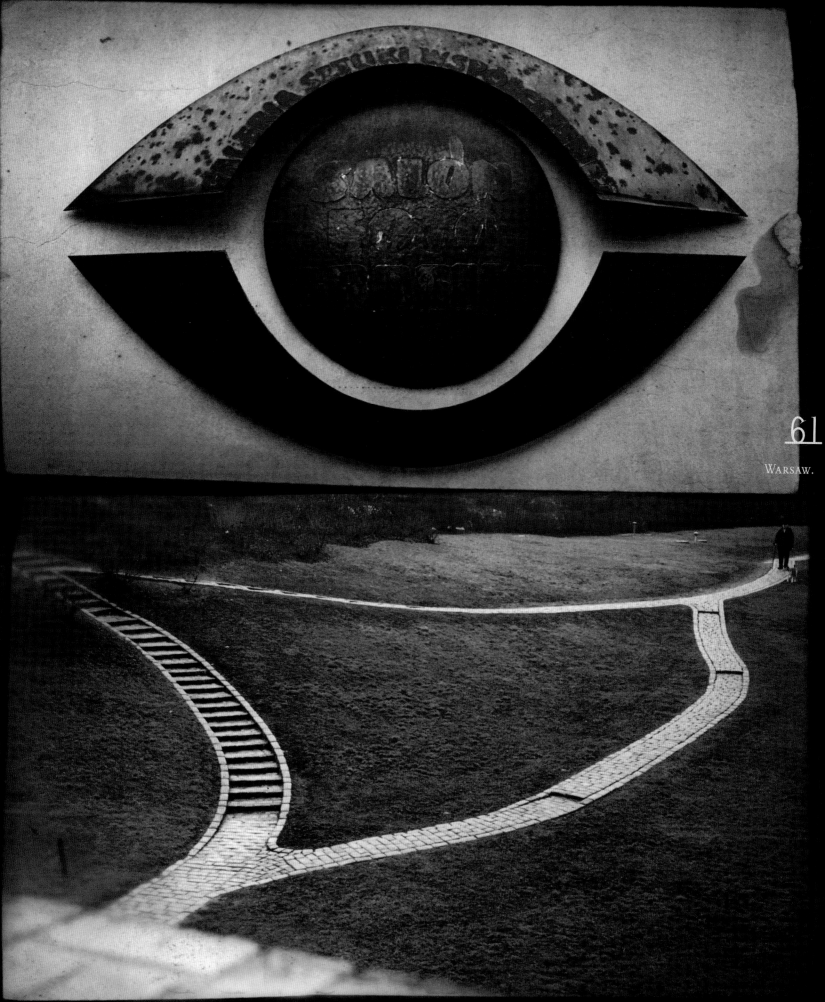

61

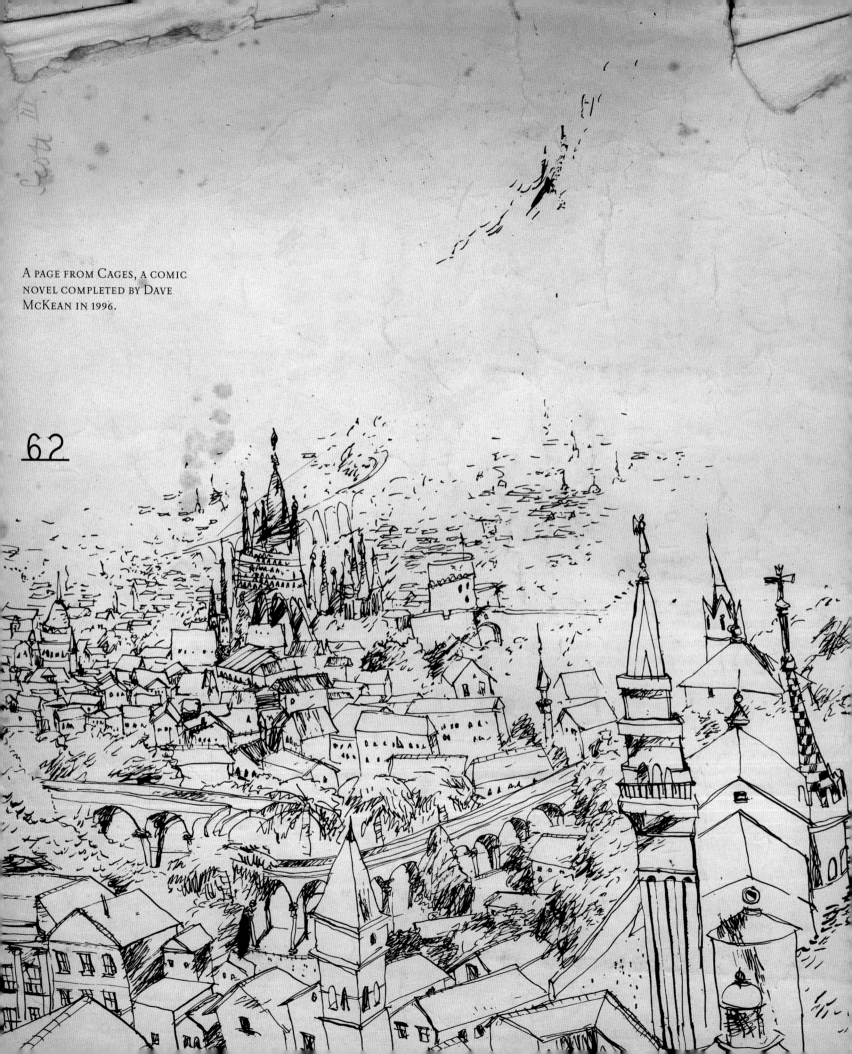

A PAGE FROM CAGES, A COMIC
NOVEL COMPLETED BY DAVE
McKEAN IN 1996.

62

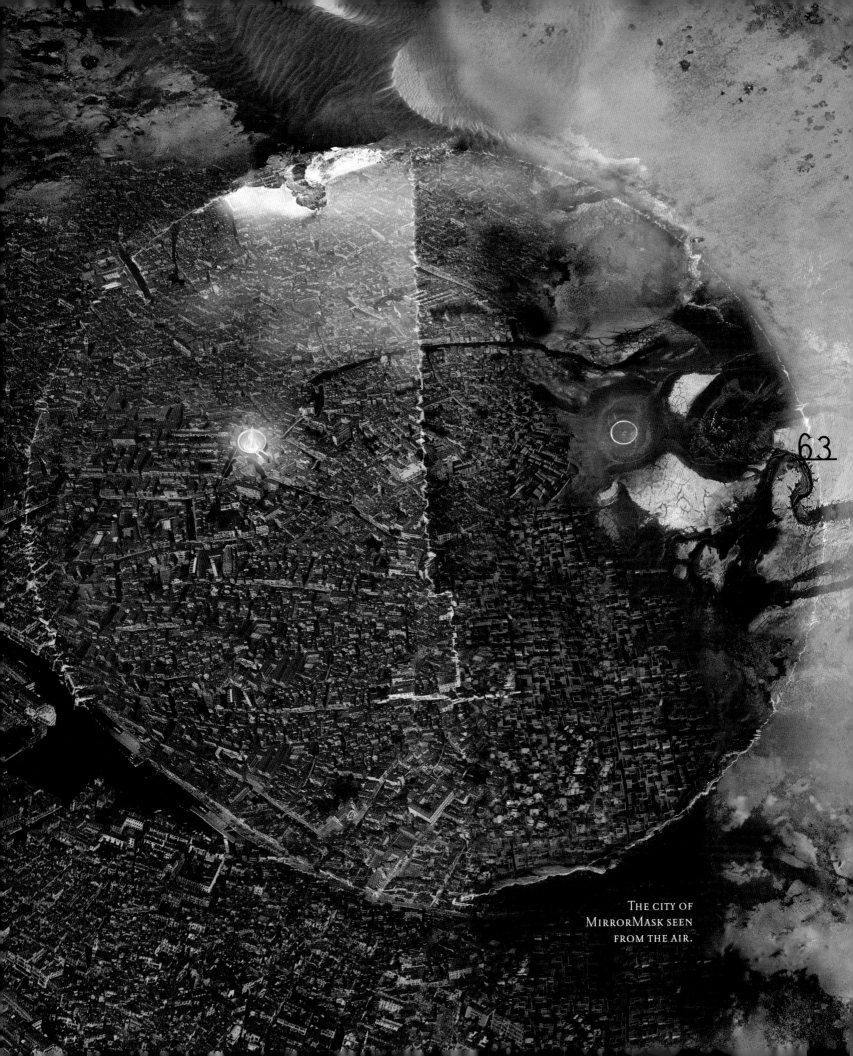

63

THE CITY OF
MIRRORMASK SEEN
FROM THE AIR.

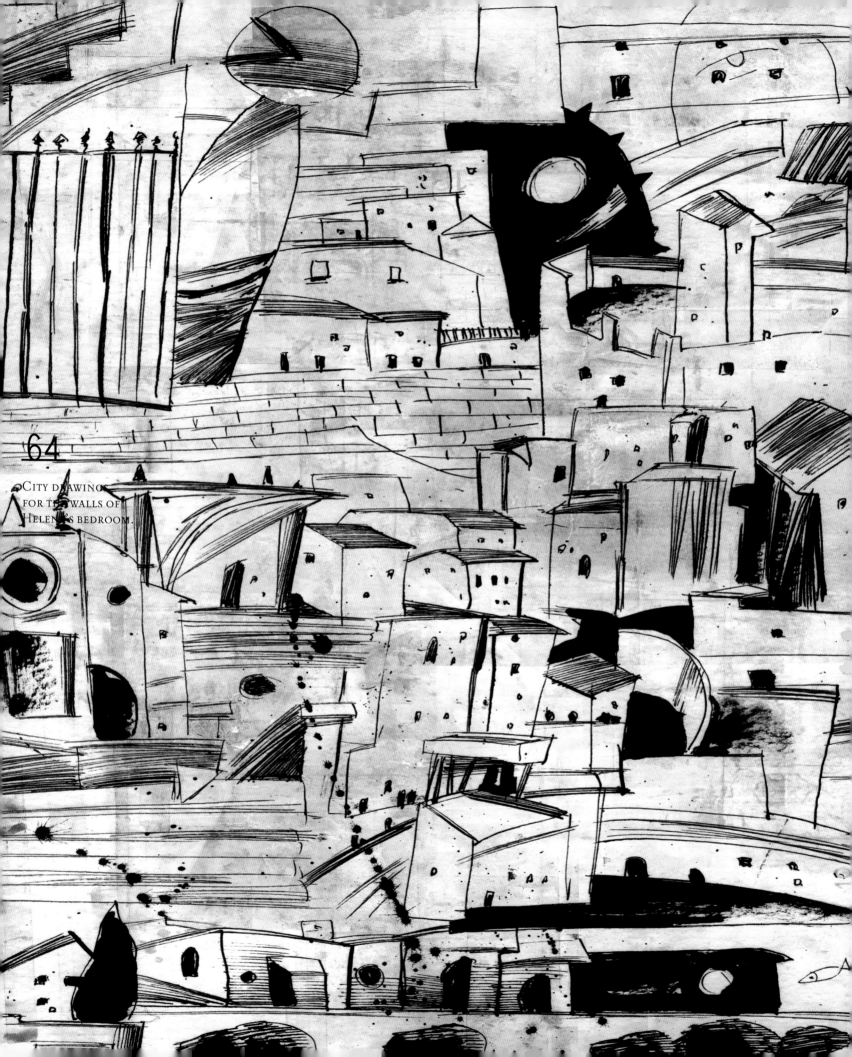

64

CITY DRAWINGS
FOR THE WALLS OF
HELEN'S BEDROOM.

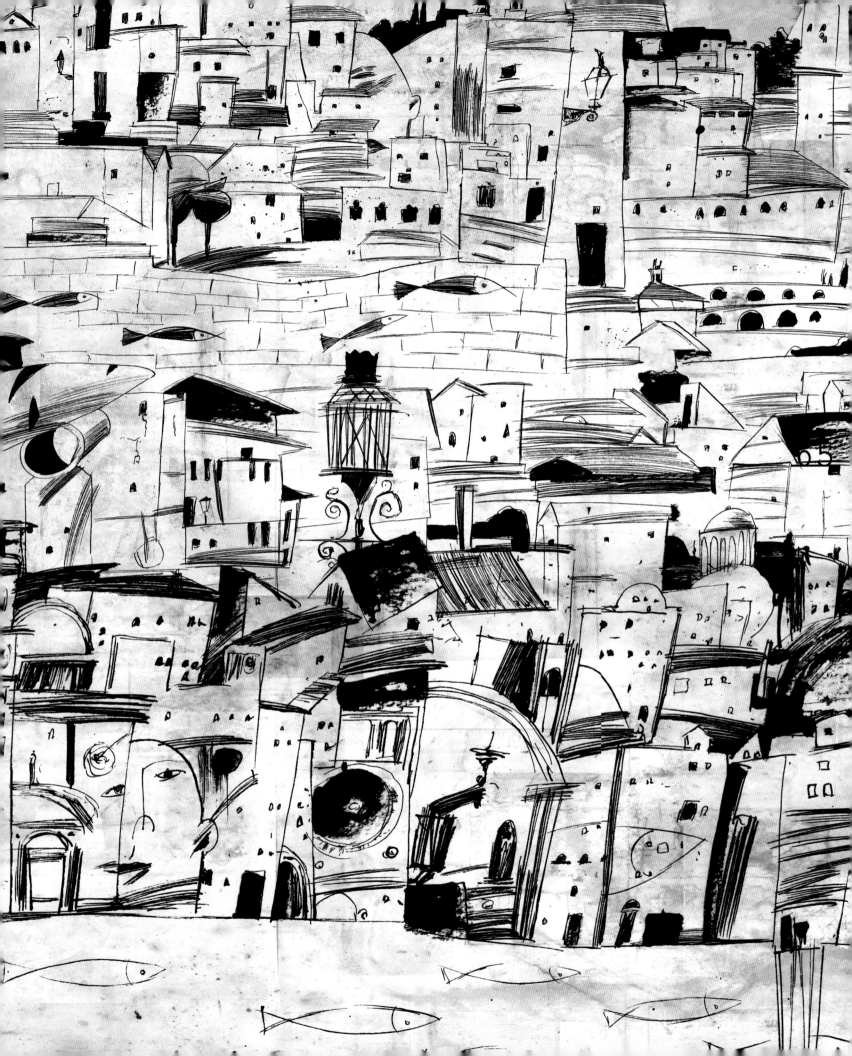

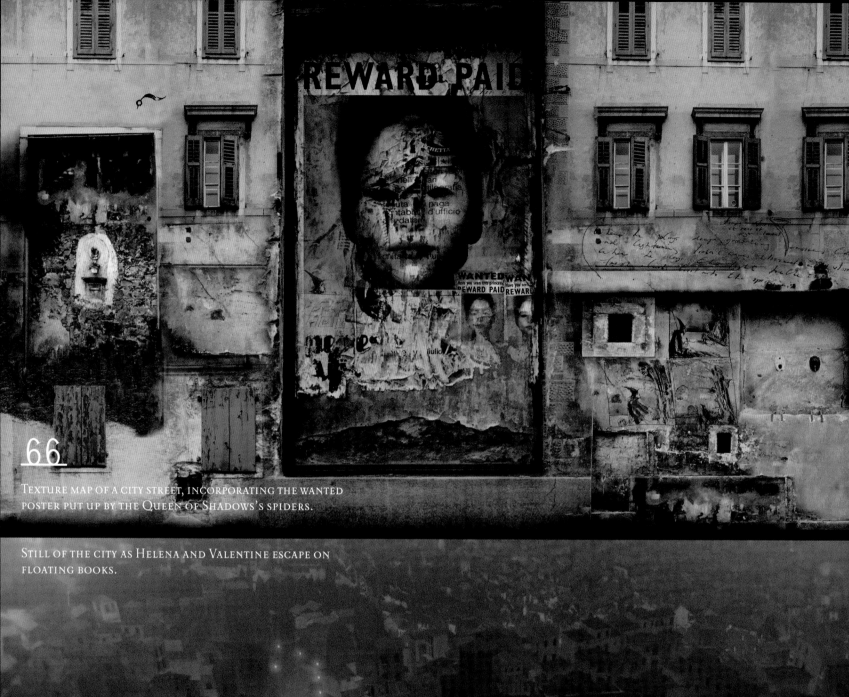

66

Texture map of a city street, incorporating the wanted
poster put up by the Queen of Shadows's spiders.

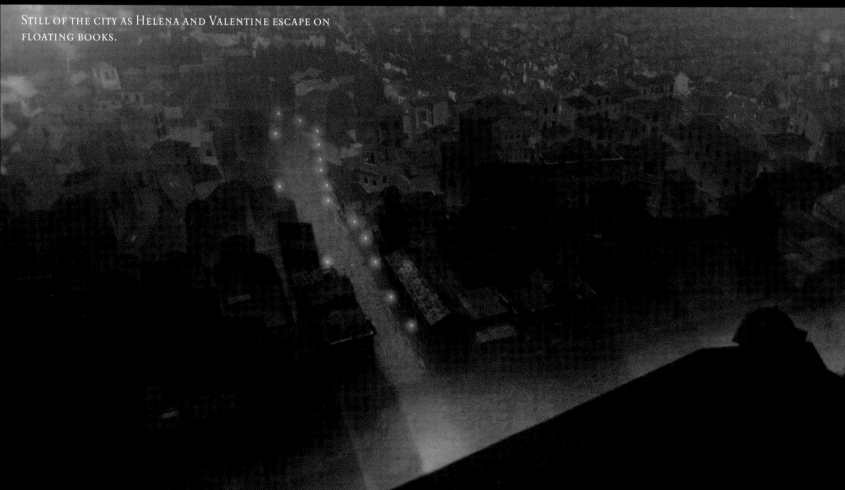

Still of the city as Helena and Valentine escape on
floating books.

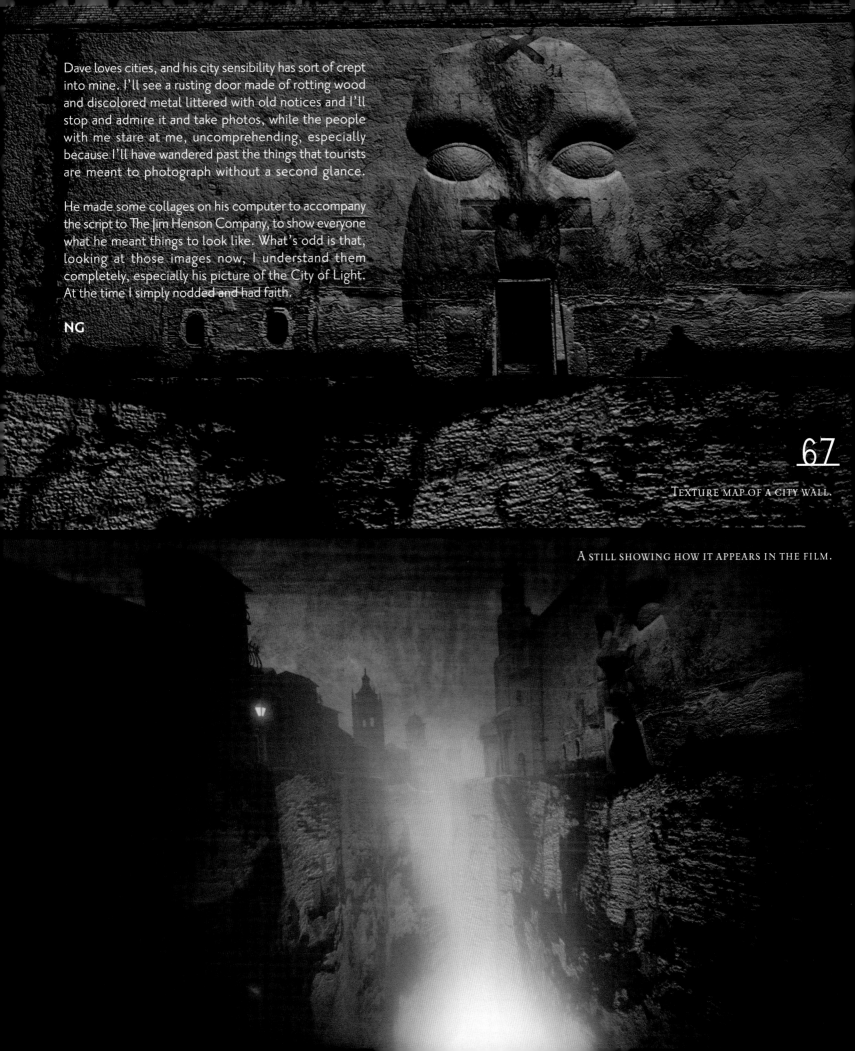

Dave loves cities, and his city sensibility has sort of crept into mine. I'll see a rusting door made of rotting wood and discolored metal littered with old notices and I'll stop and admire it and take photos, while the people with me stare at me, uncomprehending, especially because I'll have wandered past the things that tourists are meant to photograph without a second glance.

He made some collages on his computer to accompany the script to The Jim Henson Company, to show everyone what he meant things to look like. What's odd is that, looking at those images now, I understand them completely, especially his picture of the City of Light. At the time I simply nodded and had faith.

NG

67

Texture map of a city wall.

A still showing how it appears in the film.

This was really the most difficult part to cast and perform. We needed a young actor who could be dramatic and funny while wearing an uncomfortable latex mask for six weeks. Jason Barry's deadpan Irish accent and delivery was the only performance during casting to make me laugh out loud. I played the tape to Neil when he visited for the read-through. We both laughed in exactly the same places. Neil added his vote to the Barry camp.

This film was a painful shoot for him. Having to look through tiny eyeholes all the time gave him migraine headaches and the heat in the studio made his latex chin peel. He was always (nearly) in relaxed, good humor on set, but I think a fair amount of violent, vitriolic stress relief went on upstairs.

To be honest, I wish I had had more time to work on the mask. Occasionally it worked very well, but I would have liked something more textural. The length of time involved in getting Jason's casting approved by Sony and The Jim Henson Company, and then once approved, the time needed to get his face casting done and molds sculpted and replicated, meant that it was all a bit of a crush.

Valentine had a lot more lines in the script, but it was a credit to Jason that he made the character work so well with his nervy body language, much funnier than the verbal routines we had penciled for him.

Also, I love Robert Lever's saggy, floppy coat. We discovered that when Jason let the sleeves drop, he could do a very funny and rather pathetic flap.

DM

68

VALENTINE PUPPET ADAPTED
FROM A VENETIAN PULCINELLA.

STORYBOARD
SKETCHES OF
VALENTINE.

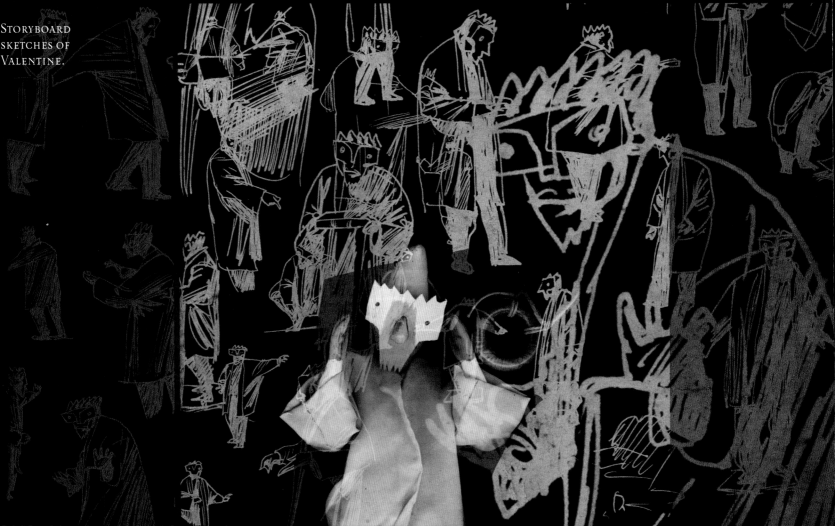

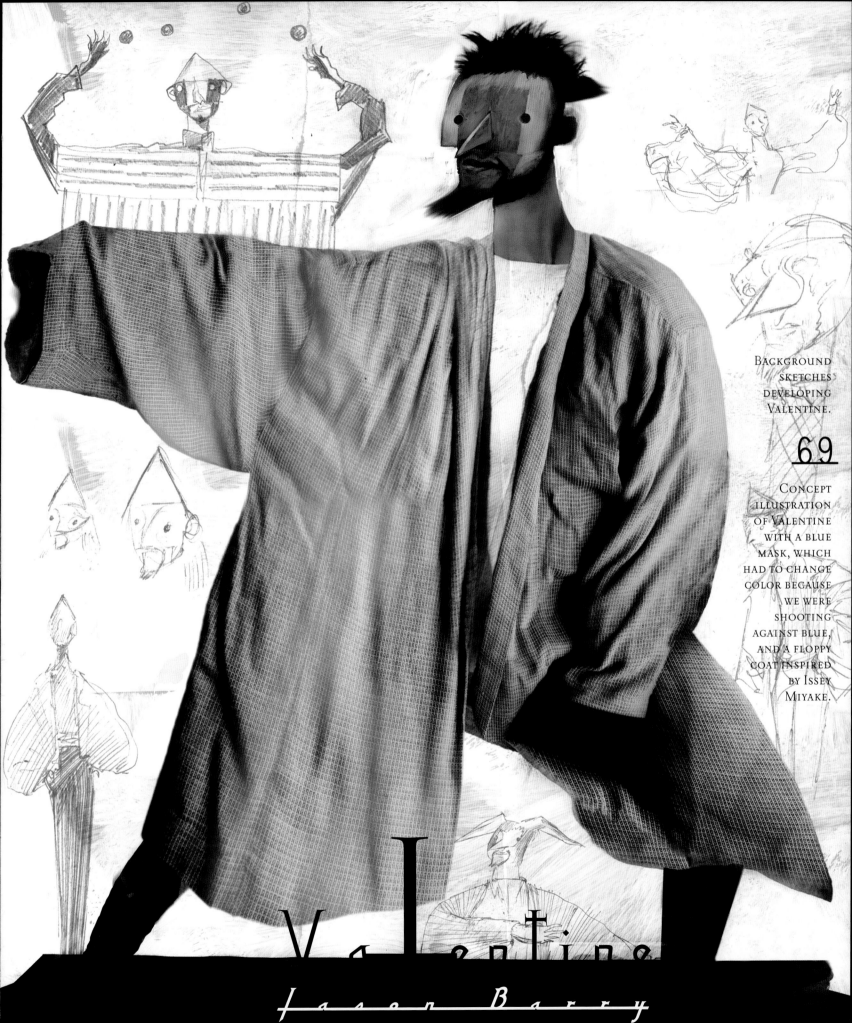

BACKGROUND
SKETCHES
DEVELOPING
VALENTINE.

69

CONCEPT
ILLUSTRATION
OF VALENTINE
WITH A BLUE
MASK, WHICH
HAD TO CHANGE
COLOR BECAUSE
WE WERE
SHOOTING
AGAINST BLUE,
AND A FLOPPY
COAT INSPIRED
BY ISSEY
MIYAKE.

Valentine

Jason Barry

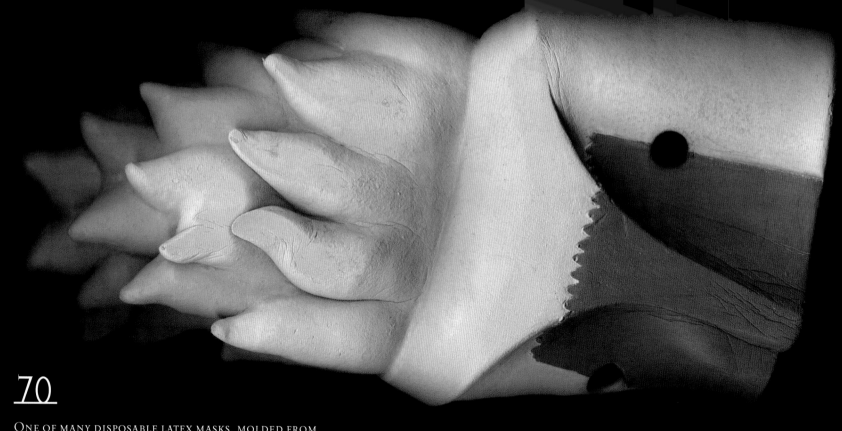

One of many disposable latex masks, molded from
Jason Barry's face. A new one was made for each day's filming.

Jason against blue-screen background.

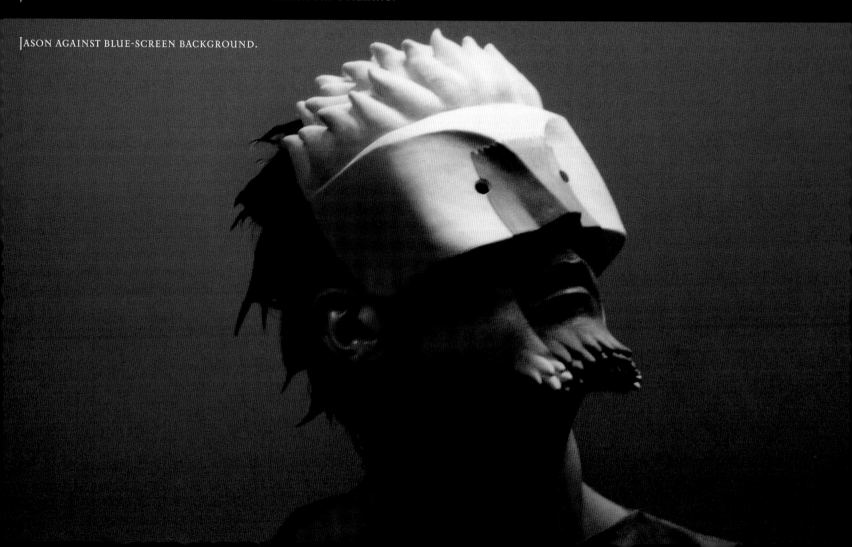

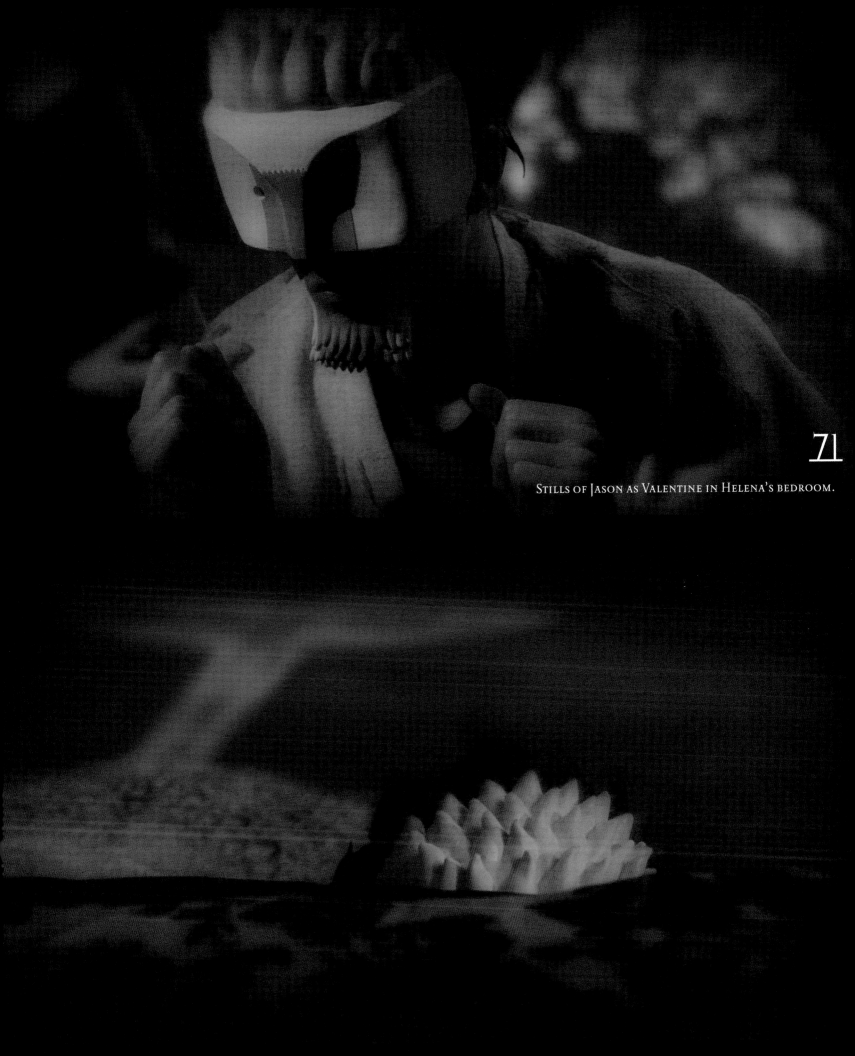

STILLS OF JASON AS VALENTINE IN HELENA'S BEDROOM.

71

He was called Puck in the script when we began writing it (on about February 3, 2002, for those of you keeping track of these things). And then it was nearly Valentine's Day, and we knew we needed a name that had a bit more romance in it, and I decided that he'd like to have a day of his own.

Some things you think will be easy turn out to be almost impossibly hard to do. I had the idea that Valentine would be able to take his face off and talk to the old masks, and they'd talk back to him. It was the scene that the actors auditioned with. We even filmed it. Turned out, Dave and the animators simply couldn't get it to work given the time constraints, and with regret we let it go. I didn't really mind losing it, on the basis that every other impossible thing that I'd asked for they'd done with ease.

According to VARIETY's review of MIRRORMASK, Valentine's face is CG, which will come as a surprise to Jason Barry, who had it carefully stuck onto his face every morning, and got headaches from peering through the holes.

NG

72

STORYBOARD SKETCHES.

JASON SHOOTING
MRS. BAGWELL'S SCENE

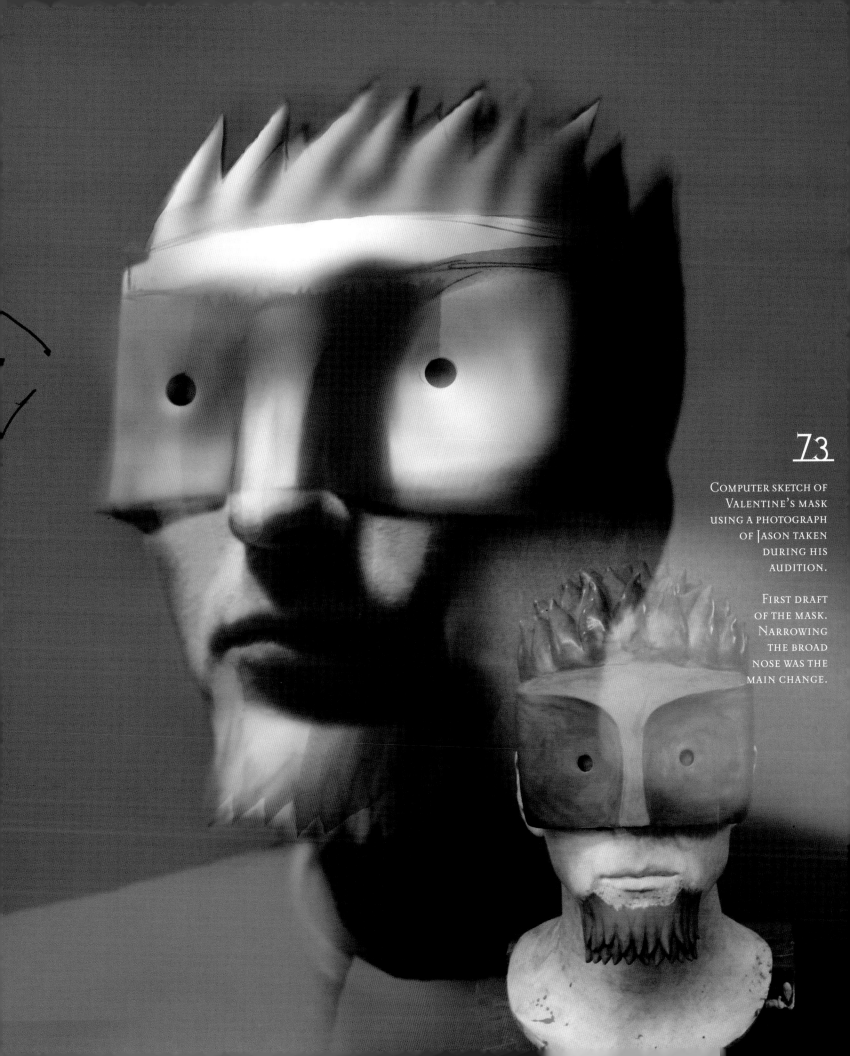

73

COMPUTER SKETCH OF
VALENTINE'S MASK
USING A PHOTOGRAPH
OF JASON TAKEN
DURING HIS
AUDITION.

FIRST DRAFT
OF THE MASK.
NARROWING
THE BROAD
NOSE WAS THE
MAIN CHANGE.

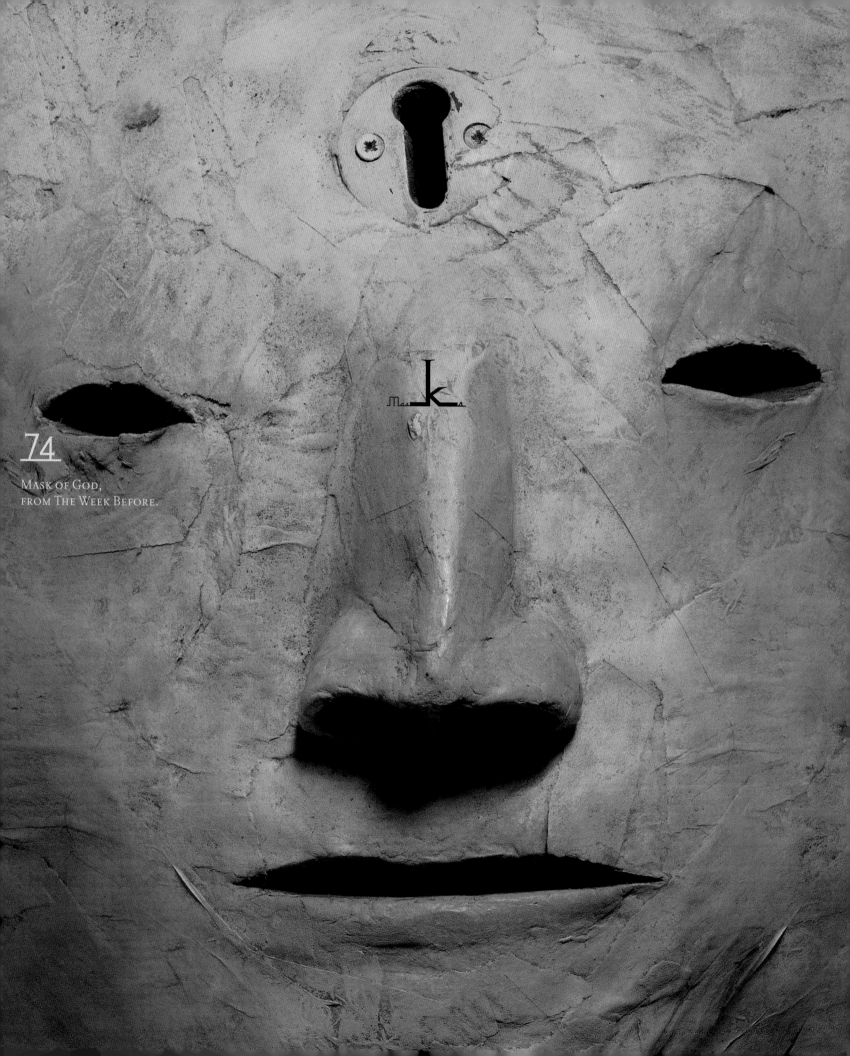

74

Mask of God,
from The Week Before.

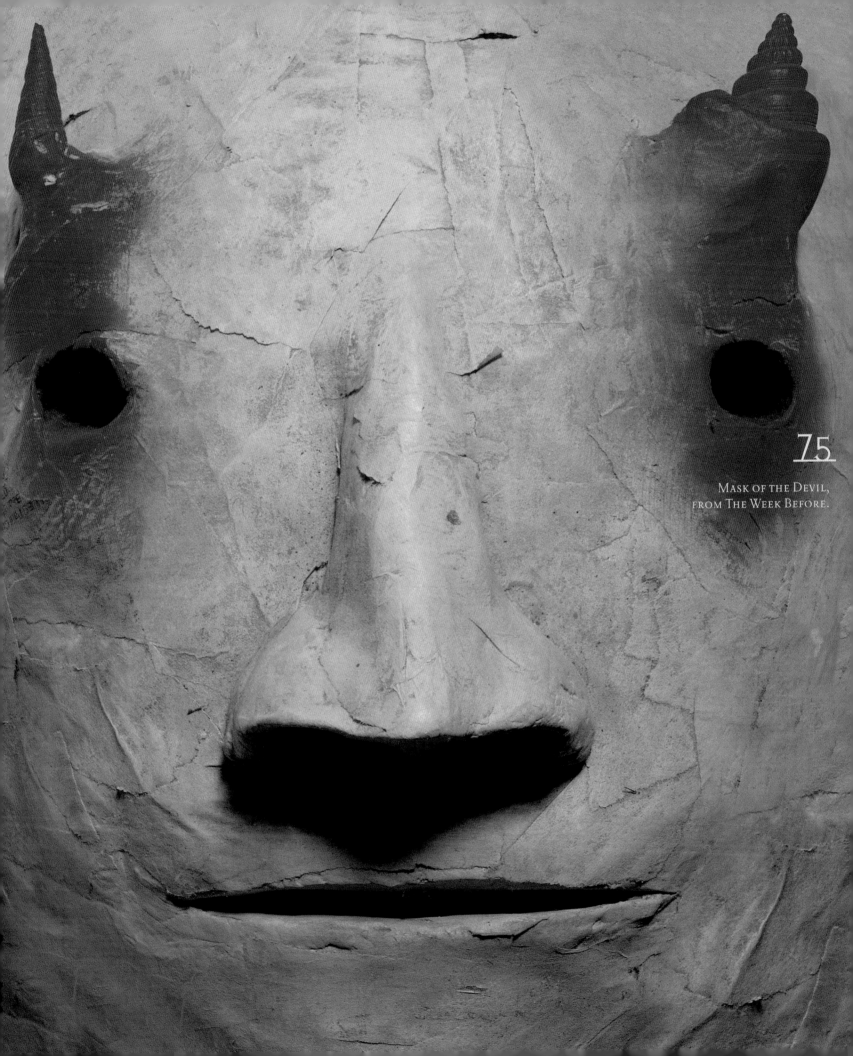

MASK OF THE DEVIL,
FROM THE WEEK BEFORE.

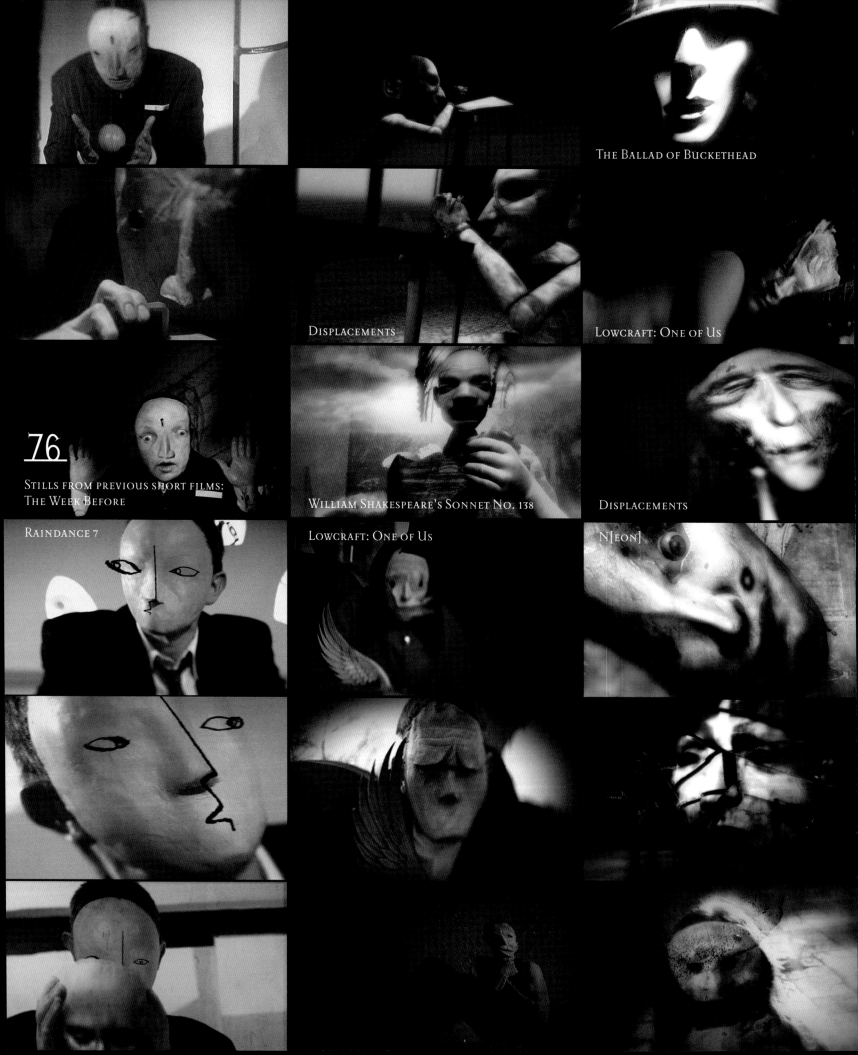

THE BALLAD OF BUCKETHEAD

DISPLACEMENTS

LOWCRAFT: ONE OF US

76

STILLS FROM PREVIOUS SHORT FILMS:
THE WEEK BEFORE

WILLIAM SHAKESPEARE'S SONNET NO. 138

DISPLACEMENTS

RAINDANCE 7

LOWCRAFT: ONE OF US

N[EON]

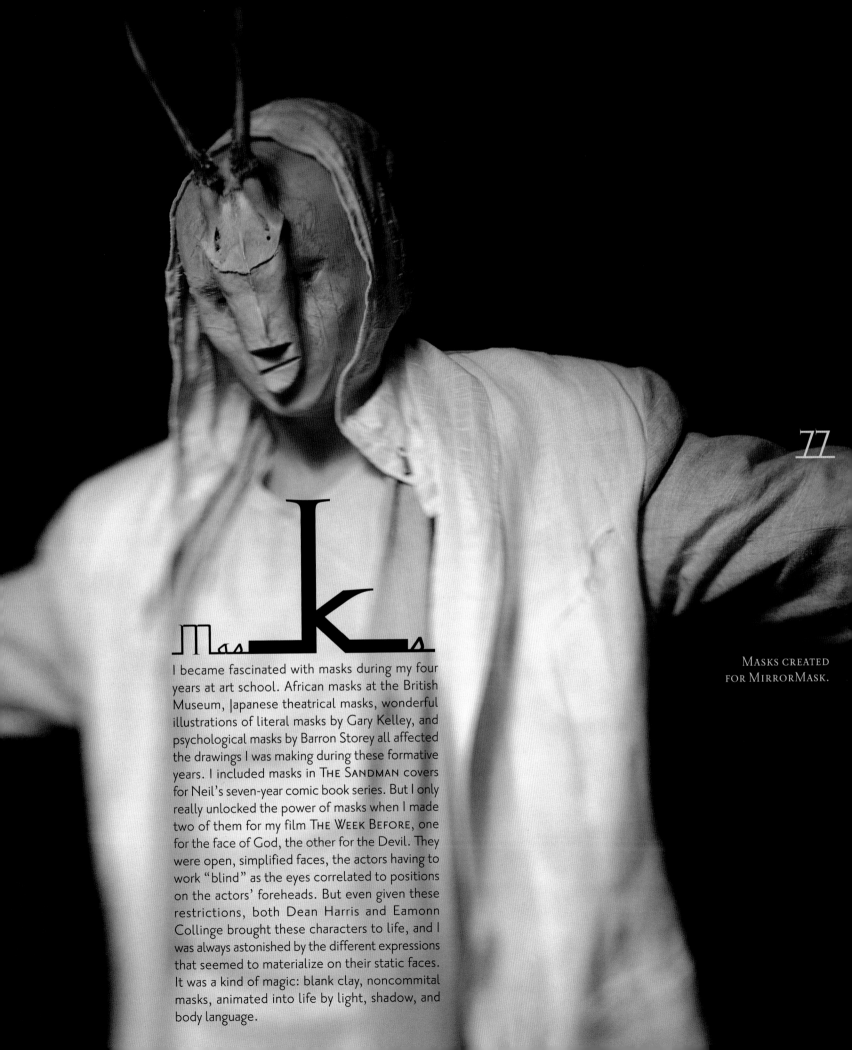

MASKS CREATED
FOR MIRRORMASK.

Masks

I became fascinated with masks during my four years at art school. African masks at the British Museum, Japanese theatrical masks, wonderful illustrations of literal masks by Gary Kelley, and psychological masks by Barron Storey all affected the drawings I was making during these formative years. I included masks in THE SANDMAN covers for Neil's seven-year comic book series. But I only really unlocked the power of masks when I made two of them for my film THE WEEK BEFORE, one for the face of God, the other for the Devil. They were open, simplified faces, the actors having to work "blind" as the eyes correlated to positions on the actors' foreheads. But even given these restrictions, both Dean Harris and Eamonn Collinge brought these characters to life, and I was always astonished by the different expressions that seemed to materialize on their static faces. It was a kind of magic: blank clay, noncommital masks, animated into life by light, shadow, and body language.

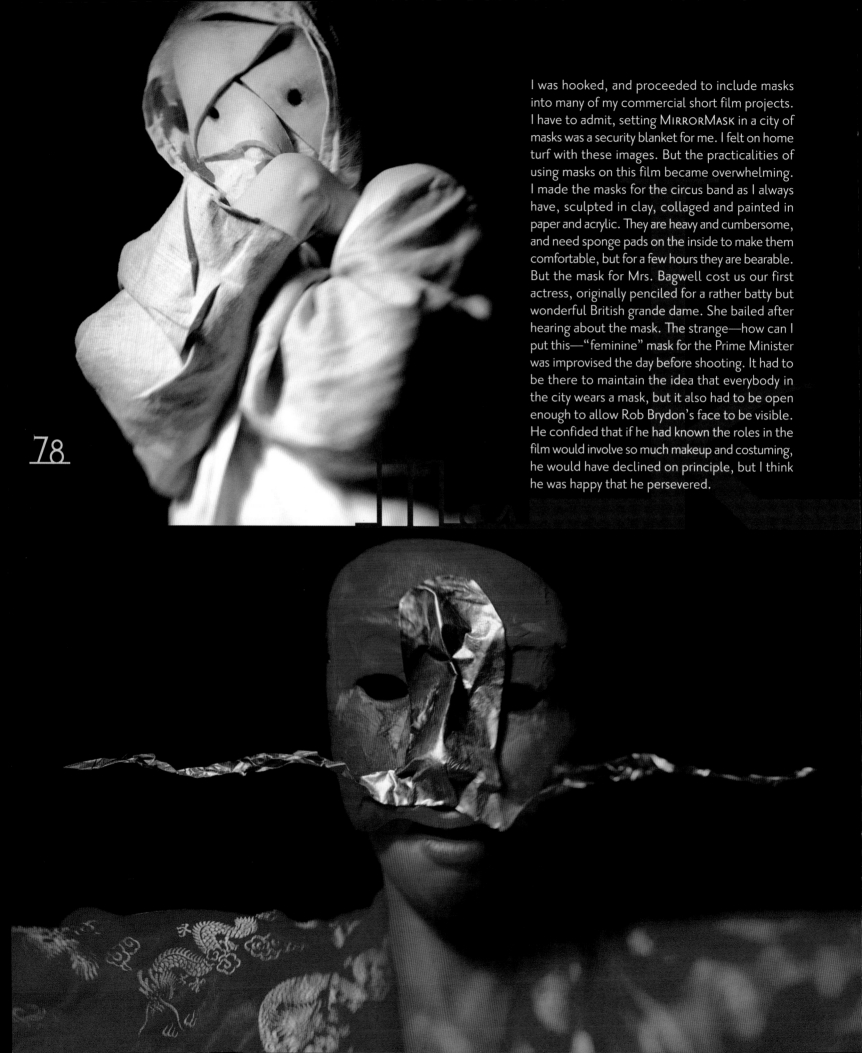

I was hooked, and proceeded to include masks into many of my commercial short film projects. I have to admit, setting MIRRORMASK in a city of masks was a security blanket for me. I felt on home turf with these images. But the practicalities of using masks on this film became overwhelming. I made the masks for the circus band as I always have, sculpted in clay, collaged and painted in paper and acrylic. They are heavy and cumbersome, and need sponge pads on the inside to make them comfortable, but for a few hours they are bearable. But the mask for Mrs. Bagwell cost us our first actress, originally penciled for a rather batty but wonderful British grande dame. She bailed after hearing about the mask. The strange—how can I put this—"feminine" mask for the Prime Minister was improvised the day before shooting. It had to be there to maintain the idea that everybody in the city wears a mask, but it also had to be open enough to allow Rob Brydon's face to be visible. He confided that if he had known the roles in the film would involve so much makeup and costuming, he would have declined on principle, but I think he was happy that he persevered.

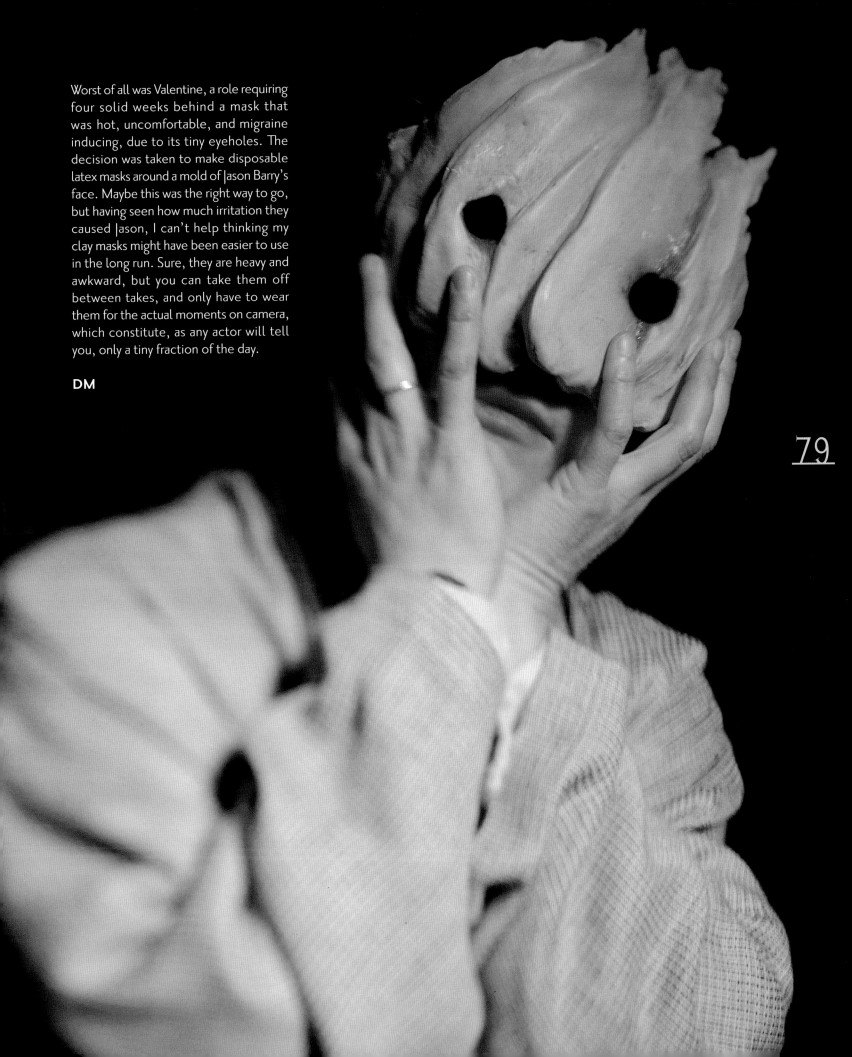

Worst of all was Valentine, a role requiring four solid weeks behind a mask that was hot, uncomfortable, and migraine inducing, due to its tiny eyeholes. The decision was taken to make disposable latex masks around a mold of |ason Barry's face. Maybe this was the right way to go, but having seen how much irritation they caused |ason, I can't help thinking my clay masks might have been easier to use in the long run. Sure, they are heavy and awkward, but you can take them off between takes, and only have to wear them for the actual moments on camera, which constitute, as any actor will tell you, only a tiny fraction of the day.

DM

79

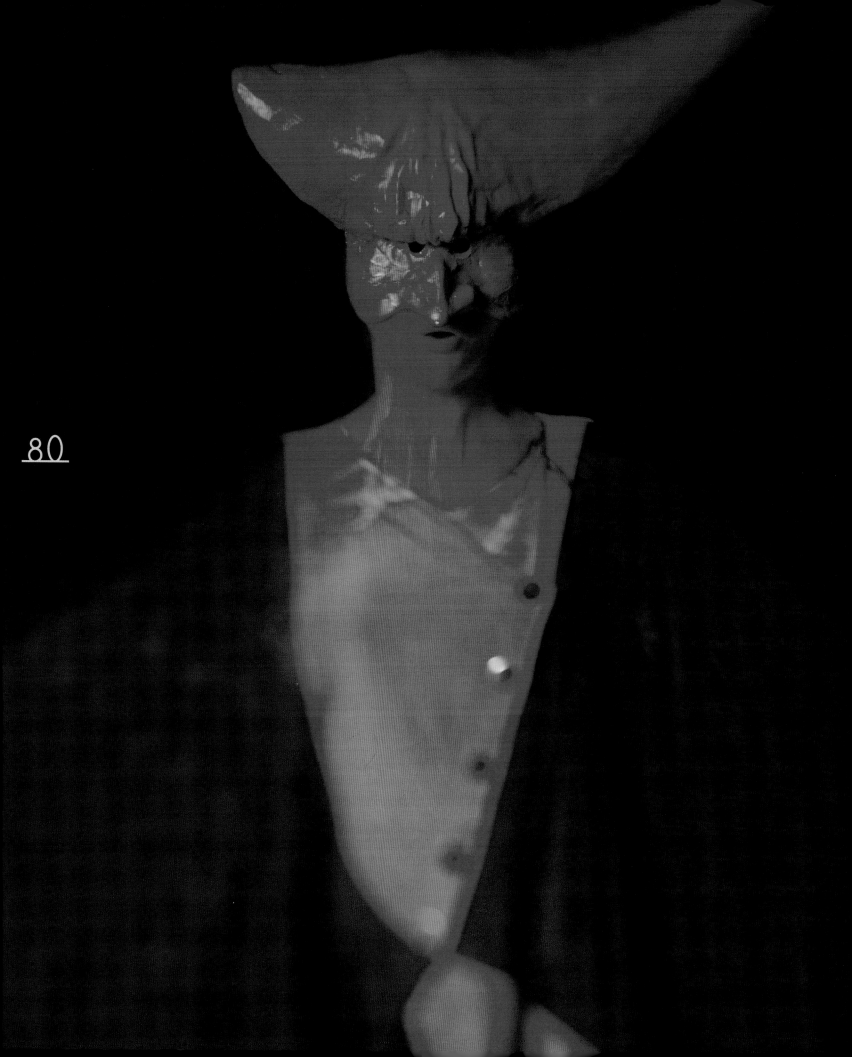

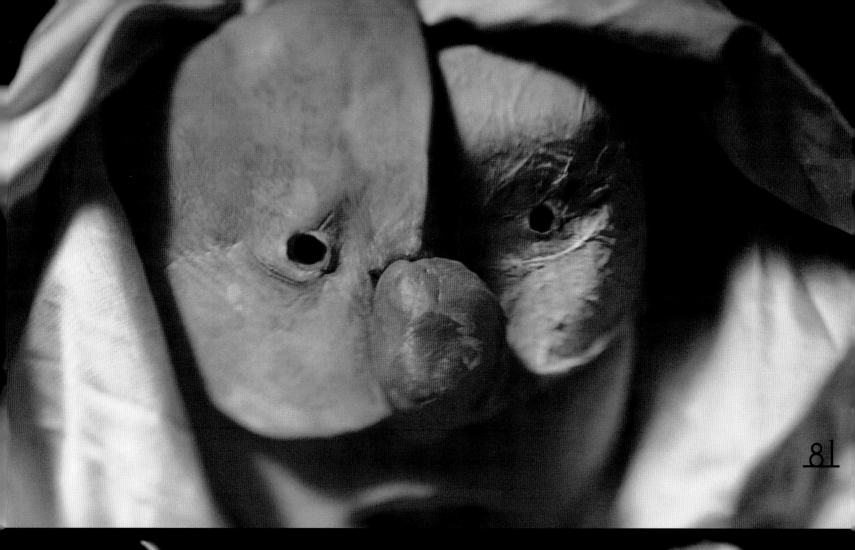

Masks, in all their guises, make up one of the themes that twine through the film (and oddly enough mirrors, and reflections, might well be one of the other themes).

Dave loves masks, and collects them (or accumulates them). He put them in his other films, like THE WEEK BEFORE. I think my favorite mask is the one in the Bagwell's mask shop that winks at Helena. I don't know why they have a mask shop in a place where people have masks instead of faces. Probably that's why it's so dusty and decayed. Still, the masks there on their dusty shelves are optimistic that one day someone will come along and buy them, and I very much hope that one day someone will.

NG

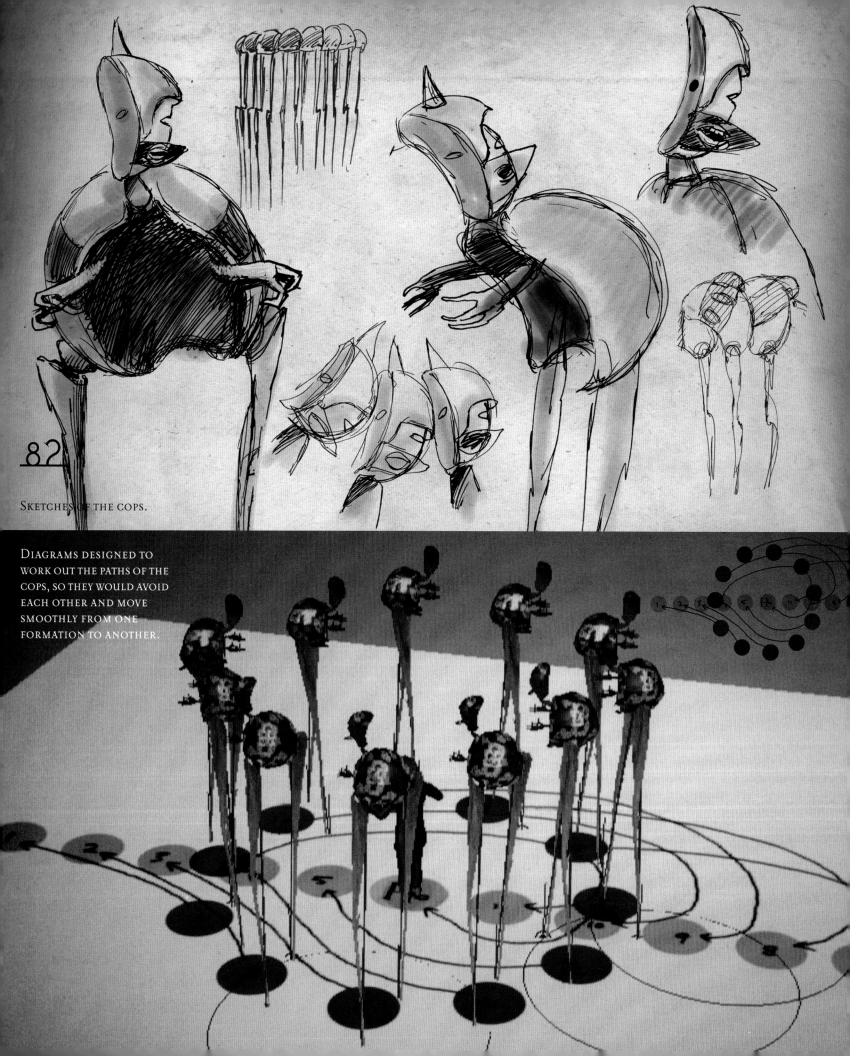

SKETCHES OF THE COPS.

DIAGRAMS DESIGNED TO
WORK OUT THE PATHS OF THE
COPS, SO THEY WOULD AVOID
EACH OTHER AND MOVE
SMOOTHLY FROM ONE
FORMATION TO ANOTHER.

Arrest Cops and the bridge

Once we got Helena into the city, we couldn't just let her wander around aimlessly. Something had to happen to her so that we could progress the plot and get her on her path for the rest of the film. So we decided to arrest her.

The cops got more and more bizarre as the characters progressed from sketches to models to animation. In the end they were so far away from any police force on the planet that we had to add a few references to "sergeant" and "officer" in the script so that the audience would make the connection. Eventually they became a troupe of stilt-walking beetley guys, all voiced by Lenny Henry.

The pedestrians were the first animated walk cycles to be completed by animator Jamie Niman, and it was a great moment seeing the "African" group toddle across the screen. Max and I took turns doing silly walks outside as reference for the animators.

83

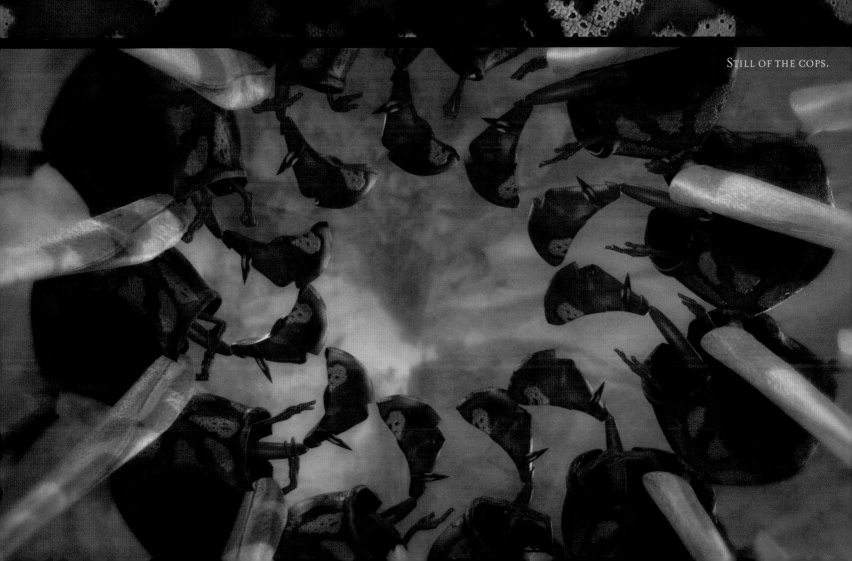

STILL OF THE COPS.

Helena's arrest takes place on a bridge, a set that included a procedural school of fish created by Mike Nixon. Neil and I have a history with fish. They have featured on many of our SANDMAN covers and in our children's books. They are a very important part of our lives. We did a couple of preview panels at the San Diego Comic Conventions in 2003 and 2004. Someone asked us how many fish there were in the film and I made the mistake of saying that since they were a computer-generated school, we could get Maya to cough up an actual fish count. Back in England I asked Mike, but he was evasive. Unfortunately Neil started to get a steady flow of e-mails to his Web site demanding to know what the fish count was. I suggested posting a message saying that it turned out to be more than I thought, but less than I imagined. This didn't go down well with Neil, who told me that I wasn't taking the situation seriously and that fish counters actually are a proactive and vocal group who can have a devastating effect on the performance of a film at the box office.

DM

84

TEXTURE MAP FOR THE BRIDGE PLUS CALLIGRAPHIC SWIRLS FOR THE SKY.

FOOTAGE OF HELENA ON A FLAT, CARRIED BY THE ANIMATED COPS' CRADLE.

I think that there was an original plan to have the police wear blue uniforms and have little police hats, but that sort of fell by the way and they became bright red beetles instead.

Lenny Henry did the various voices in a number of different styles, including the Jamaican Rasta beetle stilt-cops, a version that didn't make it into the film because we figured people would still be trying to get used to the whole idea of red beetle stilt-walking caterpillar cops.

NG

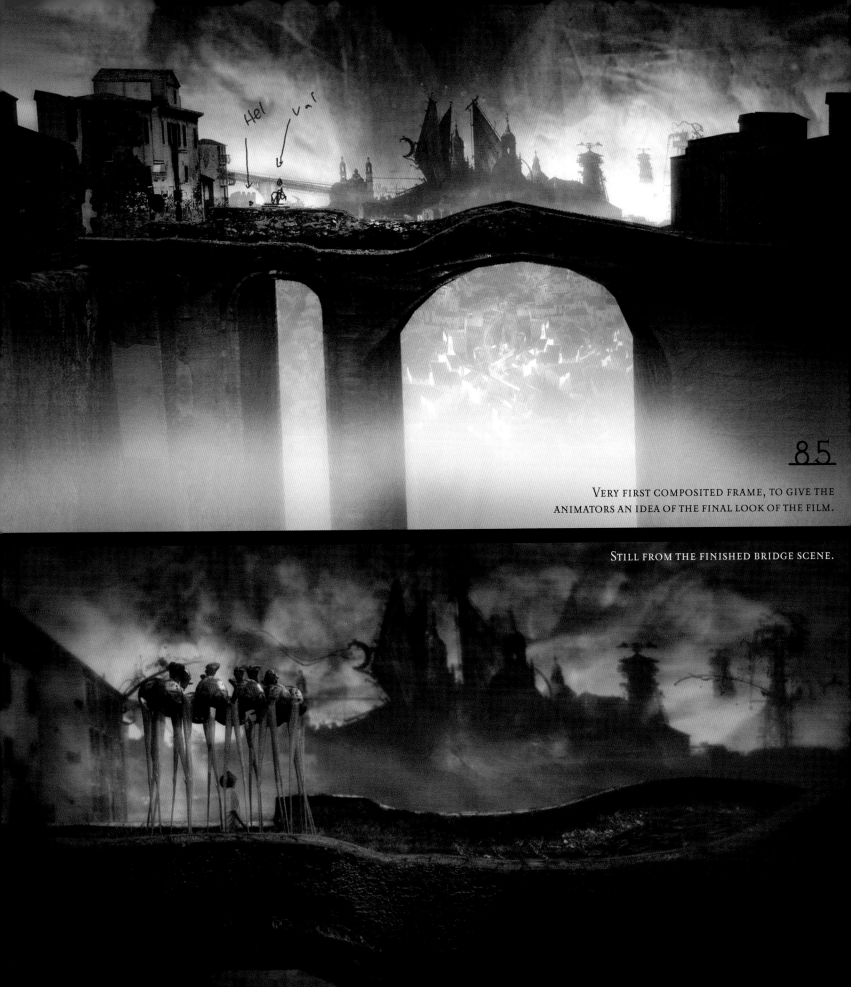

85

VERY FIRST COMPOSITED FRAME, TO GIVE THE
ANIMATORS AN IDEA OF THE FINAL LOOK OF THE FILM.

STILL FROM THE FINISHED BRIDGE SCENE.

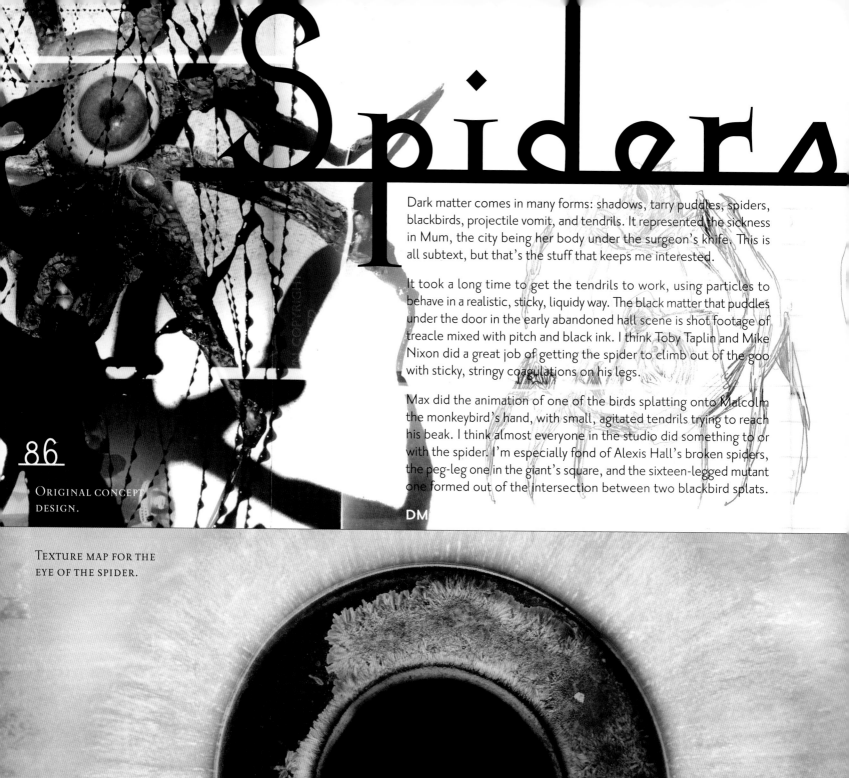

Spiders

Dark matter comes in many forms: shadows, tarry puddles, spiders, blackbirds, projectile vomit, and tendrils. It represented the sickness in Mum, the city being her body under the surgeon's knife. This is all subtext, but that's the stuff that keeps me interested.

It took a long time to get the tendrils to work, using particles to behave in a realistic, sticky, liquidy way. The black matter that puddles under the door in the early abandoned hall scene is shot footage of treacle mixed with pitch and black ink. I think Toby Taplin and Mike Nixon did a great job of getting the spider to climb out of the goo with sticky, stringy coagulations on his legs.

Max did the animation of one of the birds splatting onto Malcolm the monkeybird's hand, with small, agitated tendrils trying to reach his beak. I think almost everyone in the studio did something to or with the spider. I'm especially fond of Alexis Hall's broken spiders, the peg-leg one in the giant's square, and the sixteen-legged mutant one formed out of the intersection between two blackbird splats.

DM

TEXTURE MAP FOR THE
EYE OF THE SPIDER.

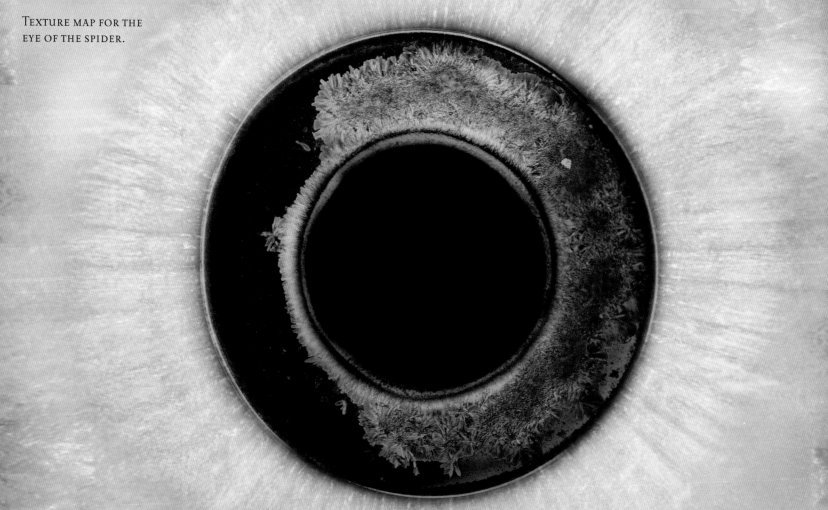

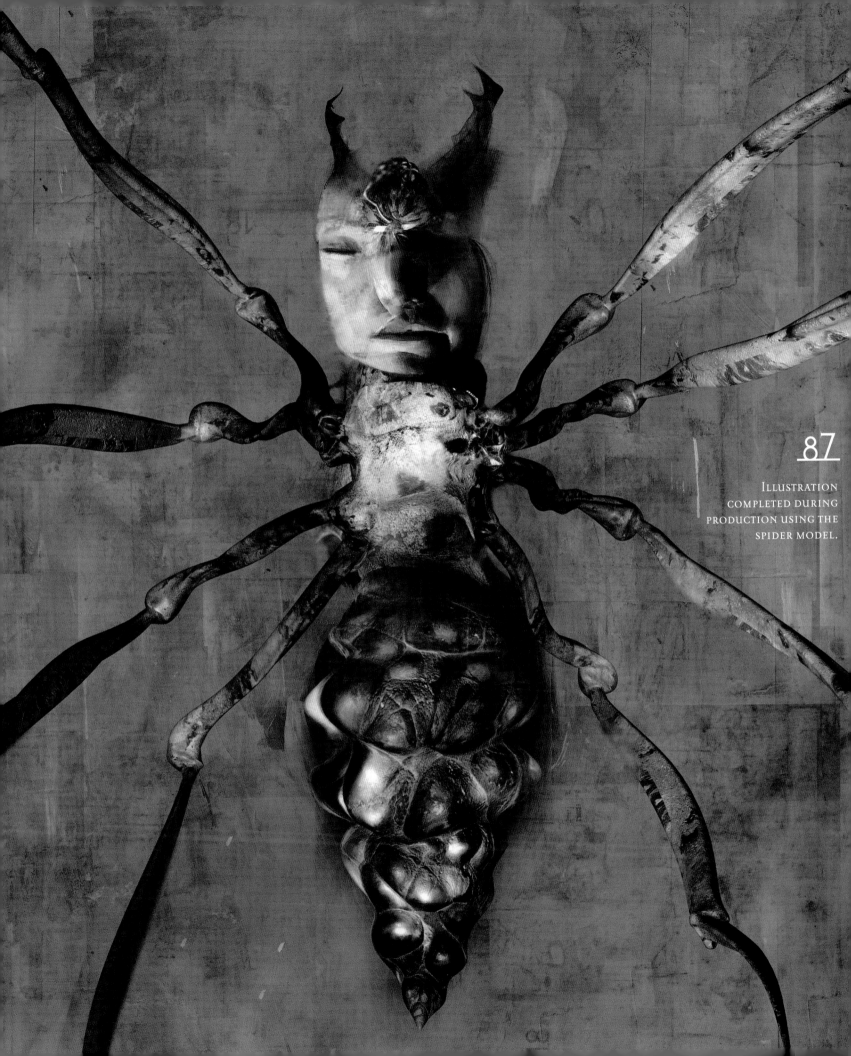

ILLUSTRATION
COMPLETED DURING
PRODUCTION USING THE
SPIDER MODEL.

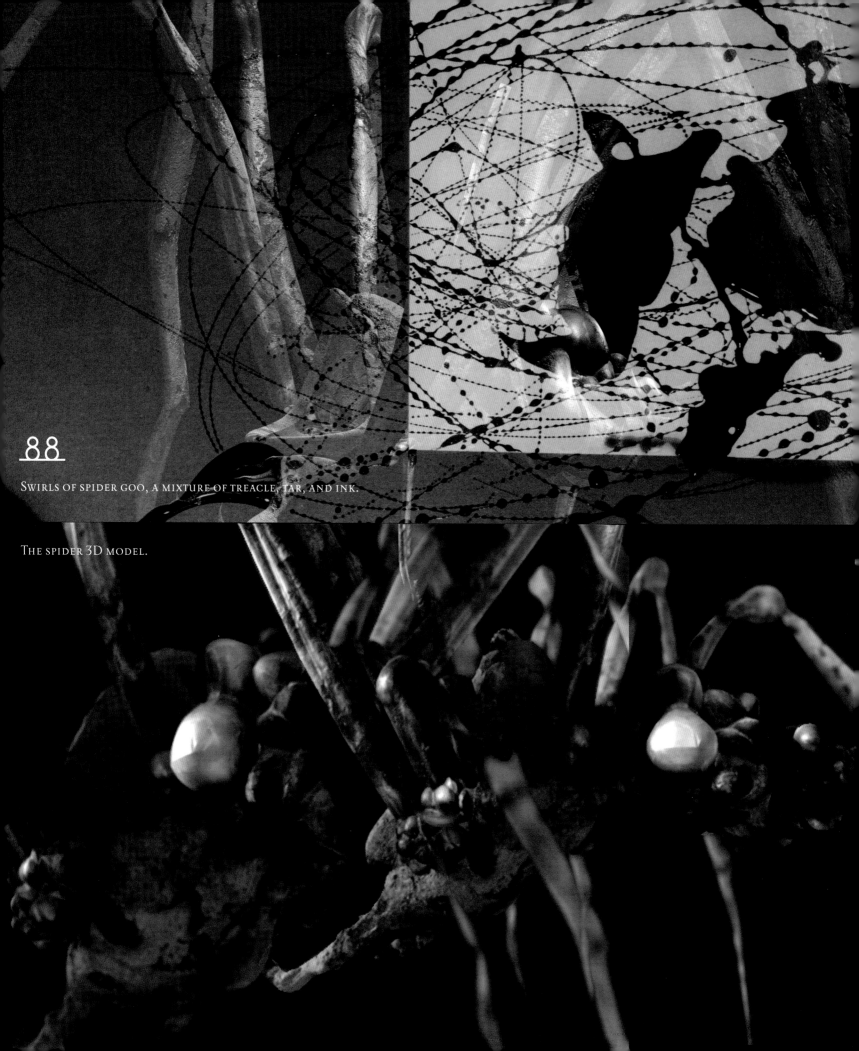

88

Swirls of spider goo, a mixture of treacle, tar, and ink.

The spider 3D model.

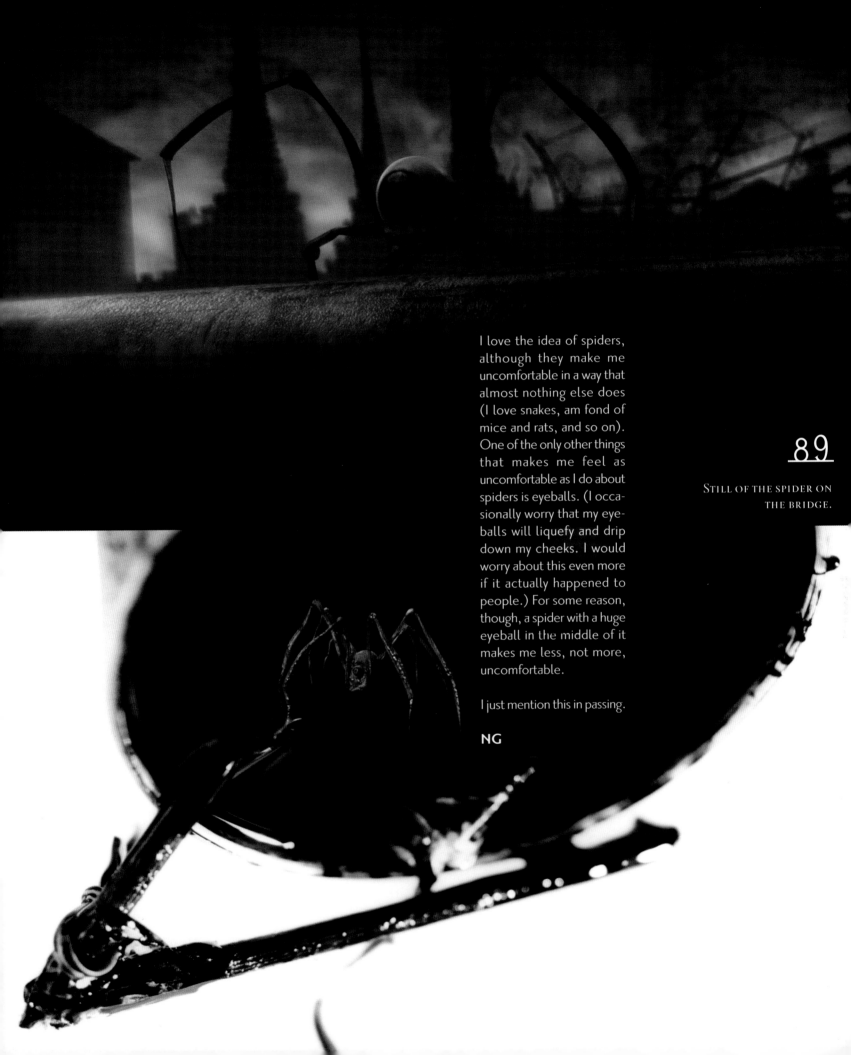

I love the idea of spiders, although they make me uncomfortable in a way that almost nothing else does (I love snakes, am fond of mice and rats, and so on). One of the only other things that makes me feel as uncomfortable as I do about spiders is eyeballs. (I occasionally worry that my eyeballs will liquefy and drip down my cheeks. I would worry about this even more if it actually happened to people.) For some reason, though, a spider with a huge eyeball in the middle of it makes me less, not more, uncomfortable.

I just mention this in passing.

NG

89

STILL OF THE SPIDER ON THE BRIDGE.

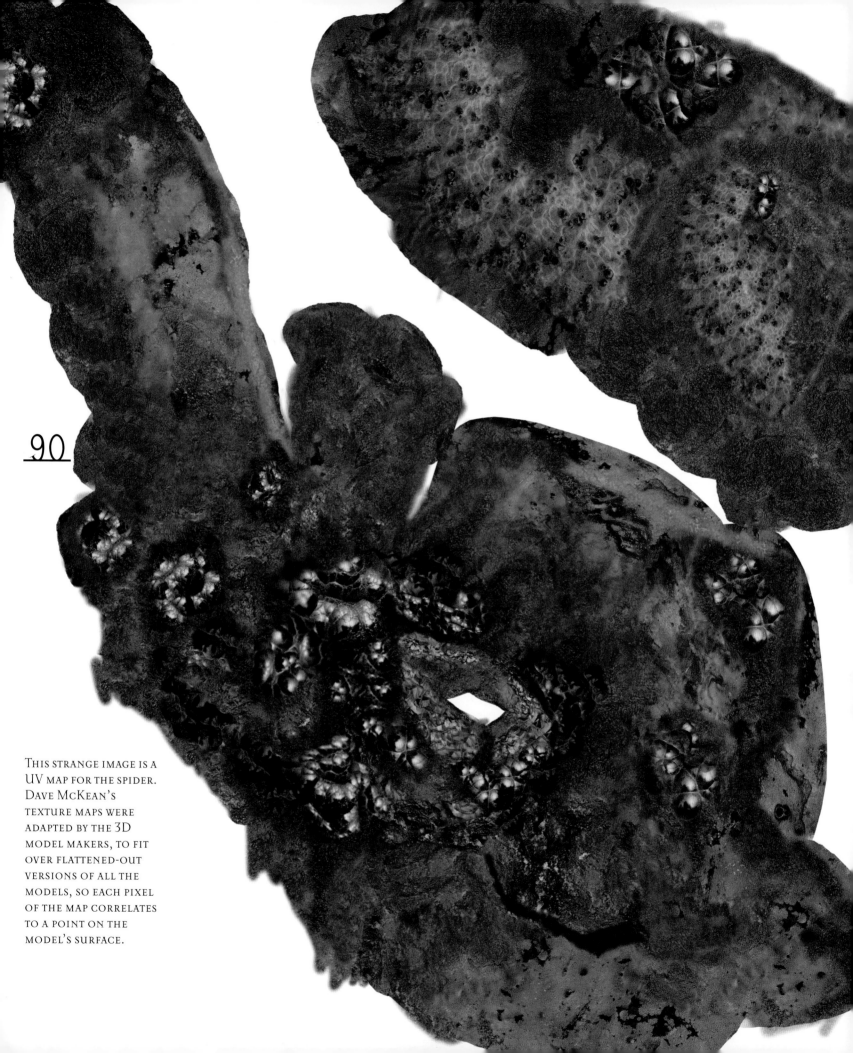

90

THIS STRANGE IMAGE IS A
UV MAP FOR THE SPIDER.
DAVE McKEAN'S
TEXTURE MAPS WERE
ADAPTED BY THE 3D
MODEL MAKERS, TO FIT
OVER FLATTENED-OUT
VERSIONS OF ALL THE
MODELS, SO EACH PIXEL
OF THE MAP CORRELATES
TO A POINT ON THE
MODEL'S SURFACE.

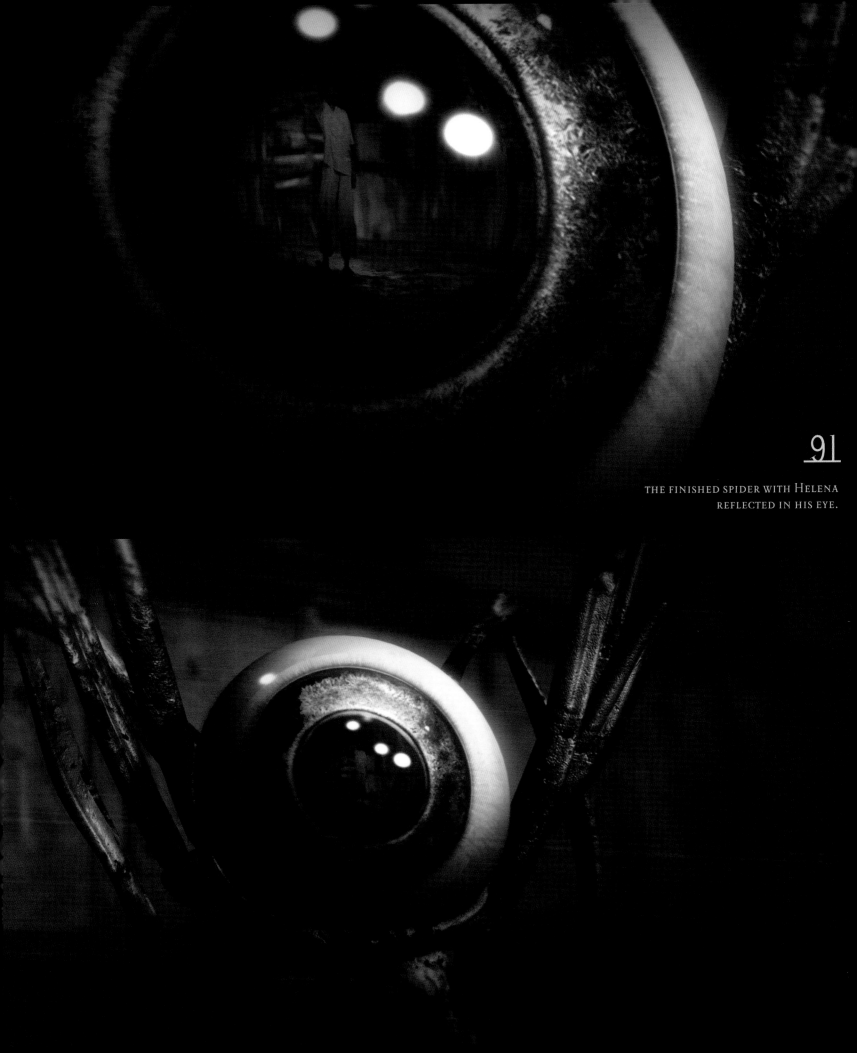

THE FINISHED SPIDER WITH HELENA
REFLECTED IN HIS EYE.

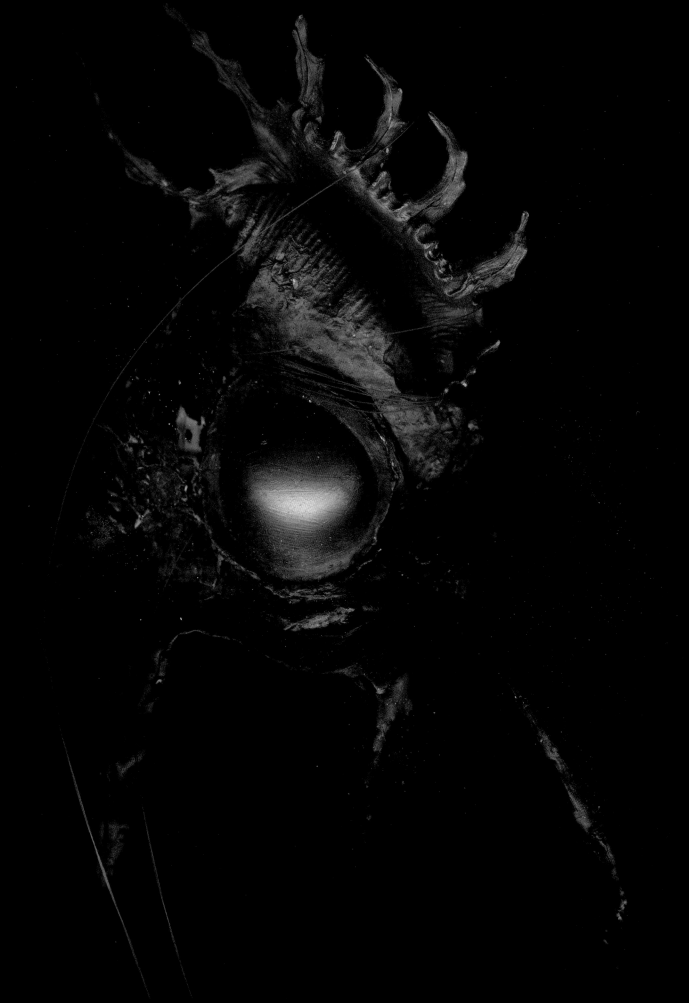

92

This is a spider mask
intended to attach to
Gina's face. During
the shoot, it seemed
obvious that it wasn't
going to work, but the
shell and clay legs
informed the 3D
model.

The Palace of Light

THIS IS A BURNED-OUT MICROPROCESSOR, FOUND BY MAX McMULLIN ON THE BEACH IN CAMBER, ENGLAND. HE BROUGHT IT INTO THE STUDIO, AND IT WAS SCANNED AND USED AS THE TEXTURE MAP FOR THE PALACE OF LIGHT AND SURROUNDING BUILDINGS.

The Queen of Light and the Prime Minister's Story

It was writing the Prime Minister's dialogue that I started to feel that the story had some kind of life to it, that it was starting to do things I hadn't expected. It made me laugh, and I called Dave and read it to him, and it made him laugh, too.

Rob Bryden did an amazing job as the Dad, and was lobbying to be the Prime Minister from the first day of shooting. (We started shooting with the part still uncast, as the powers that be were hoping for some really cool stunt casting, wherein we'd have someone really famous who'd work for cheap come in and do it. I think we were trying not to cast her Dad as the Prime Minister because we were worried people might compare it to THE WIZARD OF OZ. Either that or we were just very, very dense.) I think what I like about the finished part is not just that it's funny, it's that Rob manages to play the Prime Minister in such a way that you like and care for this strangely ineffectual man but you also learn a bit more about her Dad—or at least how she sees him.

Or possibly how her Mum sees him, if it is indeed her mother's dream.

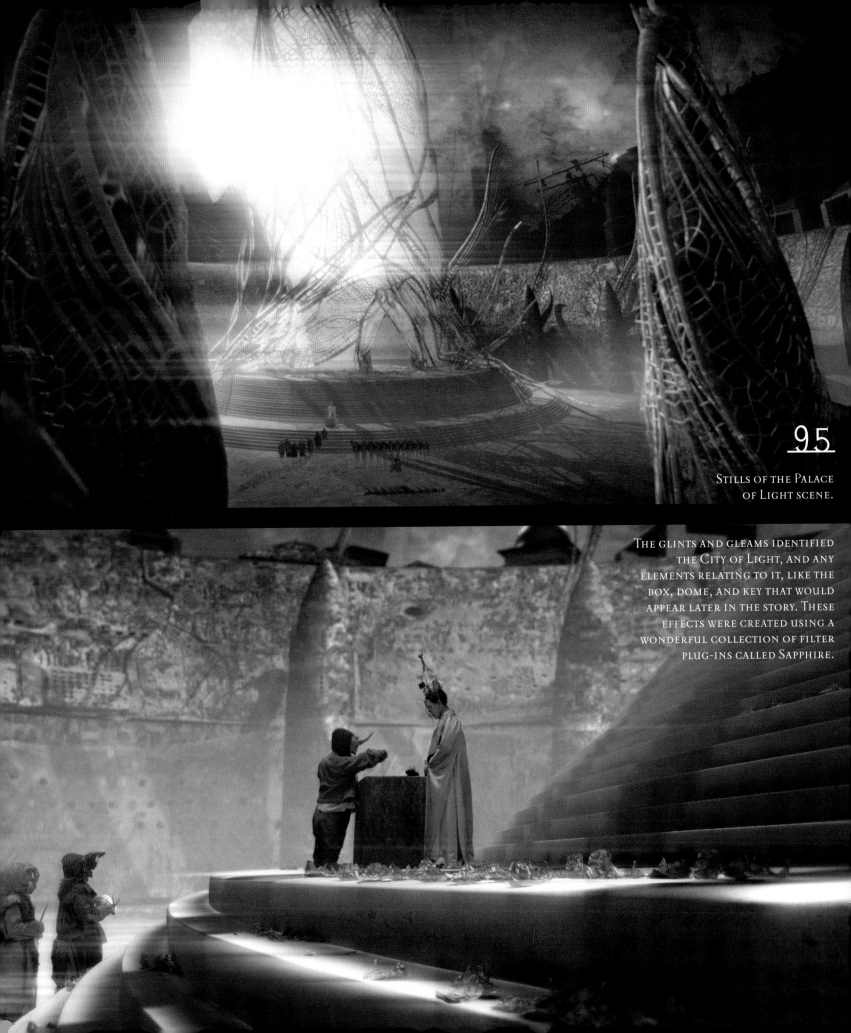

95

STILLS OF THE PALACE
OF LIGHT SCENE.

THE GLINTS AND GLEAMS IDENTIFIED
THE CITY OF LIGHT, AND ANY
ELEMENTS RELATING TO IT, LIKE THE
BOX, DOME, AND KEY THAT WOULD
APPEAR LATER IN THE STORY. THESE
EFFECTS WERE CREATED USING A
WONDERFUL COLLECTION OF FILTER
PLUG-INS CALLED SAPPHIRE.

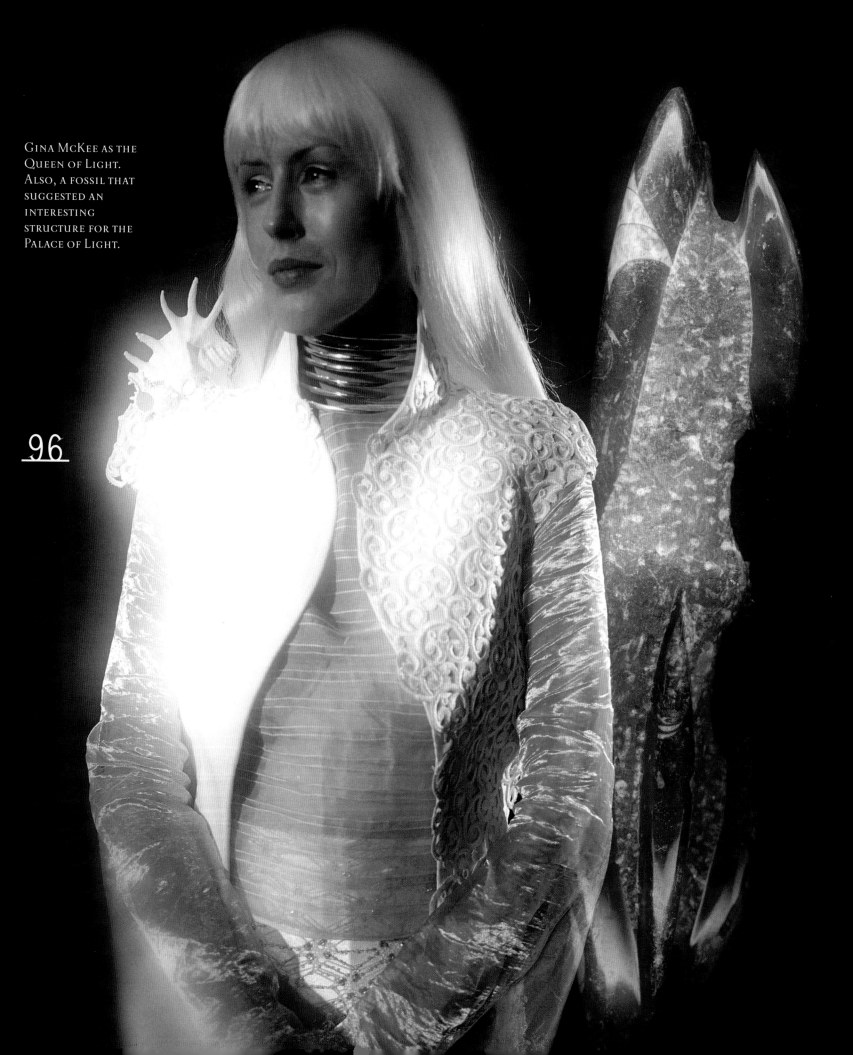

GINA MCKEE AS THE
QUEEN OF LIGHT.
ALSO, A FOSSIL THAT
SUGGESTED AN
INTERESTING
STRUCTURE FOR THE
PALACE OF LIGHT.

96

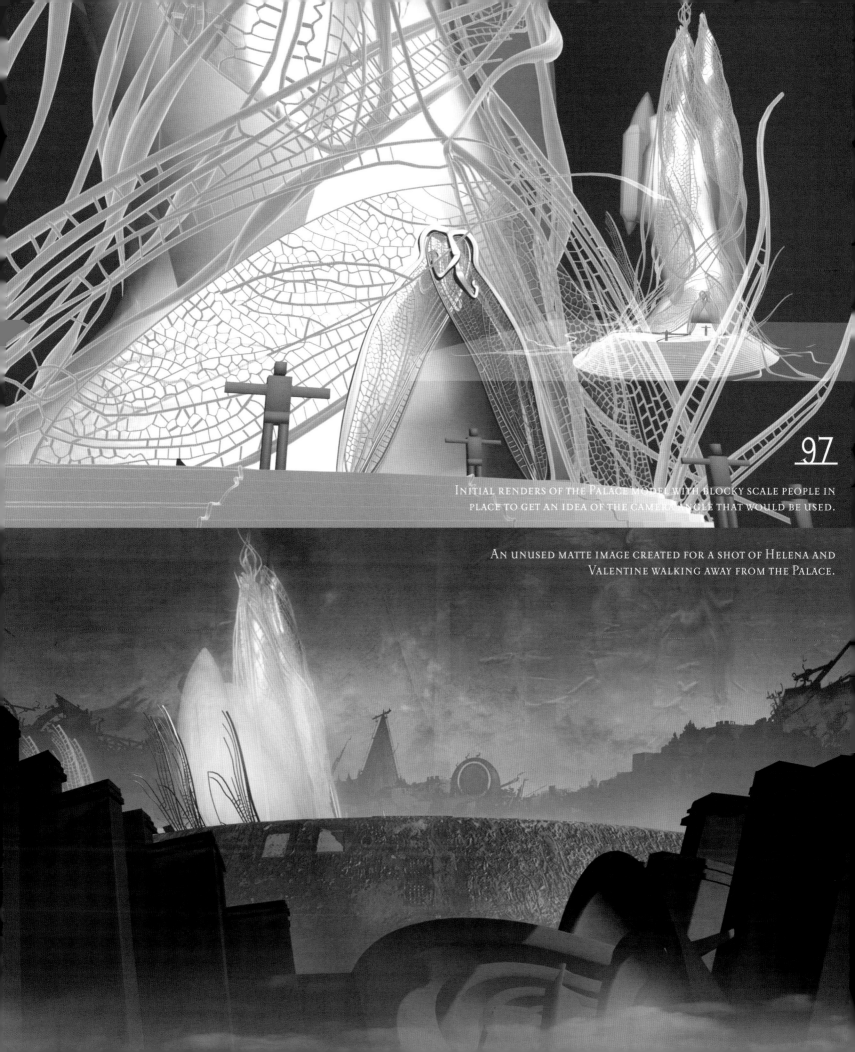

INITIAL RENDERS OF THE PALACE MODEL WITH BLOCKY SCALE PEOPLE IN PLACE TO GET AN IDEA OF THE CAMERA ANGLE THAT WOULD BE USED.

AN UNUSED MATTE IMAGE CREATED FOR A SHOT OF HELENA AND VALENTINE WALKING AWAY FROM THE PALACE.

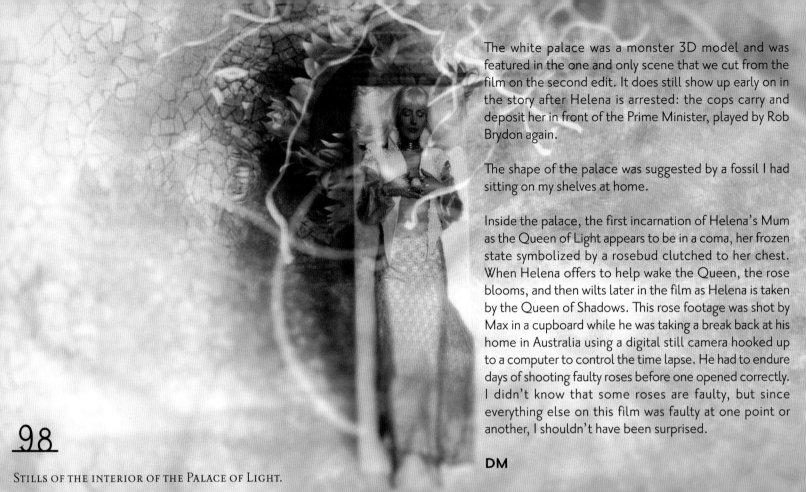

The white palace was a monster 3D model and was featured in the one and only scene that we cut from the film on the second edit. It does still show up early on in the story after Helena is arrested: the cops carry and deposit her in front of the Prime Minister, played by Rob Brydon again.

The shape of the palace was suggested by a fossil I had sitting on my shelves at home.

Inside the palace, the first incarnation of Helena's Mum as the Queen of Light appears to be in a coma, her frozen state symbolized by a rosebud clutched to her chest. When Helena offers to help wake the Queen, the rose blooms, and then wilts later in the film as Helena is taken by the Queen of Shadows. This rose footage was shot by Max in a cupboard while he was taking a break back at his home in Australia using a digital still camera hooked up to a computer to control the time lapse. He had to endure days of shooting faulty roses before one opened correctly. I didn't know that some roses are faulty, but since everything else on this film was faulty at one point or another, I shouldn't have been surprised.

DM

98

STILLS OF THE INTERIOR OF THE PALACE OF LIGHT.

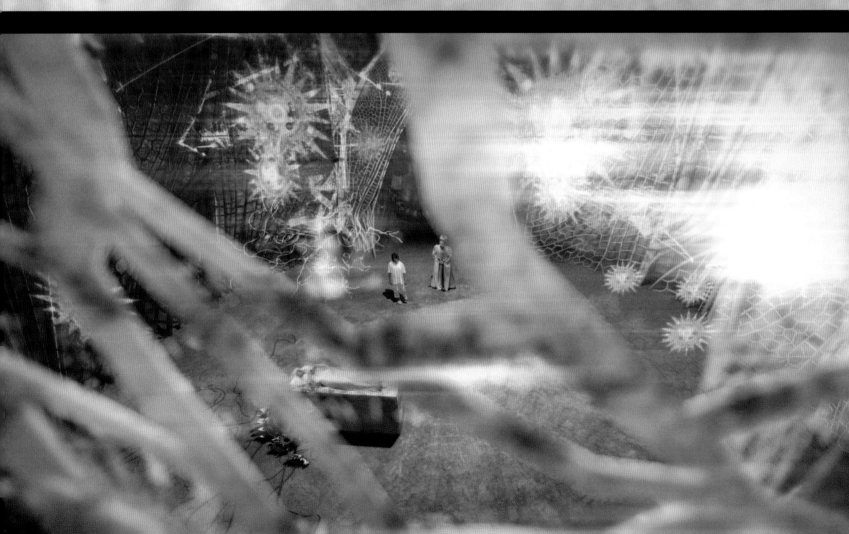

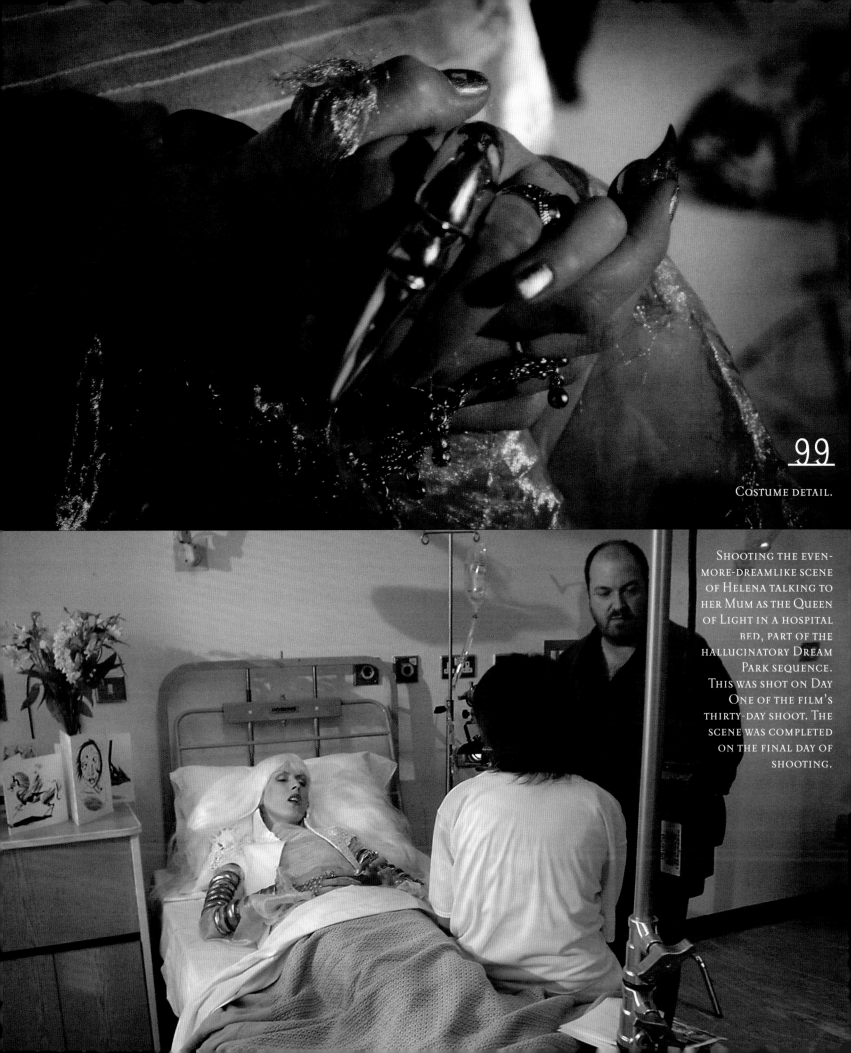

99

COSTUME DETAIL.

SHOOTING THE EVEN-
MORE-DREAMLIKE SCENE
OF HELENA TALKING TO
HER MUM AS THE QUEEN
OF LIGHT IN A HOSPITAL
BED, PART OF THE
HALLUCINATORY DREAM
PARK SEQUENCE.
THIS WAS SHOT ON DAY
ONE OF THE FILM'S
THIRTY-DAY SHOOT. THE
SCENE WAS COMPLETED
ON THE FINAL DAY OF
SHOOTING.

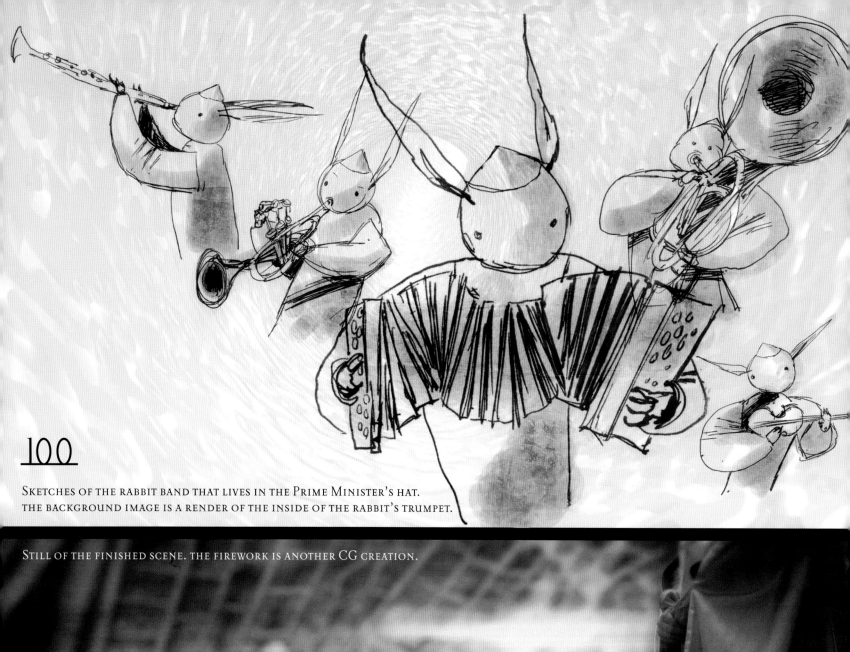

100

SKETCHES OF THE RABBIT BAND THAT LIVES IN THE PRIME MINISTER'S HAT.
THE BACKGROUND IMAGE IS A RENDER OF THE INSIDE OF THE RABBIT'S TRUMPET.

STILL OF THE FINISHED SCENE. THE FIREWORK IS ANOTHER CG CREATION.

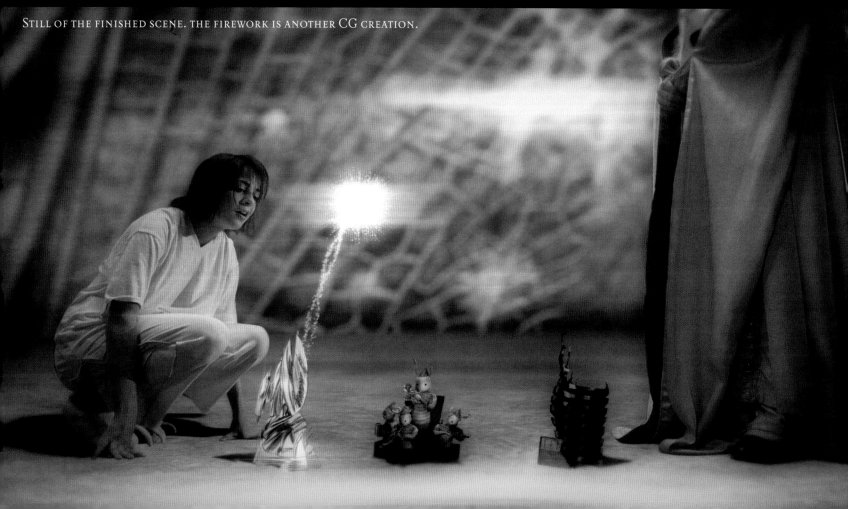

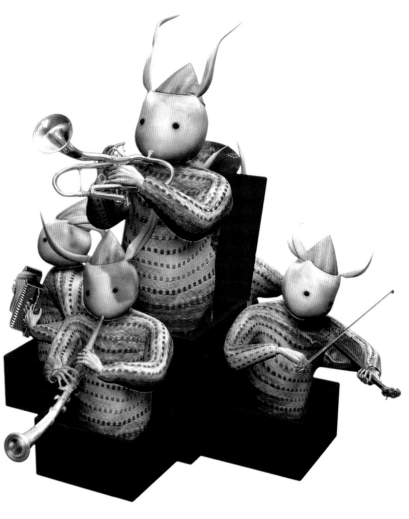

THE FINAL RABBIT BAND MODEL.

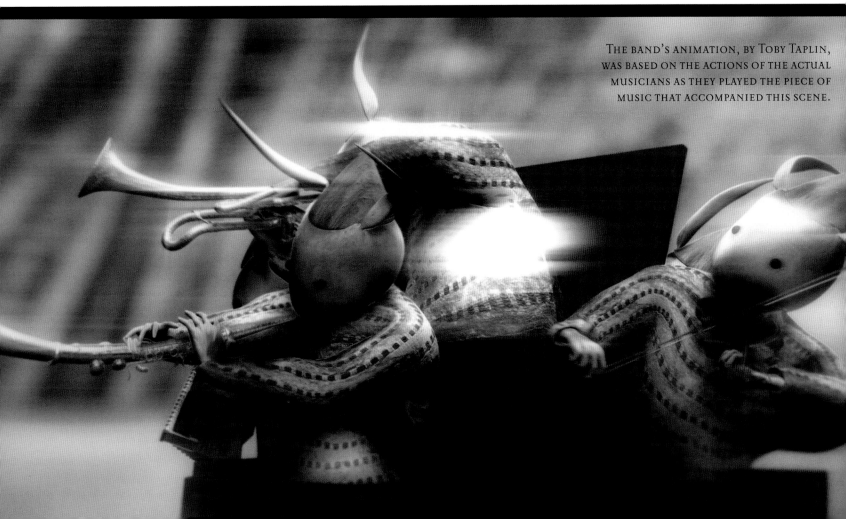

THE BAND'S ANIMATION, BY TOBY TAPLIN,
WAS BASED ON THE ACTIONS OF THE ACTUAL
MUSICIANS AS THEY PLAYED THE PIECE OF
MUSIC THAT ACCOMPANIED THIS SCENE.

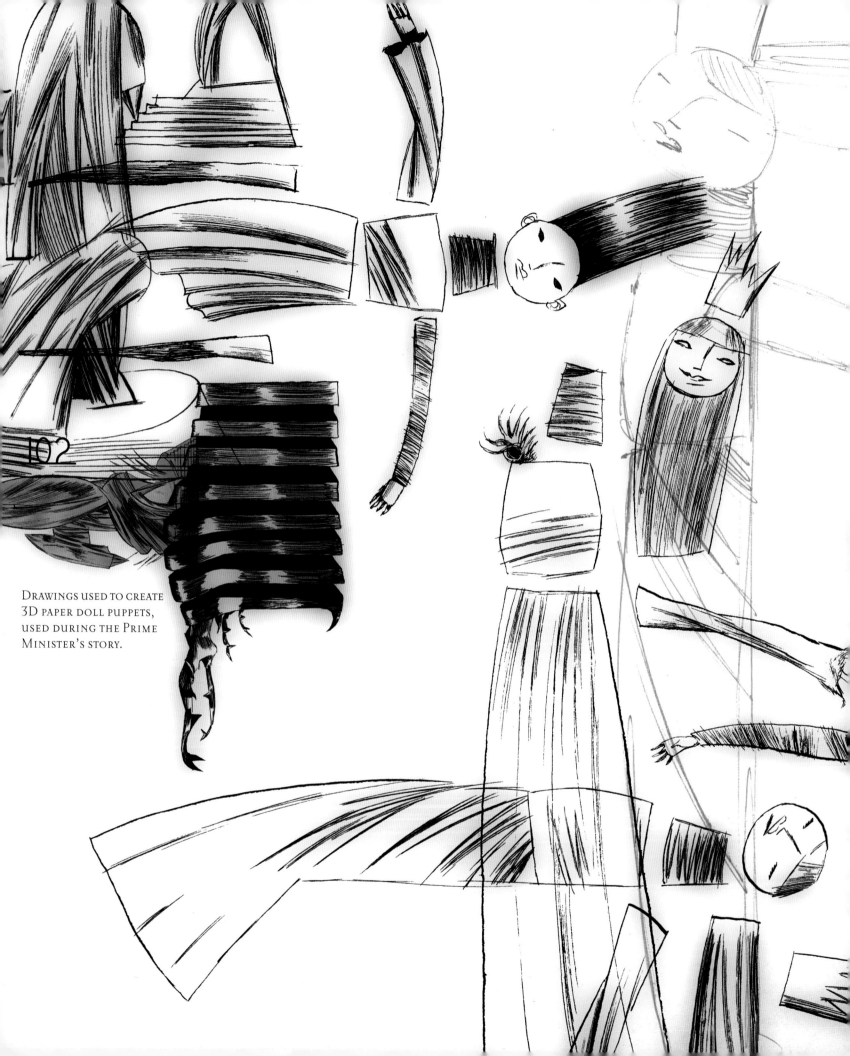

DRAWINGS USED TO CREATE
3D PAPER DOLL PUPPETS,
USED DURING THE PRIME
MINISTER'S STORY.

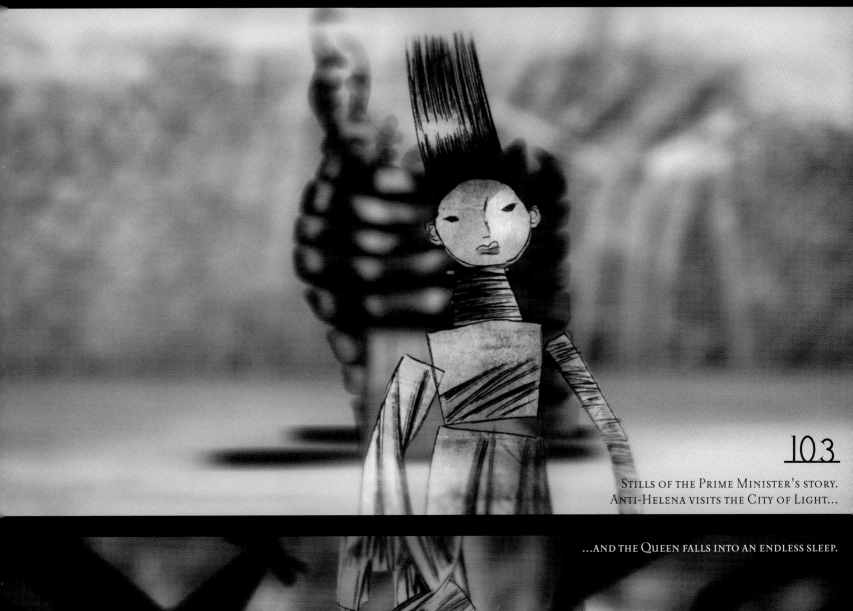

103

STILLS OF THE PRIME MINISTER'S STORY.
ANTI-HELENA VISITS THE CITY OF LIGHT...

...AND THE QUEEN FALLS INTO AN ENDLESS SLEEP.

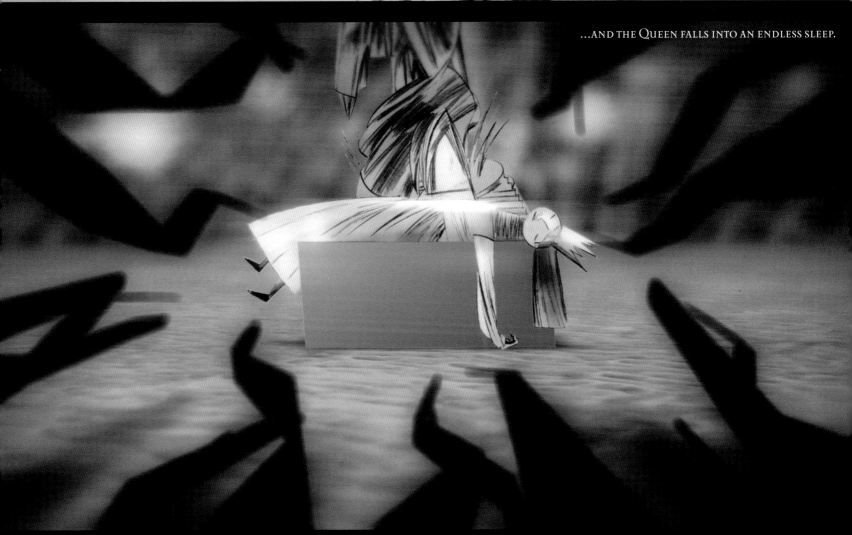

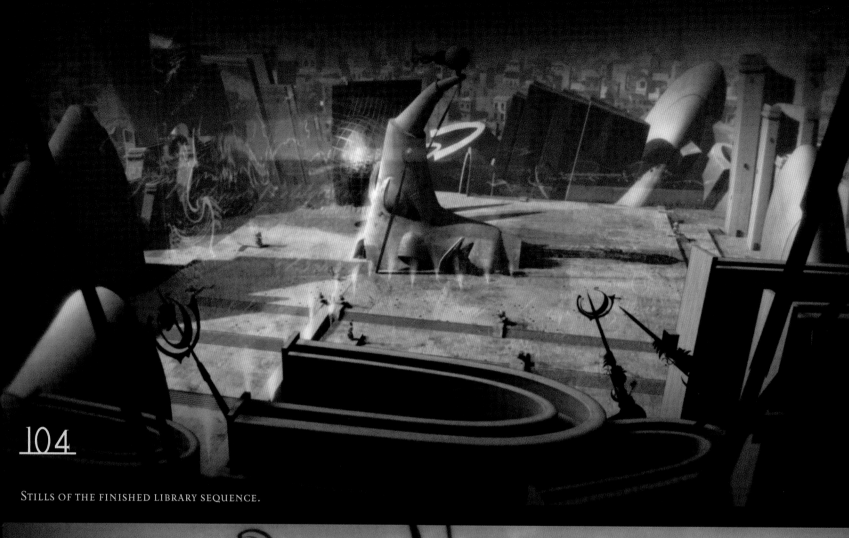

Stills of the finished library sequence.

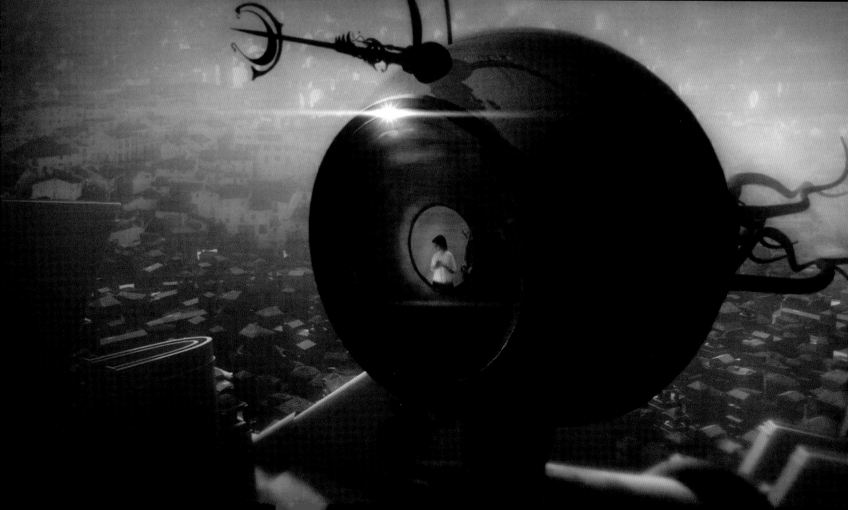

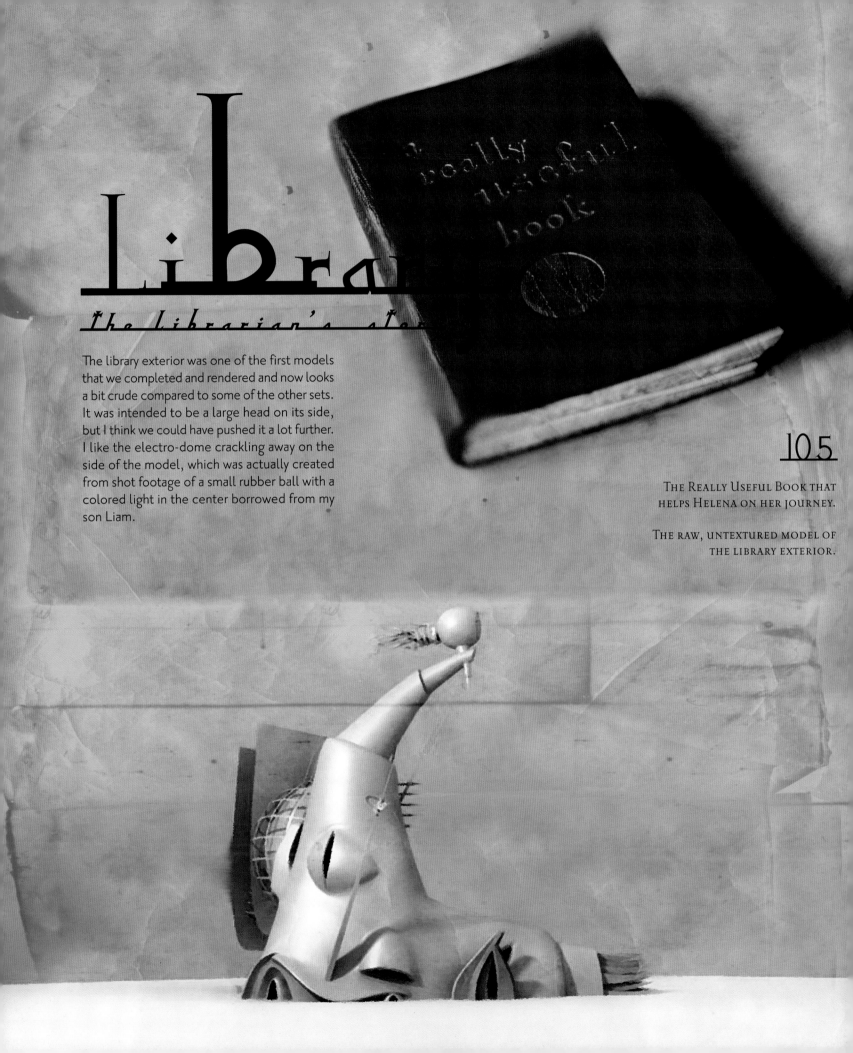

Library
The Librarian's story

The library exterior was one of the first models that we completed and rendered and now looks a bit crude compared to some of the other sets. It was intended to be a large head on its side, but I think we could have pushed it a lot further. I like the electro-dome crackling away on the side of the model, which was actually created from shot footage of a small rubber ball with a colored light in the center borrowed from my son Liam.

THE REALLY USEFUL BOOK THAT HELPS HELENA ON HER JOURNEY.

THE RAW, UNTEXTURED MODEL OF THE LIBRARY EXTERIOR.

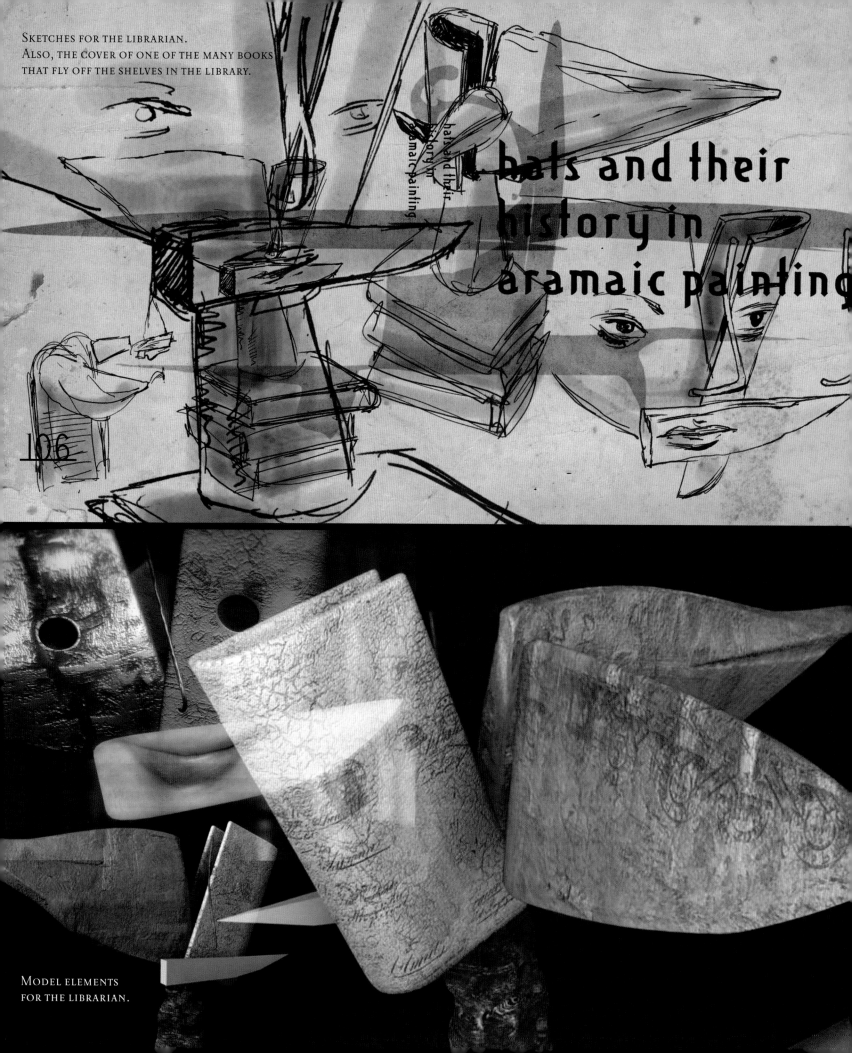

SKETCHES FOR THE LIBRARIAN.
ALSO, THE COVER OF ONE OF THE MANY BOOKS
THAT FLY OFF THE SHELVES IN THE LIBRARY.

hats and their
history in
aramaic painting

MODEL ELEMENTS
FOR THE LIBRARIAN.

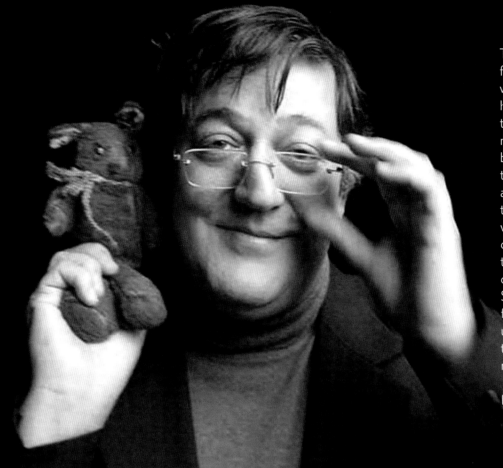

The librarian was performed by Stephen Fry, who set a record by doing his part for the film in twenty minutes flat. (This record was beaten later by Lenny Henry, who did the cops in seventeen and a half minutes.) Two read-throughs and Stephen was gone, but that was one read-through more than he needed. No one can do Stephen Fry like Stephen Fry. We shot footage of his mouth to use on the little panel on the face of the librarian model.

DM

A PHOTOGRAPH OF STEPHEN FRY HOLDING A SMALL TEDDY, TAKEN BY TONY SHEARN. TONY HAS DOZENS OF SUCH PHOTOGRAPHS, WITH THIS ODD LITTLE BEAR APPEARING WITH SOME OF THE GREATEST ACTORS IN THE WORLD. SOMEDAY A BOOK WILL BE PUBLISHED.

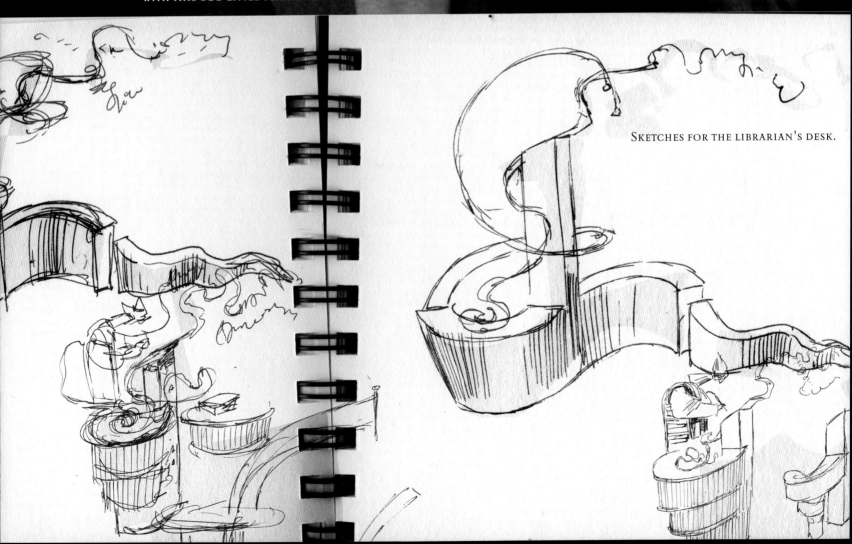

SKETCHES FOR THE LIBRARIAN'S DESK.

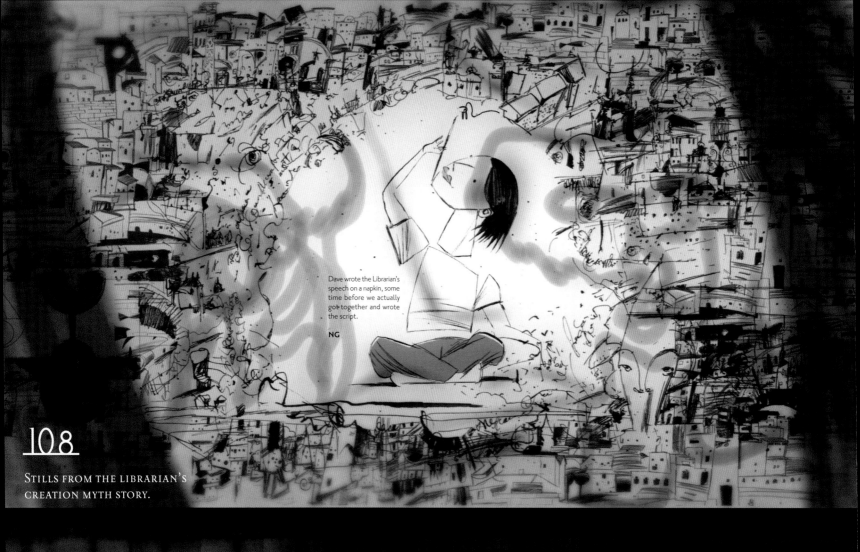

Dave wrote the Librarian's speech on a napkin, some time before we actually got together and wrote the script.

NG

108

The librarian reads a creation myth that explains the origins of the city—a mystical interpretation of Helena finding herself in the spare, empty bedroom at her Aunt Nan's flat, and creating a wall full of city drawings and characters to keep her company while the family waits to see what will happen to Mum. This story-within-a-story was one of the few scenes I scripted, and was visualized in a 2D/3D style of pen-and-ink drawings.

We first meet the little REALLY USEFUL BOOK upstairs in the library. I really think there should be such a thing. A COMPLETE HISTORY OF EVERYTHING would be useful as well.

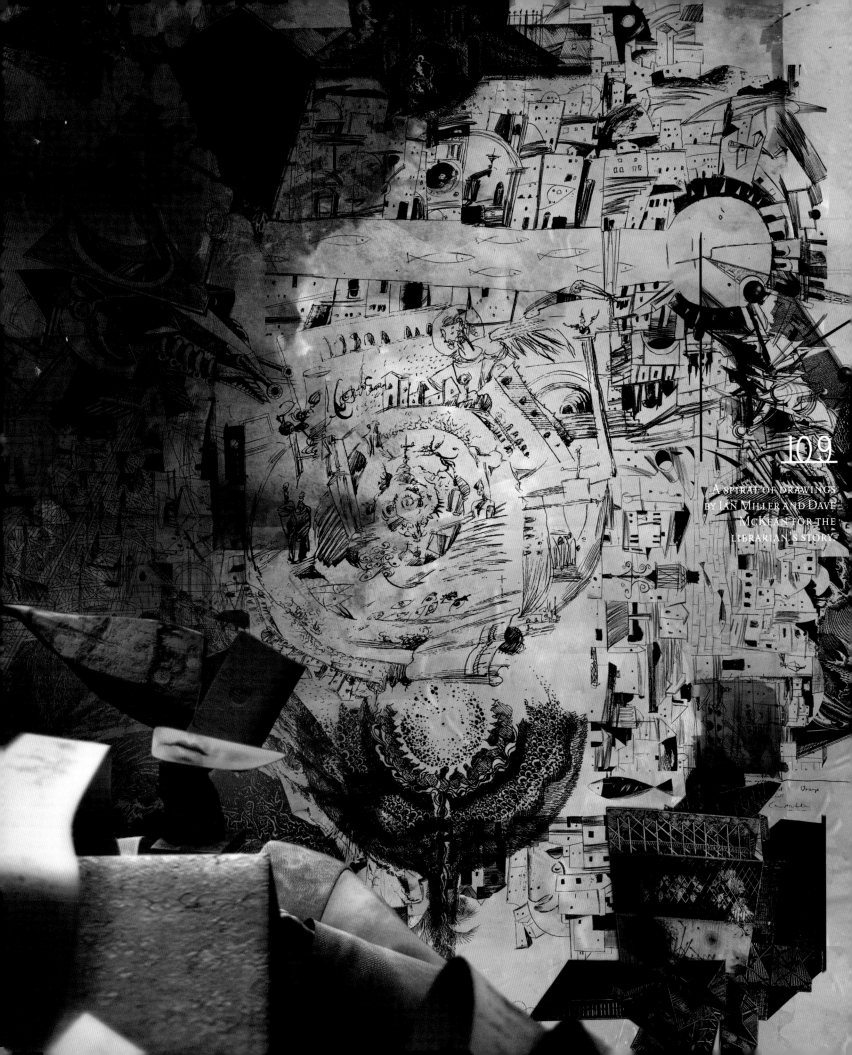

A SPIRAL OF DRAWINGS
BY IAN MILLER AND DAVE
MCKEAN FOR THE
LIBRARIAN'S STORY.

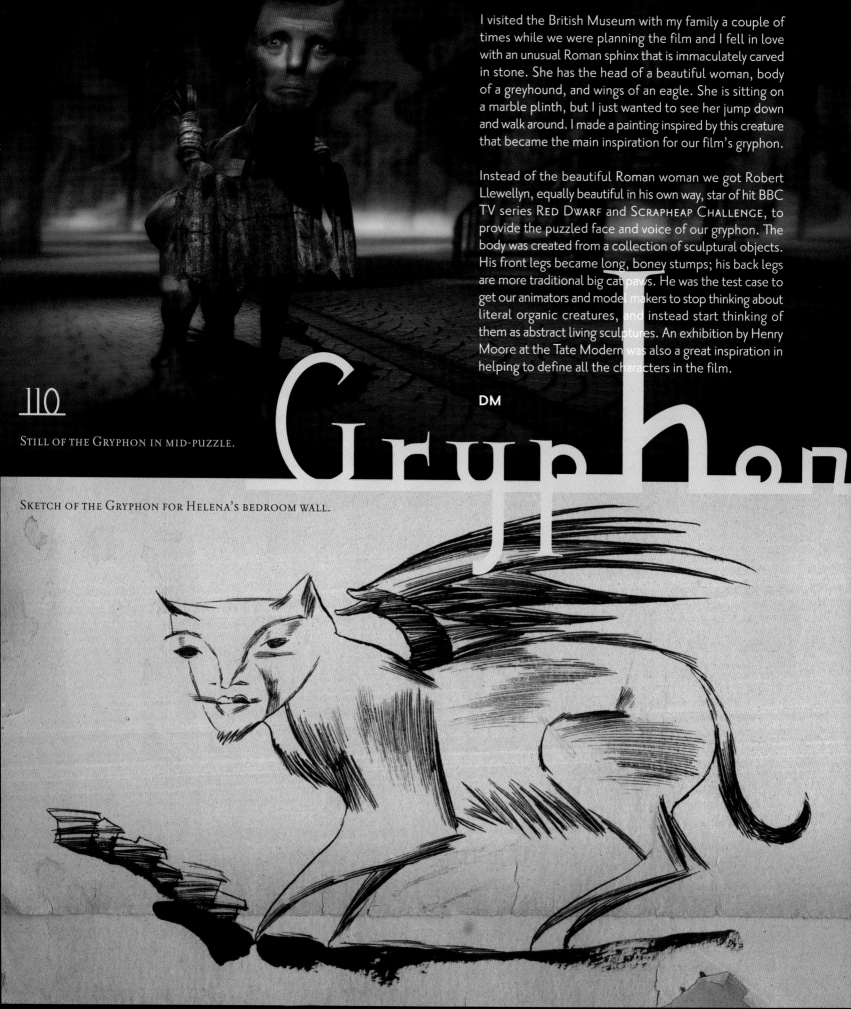

I visited the British Museum with my family a couple of times while we were planning the film and I fell in love with an unusual Roman sphinx that is immaculately carved in stone. She has the head of a beautiful woman, body of a greyhound, and wings of an eagle. She is sitting on a marble plinth, but I just wanted to see her jump down and walk around. I made a painting inspired by this creature that became the main inspiration for our film's gryphon.

Instead of the beautiful Roman woman we got Robert Llewellyn, equally beautiful in his own way, star of hit BBC TV series RED DWARF and SCRAPHEAP CHALLENGE, to provide the puzzled face and voice of our gryphon. The body was created from a collection of sculptural objects. His front legs became long, boney stumps; his back legs are more traditional big cat paws. He was the test case to get our animators and model makers to stop thinking about literal organic creatures, and instead start thinking of them as abstract living sculptures. An exhibition by Henry Moore at the Tate Modern was also a great inspiration in helping to define all the characters in the film.

DM

Gryphon

STILL OF THE GRYPHON IN MID-PUZZLE.

SKETCH OF THE GRYPHON FOR HELENA'S BEDROOM WALL.

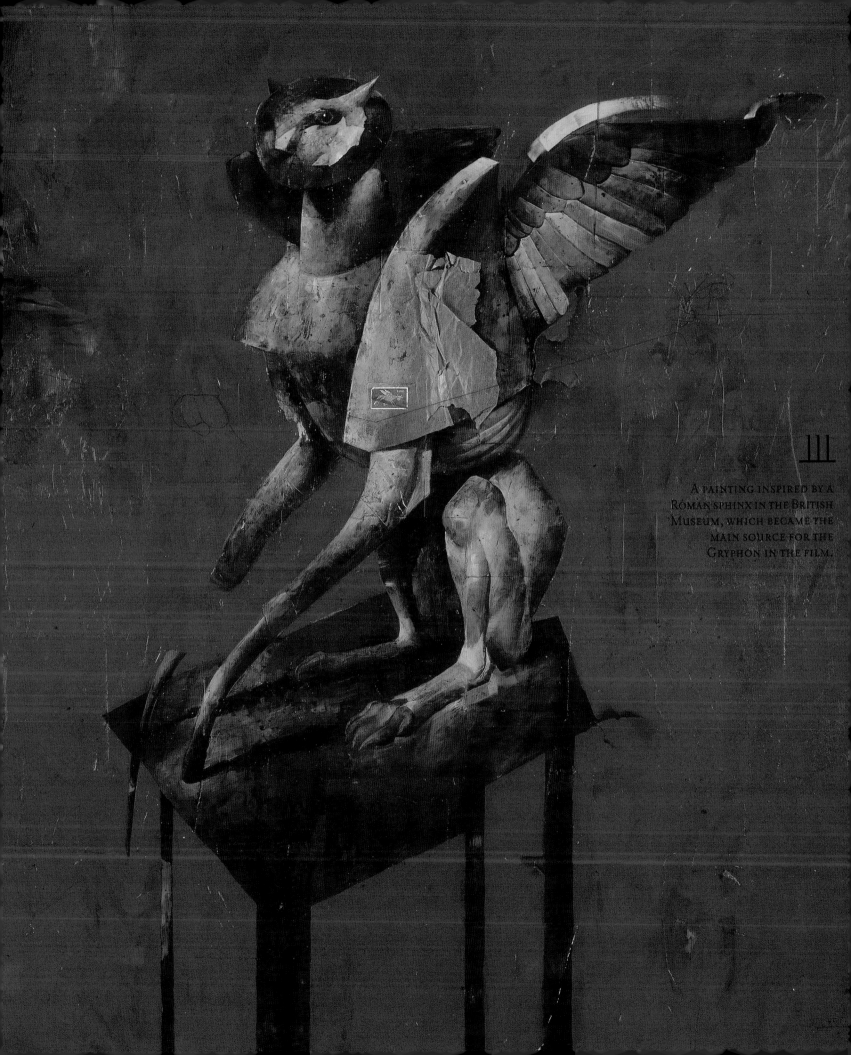

A painting inspired by a
Roman sphinx in the British
Museum, which became the
main source for the
Gryphon in the film.

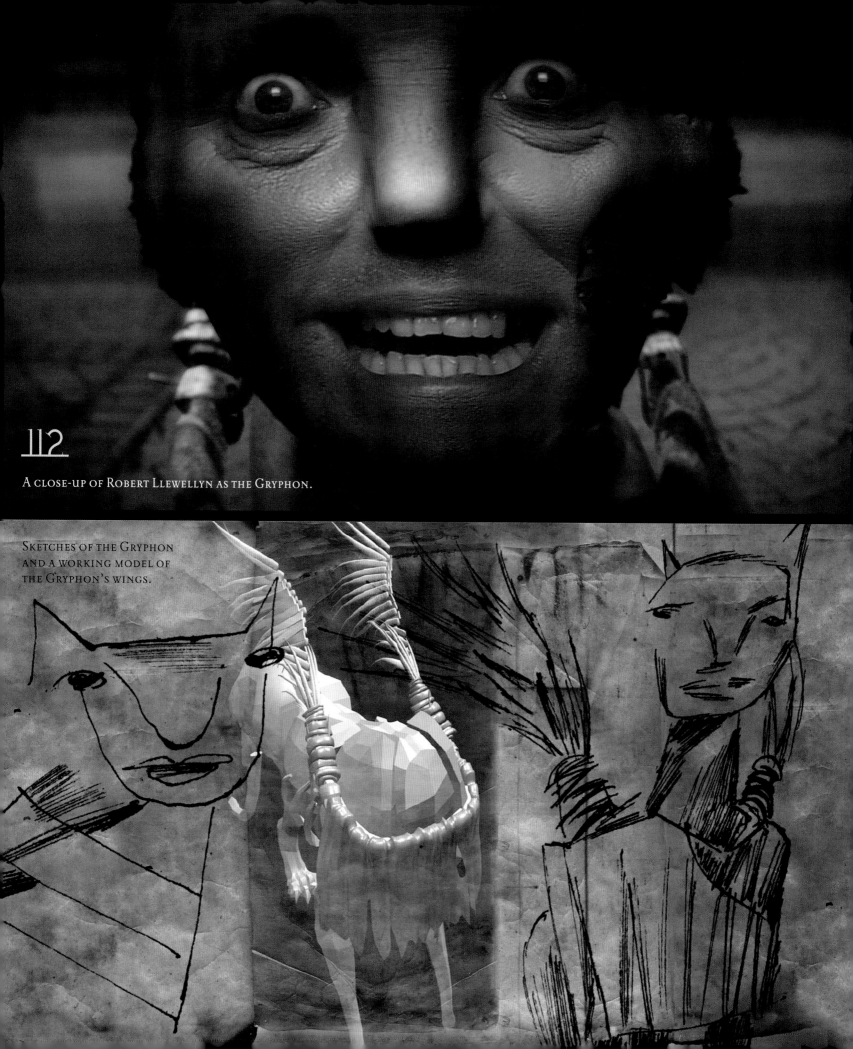

112

A close-up of Robert Llewellyn as the Gryphon.

Sketches of the Gryphon
and a working model of
the Gryphon's wings.

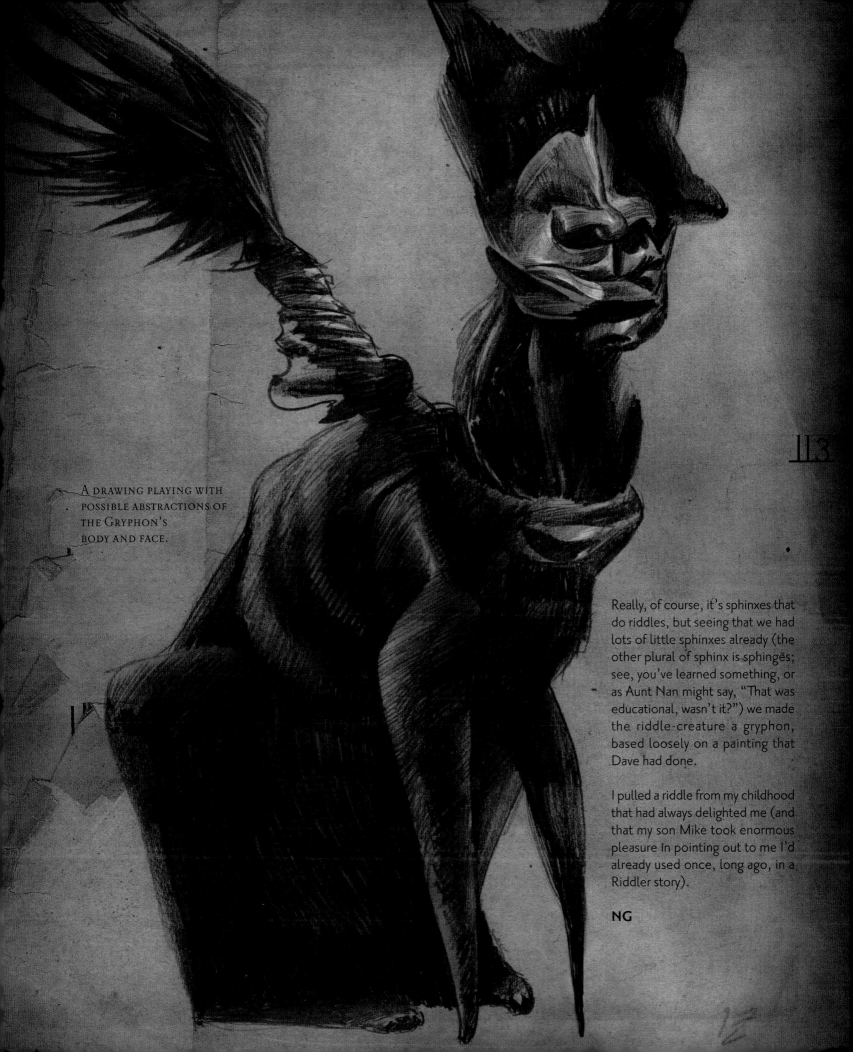

A DRAWING PLAYING WITH
POSSIBLE ABSTRACTIONS OF
THE GRYPHON'S
BODY AND FACE.

Really, of course, it's sphinxes that
do riddles, but seeing that we had
lots of little sphinxes already (the
other plural of sphinx is sphinges;
see, you've learned something, or
as Aunt Nan might say, "That was
educational, wasn't it?") we made
the riddle-creature a gryphon,
based loosely on a painting that
Dave had done.

I pulled a riddle from my childhood
that had always delighted me (and
that my son Mike took enormous
pleasure in pointing out to me I'd
already used once, long ago, in a
Riddler story).

NG

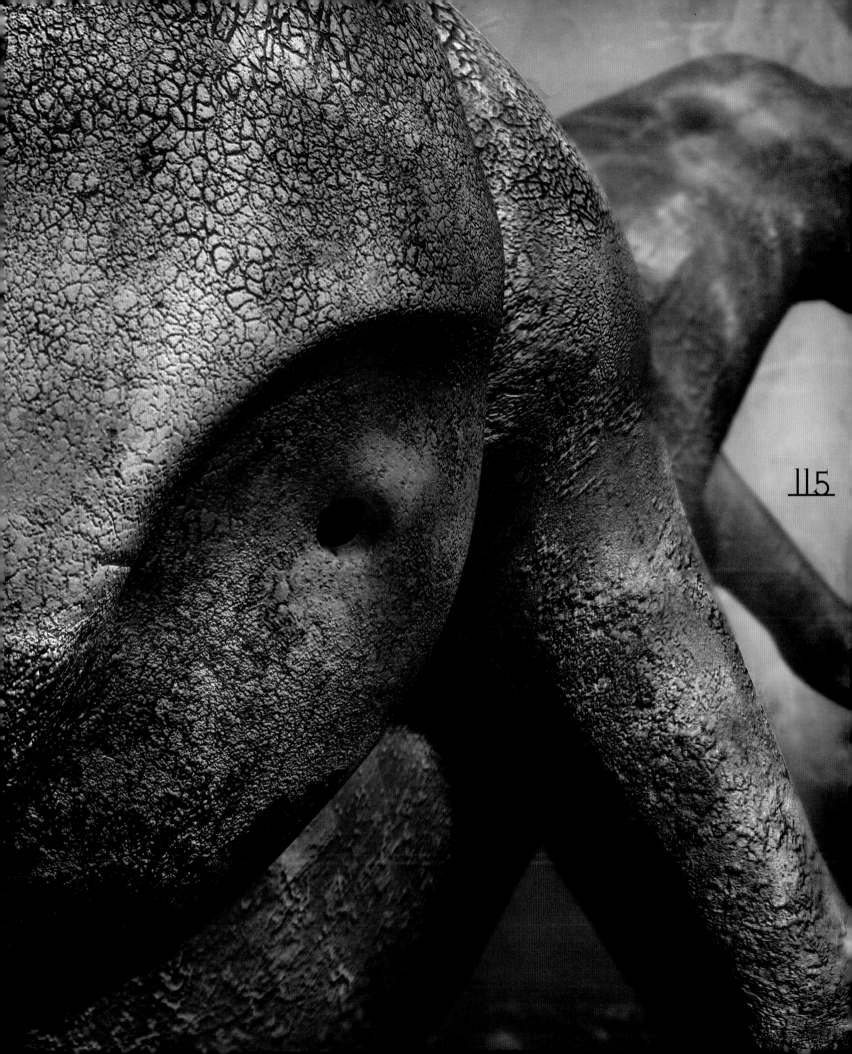

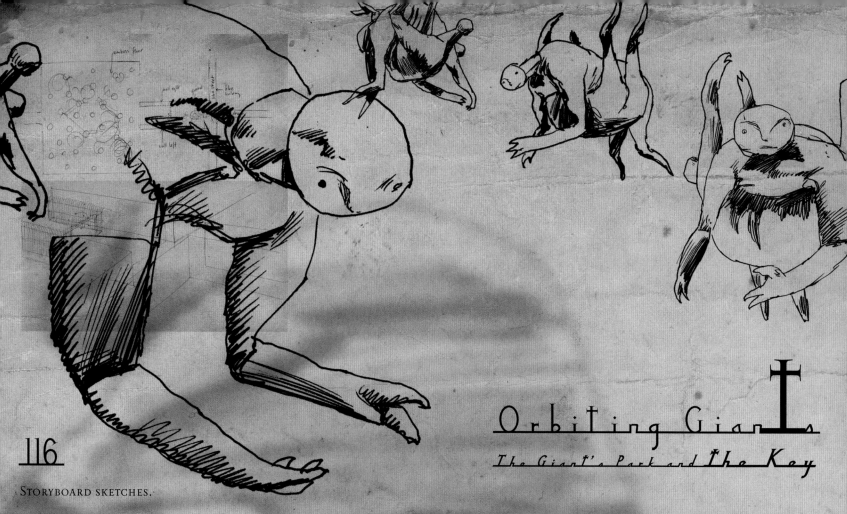

Orbiting Giants
The Giant's Park and The Key

STORYBOARD SKETCHES.

ROUGH CLAY MODEL TO
HELP WORK OUT ANGLES
AND LIGHTING.

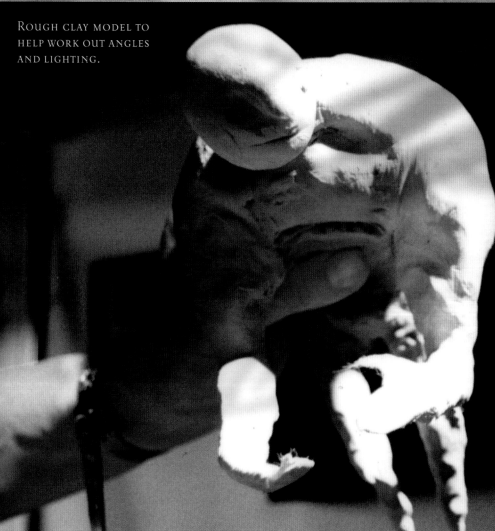

The inspiration for the giants came from a software demonstration. I knew that we were going to be using MAYA and intended to learn how to use it during the year we were completing the animation. It's a fiendishly difficult program to get your head around, which is not helped by the fact that you need to write code to patch up the bits that are missing. It seemed to me to be the software equivalent of a car with no brakes, three wheels, and half a steering column.

"Oh, you wanted brakes? You should have said."

So I left the head-scratching and general confusion to the team and stayed with the compositing end of the process, but I did attend a couple of demos and loved some of the features, one of them being the ability to apply gravity to an object, in any direction, making it tumble beautifully in space and fall against other objects in a completely realistic motion.

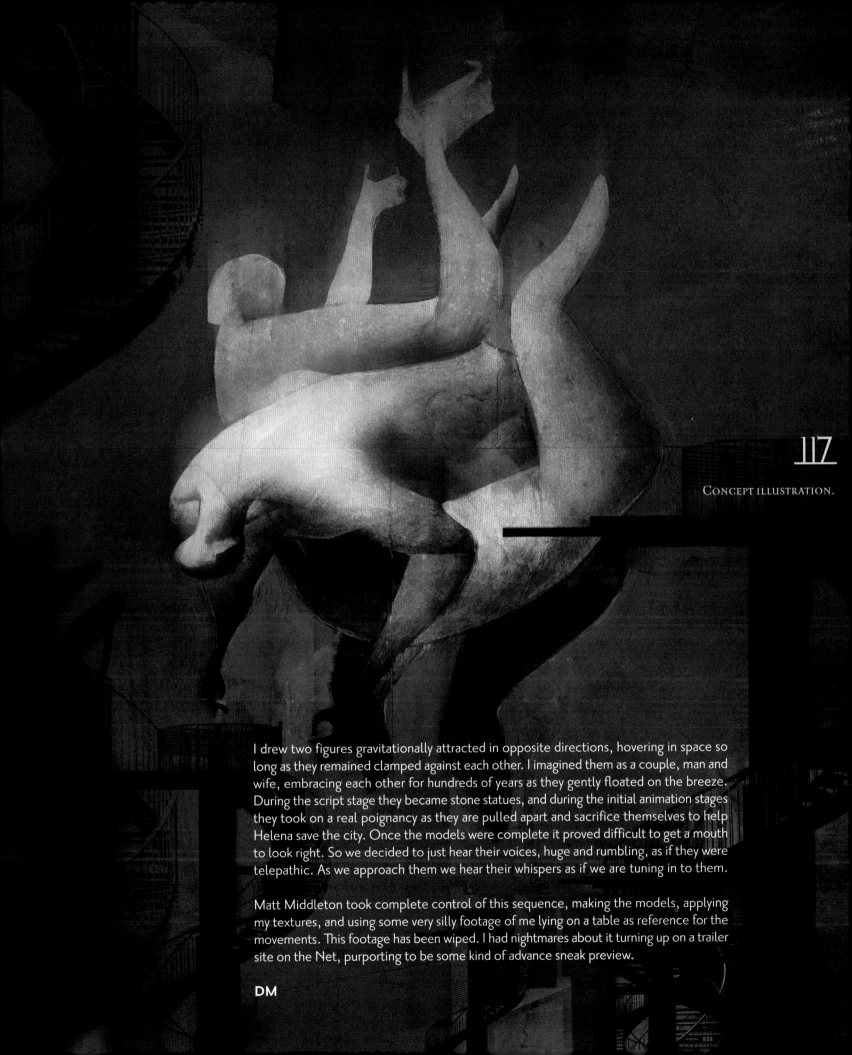

Concept illustration.

I drew two figures gravitationally attracted in opposite directions, hovering in space so long as they remained clamped against each other. I imagined them as a couple, man and wife, embracing each other for hundreds of years as they gently floated on the breeze. During the script stage they became stone statues, and during the initial animation stages they took on a real poignancy as they are pulled apart and sacrifice themselves to help Helena save the city. Once the models were complete it proved difficult to get a mouth to look right. So we decided to just hear their voices, huge and rumbling, as if they were telepathic. As we approach them we hear their whispers as if we are tuning in to them.

Matt Middleton took complete control of this sequence, making the models, applying my textures, and using some very silly footage of me lying on a table as reference for the movements. This footage has been wiped. I had nightmares about it turning up on a trailer site on the Net, purporting to be some kind of advance sneak preview.

DM

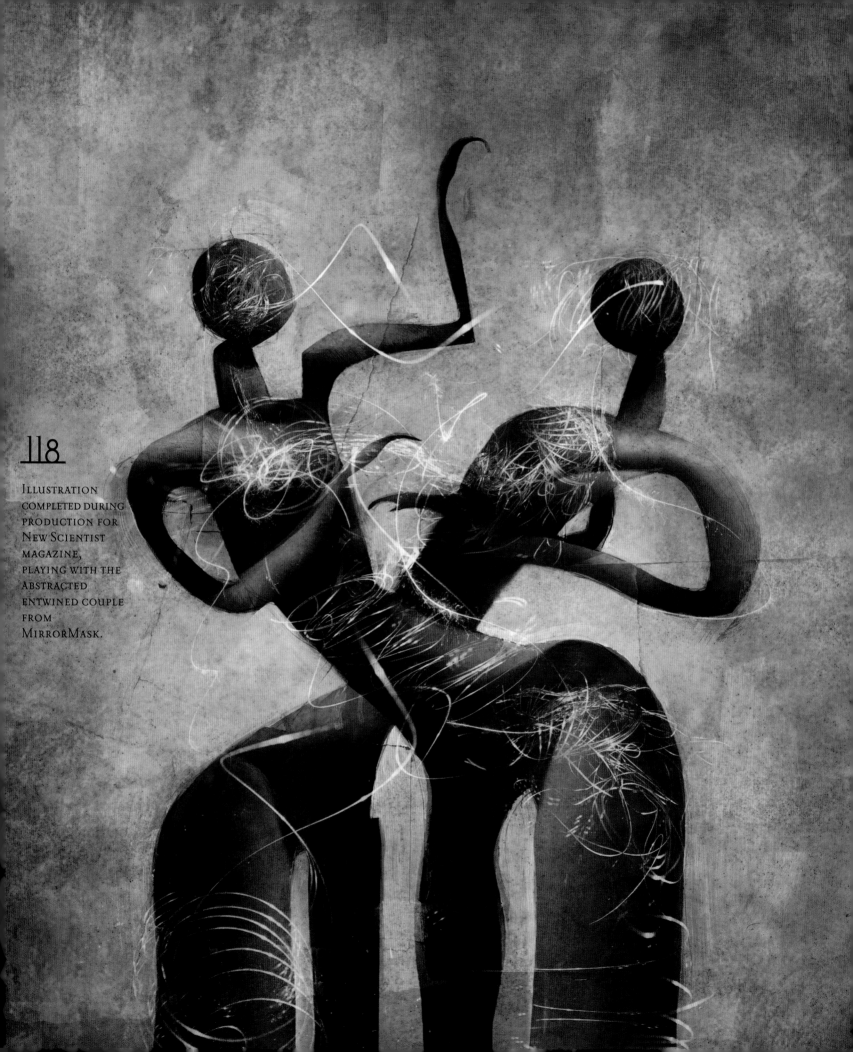

118

Illustration
completed during
production for
New Scientist
magazine,
playing with the
Abstracted
entwined couple
from
MirrorMask.

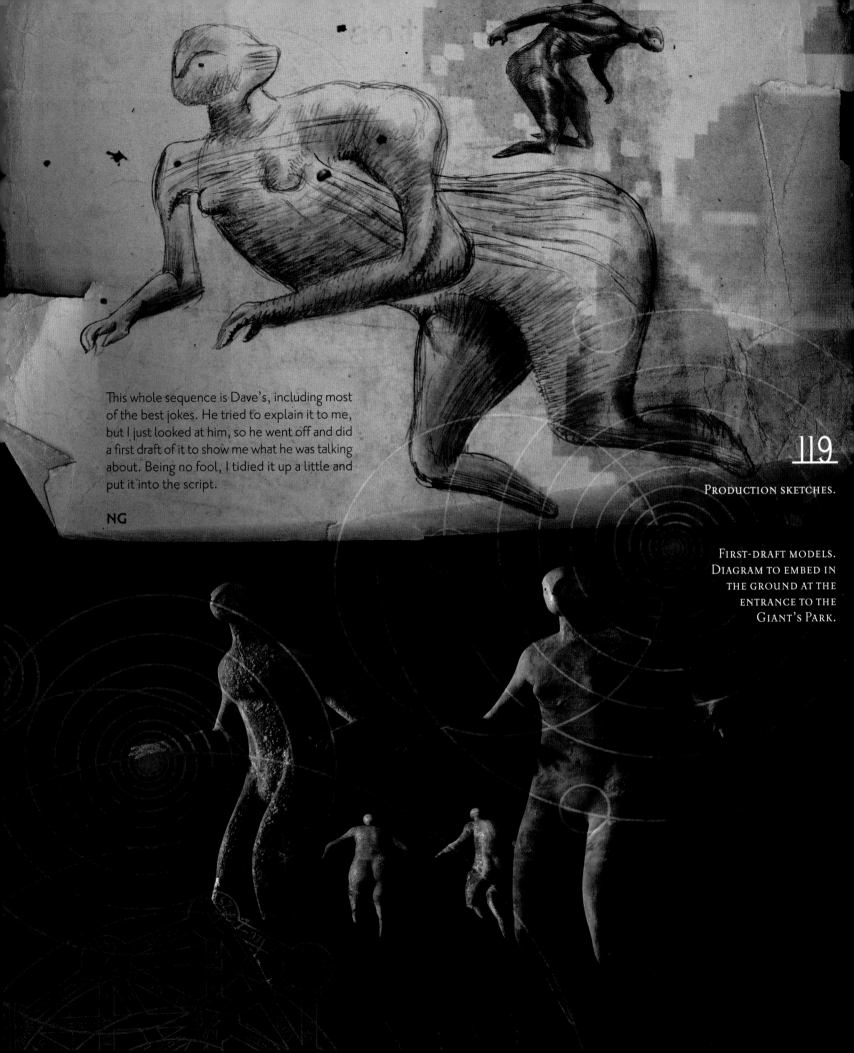

This whole sequence is Dave's, including most of the best jokes. He tried to explain it to me, but I just looked at him, so he went off and did a first draft of it to show me what he was talking about. Being no fool, I tidied it up a little and put it into the script.

NG

119

Production sketches.

First-draft models. Diagram to embed in the ground at the entrance to the Giant's Park.

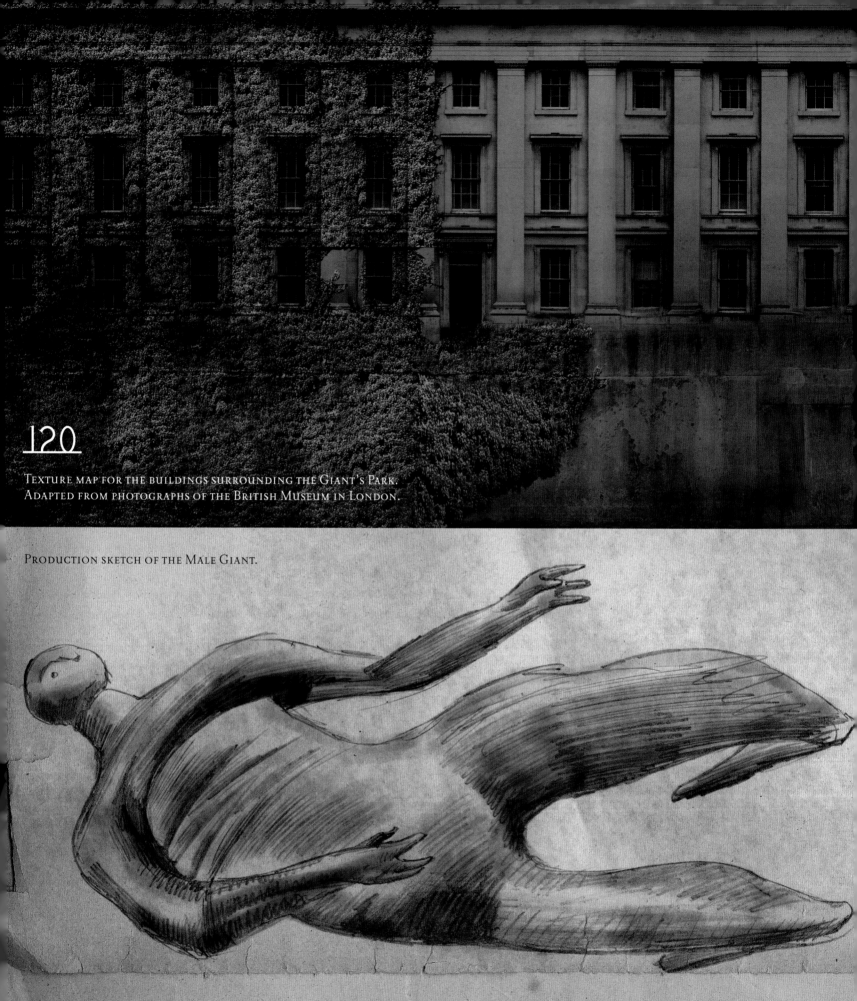

Texture map for the buildings surrounding the Giant's Park.
Adapted from photographs of the British Museum in London.

Production sketch of the Male Giant.

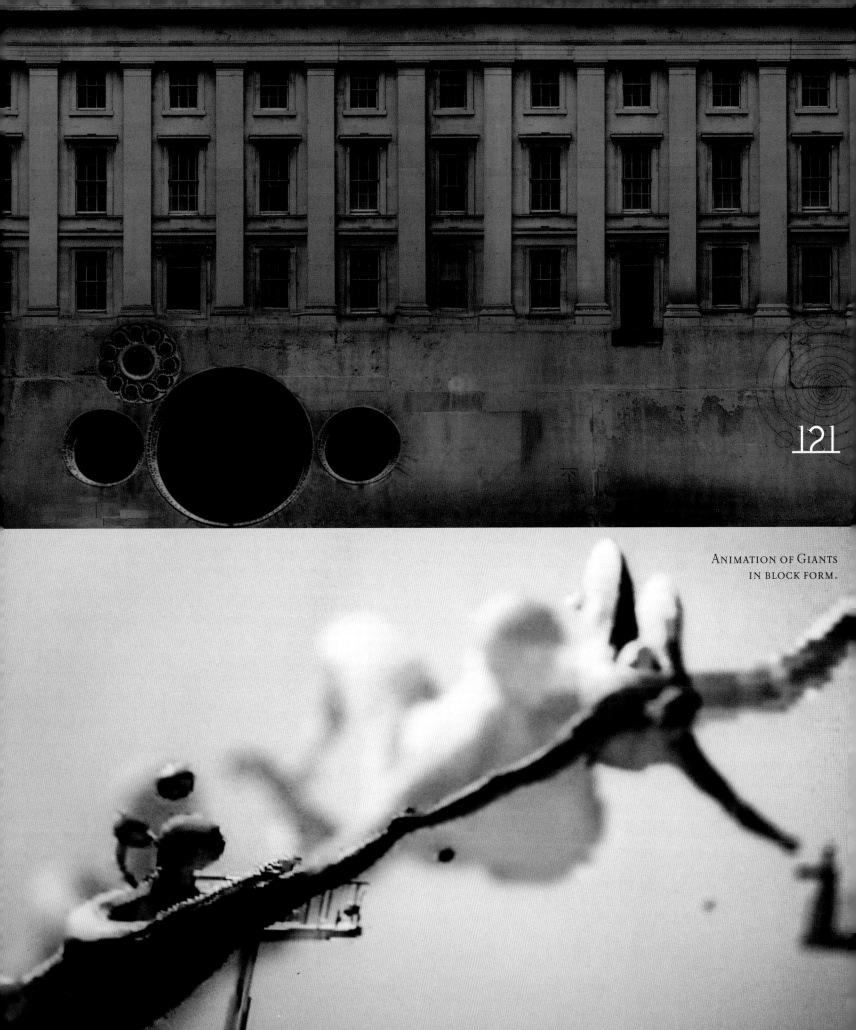

121

ANIMATION OF GIANTS
IN BLOCK FORM.

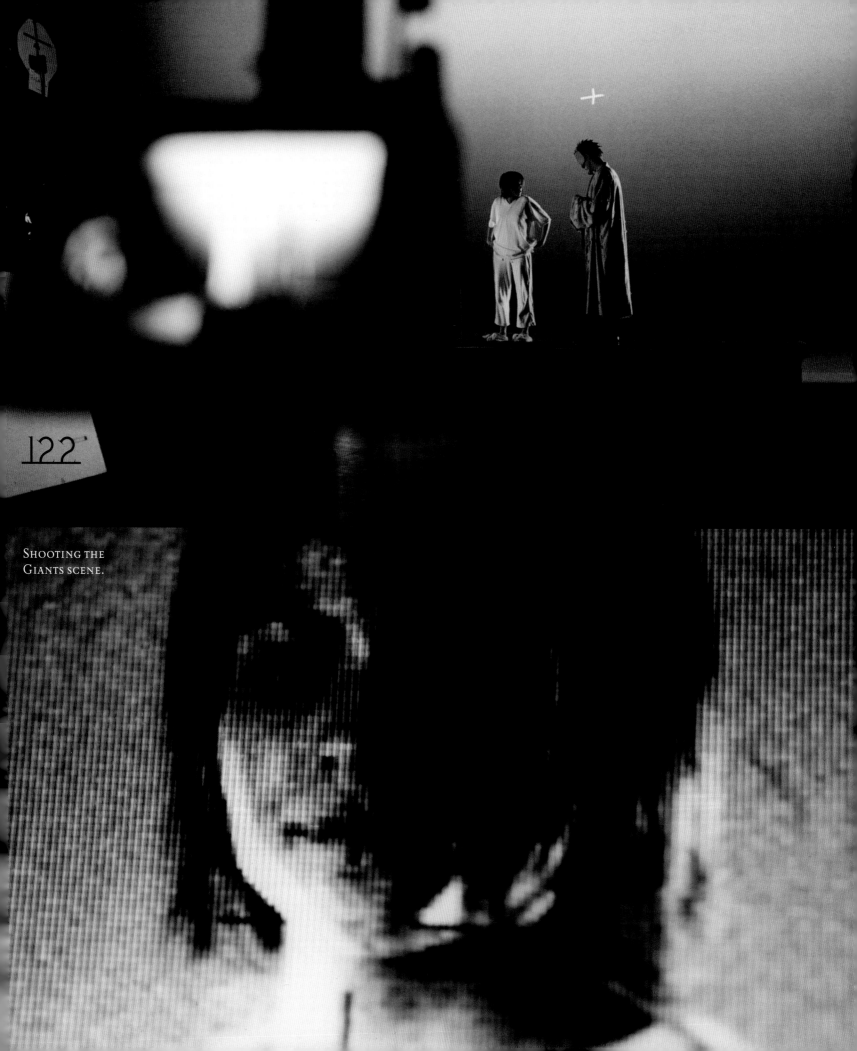

SHOOTING THE
GIANTS SCENE.

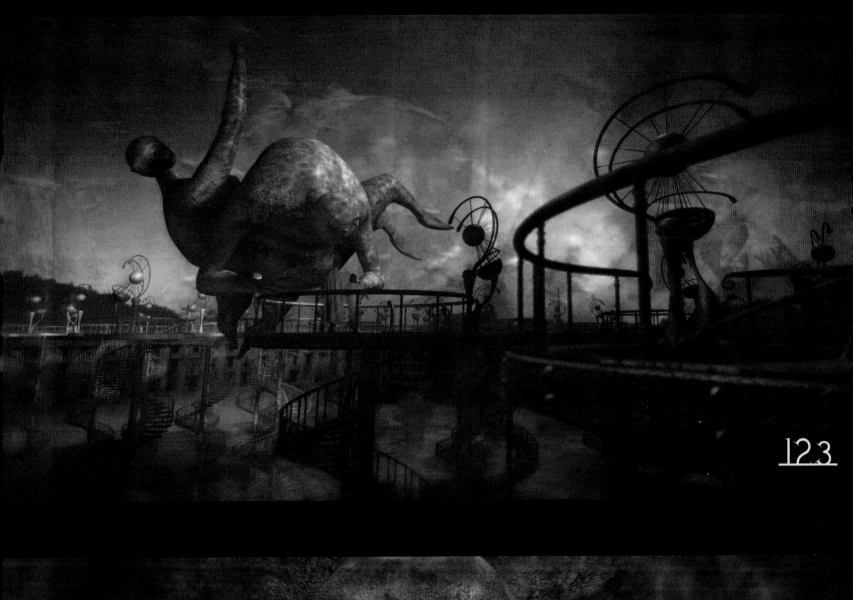

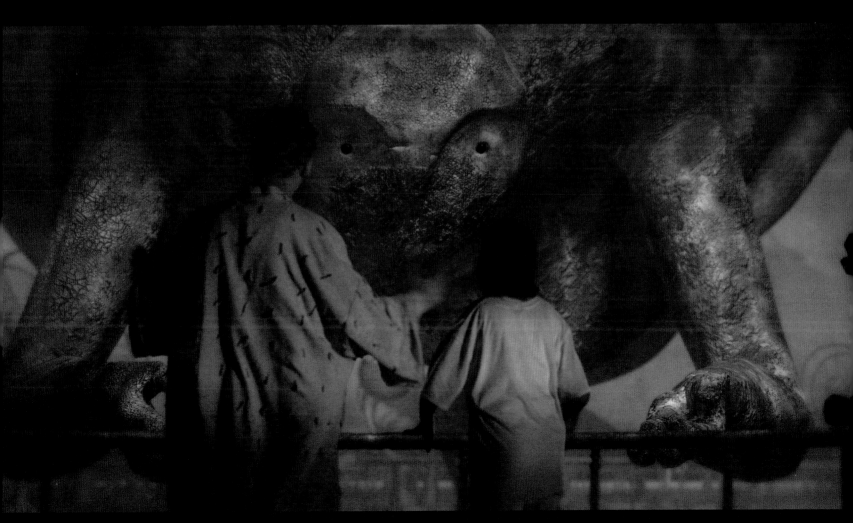

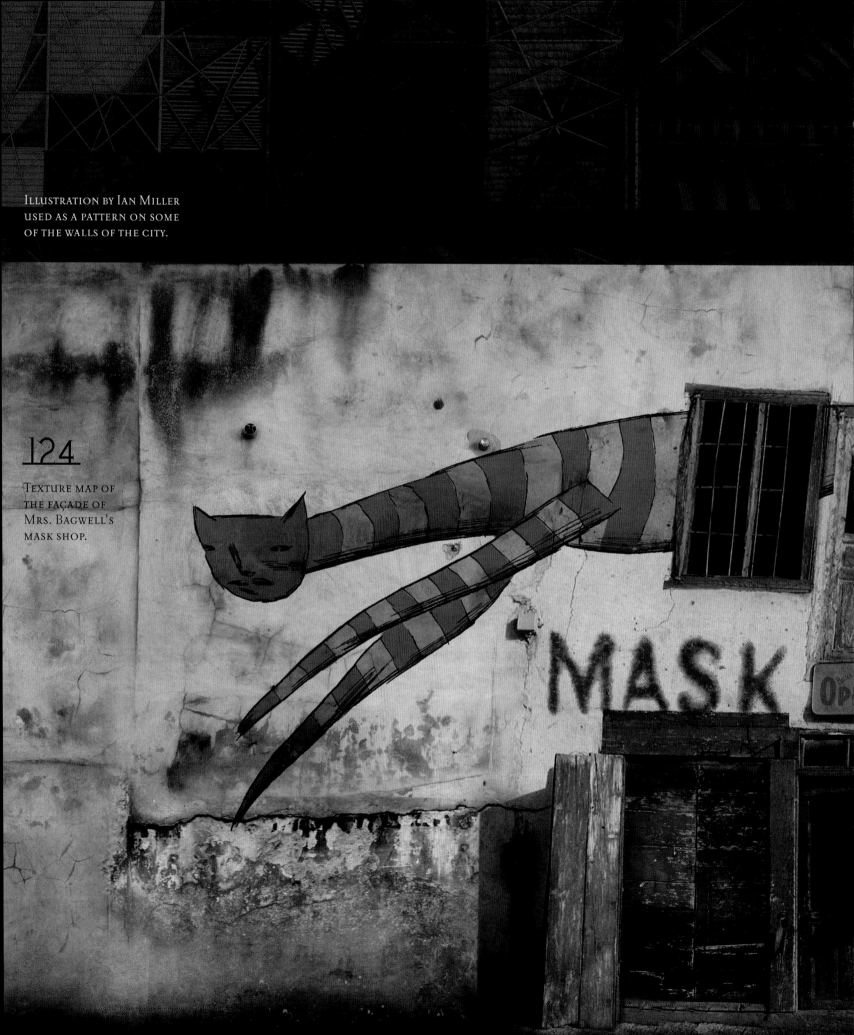

124

TEXTURE MAP OF
THE FAÇADE OF
MRS. BAGWELL'S
MASK SHOP.

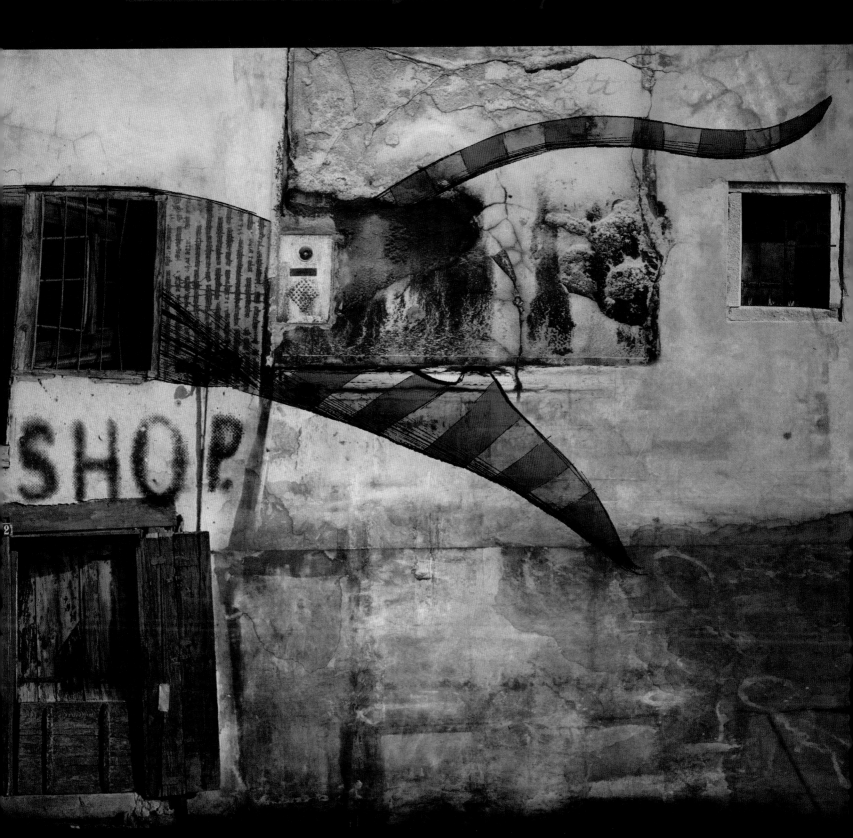

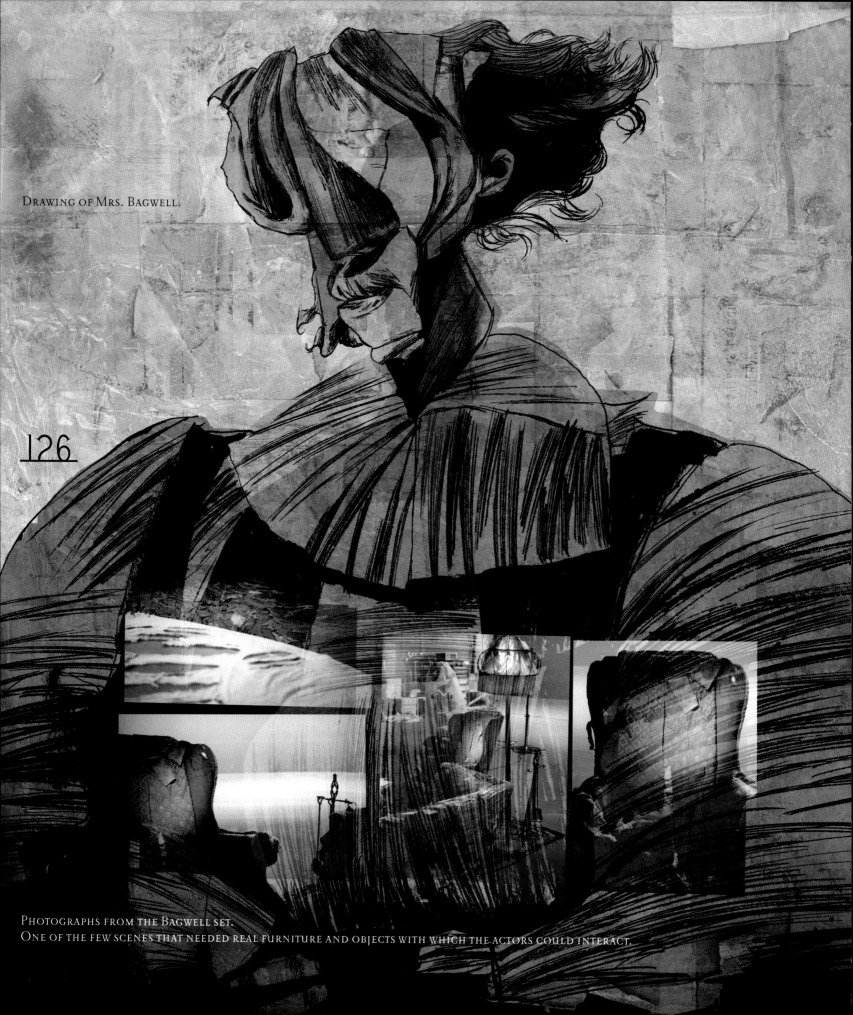

Drawing of Mrs. Bagwell:

126

Photographs from the Bagwell set.
One of the few scenes that needed real furniture and objects with which the actors could interact.

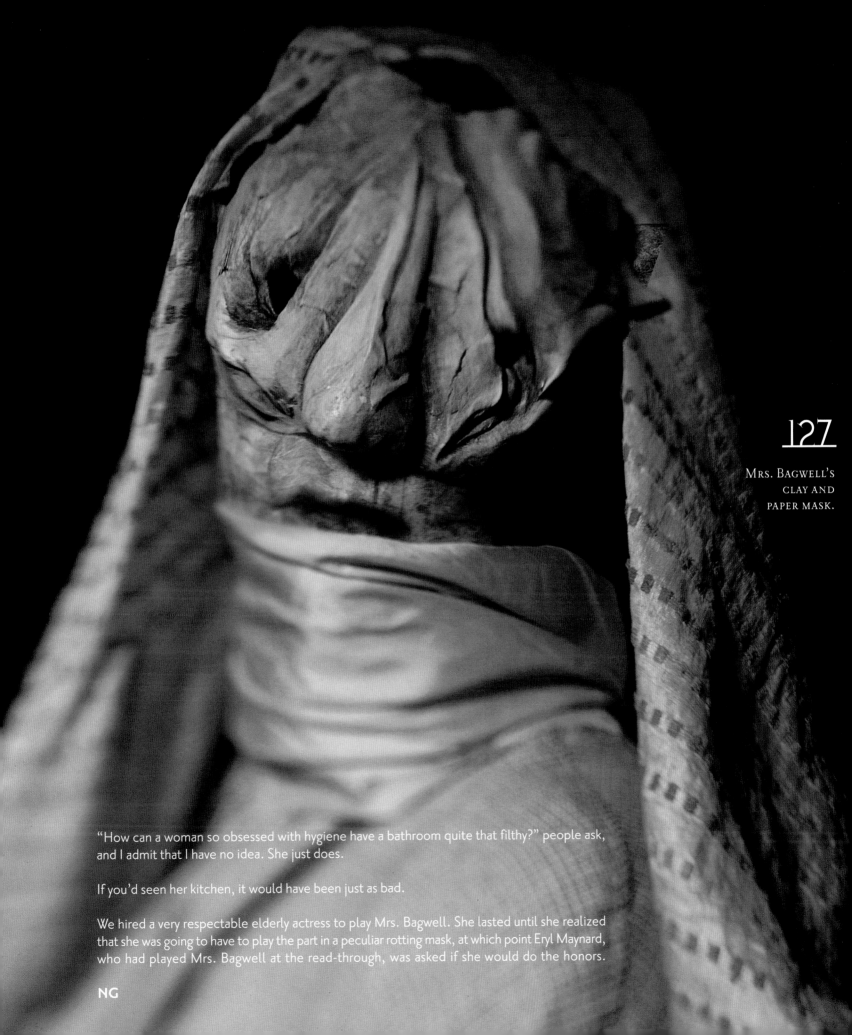

"How can a woman so obsessed with hygiene have a bathroom quite that filthy?" people ask, and I admit that I have no idea. She just does.

If you'd seen her kitchen, it would have been just as bad.

We hired a very respectable elderly actress to play Mrs. Bagwell. She lasted until she realized that she was going to have to play the part in a peculiar rotting mask, at which point Eryl Maynard, who had played Mrs. Bagwell at the read-through, was asked if she would do the honors.

NG

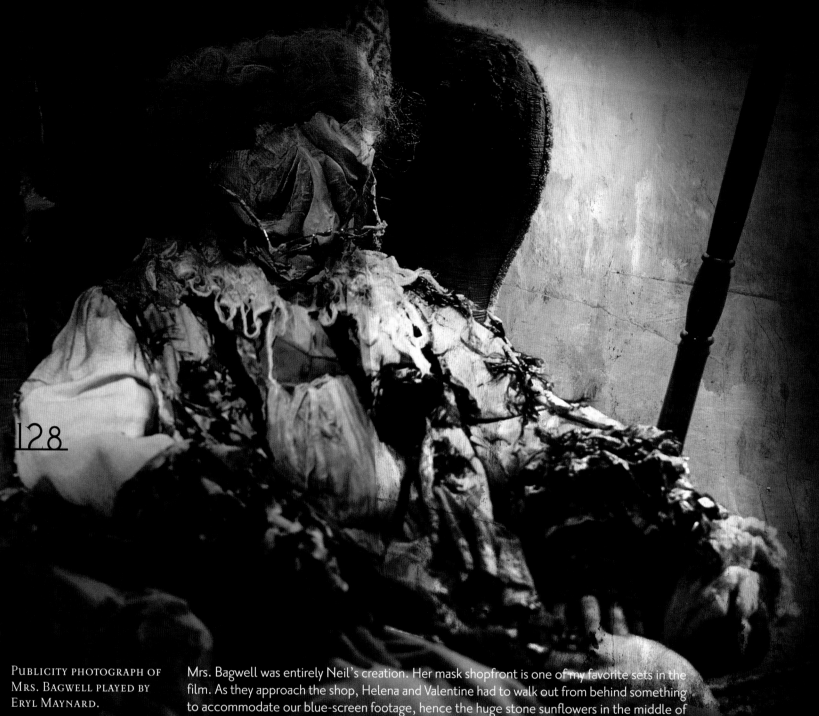

128

PUBLICITY PHOTOGRAPH OF
MRS. BAGWELL PLAYED BY
ERYL MAYNARD.

Mrs. Bagwell was entirely Neil's creation. Her mask shopfront is one of my favorite sets in the film. As they approach the shop, Helena and Valentine had to walk out from behind something to accommodate our blue-screen footage, hence the huge stone sunflowers in the middle of the street.

Inside, as Mrs. Bagwell entertains the two travelers, her living room features paintings by Max McMullin. They have always decorated the walls of the various studios we've shared together, so it was nice to give them a home.

In the script, Mrs. Bagwell chastises one the sphinxes, called Fluffy: "Fluffy, don't DO that!" But we never really knew what Fluffy was doing. Various things were suggested. Some involved implausibly complicated animation, some were inevitably obscene. Some were rather nasty, and others involved the chicken from the white palace scene, but I didn't really want to go there. Meanwhile Iain Ballamy had composed a wonderful mad rhumba to be played over the gramophone in the corner of the room, so it seemed like a good idea to bring that into play and have Fluffy scraping the record and slowing the turntable to a crawl, and then, when caught in the act, jumping back with a guilty look on his face.

DM

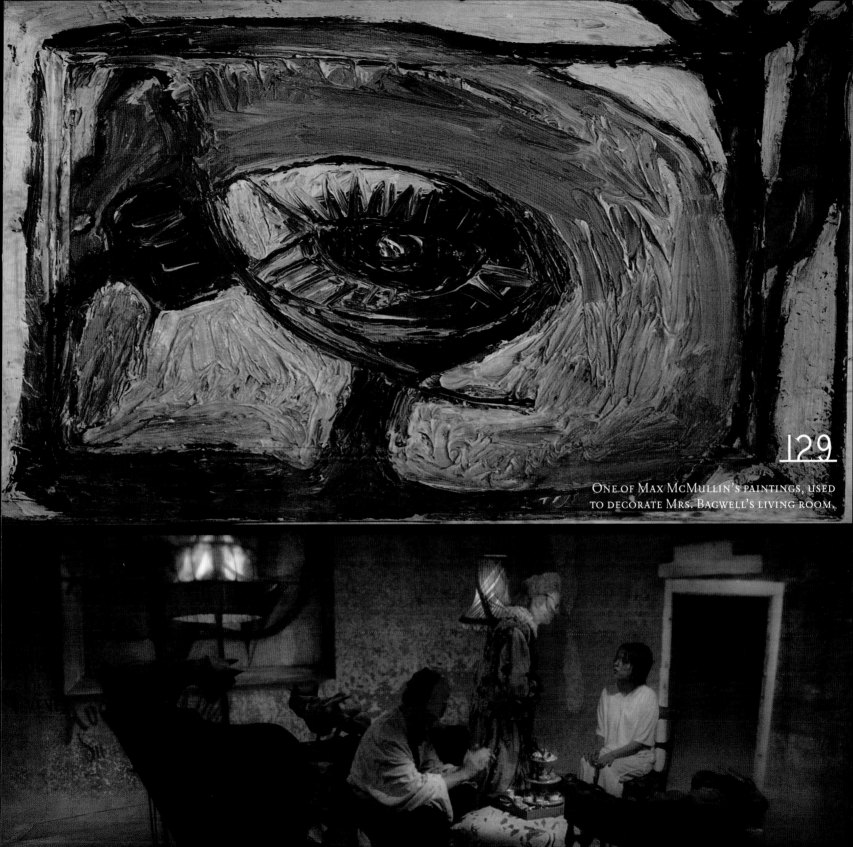

129

One of Max McMullin's paintings, used
to decorate Mrs. Bagwell's living room.

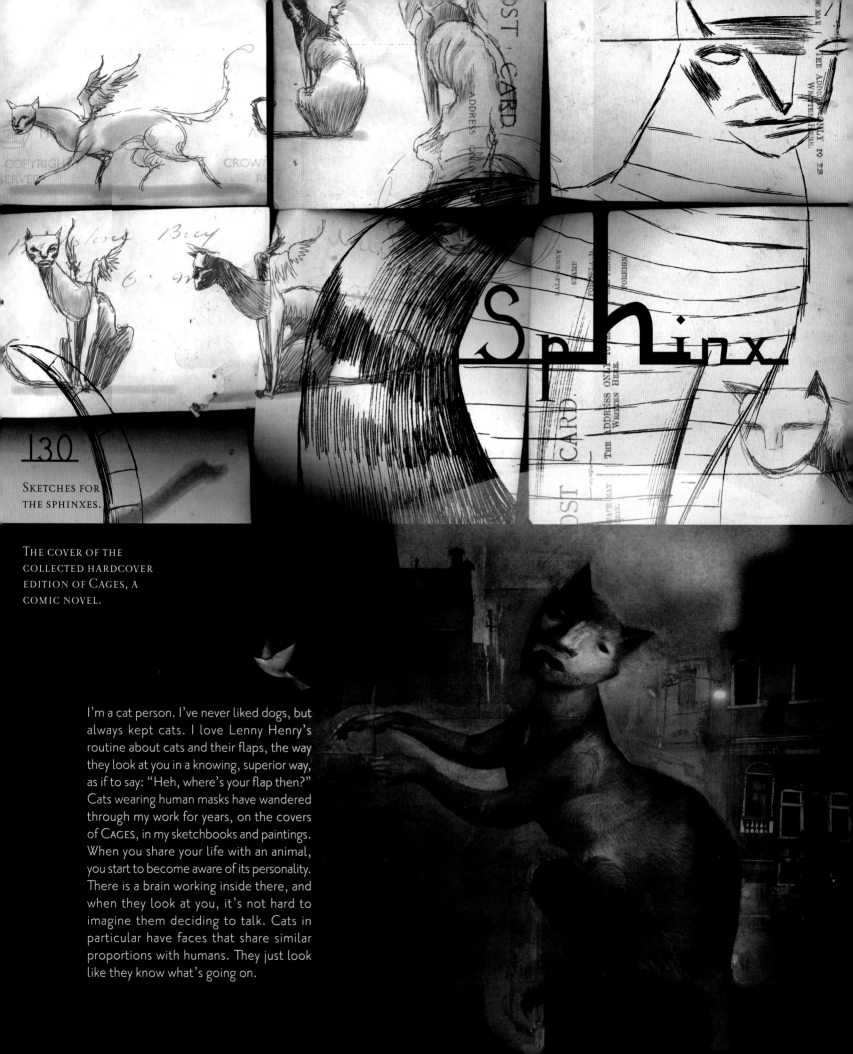

Sphinx

130

SKETCHES FOR
THE SPHINXES.

THE COVER OF THE
COLLECTED HARDCOVER
EDITION OF CAGES, A
COMIC NOVEL.

I'm a cat person. I've never liked dogs, but always kept cats. I love Lenny Henry's routine about cats and their flaps, the way they look at you in a knowing, superior way, as if to say: "Heh, where's your flap then?" Cats wearing human masks have wandered through my work for years, on the covers of CAGES, in my sketchbooks and paintings. When you share your life with an animal, you start to become aware of its personality. There is a brain working inside there, and when they look at you, it's not hard to imagine them deciding to talk. Cats in particular have faces that share similar proportions with humans. They just look like they know what's going on.

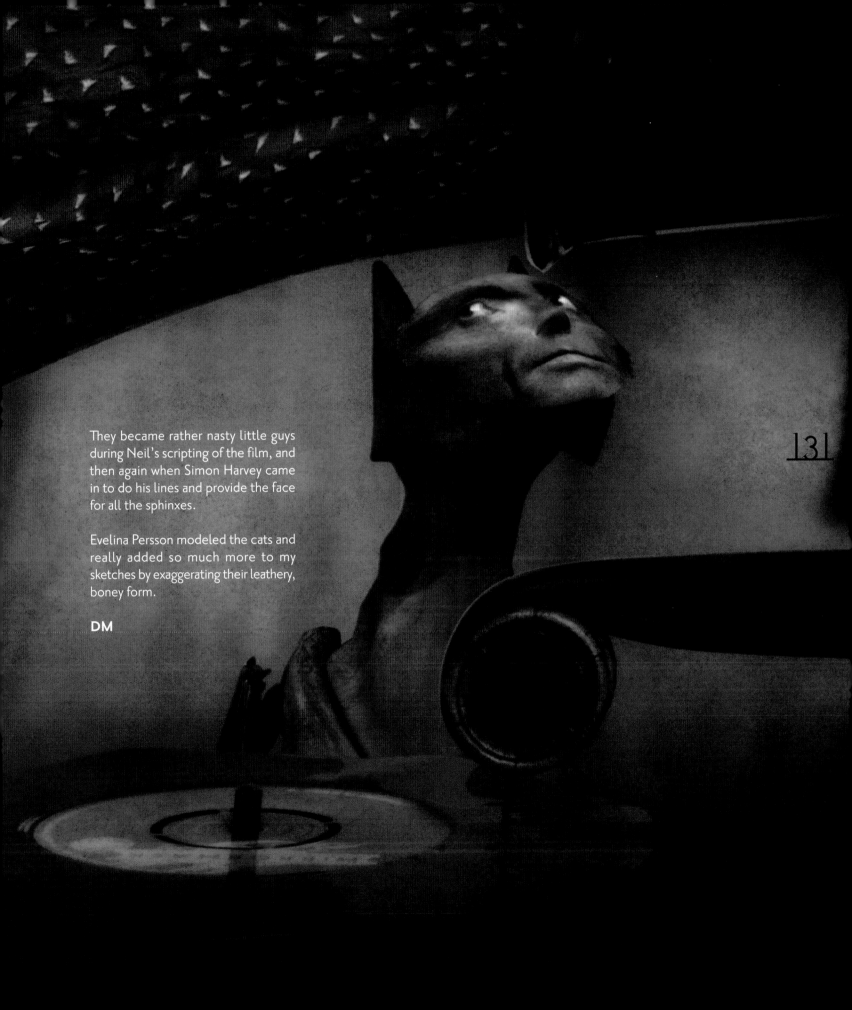

They became rather nasty little guys during Neil's scripting of the film, and then again when Simon Harvey came in to do his lines and provide the face for all the sphinxes.

Evelina Persson modeled the cats and really added so much more to my sketches by exaggerating their leathery, boney form.

DM

131

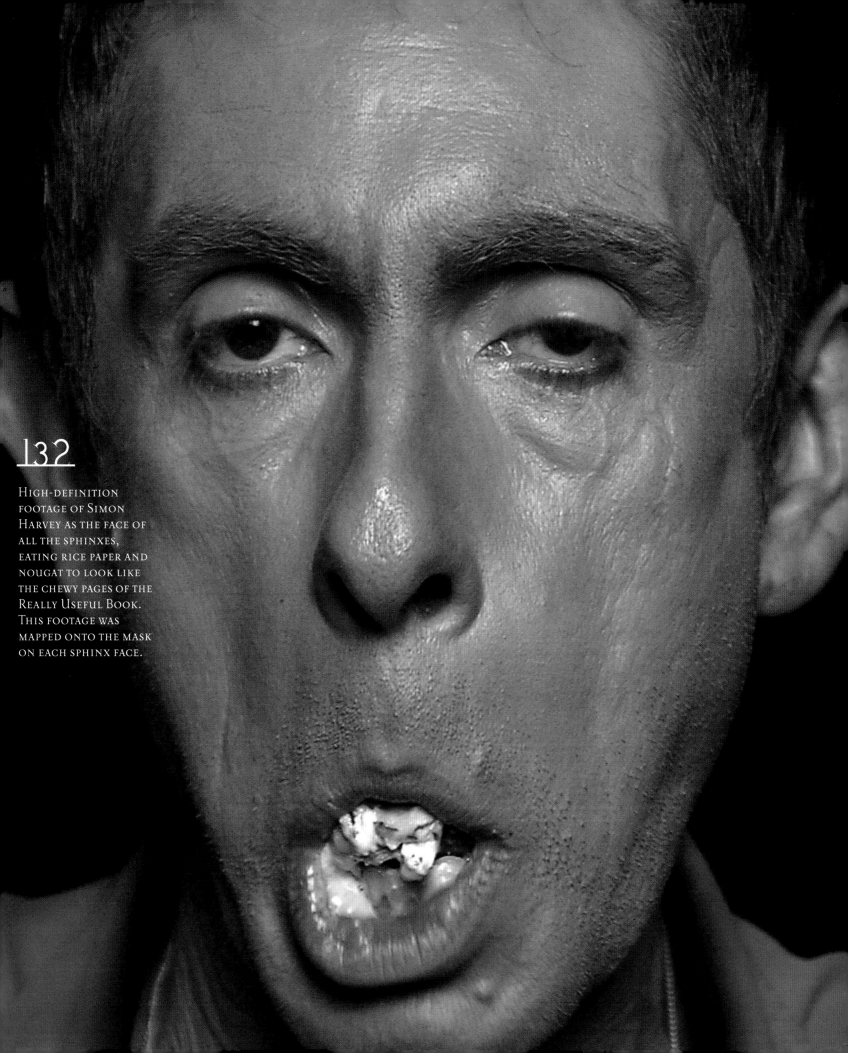

132

High-definition footage of Simon Harvey as the face of all the sphinxes, eating rice paper and nougat to look like the chewy pages of the Really Useful Book. This footage was mapped onto the mask on each sphinx face.

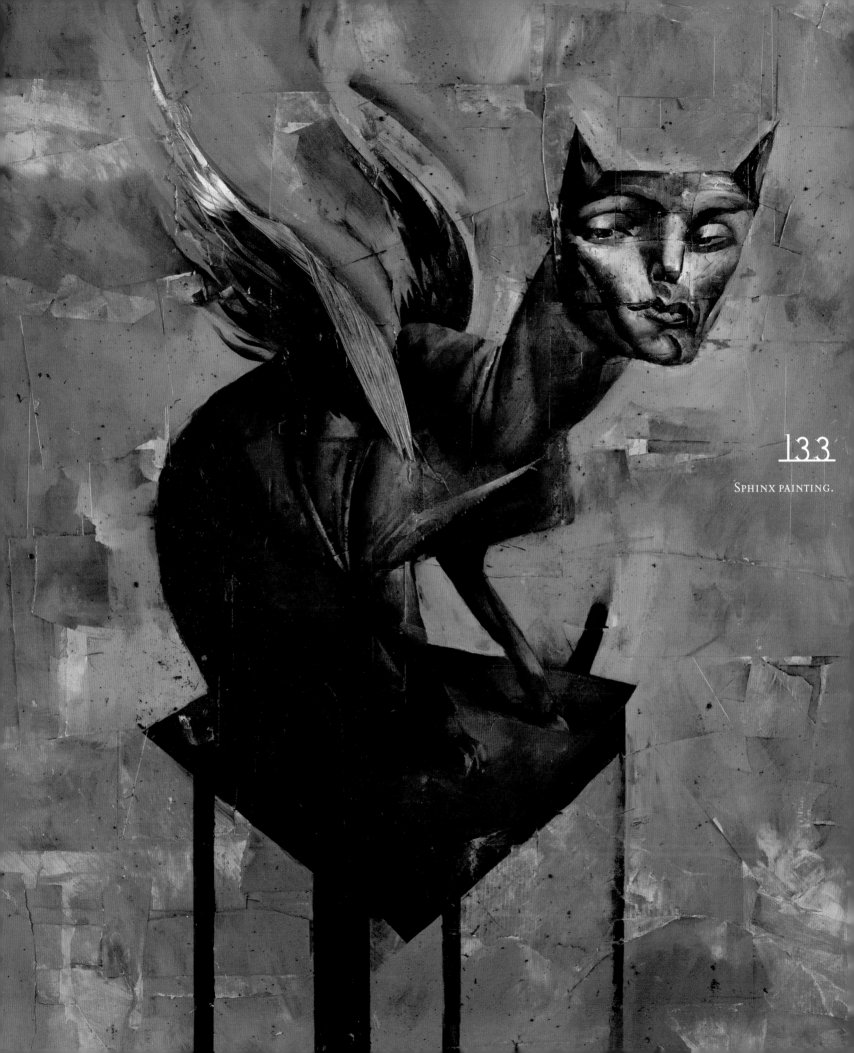

Sphinx painting.

<u>134</u>

Some jokes just don't work. I thought it was terribly funny that all the names for the sphinxes—Ginger, Snowball, Fluffy, Blacky, Stripes, and so on—are descriptive names, and that all the sphinxes were a) identical and b) neither ginger, white, fluffy, black, nor striped.

STILL OF THE FINAL SCENE IN MRS. BAGWELL'S LIVING ROOM.

NG

WORKING ON THE ANIMATION OF THE ABOVE SCENE.

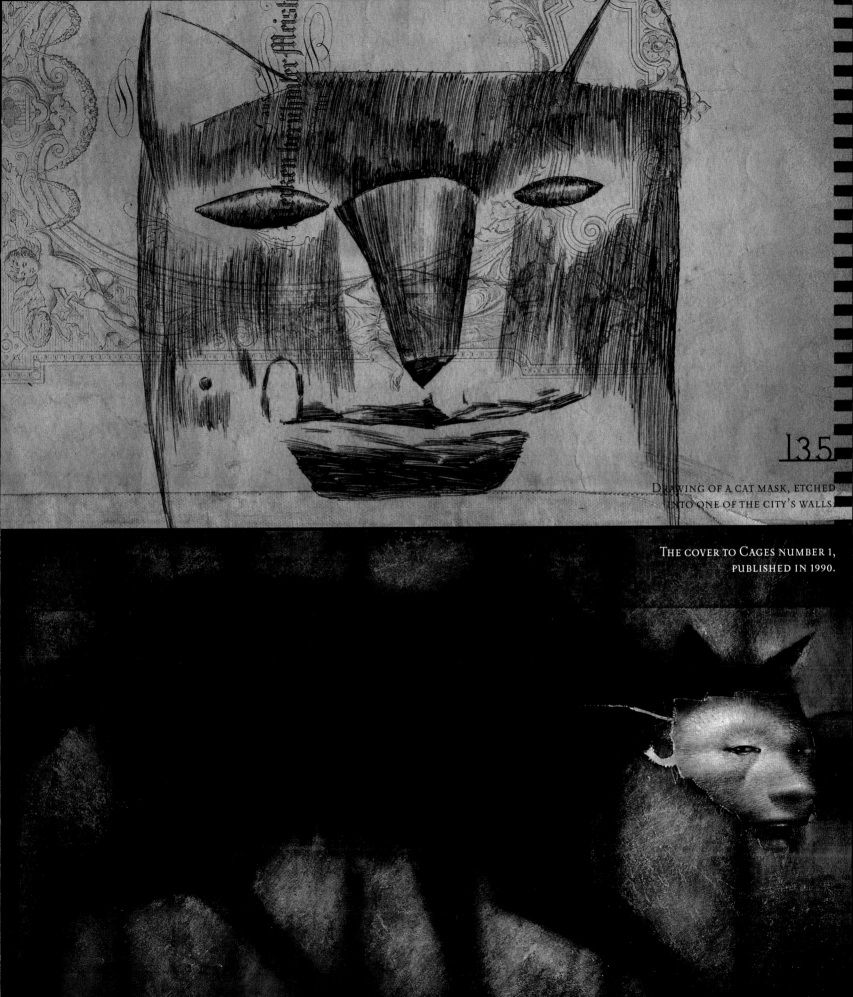

DRAWING OF A CAT MASK, ETCHED
INTO ONE OF THE CITY'S WALLS.

THE COVER TO CAGES NUMBER 1,
PUBLISHED IN 1990.

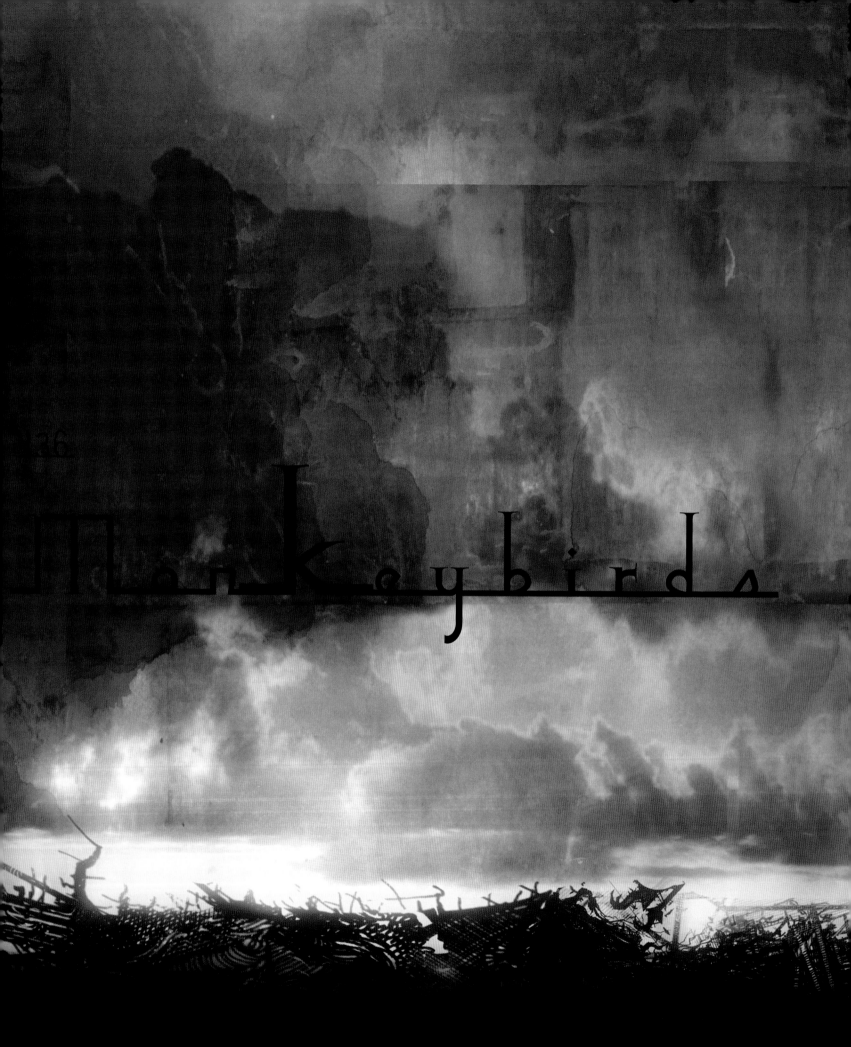

Monkeybirds

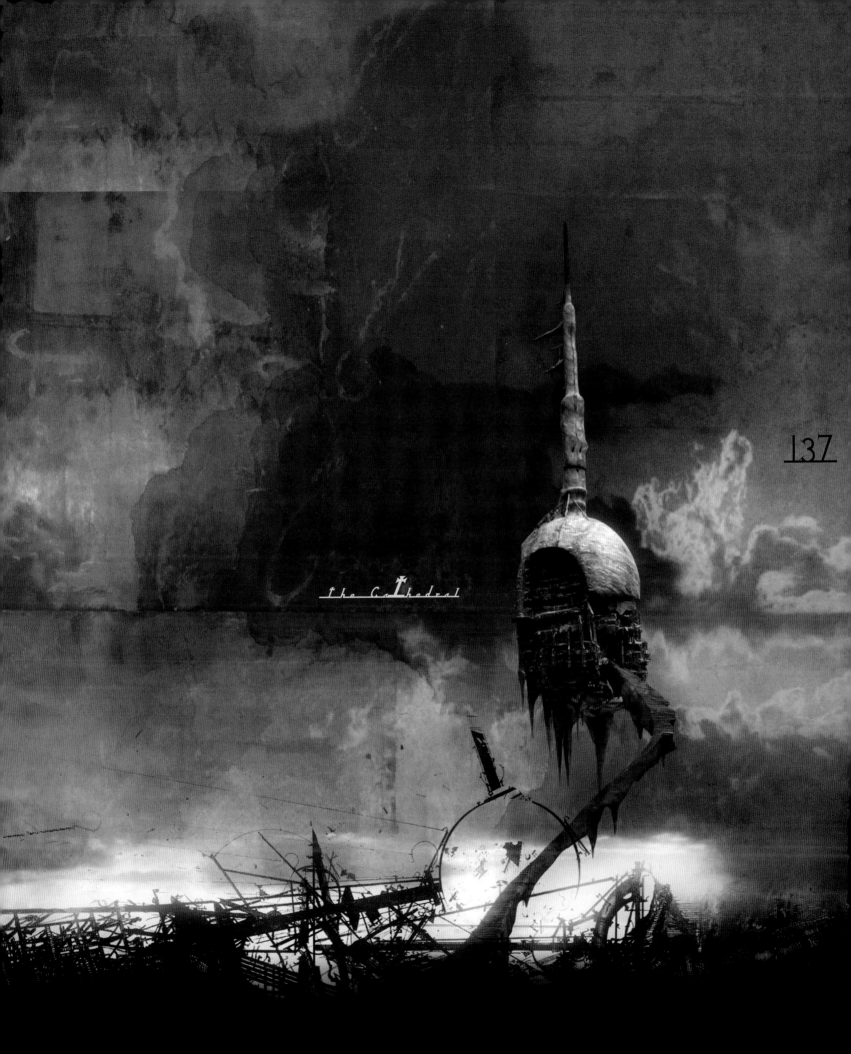

the Cathedral

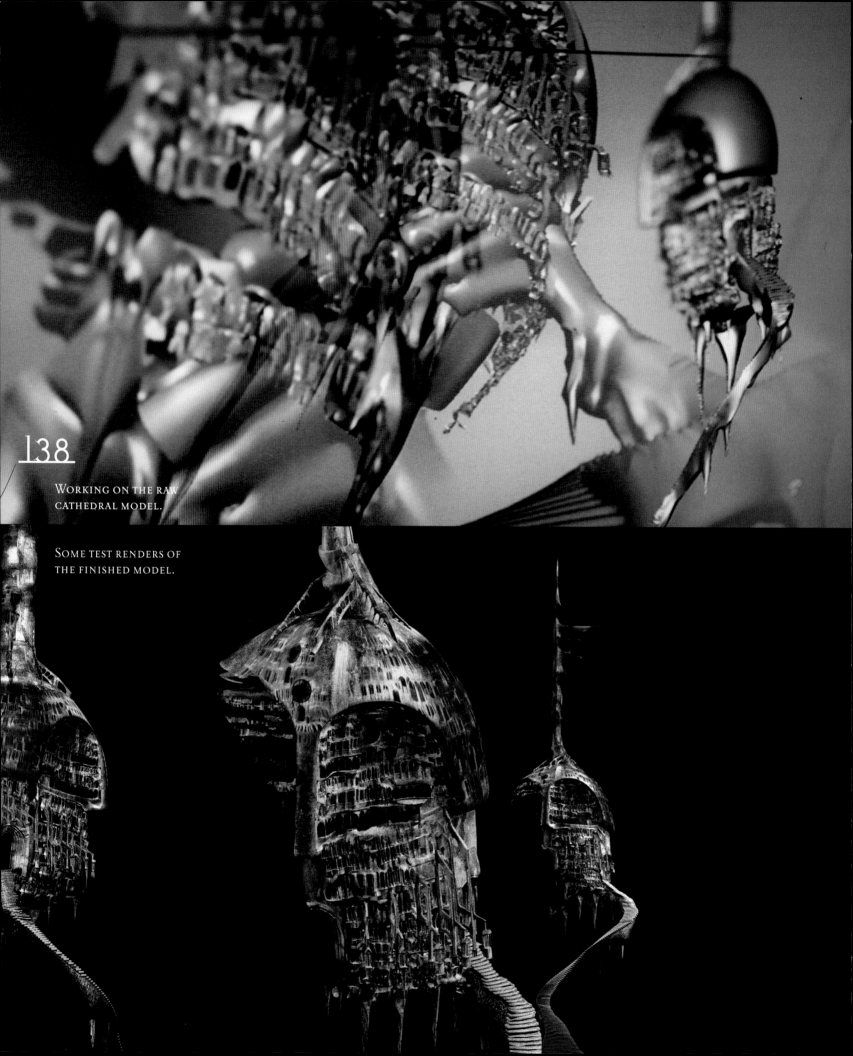

138

WORKING ON THE RAW
CATHEDRAL MODEL.

SOME TEST RENDERS OF
THE FINISHED MODEL.

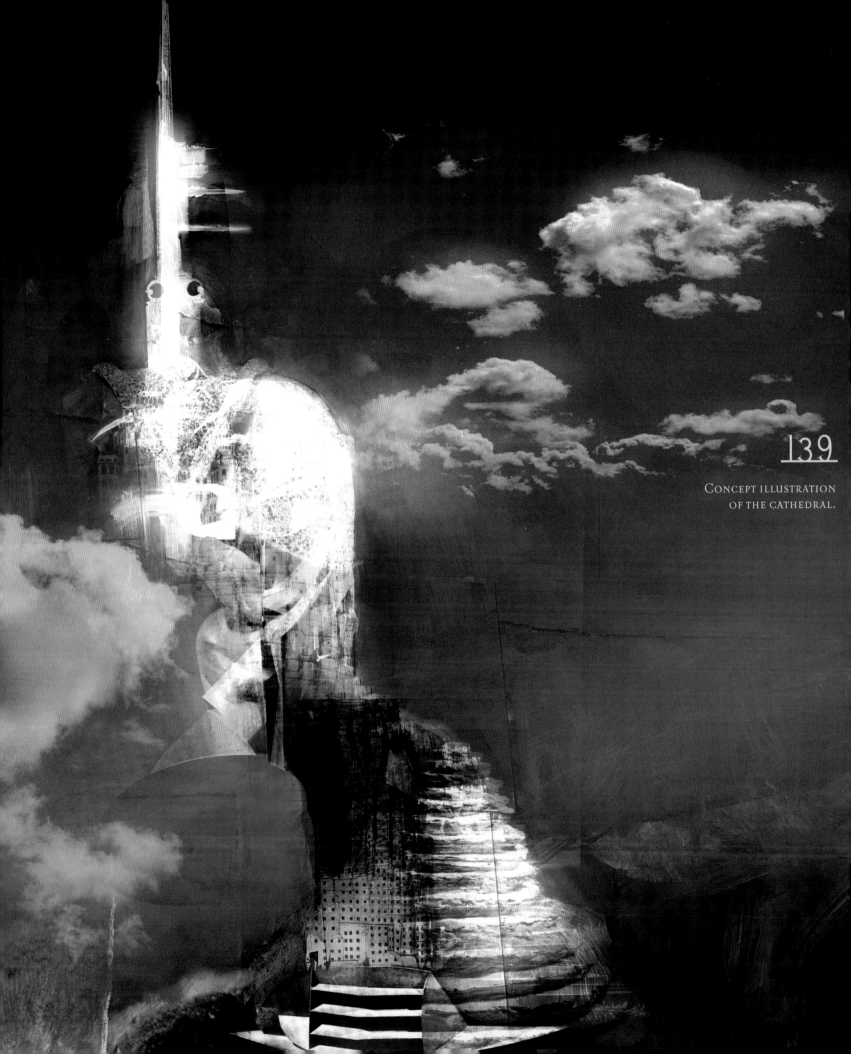

CONCEPT ILLUSTRATION
OF THE CATHEDRAL.

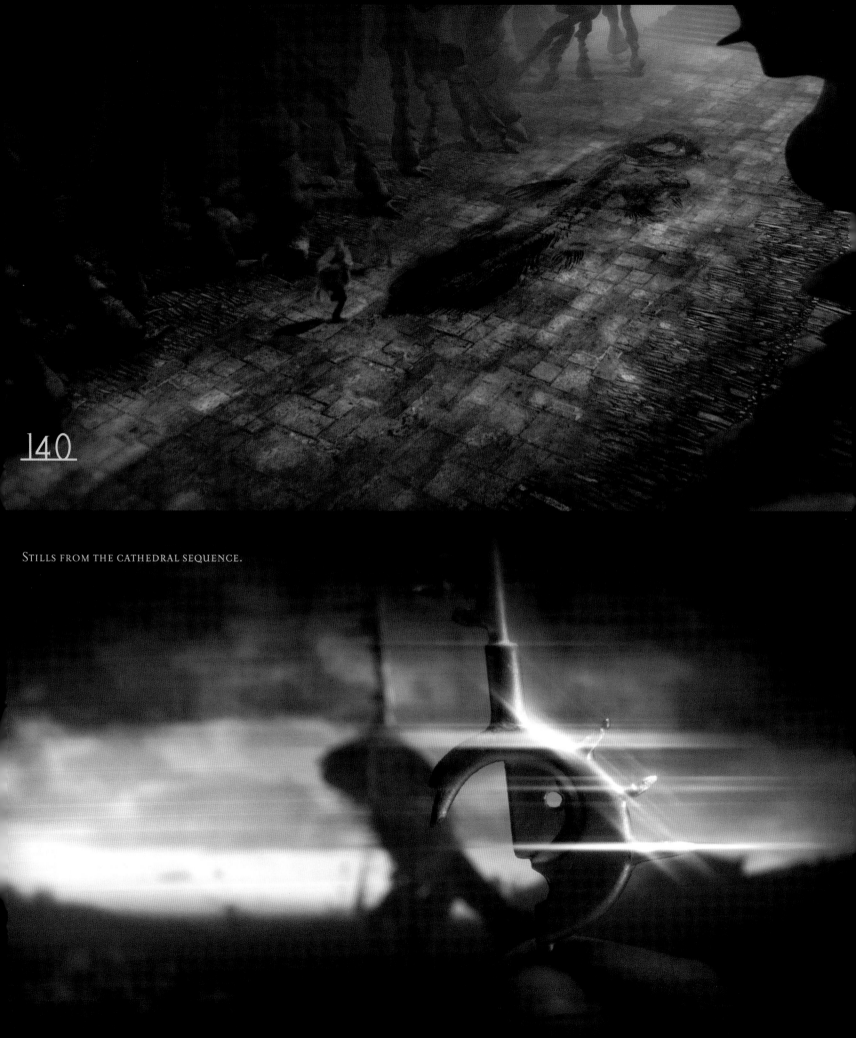

140

STILLS FROM THE CATHEDRAL SEQUENCE.

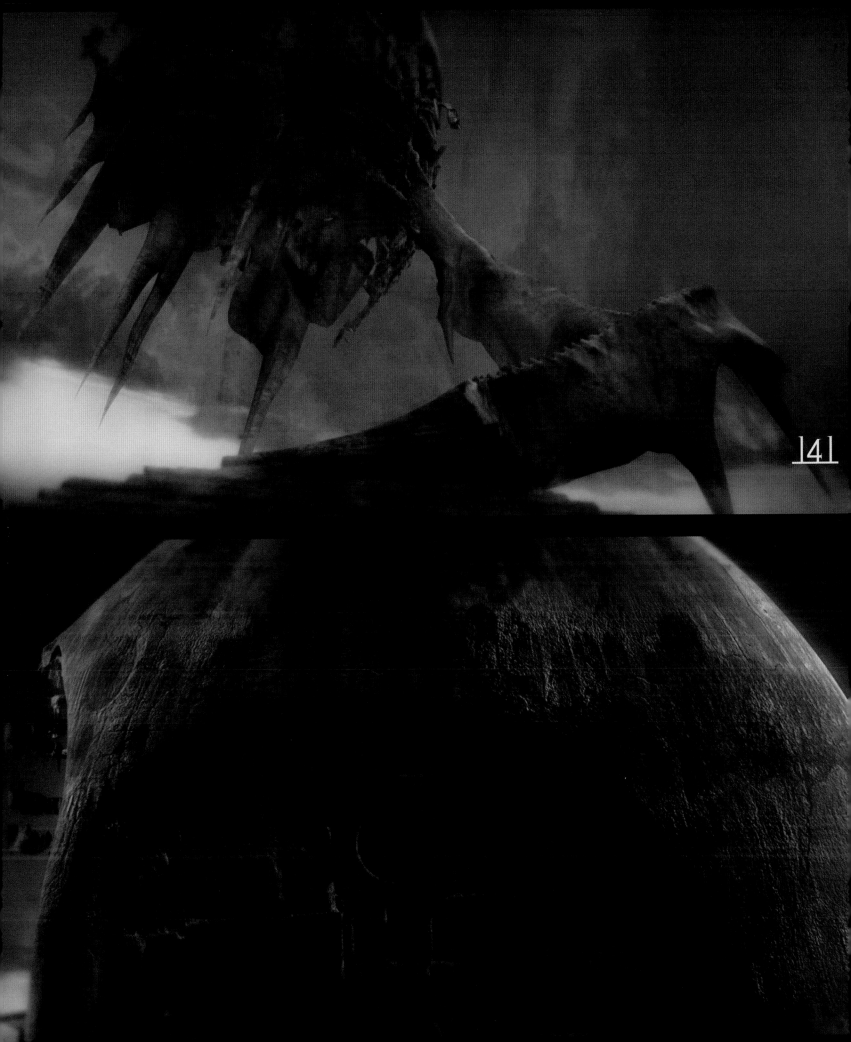

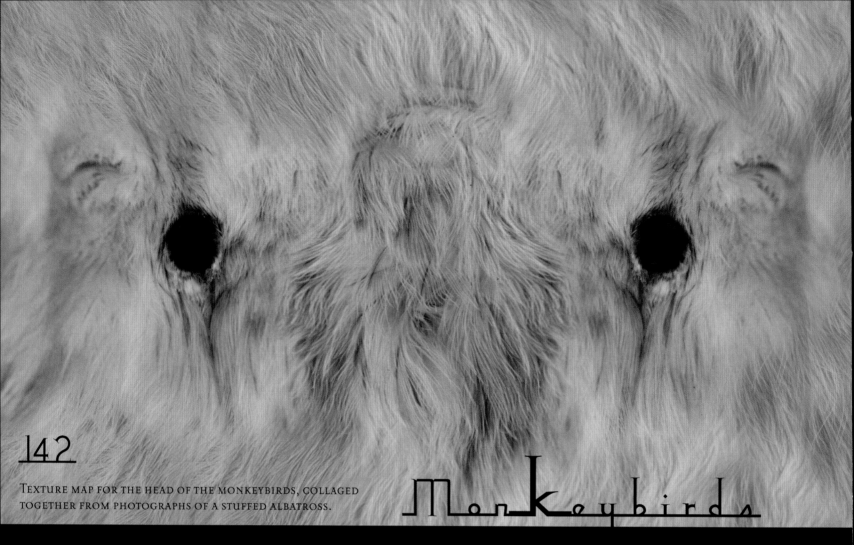

Texture map for the head of the monkeybirds, collaged together from photographs of a stuffed albatross.

Monkeybirds

Basic model of a monkeybird.

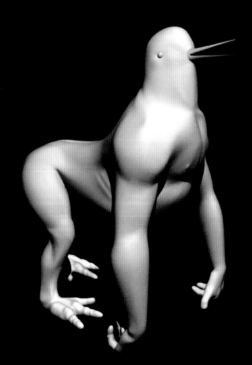

…or chicken apes, as the sound department kept calling them.

Lisa Henson said she assumed they would have bird bodies and monkey heads rather than the other way round. That would be MaskMirror, a film unlikely to be made in my lifetime.

It's very hard for me to watch this scene, with the monkeybirds slapping each other on the back of the head, without thinking about the animator in question, Jamie Niman, watching himself in a mirror and mimicking his own movements. There's a lot of Jamie in Malcolm, the put-upon monkeybird that dares to be different. I think he learned a lot about himself during the months he was working on this sequence. Animation as alternative psychotherapy.

Malcolm is the only one to step out of the group of otherwise identical monkeybirds, talk out of turn, and make sense to Helena, so I named him after my main art teacher in college, Malcolm Hatton. Also, to be honest, Malcolm is just a funny name. That's the big problem with The Lord of the Rings for me. You never get Orcs called Malcolm, or Bob, or Gerald, and I think it's the poorer for it. Actually, you never get Orcs just having a night off. They never just put their feet up, have a jam sandwich, do a little gardening. There's always too much stomping around being evil to be getting on with.

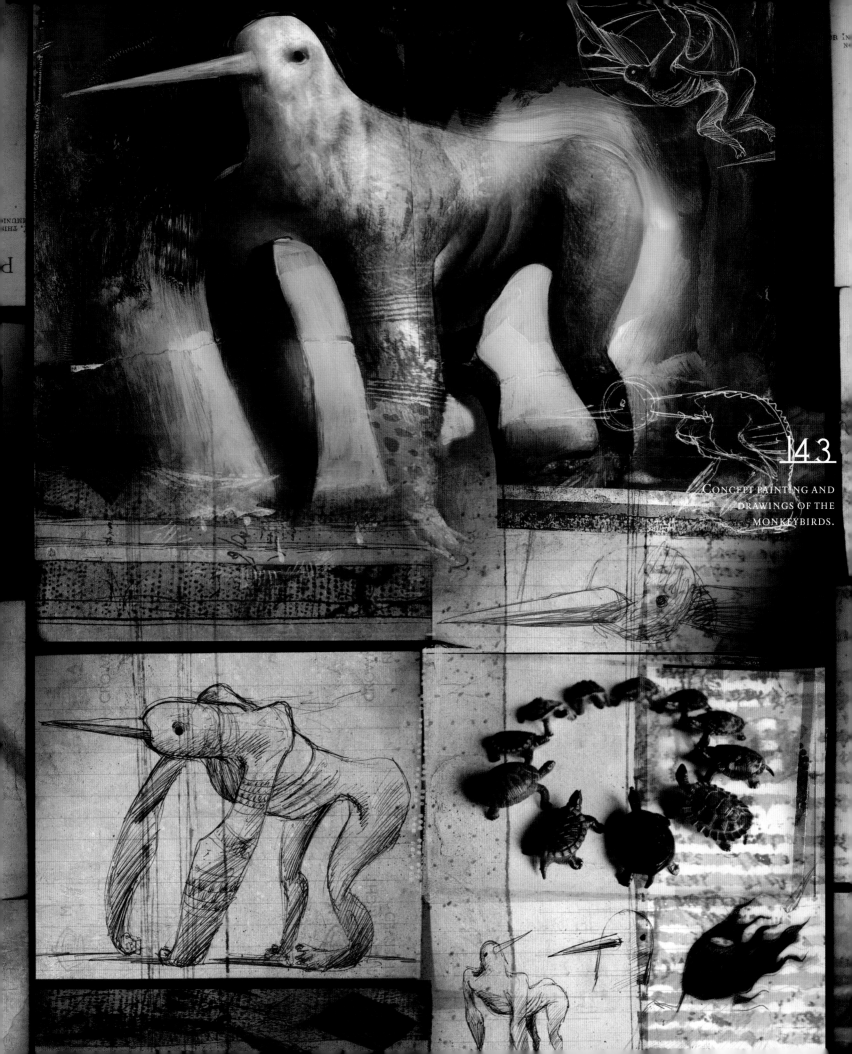

Concept painting and
drawings of the
monkeybirds.

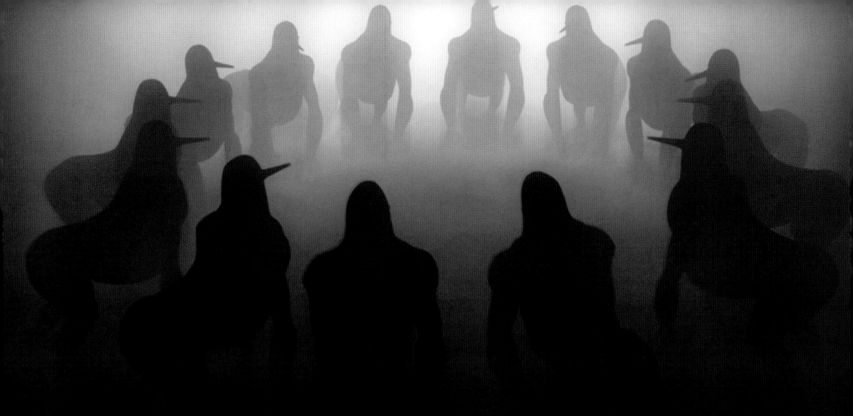

Most scenes in the film included a separate "fog" pass that was blended with the rest of the scene to create a feeling of depth and misty, dusty spaces. The scenes had to be prioritized into "cheap fog," simple Maya, or flat 2D fog, or "expensive fog," a procedural 3D block of fog that would interact with its surroundings, animate, and generally look more convincing.

A storyboard panel.

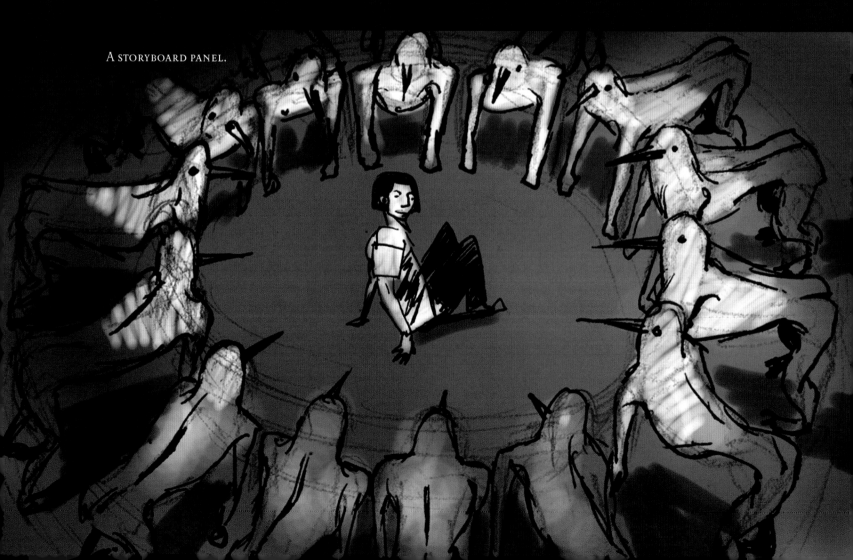

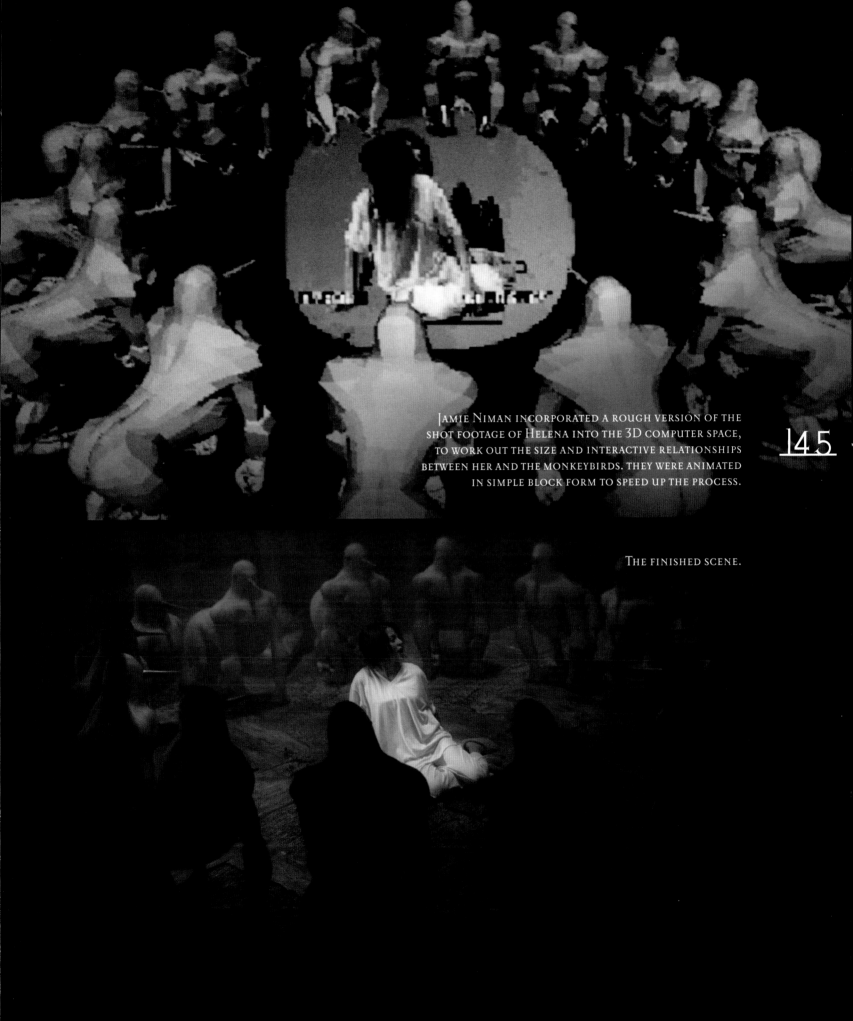

JAMIE NIMAN INCORPORATED A ROUGH VERSION OF THE
SHOT FOOTAGE OF HELENA INTO THE 3D COMPUTER SPACE,
TO WORK OUT THE SIZE AND INTERACTIVE RELATIONSHIPS
BETWEEN HER AND THE MONKEYBIRDS. THEY WERE ANIMATED
IN SIMPLE BLOCK FORM TO SPEED UP THE PROCESS.

145

THE FINISHED SCENE.

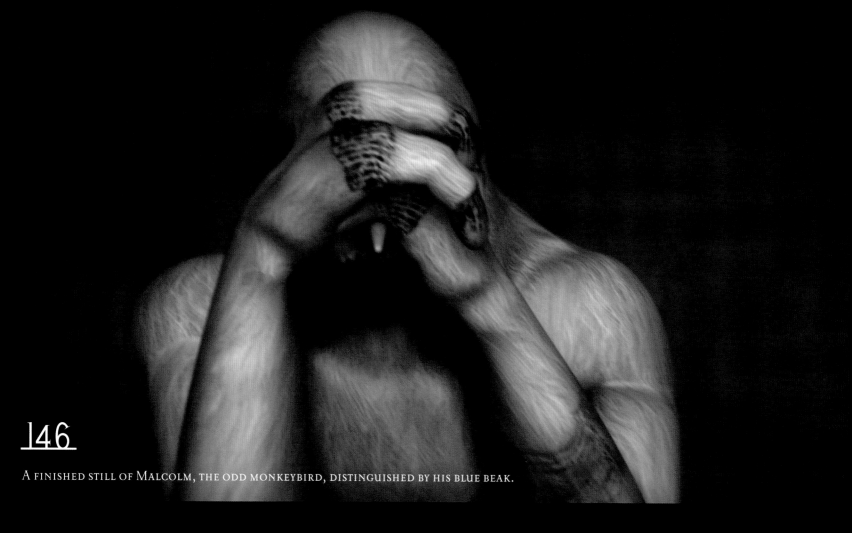

146

A FINISHED STILL OF MALCOLM, THE ODD MONKEYBIRD, DISTINGUISHED BY HIS BLUE BEAK.

THE CATHEDRAL INTERIOR SET.

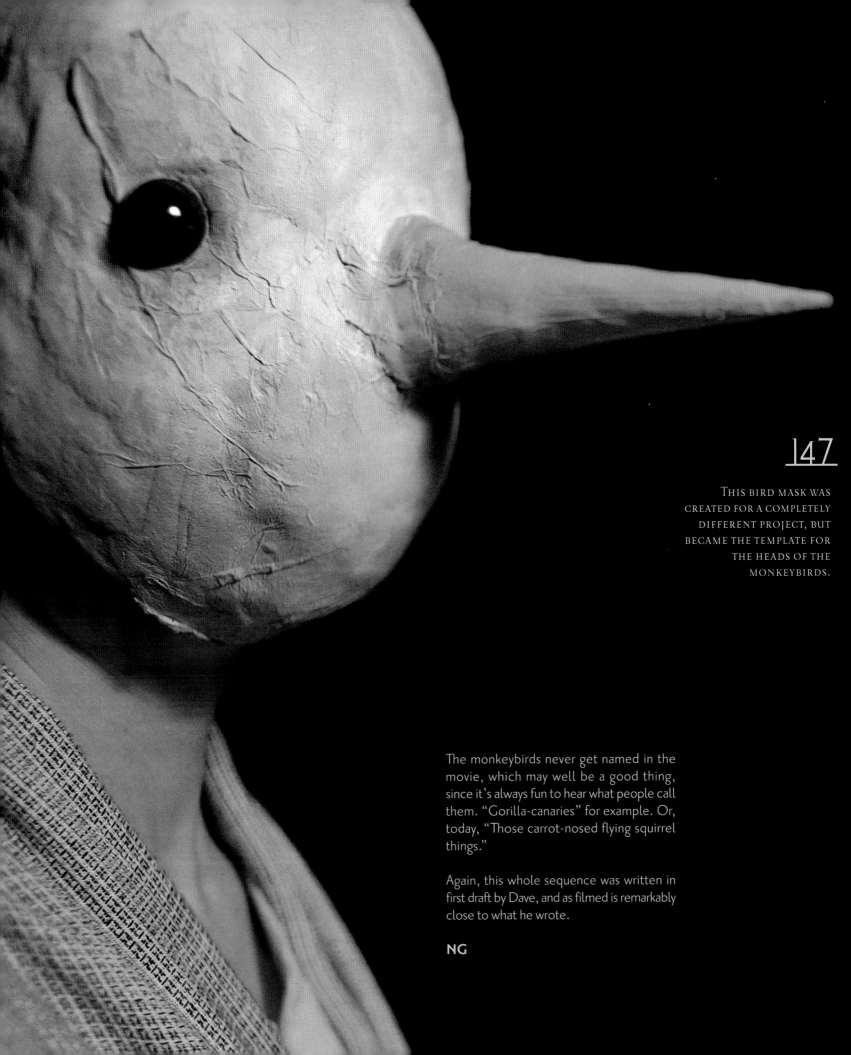

147

This bird mask was created for a completely different project, but became the template for the heads of the monkeybirds.

The monkeybirds never get named in the movie, which may well be a good thing, since it's always fun to hear what people call them. "Gorilla-canaries" for example. Or, today, "Those carrot-nosed flying squirrel things."

Again, this whole sequence was written in first draft by Dave, and as filmed is remarkably close to what he wrote.

NG

148

Surrounding
drawings by
Dave McKean.

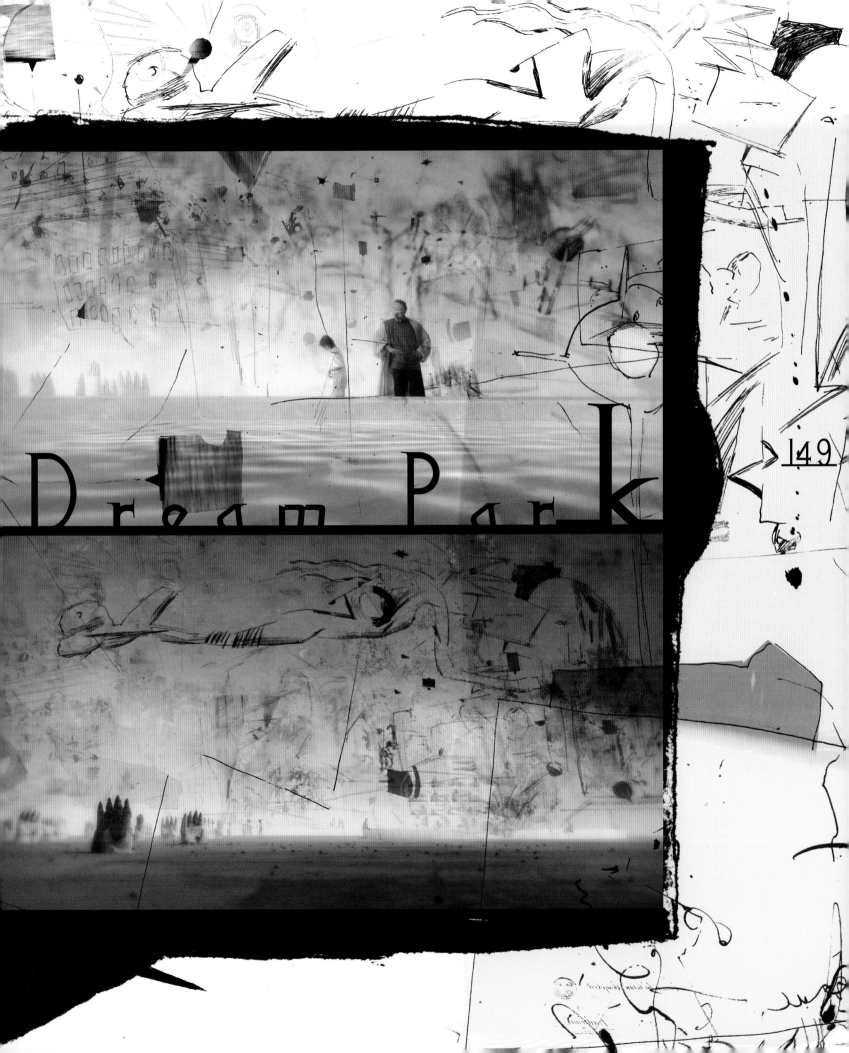

Dream Park

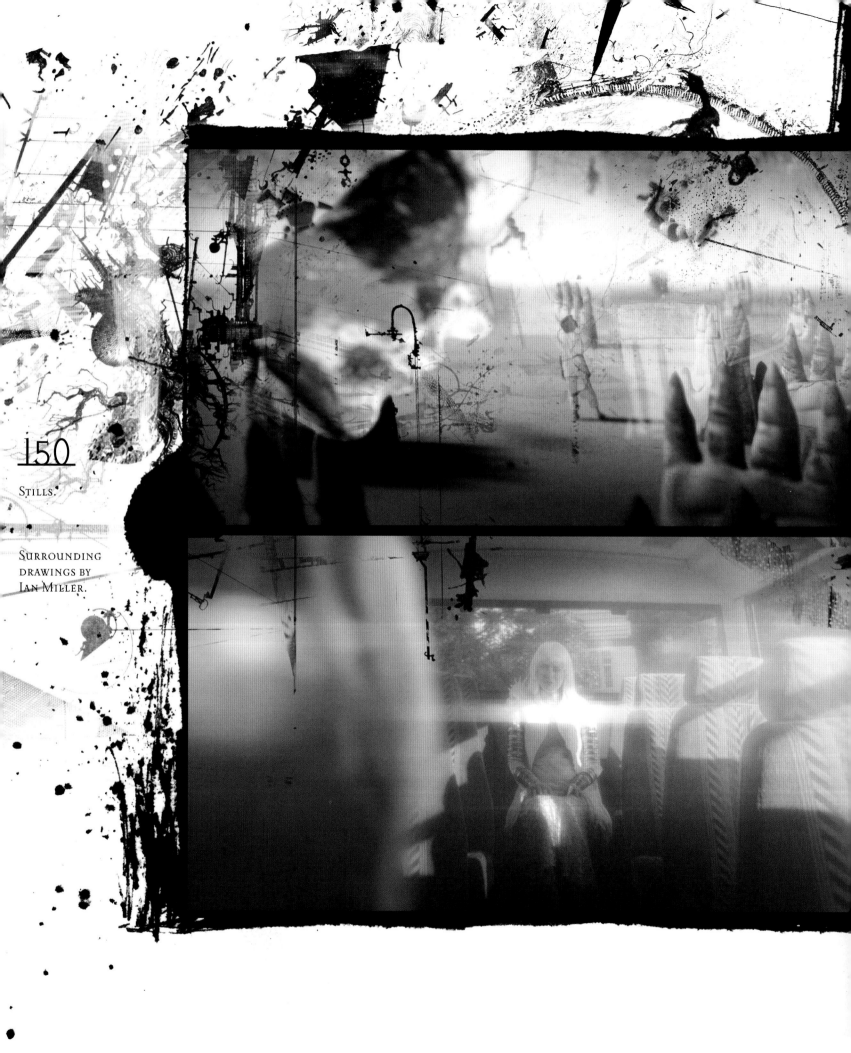

150

Stills.

Surrounding
drawings by
Ian Miller.

152

A DRAWING OF THE
DOME, INCLUDED ON
HELENA'S BEDROOM
WALL.

PHOTOGRAPH OF THE
DOME SET. THE DOOR
AND WINDOW OPEN
ONTO THE BLUE-SCREEN
STAGE.

The Dream Park was pretty vague in the script. It was a borderland, an in-between place, where images are sketched and fade and shift. We could have blown the whole budget on this space, but at the end of the day I decided to really try and make it a place of doodles and half-formed ideas. The soundscape became detuned low-band radio phasing in and out of reception.

I asked Ian Miller to be involved in the film because of this scene, and also to help with the wall of drawings in Helena's bedroom. I didn't have the time to produce enough drawings myself to wallpaper these two areas of the film, so I asked Ian if I could have access to his huge back catalogue of drawings to incorporate into the backgrounds of the film. Ian has worked on several Ralph Bakshi projects and very kindly let me rifle through his drawers, so to speak, and take away a portfolio of amazing sketches, illustrations, and paintings that found themselves embedded into the walls, describing distant skylines and hanging in the air around the Dream Park.

DM

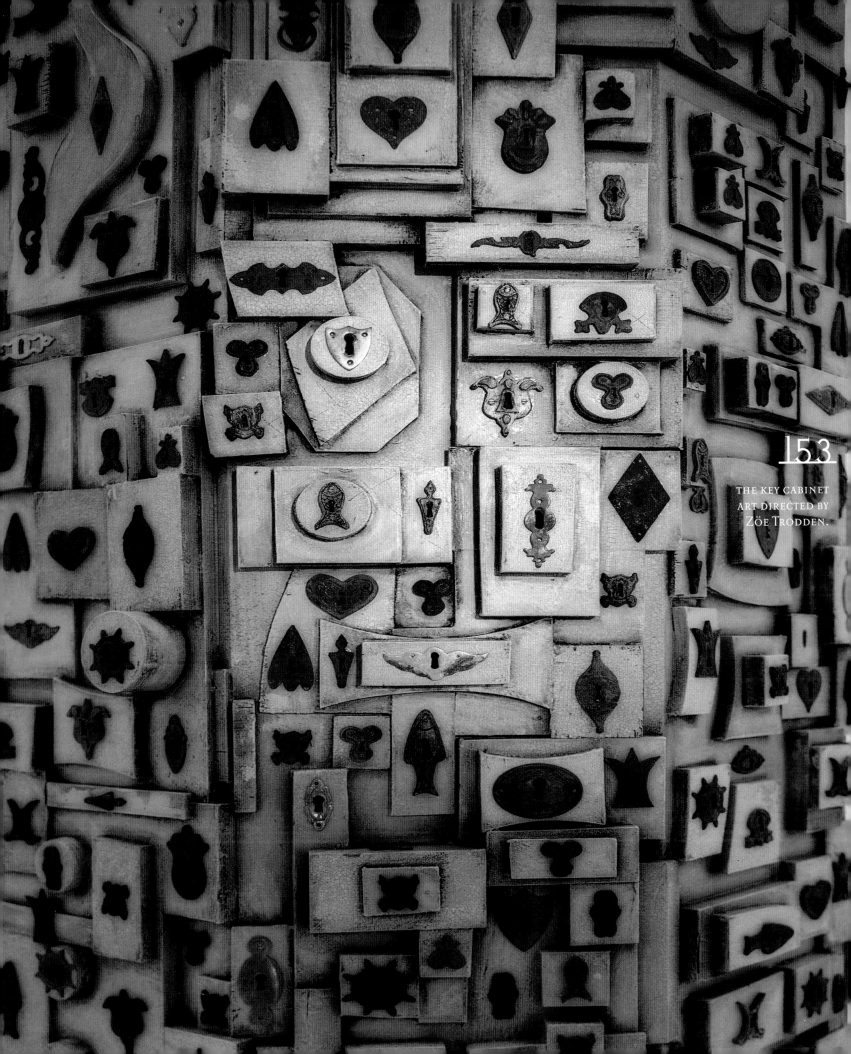

153

THE KEY CABINET
ART DIRECTED BY
ZÖE TRODDEN.

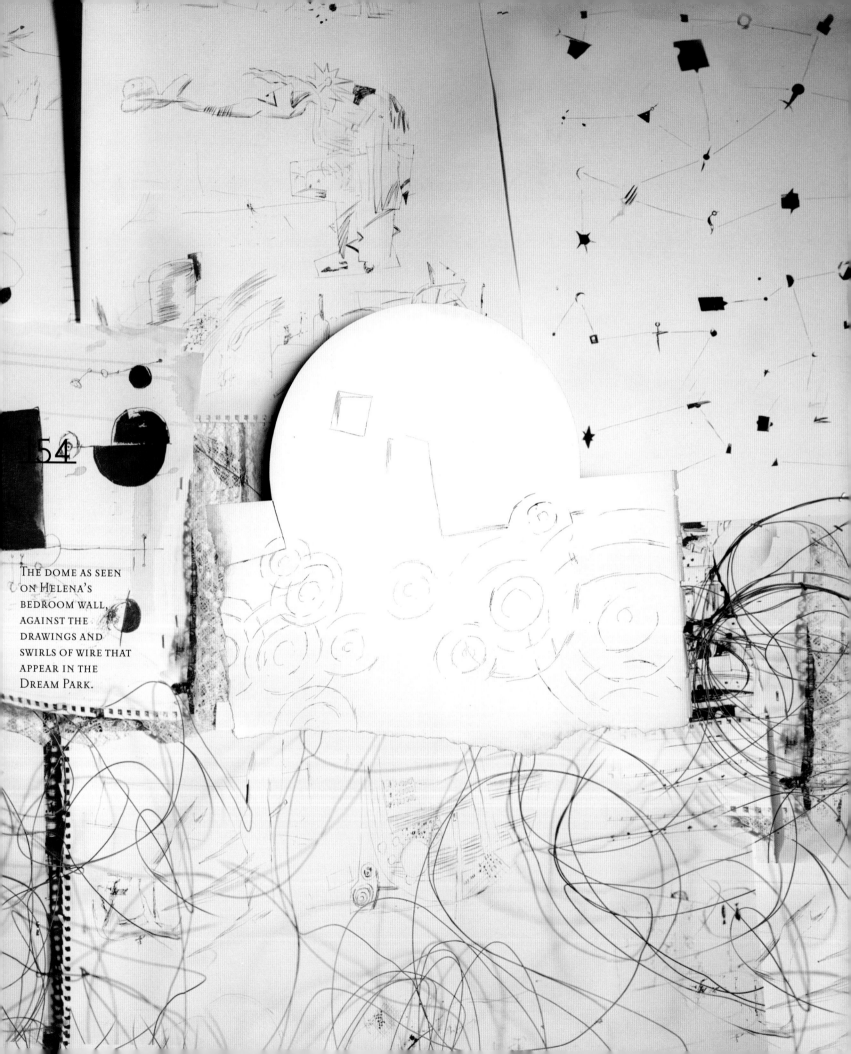

54

THE DOME AS SEEN
ON HELENA'S
BEDROOM WALL,
AGAINST THE
DRAWINGS AND
SWIRLS OF WIRE THAT
APPEAR IN THE
DREAM PARK.

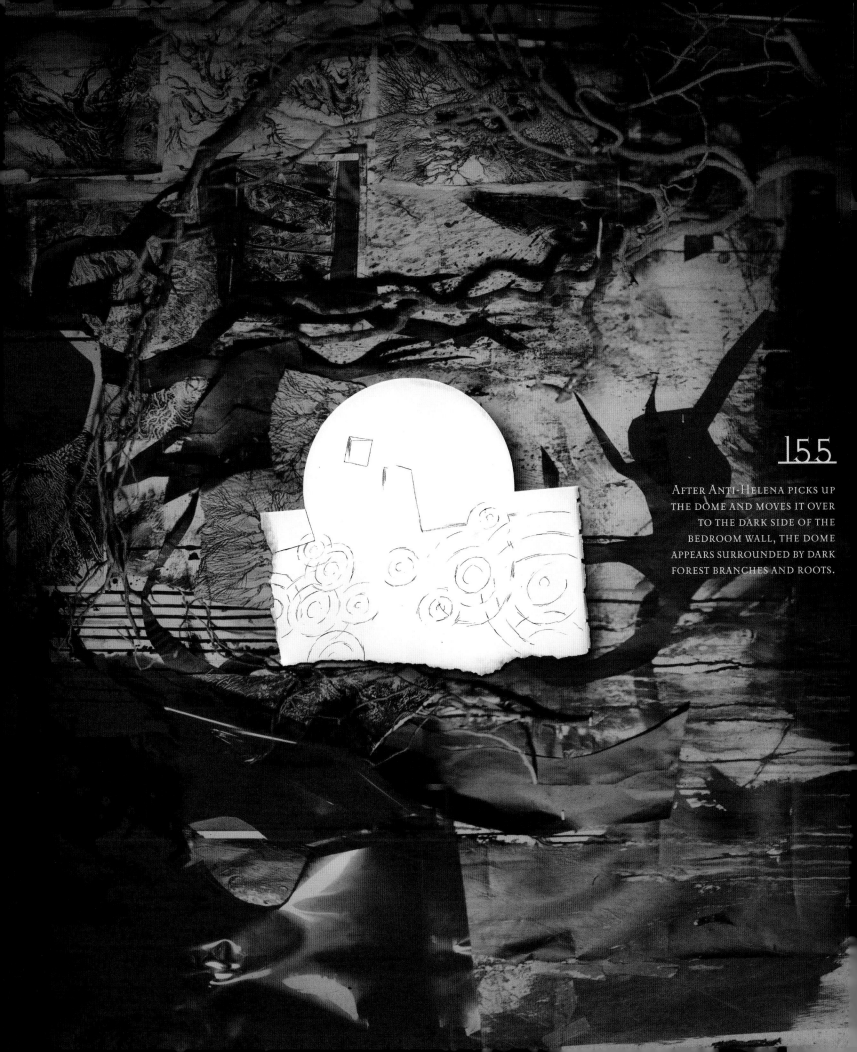

155

After Anti-Helena picks up the dome and moves it over to the dark side of the bedroom wall, the dome appears surrounded by dark forest branches and roots.

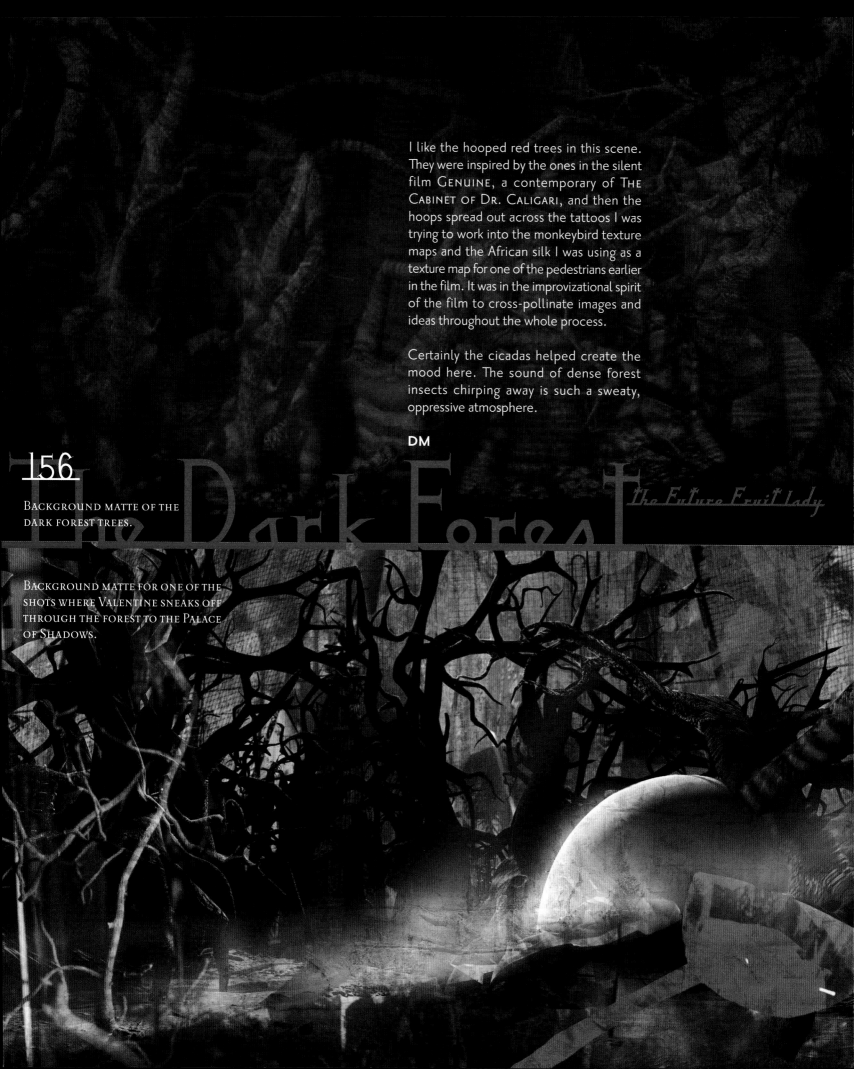

I like the hooped red trees in this scene. They were inspired by the ones in the silent film Genuine, a contemporary of The Cabinet of Dr. Caligari, and then the hoops spread out across the tattoos I was trying to work into the monkeybird texture maps and the African silk I was using as a texture map for one of the pedestrians earlier in the film. It was in the improvizational spirit of the film to cross-pollinate images and ideas throughout the whole process.

Certainly the cicadas helped create the mood here. The sound of dense forest insects chirping away is such a sweaty, oppressive atmosphere.

DM

156

The Dark Forest

The Future Fruit lady

Background matte of the dark forest trees.

Background matte for one of the shots where Valentine sneaks off through the forest to the Palace of Shadows.

157

The Future Fruit scene was, in what might be described as the zeroth draft of MIRRORMASK, going to be Douglas Prawnhead's big scene. He was the Future Fruit's first guardian, you see. He was much crosser with Valentine than the Future Fruit Lady was in the version of the story that we ended up with. It would have been his big break. People would be wearing Douglas Prawnhead tee shirts. There would probably be a whole line of Douglas Prawnhead toys by now, not to mention the Douglas Prawnhead collectible card game. There might even have been a pog revival, just so that people could have made Douglas Prawnhead pogs.

Alas, it was never to be. You can't even get your own Douglas Prawnhead hat, which would, I suppose, be a large hat in the shape of an enormous prawn. It's a tragedy, really.

I think the performance from the Future Fruit Lady was the furthest of all from the thing in our heads when we wrote her. It's grown on me, but, having given up on the idea of a small, cross man with a prawn for a hat, we'd decided we wanted someone chubby and welcoming and sleepy, with a Somerset accent like smoky honey. And what we got was something else again.

And then, when we handed in the script, nobody but us liked this scene. When we filmed it, we thought the world would be convinced, but it wasn't. It didn't work. At some point or another everyone, even me, suggested that we simply cut it. Dave held firm, convinced it would work, but even he knew that it didn't work the way that it was.

And then producer Simon Moorhead took the scene home and moved and truncated it a little, and Dave tidied that edit up, and I wrote a few lines to cover the transition, and suddenly it worked like a dream, and we even had the place in the film—the "Waiter" line—that, at Sundance, drew spontaneous applause.

I have no idea what that proves, other than a) Dave was right, and b) it's good to have a producer.

NG

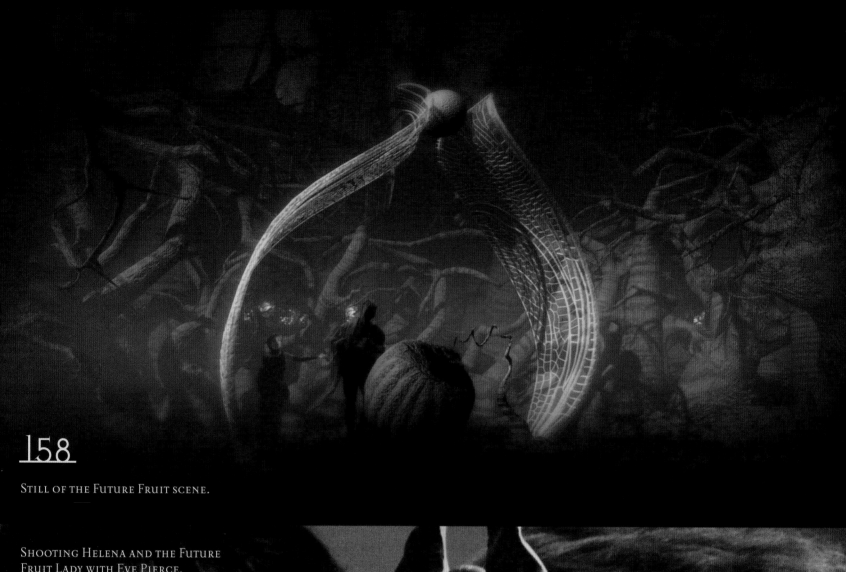

STILL OF THE FUTURE FRUIT SCENE.

SHOOTING HELENA AND THE FUTURE
FRUIT LADY WITH EVE PIERCE.

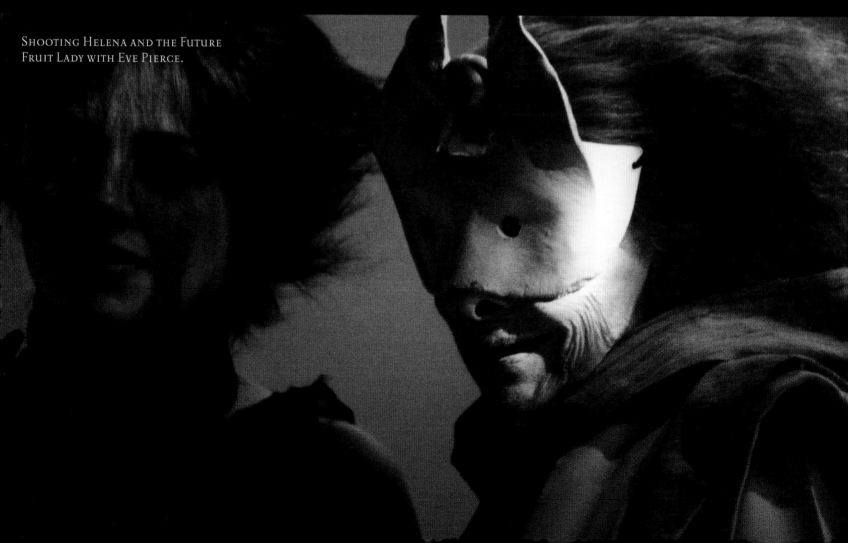

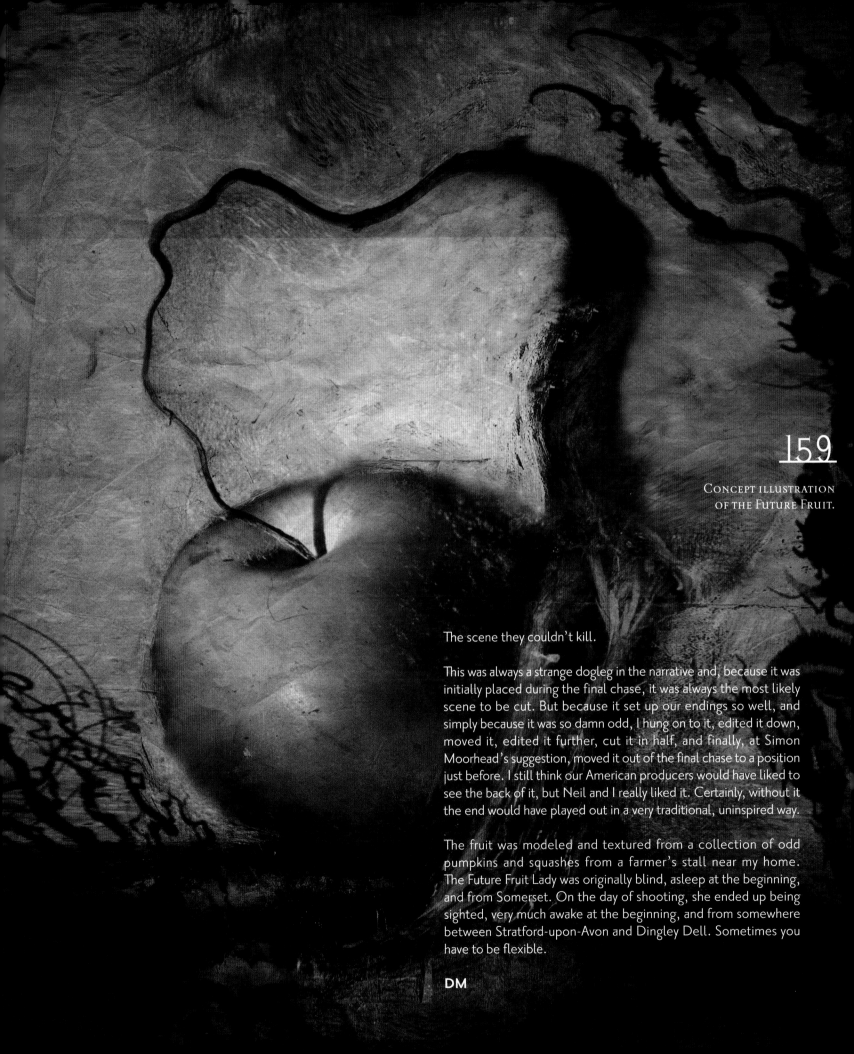

Concept illustration
of the Future Fruit.

The scene they couldn't kill.

This was always a strange dogleg in the narrative and, because it was initially placed during the final chase, it was always the most likely scene to be cut. But because it set up our endings so well, and simply because it was so damn odd, I hung on to it, edited it down, moved it, edited it further, cut it in half, and finally, at Simon Moorhead's suggestion, moved it out of the final chase to a position just before. I still think our American producers would have liked to see the back of it, but Neil and I really liked it. Certainly, without it the end would have played out in a very traditional, uninspired way.

The fruit was modeled and textured from a collection of odd pumpkins and squashes from a farmer's stall near my home. The Future Fruit Lady was originally blind, asleep at the beginning, and from Somerset. On the day of shooting, she ended up being sighted, very much awake at the beginning, and from somewhere between Stratford-upon-Avon and Dingley Dell. Sometimes you have to be flexible.

DM

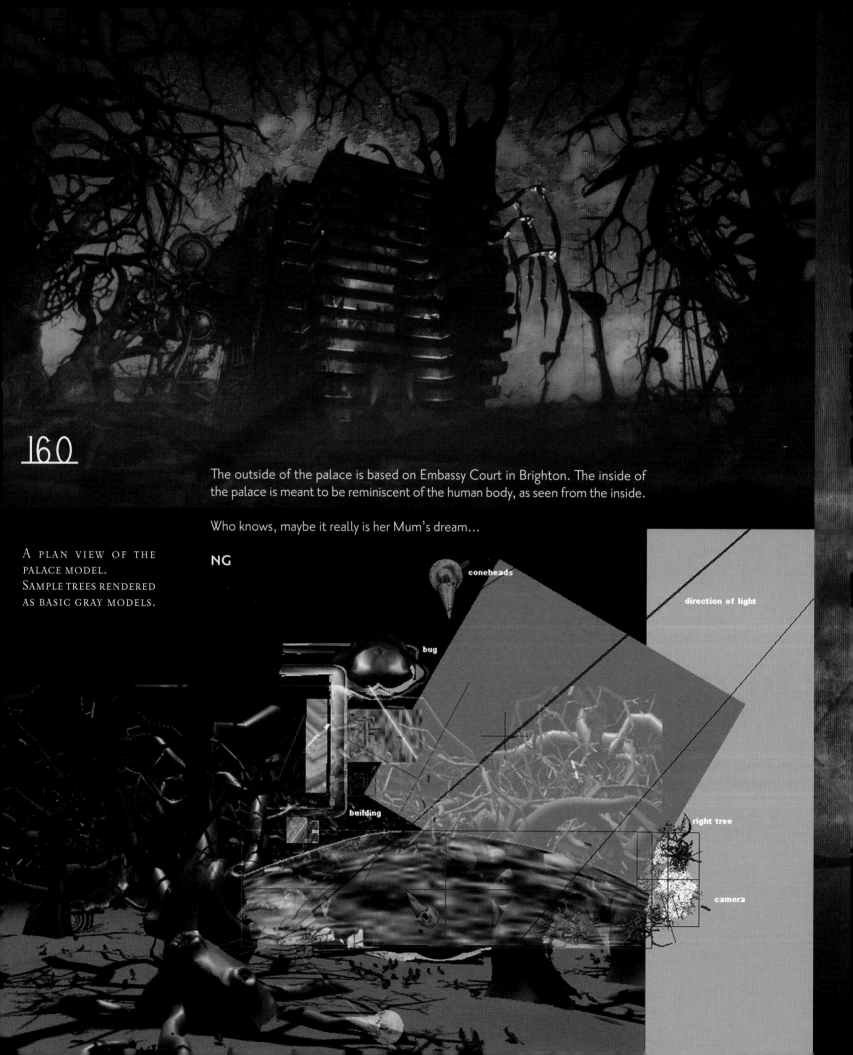

160

The outside of the palace is based on Embassy Court in Brighton. The inside of the palace is meant to be reminiscent of the human body, as seen from the inside.

Who knows, maybe it really is her Mum's dream...

A PLAN VIEW OF THE PALACE MODEL. SAMPLE TREES RENDERED AS BASIC GRAY MODELS.

NG

coneheads

direction of light

bug

building

right tree

camera

The light and shadow queens were always aspects of Mum's character, so all three rolls had to be played by the same actress. Gina McKee came to mind on the second day of writing and stayed in my head as the face of the queen throughout. I loved her performances in NOTTING HILL and THE LOST PRINCE and especially Michael Winterbottom's WONDERLAND. She invested her characters with a very real warmth when she smiled, but had a fragility that I thought would work well for when Mum was in the hospital. The Queen of Shadows was the part that she could play with, and even though I think she would have liked to push the boat out further, I preferred the balance between a very real, worried mother and an occasional spikey flare of temper.

The costume was made by Academy and then, after a meeting where Robert Lever poked and prodded it, we started to screw it up a bit. The more uneven and jagged he made it, the better it looked.

DM

The Palace of Shadows

The Queen of Shadows
Gina McKee

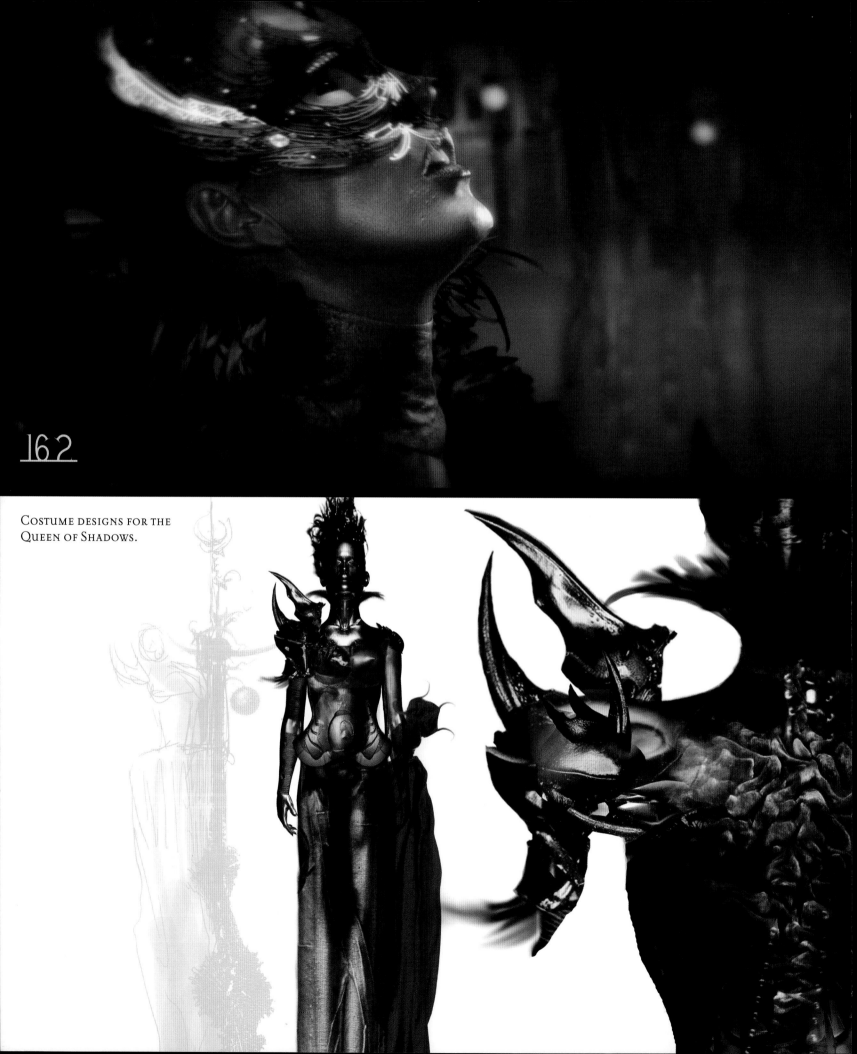

162

COSTUME DESIGNS FOR THE
QUEEN OF SHADOWS.

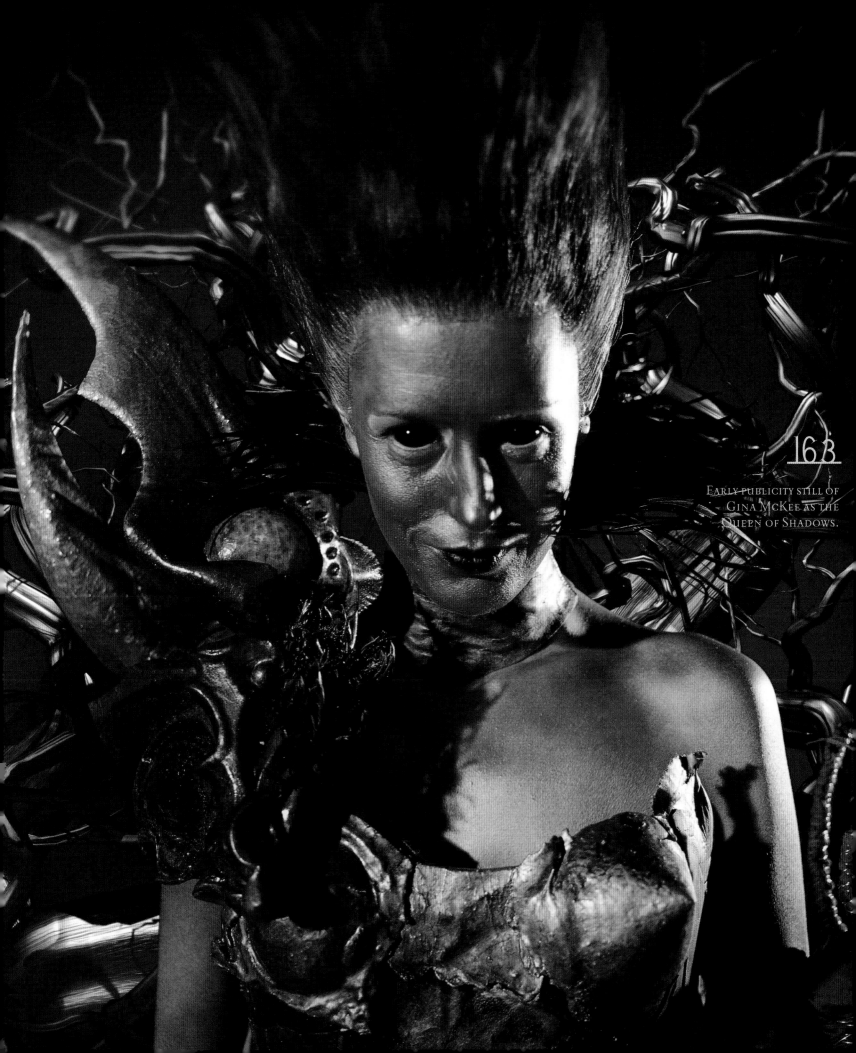

EARLY PUBLICITY STILL OF
GINA MCKEE AS THE
QUEEN OF SHADOWS.

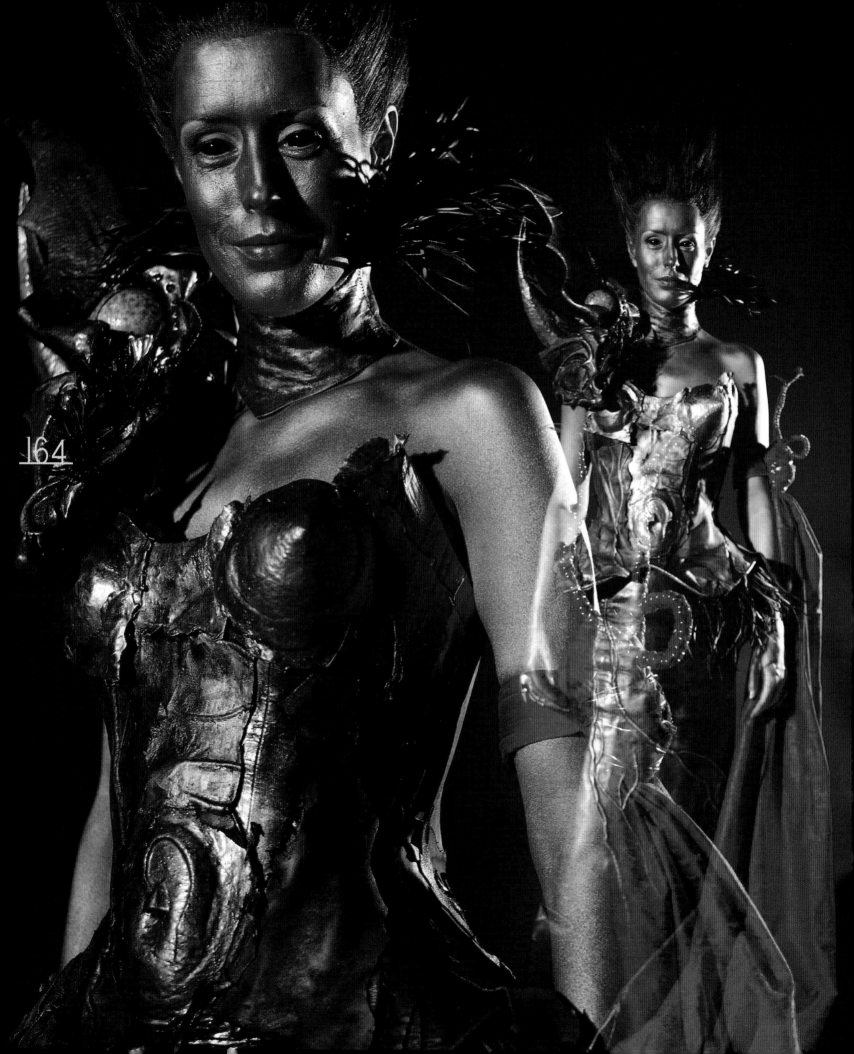

165

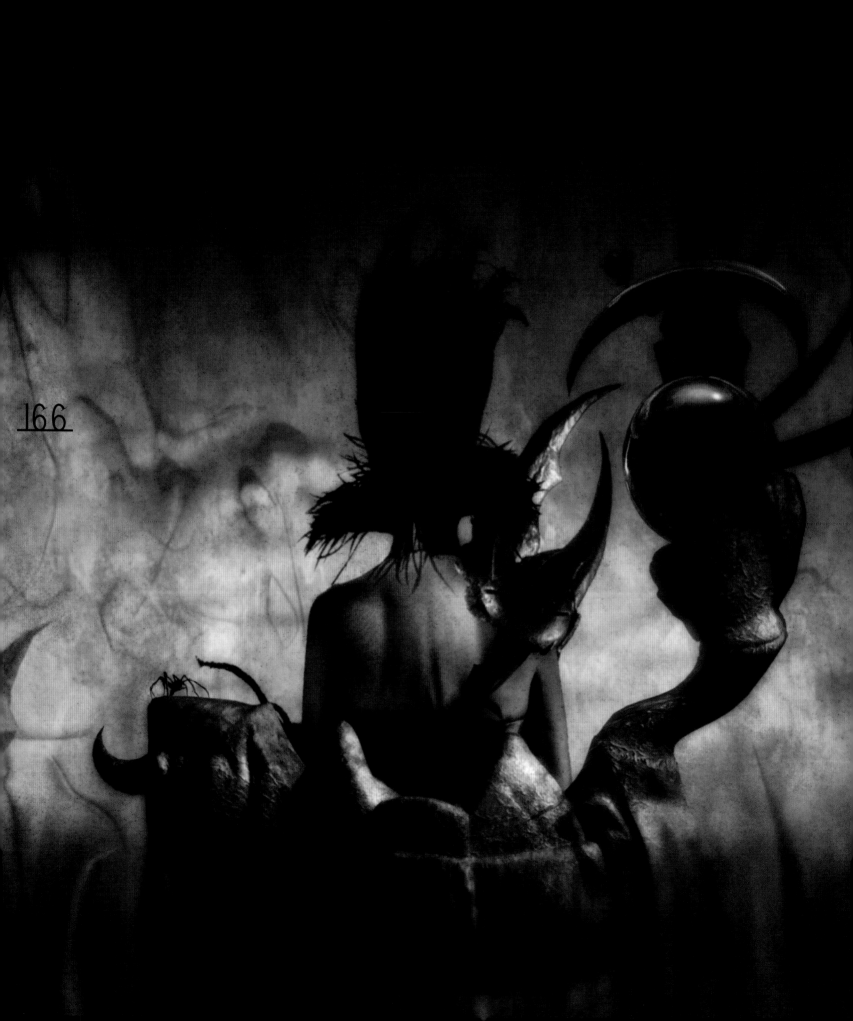

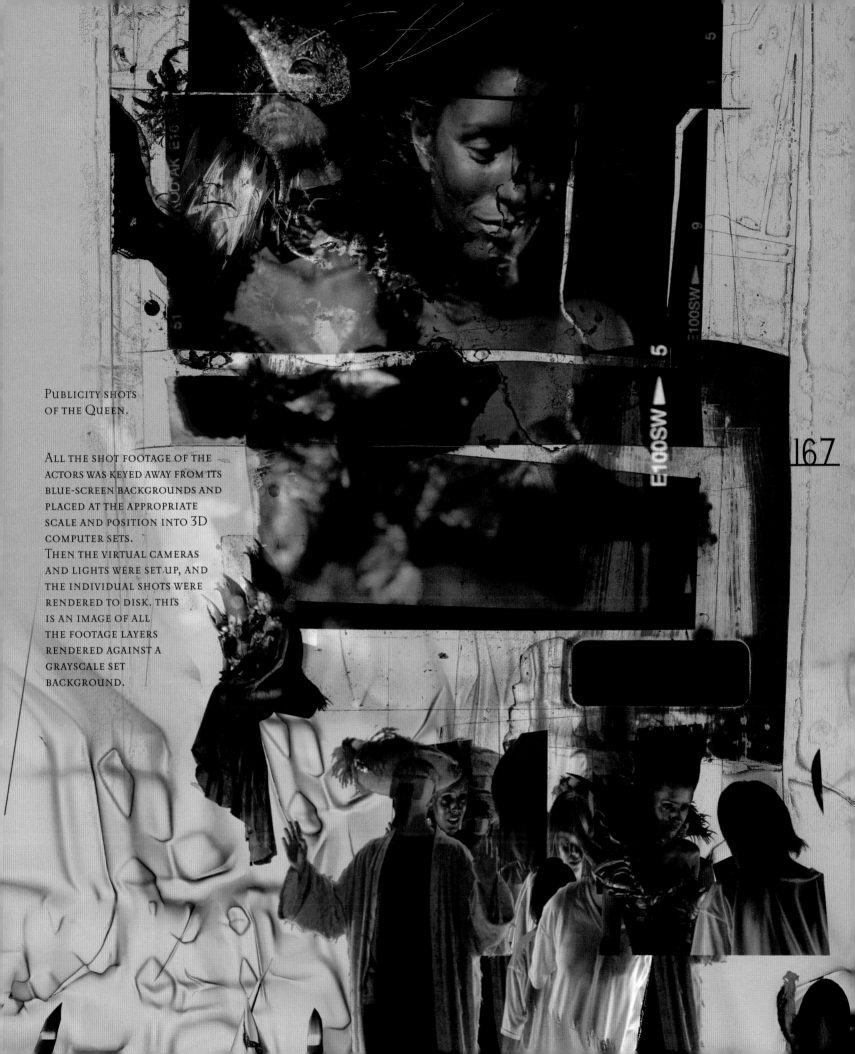

PUBLICITY SHOTS
OF THE QUEEN.

ALL THE SHOT FOOTAGE OF THE
ACTORS WAS KEYED AWAY FROM ITS
BLUE-SCREEN BACKGROUNDS AND
PLACED AT THE APPROPRIATE
SCALE AND POSITION INTO 3D
COMPUTER SETS.
THEN THE VIRTUAL CAMERAS
AND LIGHTS WERE SET UP, AND
THE INDIVIDUAL SHOTS WERE
RENDERED TO DISK. THIS
IS AN IMAGE OF ALL
THE FOOTAGE LAYERS
RENDERED AGAINST A
GRAYSCALE SET
BACKGROUND.

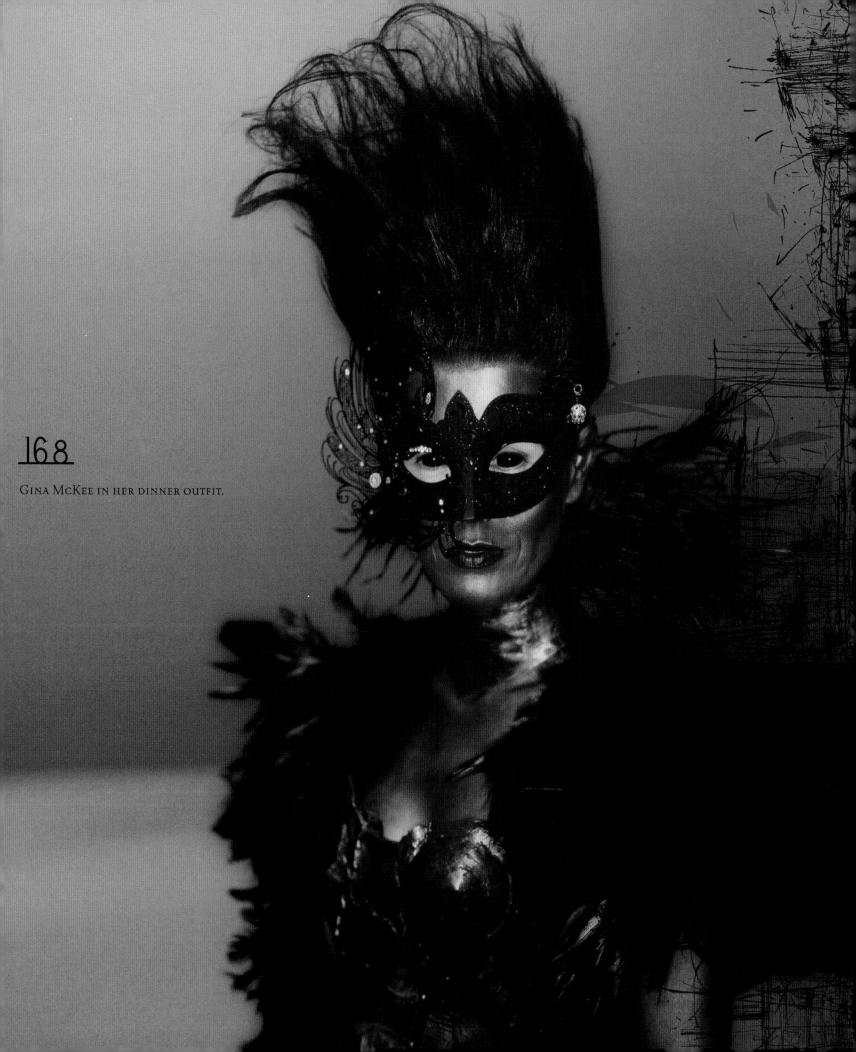

168

GINA MCKEE IN HER DINNER OUTFIT.

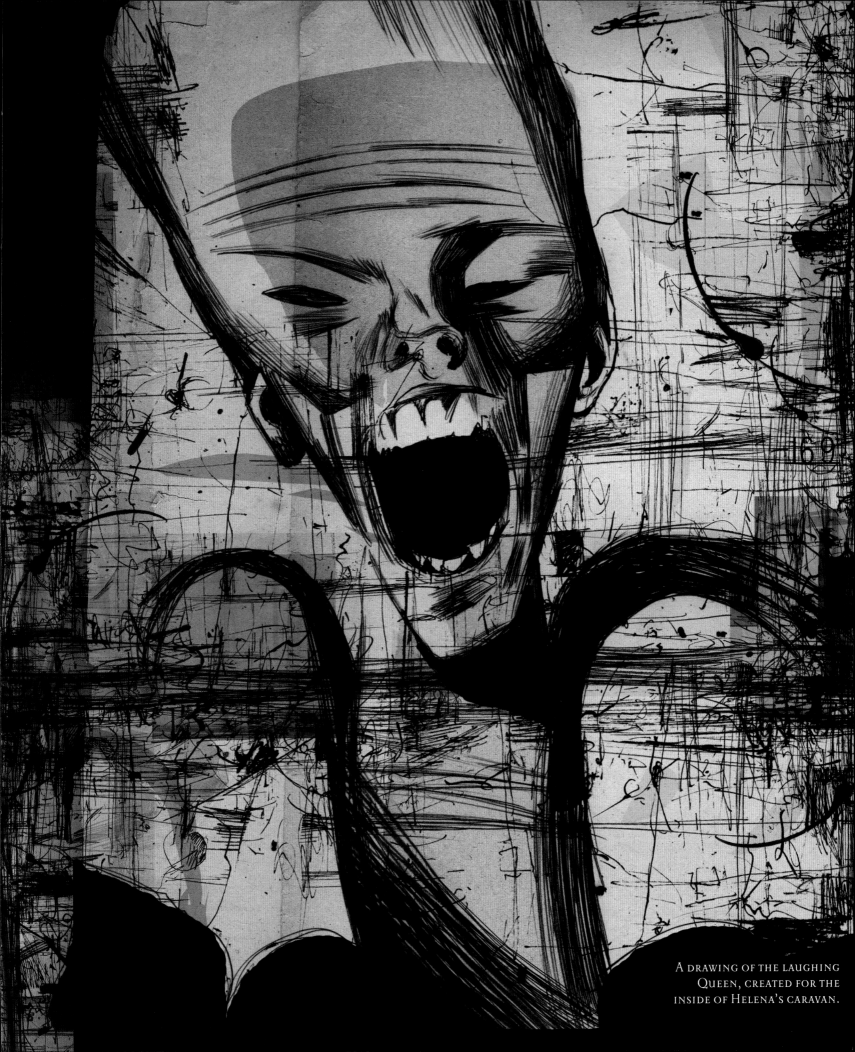

A DRAWING OF THE LAUGHING
QUEEN, CREATED FOR THE
INSIDE OF HELENA'S CARAVAN.

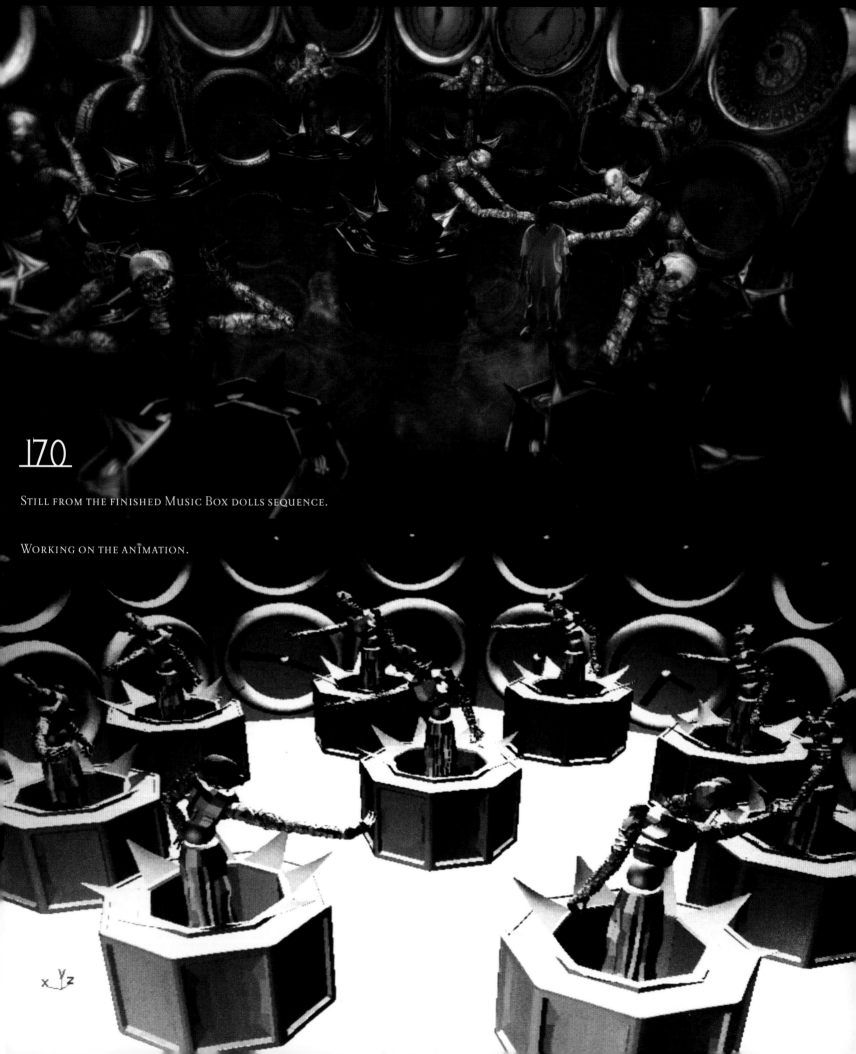

170

Still from the finished Music Box dolls sequence.

Working on the animation.

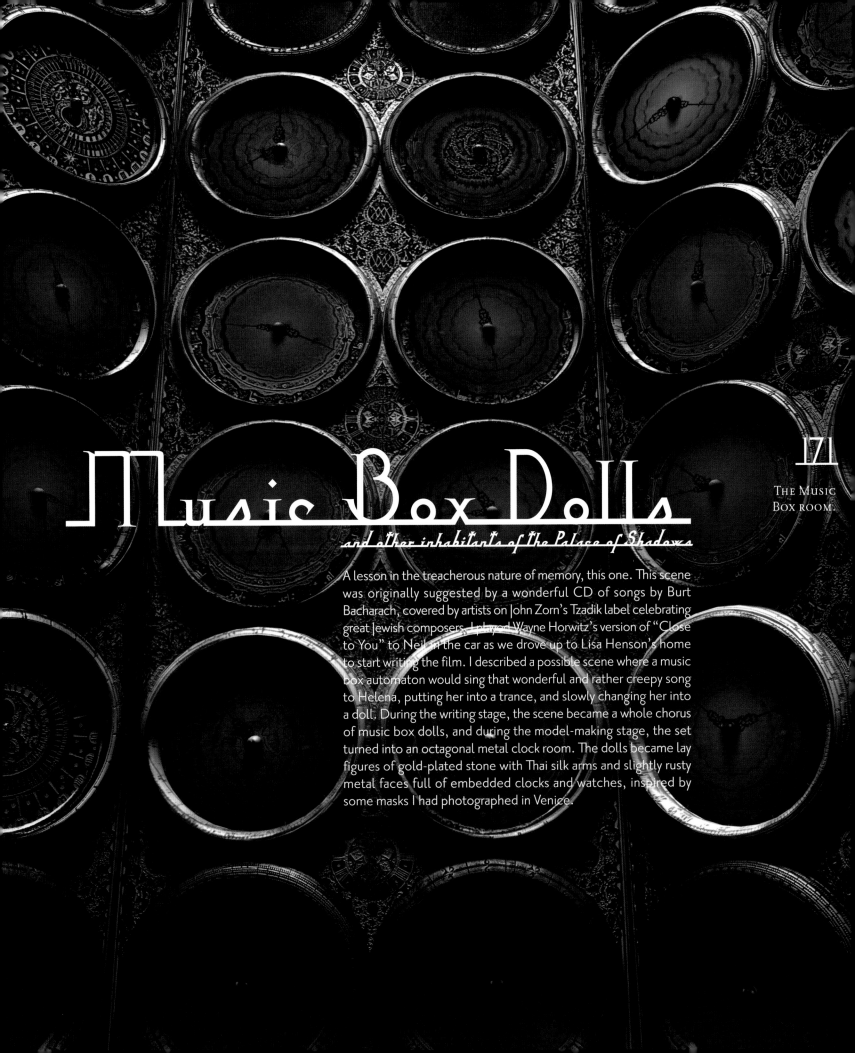

Music Box Dolls
and other inhabitants of the Palace of Shadows

A lesson in the treacherous nature of memory, this one. This scene was originally suggested by a wonderful CD of songs by Burt Bacharach, covered by artists on John Zorn's Tzadik label celebrating great Jewish composers. I played Wayne Horwitz's version of "Close to You" to Neil in the car as we drove up to Lisa Henson's home to start writing the film. I described a possible scene where a music box automaton would sing that wonderful and rather creepy song to Helena, putting her into a trance, and slowly changing her into a doll. During the writing stage, the scene became a whole chorus of music box dolls, and during the model-making stage, the set turned into an octagonal metal clock room. The dolls became lay figures of gold-plated stone with Thai silk arms and slightly rusty metal faces full of embedded clocks and watches, inspired by some masks I had photographed in Venice.

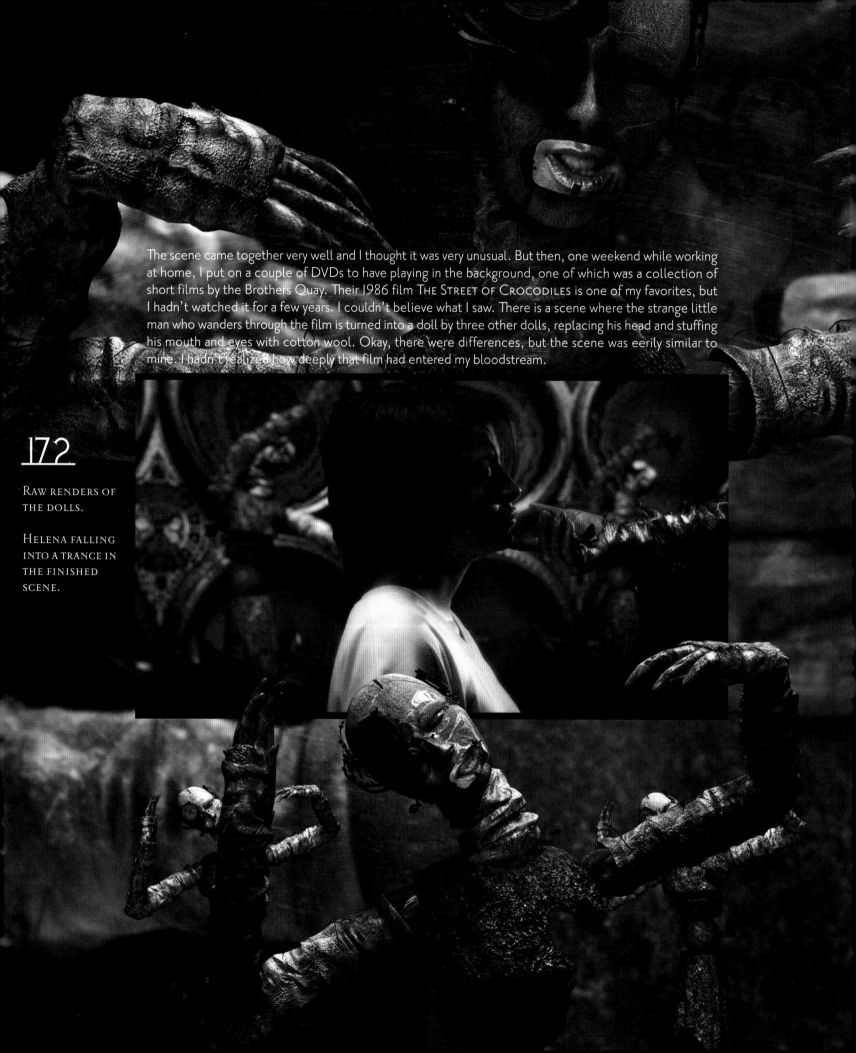

The scene came together very well and I thought it was very unusual. But then, one weekend while working at home, I put on a couple of DVDs to have playing in the background, one of which was a collection of short films by the Brothers Quay. Their 1986 film THE STREET OF CROCODILES is one of my favorites, but I hadn't watched it for a few years. I couldn't believe what I saw. There is a scene where the strange little man who wanders through the film is turned into a doll by three other dolls, replacing his head and stuffing his mouth and eyes with cotton wool. Okay, there were differences, but the scene was eerily similar to mine. I hadn't realized how deeply that film had entered my bloodstream.

172

RAW RENDERS OF
THE DOLLS.

HELENA FALLING
INTO A TRANCE IN
THE FINISHED
SCENE.

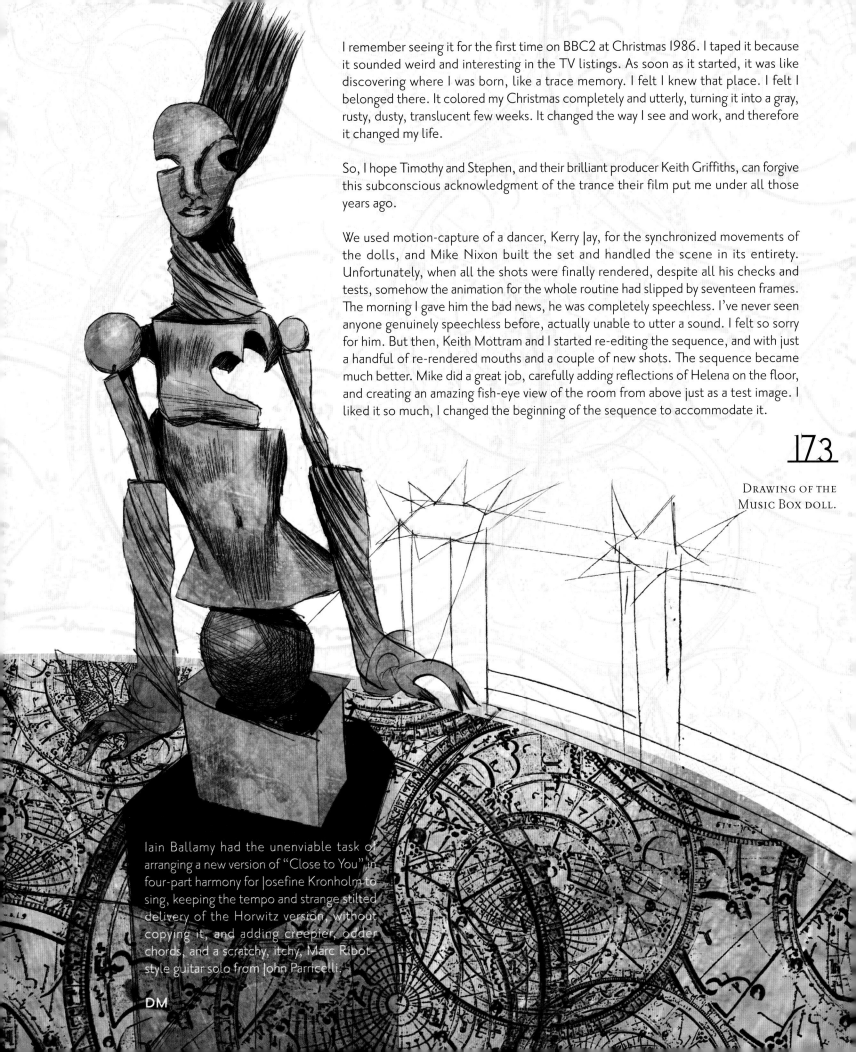

I remember seeing it for the first time on BBC2 at Christmas 1986. I taped it because it sounded weird and interesting in the TV listings. As soon as it started, it was like discovering where I was born, like a trace memory. I felt I knew that place. I felt I belonged there. It colored my Christmas completely and utterly, turning it into a gray, rusty, dusty, translucent few weeks. It changed the way I see and work, and therefore it changed my life.

So, I hope Timothy and Stephen, and their brilliant producer Keith Griffiths, can forgive this subconscious acknowledgment of the trance their film put me under all those years ago.

We used motion-capture of a dancer, Kerry Jay, for the synchronized movements of the dolls, and Mike Nixon built the set and handled the scene in its entirety. Unfortunately, when all the shots were finally rendered, despite all his checks and tests, somehow the animation for the whole routine had slipped by seventeen frames. The morning I gave him the bad news, he was completely speechless. I've never seen anyone genuinely speechless before, actually unable to utter a sound. I felt so sorry for him. But then, Keith Mottram and I started re-editing the sequence, and with just a handful of re-rendered mouths and a couple of new shots. The sequence became much better. Mike did a great job, carefully adding reflections of Helena on the floor, and creating an amazing fish-eye view of the room from above just as a test image. I liked it so much, I changed the beginning of the sequence to accommodate it.

173

DRAWING OF THE
MUSIC BOX DOLL.

Iain Ballamy had the unenviable task of arranging a new version of "Close to You" in four-part harmony for Josefine Kronholm to sing, keeping the tempo and strange stilted delivery of the Horwitz version, without copying it, and adding creepier, odder chords, and a scratchy, itchy, Marc Ribot–style guitar solo from John Parricelli.

DM

Dave had a CD in his car with "Close to You" on it, and together we came up with the idea of having the song sung to Helena by dolls in music boxes. I knew that I wanted a transformation scene—it seemed part of the genre we were working in, that place of transition between girl and young woman.

I think this is probably my favorite part of the film. I've now seen MIRRORMASK hundreds of times in various forms, and this bit always makes me happy.

NG

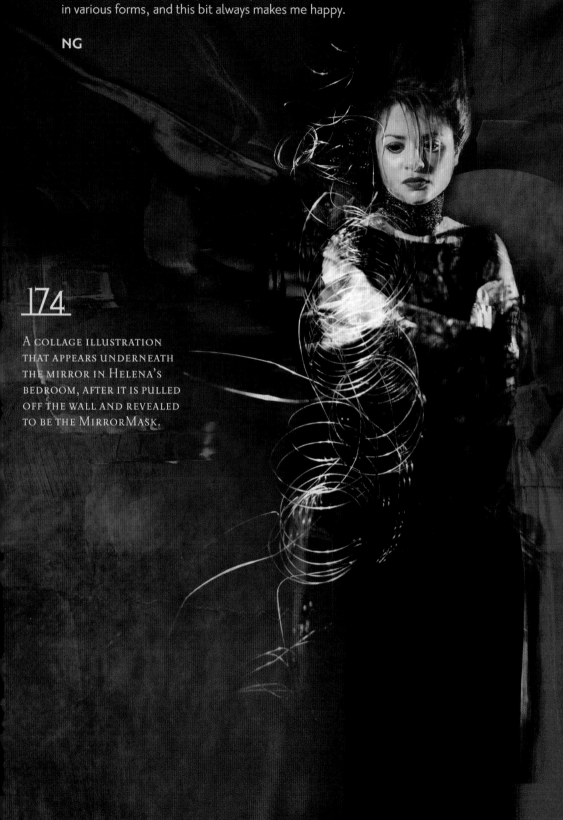

174

A COLLAGE ILLUSTRATION
THAT APPEARS UNDERNEATH
THE MIRROR IN HELENA'S
BEDROOM, AFTER IT IS PULLED
OFF THE WALL AND REVEALED
TO BE THE MIRRORMASK.

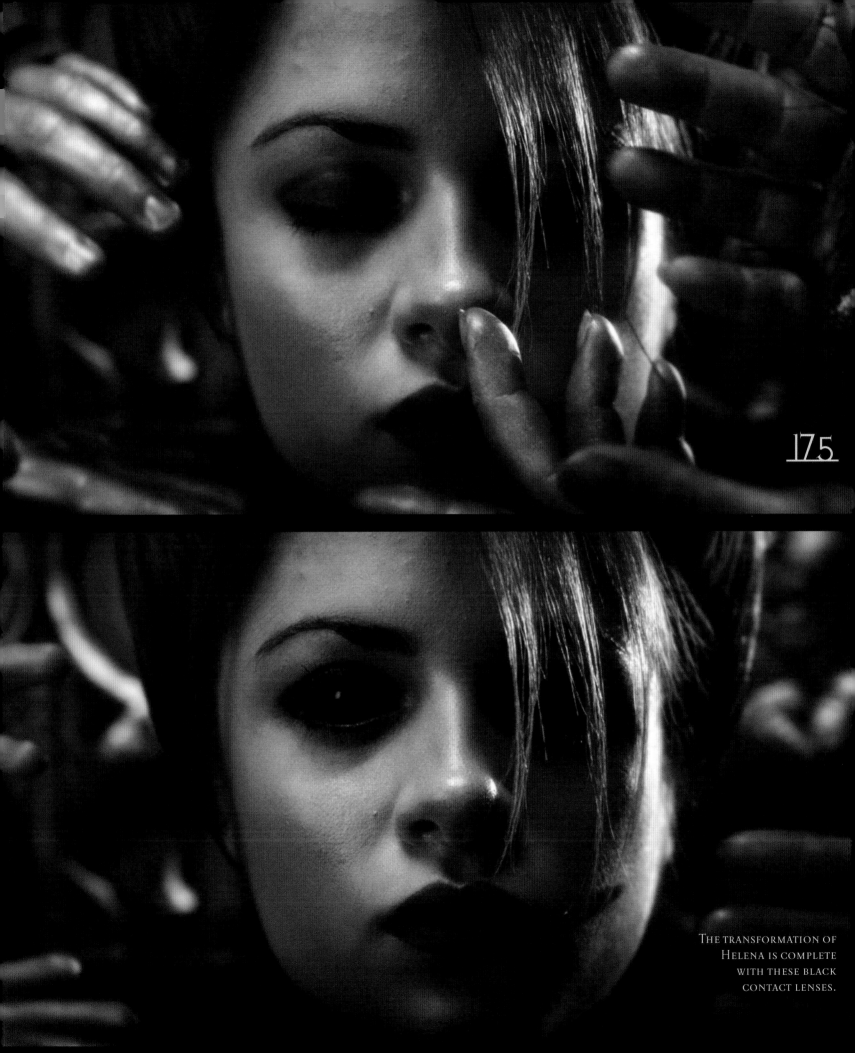

175

THE TRANSFORMATION OF
HELENA IS COMPLETE
WITH THESE BLACK
CONTACT LENSES.

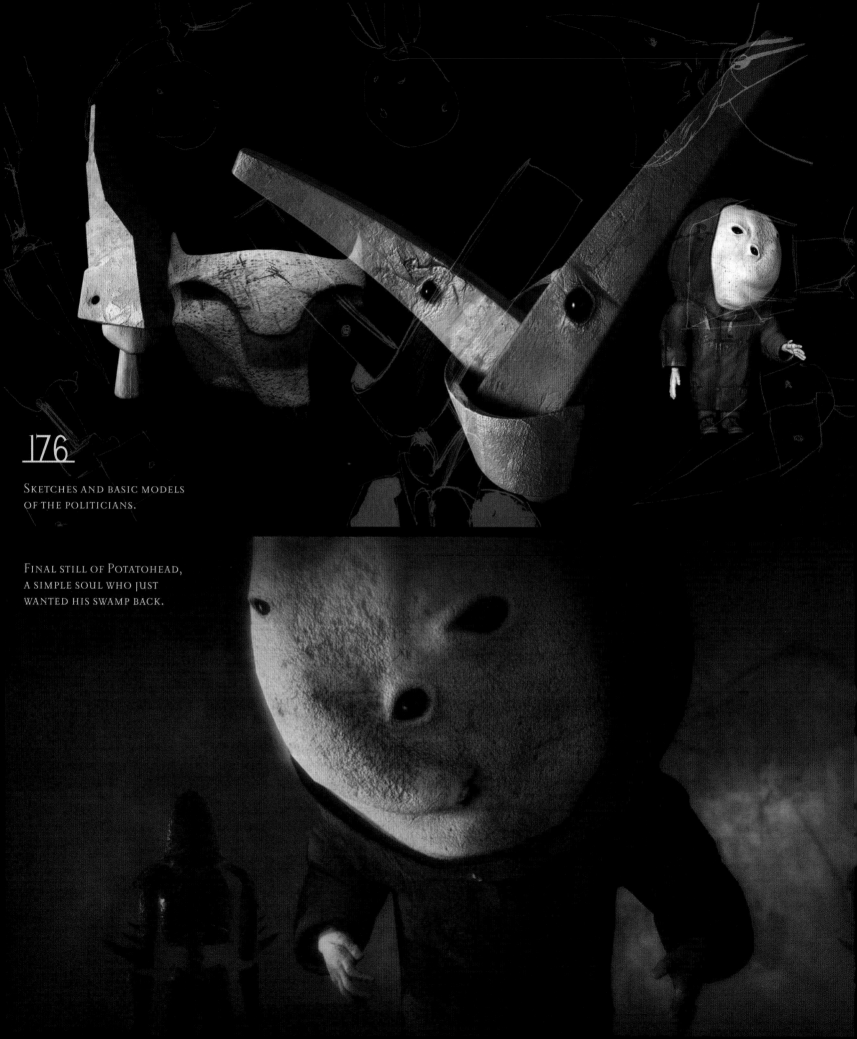

176

Sketches and basic models
of the politicians.

Final still of Potatohead,
a simple soul who just
wanted his swamp back.

The politician scenes were fun to put together, especially trying to find real-life equivalents. One was clearly an old-school Conservative Party back bencher, one a Labour Party left-wing firebrand in the Dennis Skinner mold, and one I decided in the end was probably Tony Blair, trying to appease everybody, sounding reasonable, but actually attempting to find a comfortable place in his agenda for total world destruction.

THE COUNCIL OF POLITICIANS.

The Council of Politicians

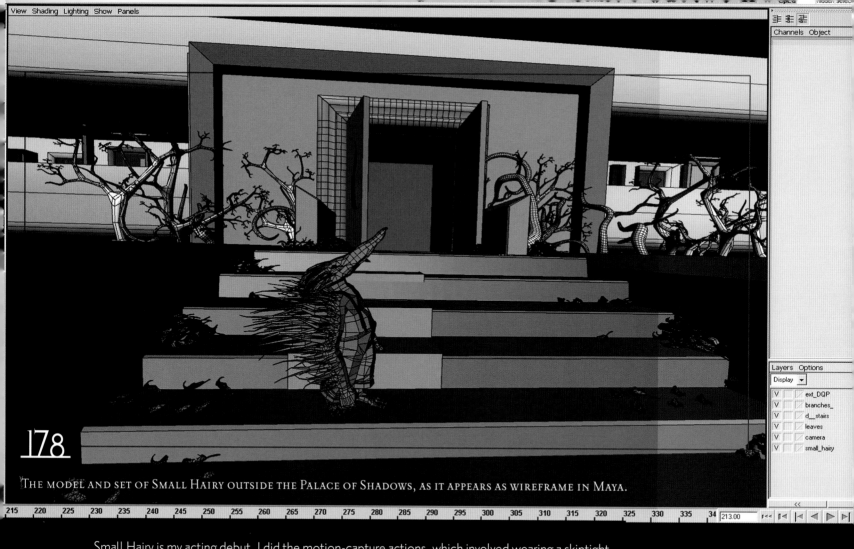

178

THE MODEL AND SET OF SMALL HAIRY OUTSIDE THE PALACE OF SHADOWS, AS IT APPEARS AS WIREFRAME IN MAYA.

215 220 225 230 235 240 245 250 255 260 265 270 275 280 285 290 295 300 305 310 315 320 325 330 335 34 213.00

Small Hairy is my acting debut. I did the motion-capture actions, which involved wearing a skintight black Lycra costume with little light-sensitive Ping-Pong balls all over it, and then walking around pretending to be a three-foot-high upright porcupine with trousers and suspenders. Sometimes it's hard to answer my kids when they ask, "What did you do at work today, Dad?" If the footage of me pretending to be the giants had to be wiped, then this tape had to be cut up, set on fire, encased in lead, and then buried in an unmarked stretch of deep Baltic Sea.

DM

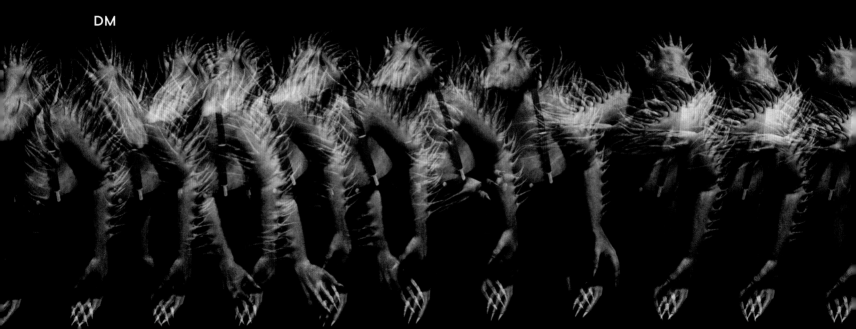

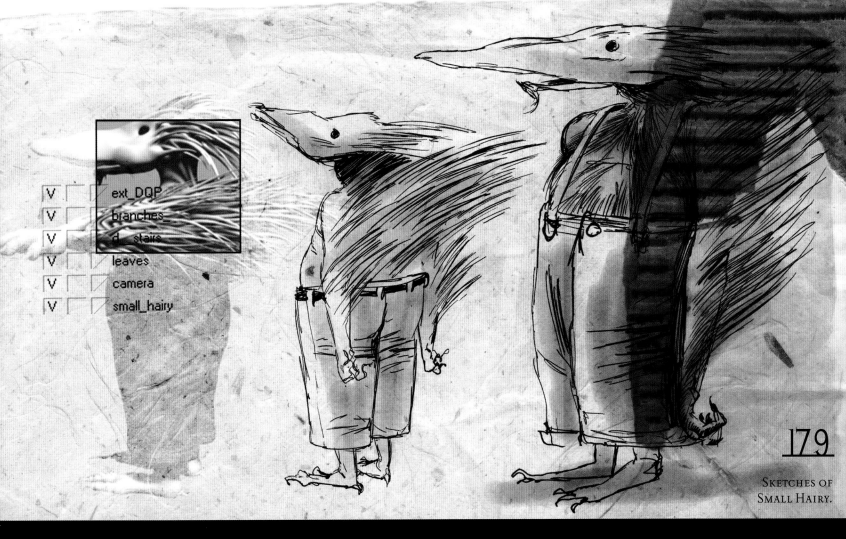

V			ext_DQP
V			branches
V			d__stairs
			leaves
			camera
V			small_hairy

179

SKETCHES OF
SMALL HAIRY.

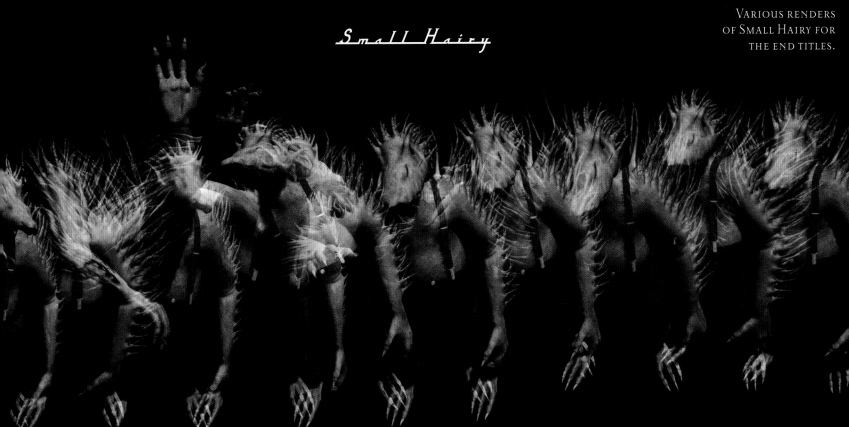

VARIOUS RENDERS
OF SMALL HAIRY FOR
THE END TITLES.

Small Hairy

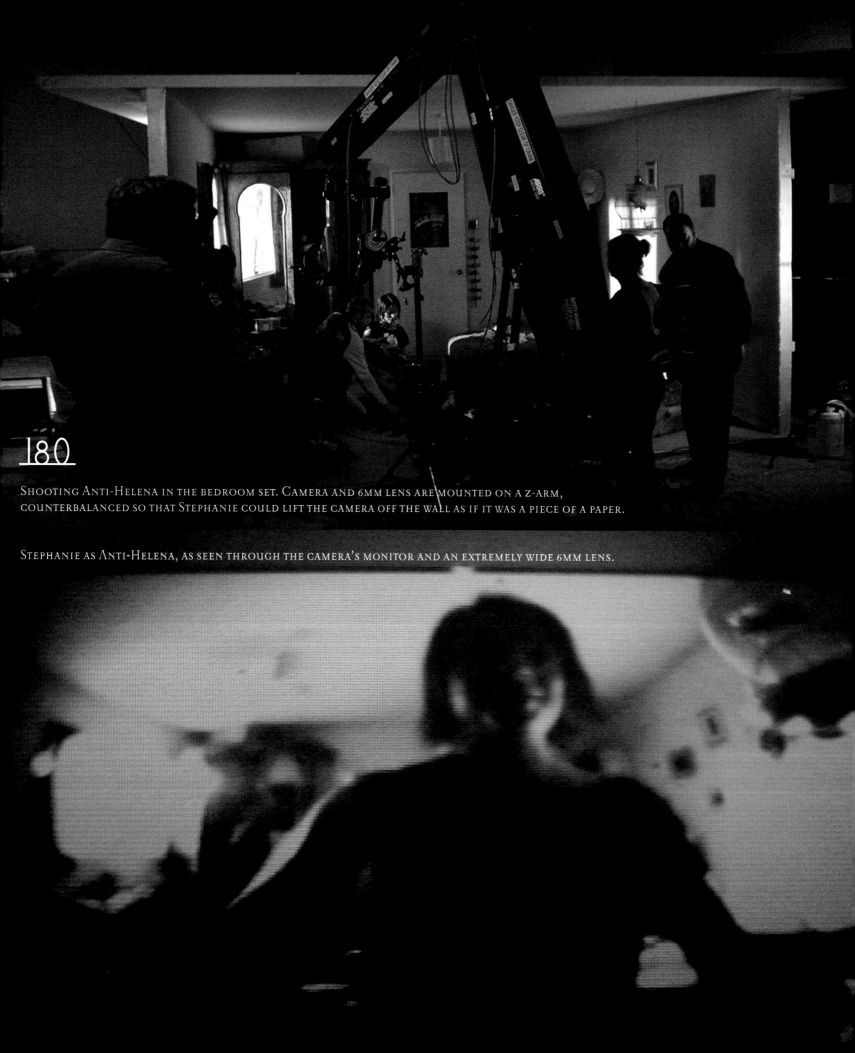

180

Shooting Anti-Helena in the bedroom set. Camera and 6mm lens are mounted on a z-arm, counterbalanced so that Stephanie could lift the camera off the wall as if it was a piece of a paper.

Stephanie as Anti-Helena, as seen through the camera's monitor and an extremely wide 6mm lens.

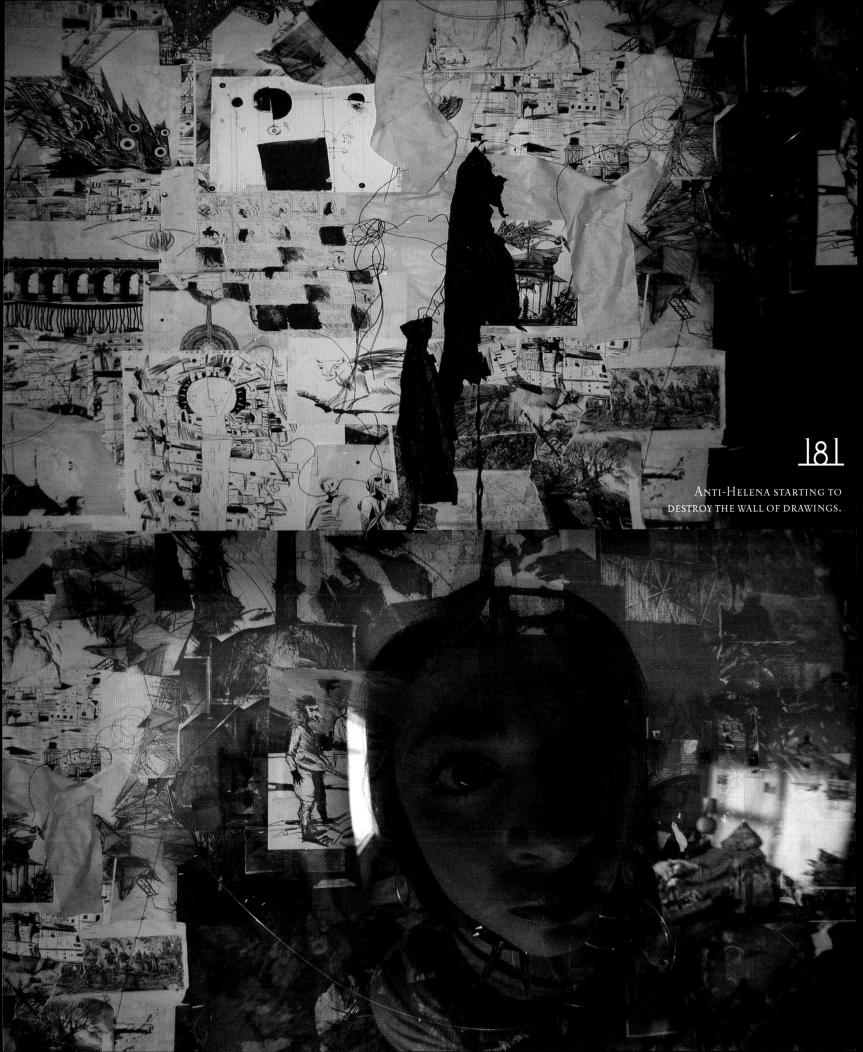

181

Anti-Helena starting to destroy the wall of drawings.

The MirrorMask

Valentine reflected in the CG MirrorMask.

Concept illustration of a wall of masks that was never used.

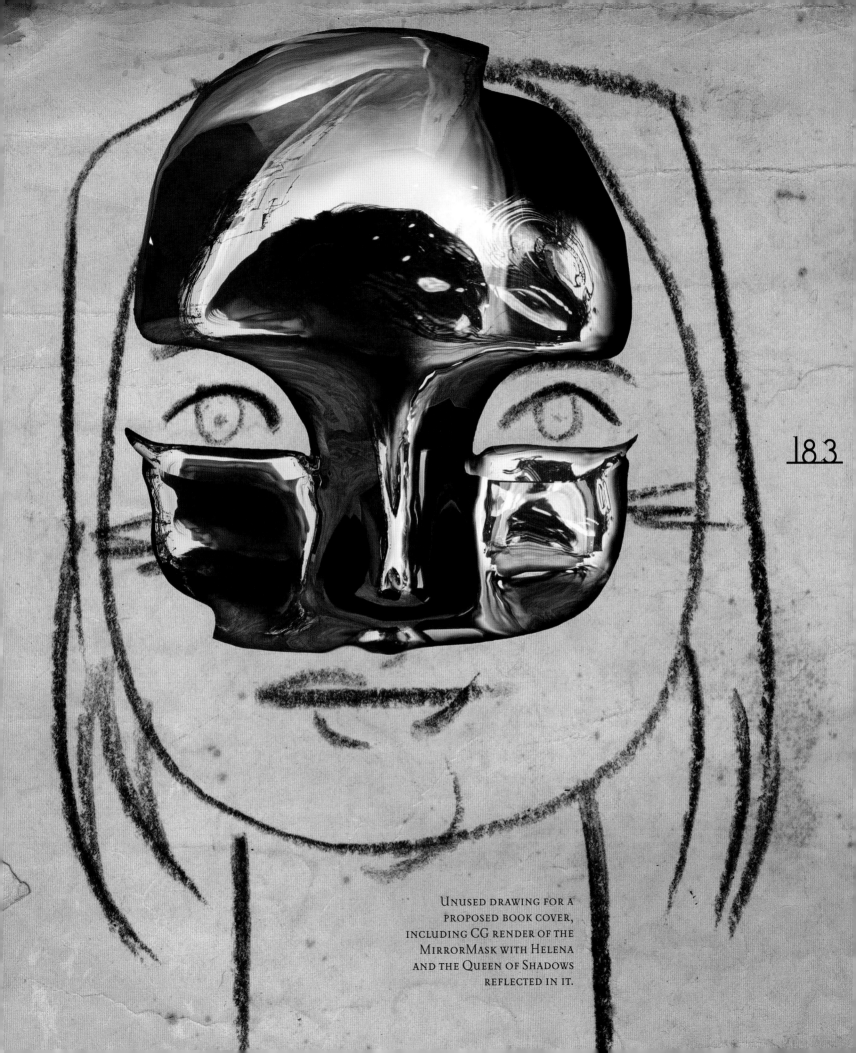

18.3

Unused drawing for a
proposed book cover,
including CG render of the
MirrorMask with Helena
and the Queen of Shadows
reflected in it.

The Queen's Head

Gina McKee is wonderful as each of the different versions of Helena's mother she plays, but I think she's astonishing as a hundred-foot-high, partly animated head with tendrils. I still wonder where the tendrils came from.

NG

This is one of my favorite parts of the film. Jordan Kirk was responsible for making the model of the Queen's head, and incorporating it into the scene. It ended up being far more involved and far better than my storyboards suggested. Gina McKee's mouth really blended well into the rest of the CG face. When we started to visualize the Queen's head beginning to scream, bloating into the huge blob that descends on Helena and Valentine, we were just doodling in 3D. It got bigger and blobbier and finally we had to create a last-minute bridging shot to show the face morphing into something resembling the enormous final creature.

Gina's comment on seeing her huge screaming face for the first time was: "Great, can I have that for my Spotlight photo, please?"

DM

184

HELENA AND VALENTINE
LOOK UP AT A CROSS ON THE
WALL REPRESENTING THE
GIANT QUEEN'S HEAD.

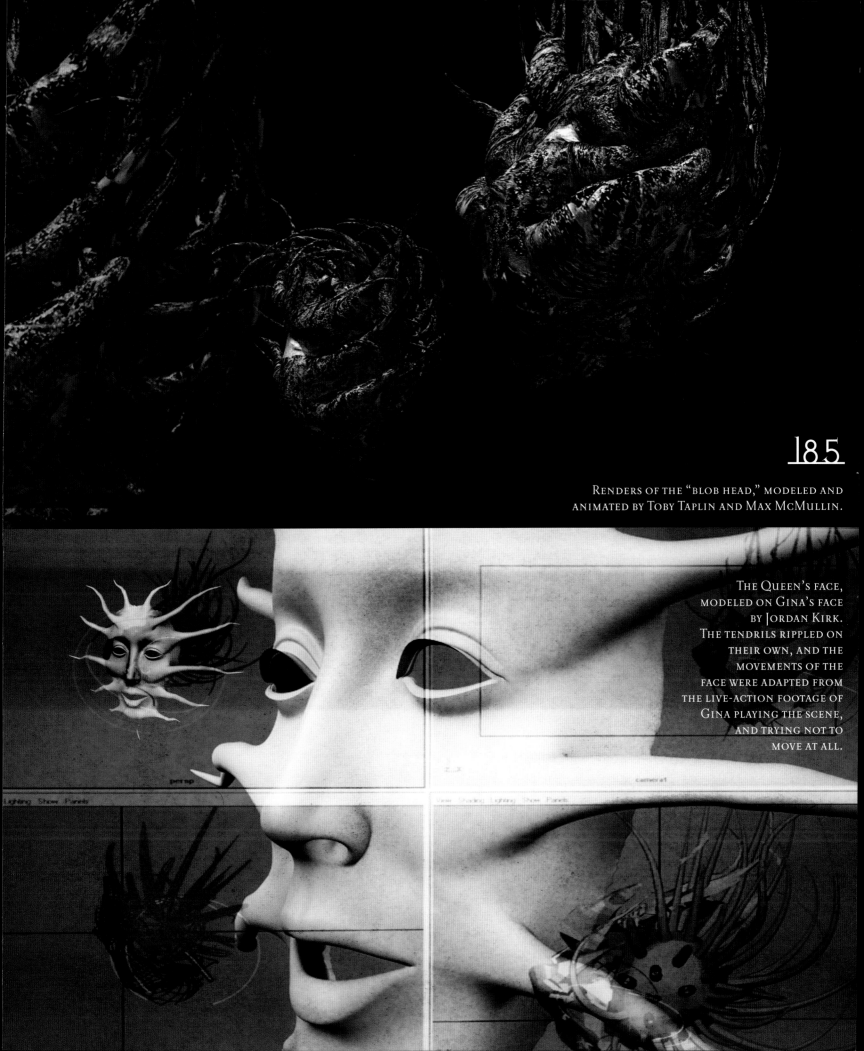

185

RENDERS OF THE "BLOB HEAD," MODELED AND ANIMATED BY TOBY TAPLIN AND MAX MCMULLIN.

THE QUEEN'S FACE, MODELED ON GINA'S FACE BY JORDAN KIRK. THE TENDRILS RIPPLED ON THEIR OWN, AND THE MOVEMENTS OF THE FACE WERE ADAPTED FROM THE LIVE-ACTION FOOTAGE OF GINA PLAYING THE SCENE, AND TRYING NOT TO MOVE AT ALL.

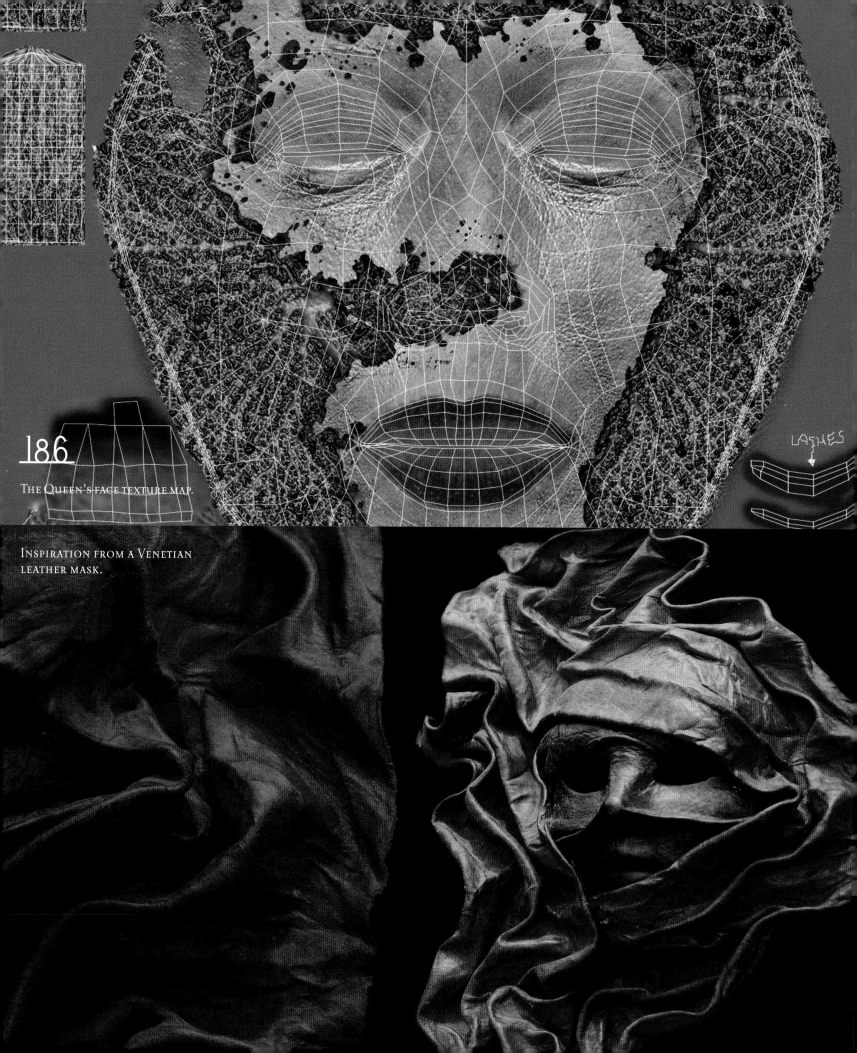

186

The Queen's face texture map.

Inspiration from a Venetian leather mask.

Lashes

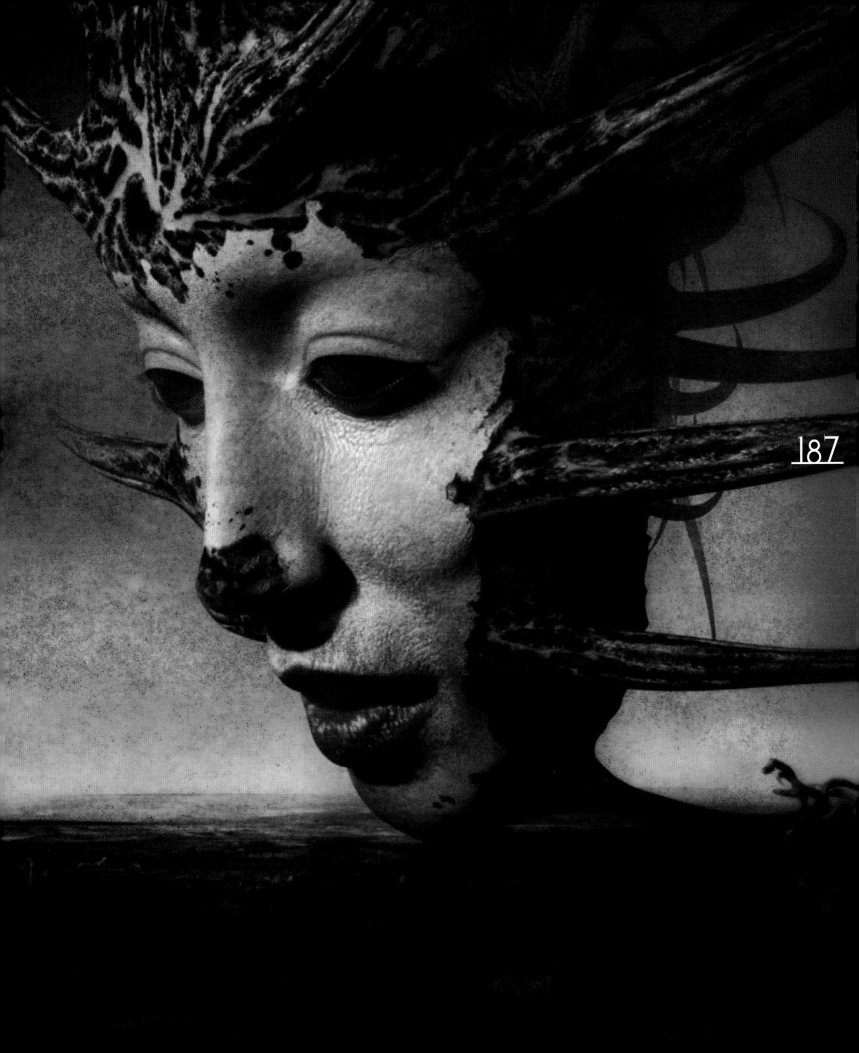

187

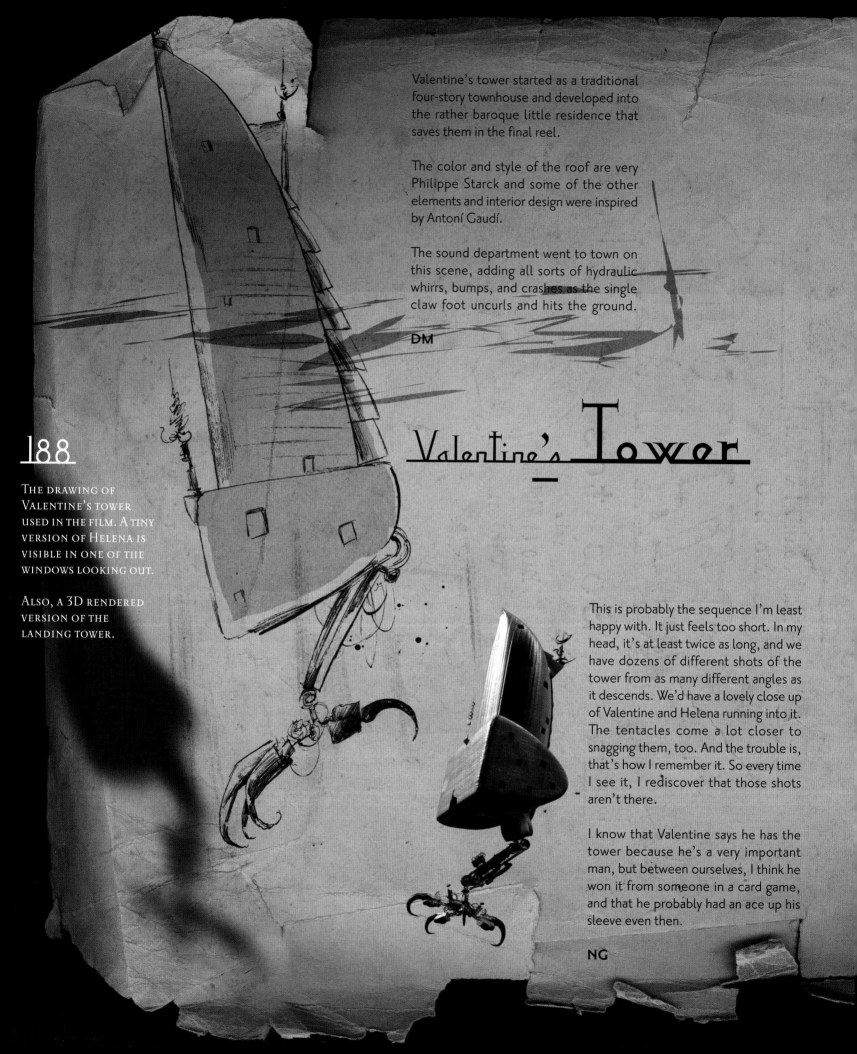

Valentine's tower started as a traditional four-story townhouse and developed into the rather baroque little residence that saves them in the final reel.

The color and style of the roof are very Philippe Starck and some of the other elements and interior design were inspired by Antoní Gaudí.

The sound department went to town on this scene, adding all sorts of hydraulic whirrs, bumps, and crashes as the single claw foot uncurls and hits the ground.

DM

Valentine's Tower

THE DRAWING OF VALENTINE'S TOWER USED IN THE FILM. A TINY VERSION OF HELENA IS VISIBLE IN ONE OF THE WINDOWS LOOKING OUT.

ALSO, A 3D RENDERED VERSION OF THE LANDING TOWER.

This is probably the sequence I'm least happy with. It just feels too short. In my head, it's at least twice as long, and we have dozens of different shots of the tower from as many different angles as it descends. We'd have a lovely close up of Valentine and Helena running into it. The tentacles come a lot closer to snagging them, too. And the trouble is, that's how I remember it. So every time I see it, I rediscover that those shots aren't there.

I know that Valentine says he has the tower because he's a very important man, but between ourselves, I think he won it from someone in a card game, and that he probably had an ace up his sleeve even then.

NG

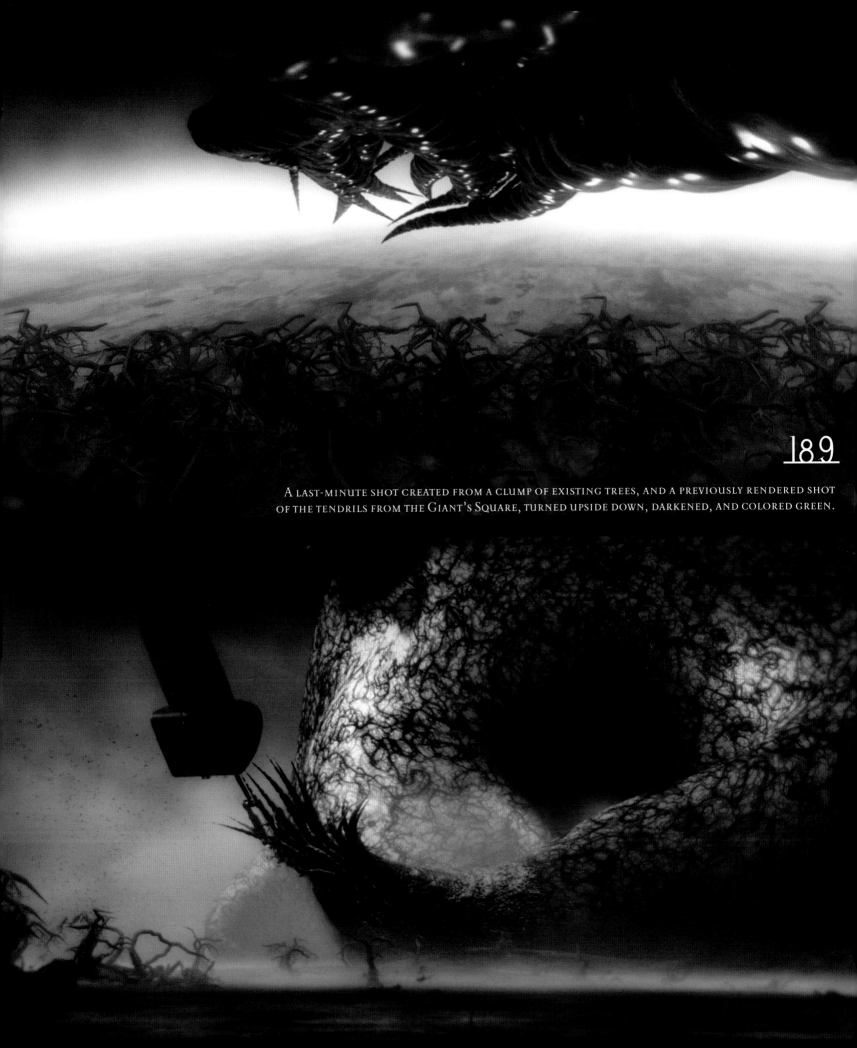

A LAST-MINUTE SHOT CREATED FROM A CLUMP OF EXISTING TREES, AND A PREVIOUSLY RENDERED SHOT OF THE TENDRILS FROM THE GIANT'S SQUARE, TURNED UPSIDE DOWN, DARKENED, AND COLORED GREEN.

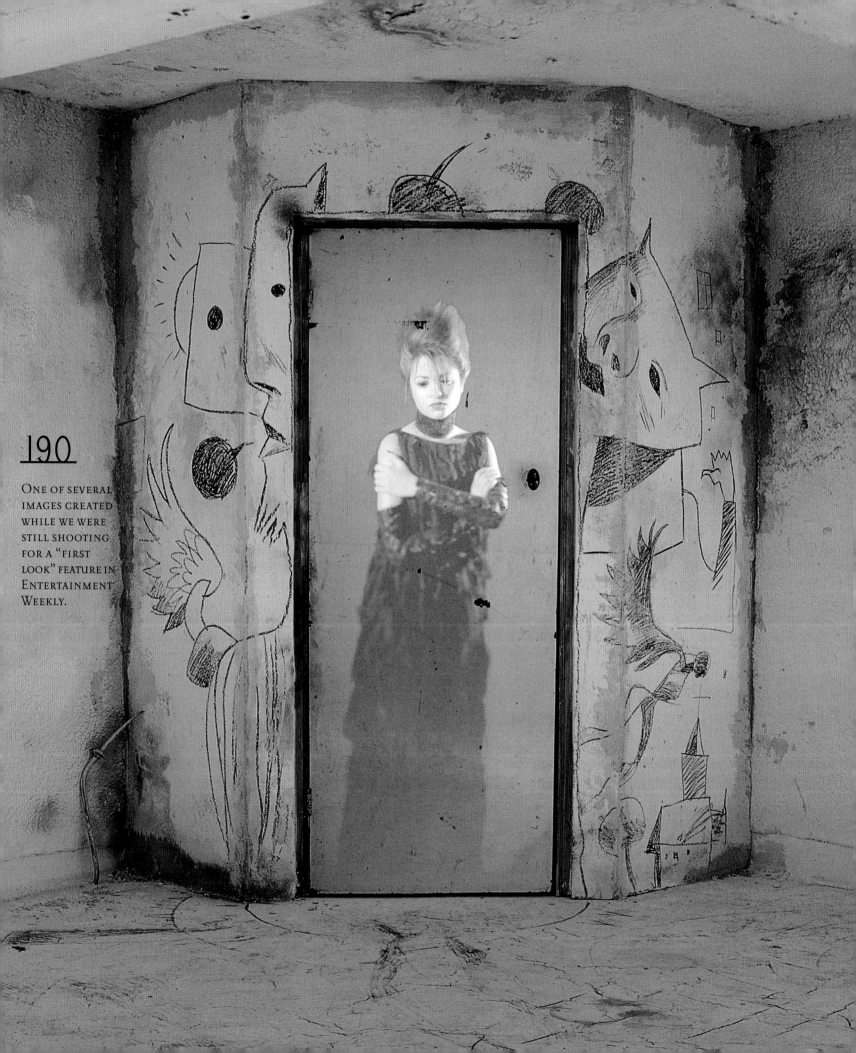

190

One of several images created while we were still shooting for a "first look" feature in Entertainment Weekly.

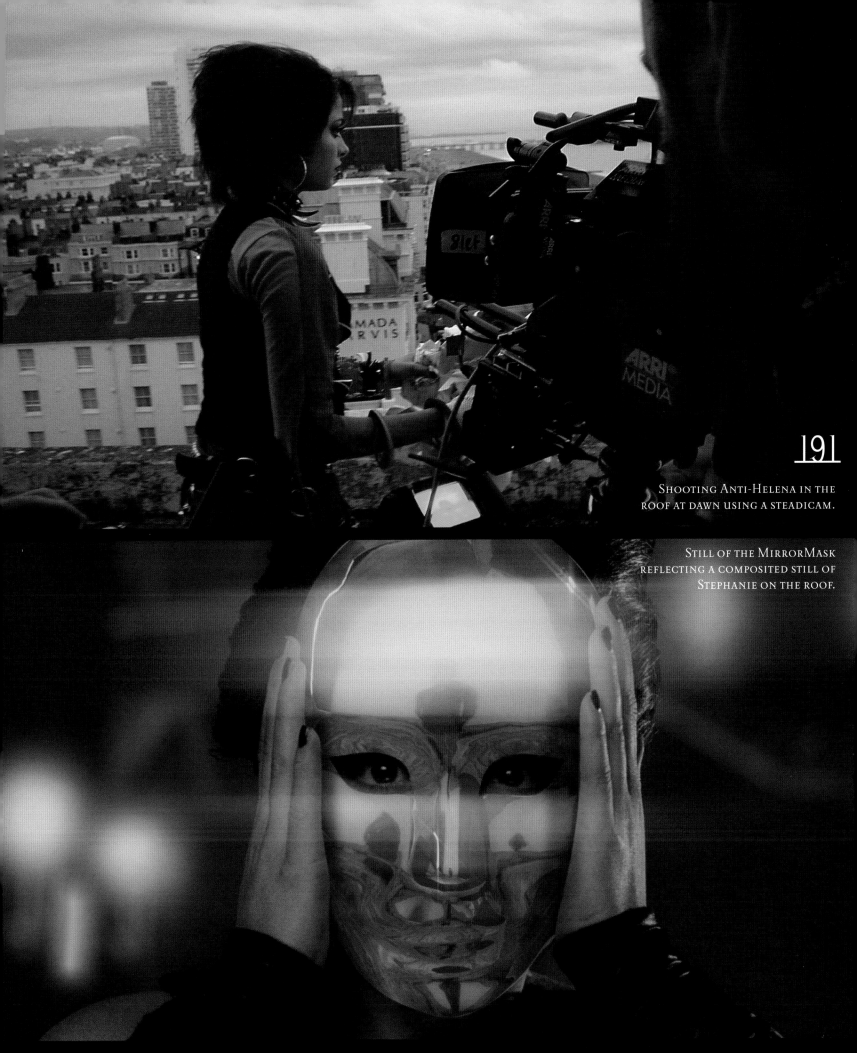

SHOOTING ANTI-HELENA IN THE
ROOF AT DAWN USING A STEADICAM.

STILL OF THE MIRRORMASK
REFLECTING A COMPOSITED STILL OF
STEPHANIE ON THE ROOF.

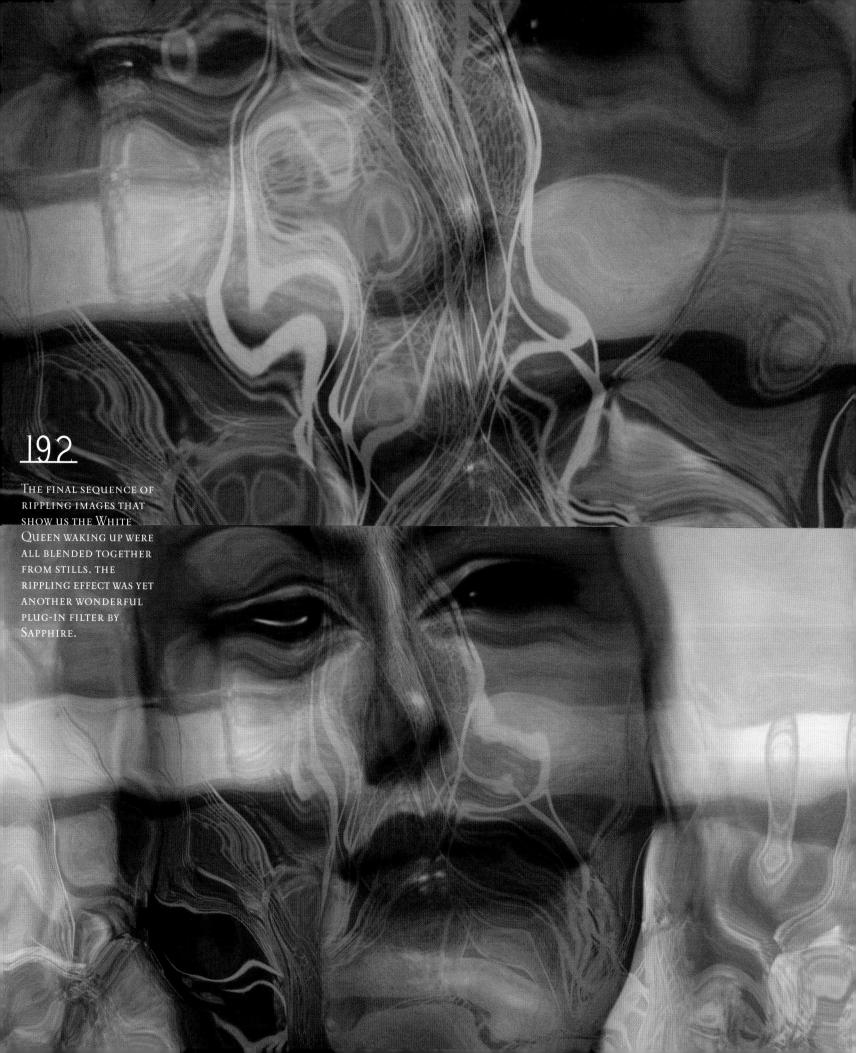

192

The final sequence of rippling images that show us the White Queen waking up were all blended together from stills. The rippling effect was yet another wonderful plug-in filter by Sapphire.

Awake

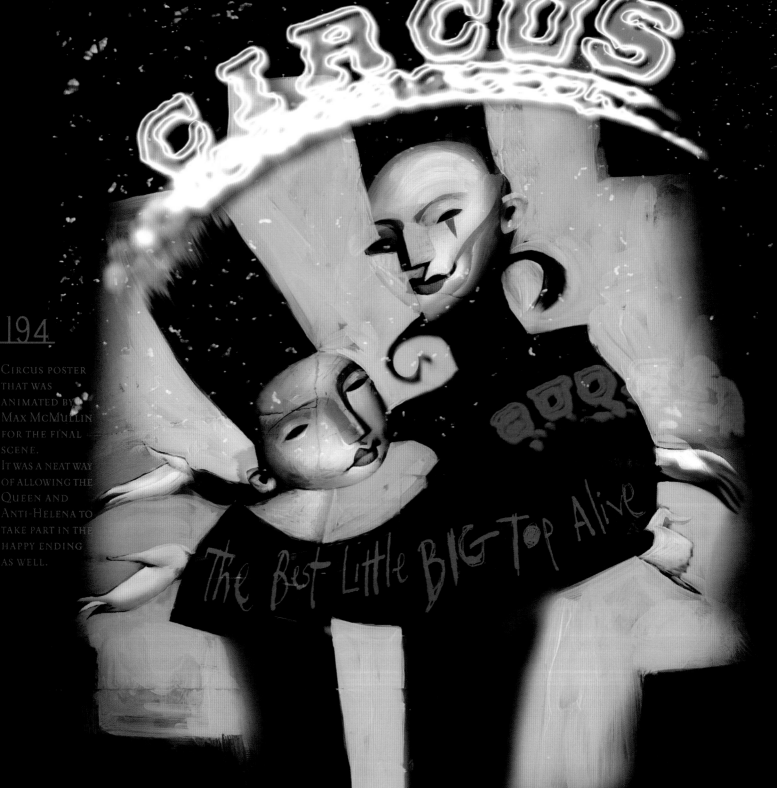

The CAMPBELL FAMILY

CIRCUS

The Best Little BIG-Top Alive

194

Circus poster that was animated by Max McMullin for the final scene. It was a neat way of allowing the Queen and Anti-Helena to take part in the happy ending as well.

3pm and 7pm. Saturday 2nd. July - Sunday 10th. July, Moorhead Park, Brighton.
Ticket prices adults: £6 - £12, children: £2 - £6
Tickets available from Bakers in the High Street, and from Hensons under the railway arches.

I wanted to show that maybe the Dark Queen had learned something, and that maybe the Princess had as well, and wanted a shot of them together in the Palace of Shadows, before the White Queen woke up.

Dave did it much more subtly than that: As we begin we see the new poster (and I'm pretty certain that Helena does the posters for the Circus, although where she keeps the computer I have no idea) showing the Dark Queen and the Princess reunited.

Because many people were not certain whether or not the Future Fruit scene would make it in, Dave recorded several alternatives to Helena's final line of "You would have made a lousy waiter," all of which, he assured me, were dire enough to make it vital that the Future Fruit scene worked.

NG

195

ROB'S LAST LINE ON THE ROOF: "COME ON, WE'RE GOING TO BE FINE . . ."

AND THEY WERE...

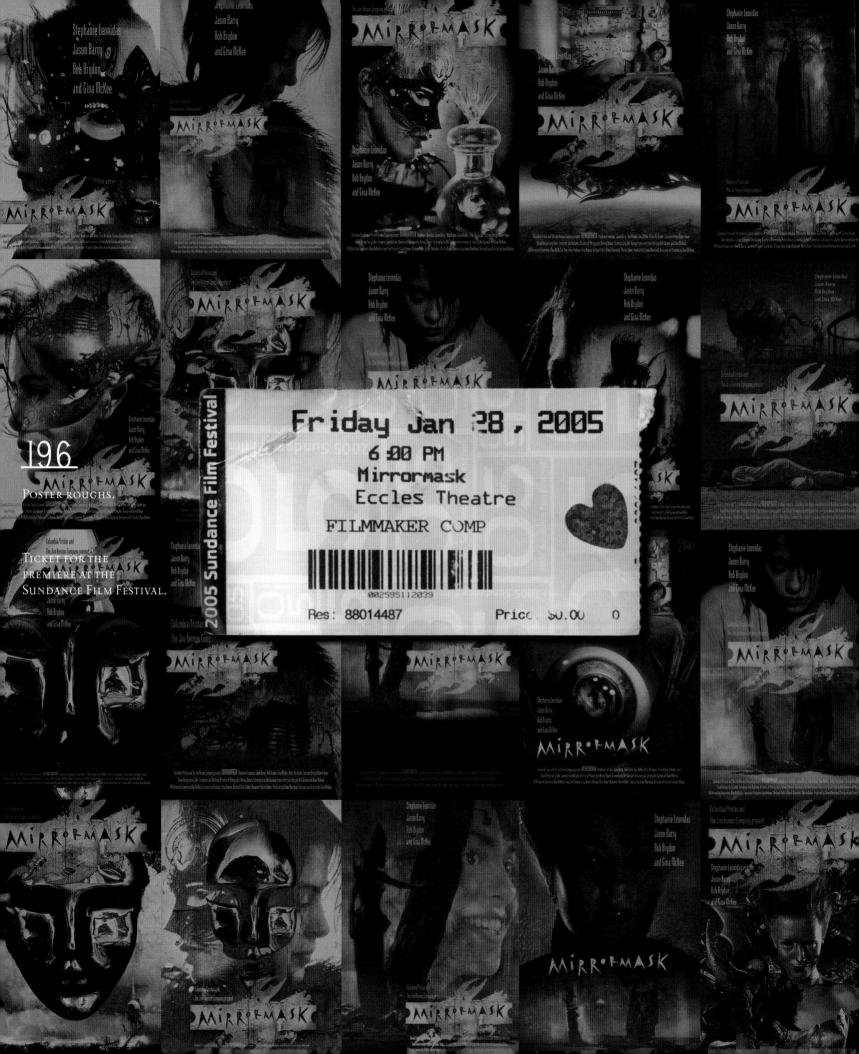

196

Poster roughs.

Ticket for the premiere at the Sundance Film Festival.

2005 Sundance Film Festival

Friday Jan 28, 2005
6:00 PM
Mirrormask
Eccles Theatre

FILMMAKER COMP

002595112039

Res: 88014487 Price $0.00 0

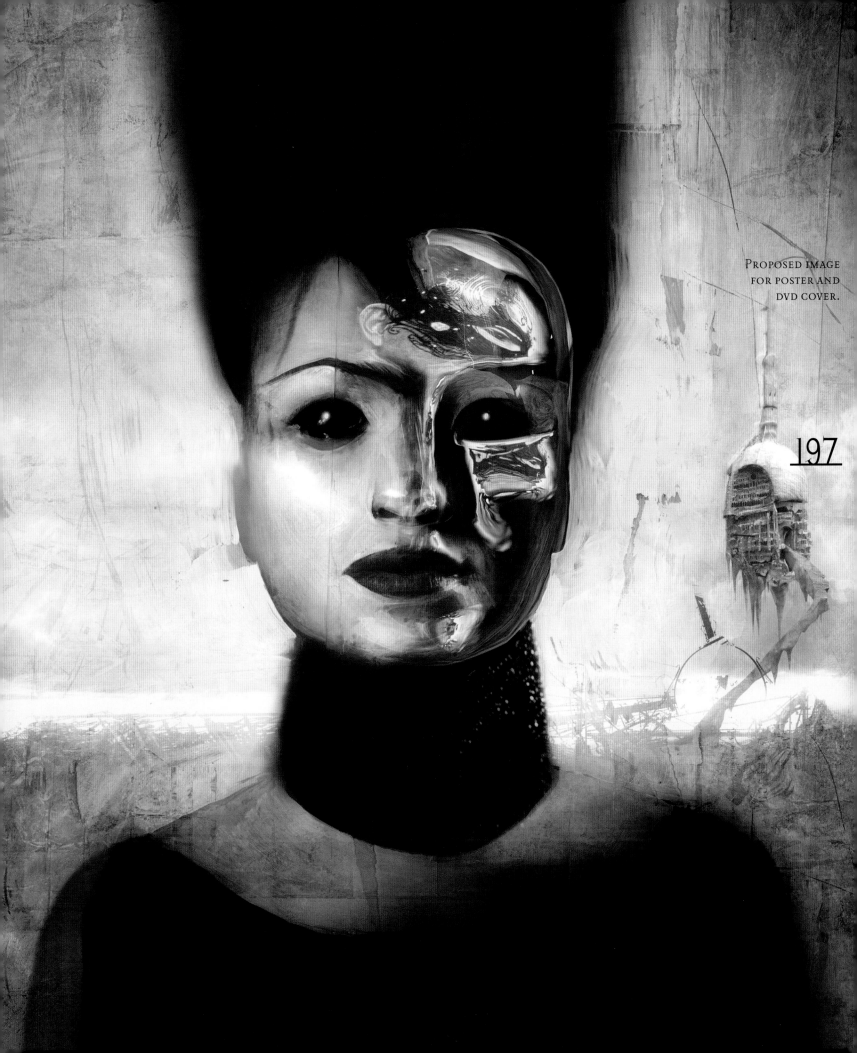

PROPOSED IMAGE
FOR POSTER AND
DVD COVER.

197

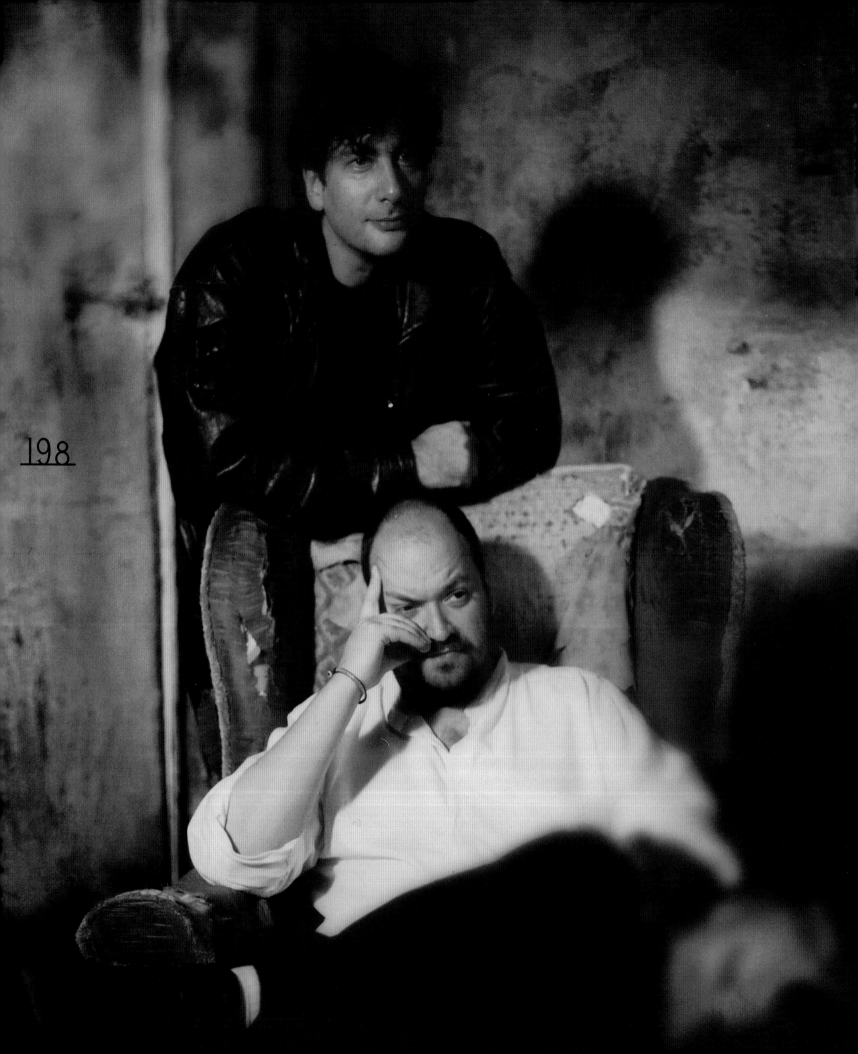

198

Dave McKean was born in Taplow, Berkshire, in 1963. He attended Berkshire College of Art and Design from 1982–86 and, before leaving, started working as an illustrator. In 1986 he met author Neil Gaiman, with whom he has collaborated on many projects since. Their first book, Violent Cases (1987), has been printed in many editions worldwide, and adapted for the stage. Since then they have produced Black Orchid (1988), Signal to Noise (1990) for The Face magazine and Mr. Punch (1994). Dave has contributed all the cover illustrations and design for the popular Sandman series of graphic novels, for which he won the World Fantasy Award, and a collection of this work, Dust Covers, was published in 1998. Arkham Asylum (1989), written by Scottish author/playwright Grant Morrison, still the single-most successful graphic novel ever published, was also illustrated by Dave. 1995 saw collaborations with the Rolling Stones (The Voodoo Lounge) and Rachel Pollack (The Vertigo Tarot). Between 1990 and 1996, Dave also wrote and illustrated the 500-page comic novel Cages, which won the Harvey Award for Best New Comic in 1992, best graphic novel in 1997, the International Alph Art Award, and Italy's La Pantera Award in 1999.

His most recent collection of short stories in comics form, Pictures That Tick, won the Victoria and Albert Museum's Illustrated Book Awards Overall First Prize.

In 1995 he produced the image to launch the Sony PlayStation, and in 1996 was one of four photographers chosen by Kodak and Saatchi to launch their new color film with a book, video, and global ad package.

He has also produced campaigns for Smirnoff, British Telecom, 3dfx Voodoo, BMW/Mini, Nike, the British Government's Social Work Department, and Eurostar.

He has contributed many illustrations to The New Yorker, Playboy, and other magazines, and has contributed promotional work for the films Blade, Alien Resurrection, The King Is Alive, Dust, and Sleepy Hollow. He has won various awards, including the international Amid Award for the Best Album Cover of the Year, one of more than a hundred and fifty covers designed, illustrated, and photographed since 1990, including releases by Michael Nyman, Tori Amos, Real World, Altan, Toad the Wet Sprocket, Bill Laswell, Alice Cooper, Dream Theater, Counting Crows, Front Line Assembly, and Bill Bruford.

He has composed and performed the music for the BBC Radio adaptations of Signal to Noise and Mr. Punch, and with saxophonist Iain Ballamy, has initiated the Feral Records label.

Dave's Hourglass studio and Allen Spiegel Fine Arts in California have also copublished three collections of photographs; A Small Book of Black & White Lies, Option:Click, and The Particle Tarot, which includes an introduction by legendary director and Tarot master Alejandro Jodorowsky. Three touring exhibitions have traveled the UK and Europe, with the most recent show, Narcolepsy, attracting more than 30,000 visitors in six cities.

In the last few years Dave completed his first children's books: The Day I Swapped My Dad for Two Goldfish and The Wolves in the Walls (New York Times Illustrated Book of the Year), both written by Neil Gaiman, and Varjak Paw (Smarties Gold Award), written by S.F. Said. He has also completed a book with Stephen King (The Dark Tower: Wizard & Glass), concept designs for the second and third Harry Potter films, designs for Lars Von Trier's new interactive project, books, and TV films with Iain Sinclair (Slow Chocolate Autopsy, Asylum, and The Falconer, which won Best Short Film at Montreal Film Festival), and designs for the autobiography of John Cale: What's Welsh for Zen.

In 1998, Dave decided to make some films. The Week Before and N[eon] are short films that played the festival circuits worldwide and N[eon] won First Prize at the Clermont-Ferrand Film Festival. These films brought Dave to the attention of Lisa Henson from The Jim Henson Company, and together with Neil Gaiman and Dave's small crew from these shorts, they embarked on MirrorMask, a feature fantasy film for Columbia/Tristar. He is currently working on two scripts for feature films, three books to tie in with the release of MirrorMask, extensive designs, films, and photographs for a Broadway musical and a new children's book, Crazy Hair, again with Neil Gaiman.

He lives on the Isle of Oxney in Kent, England, with his wife and studio manager, Clare, and their two children.

A professional writer for more than twenty years, Neil Gaiman has been one of the top writers in modern comics, and is now a bestselling novelist. His work has appeared in translation in more than nineteen countries, and nearly all of his novels, graphic and otherwise, have been optioned for films. He is listed in the Dictionary of Literary Biography as one of the top ten living postmodern writers.

Gaiman was the creator/writer of the monthly cult DC Comics series, Sandman, which won Neil nine Will Eisner Comic Industry Awards, including the award for Best Writer four times, and three Harvey Awards. Sandman #19 took the 1991 World Fantasy Award for Best Short Story, making it the first comic ever to be given a literary award.

His six-part fantastical TV series for the BBC, Neverwhere, was broadcast in 1996. His novel, also called Neverwhere, and set in the same strange underground world as the television series, was released in 1997; it appeared on a number of bestseller lists, including those of the Los Angeles Times, the San Francisco Chronicle, and Locus.

Stardust, an illustrated prose novel in four parts, began to appear from DC Comics in 1997. In 1999 Avon released the all-prose unillustrated version, which appeared on a number of bestseller lists, was selected by Publishers Weekly as one of the best books of the year, and was awarded the prestigious Mythopoeic Award as Best Novel for Adults.

American Gods, a novel for adults, was published in 2001 and appeared on many best-of-the-year lists, was a New York Times bestseller in both hardcover and paperback, and won the Hugo, Nebula, SFX, Bram Stoker, and Locus Awards.

Coraline (2002), his first novel for children, was a New York Times and international bestseller, was nominated for the Prix Tam-Tam, and won the Elizabeth Burr/Worzalla Award, the BSFA Award, the Hugo, the Nebula, and the Bram Stoker Awards.

2003 saw the publication of bestseller The Wolves in the Walls, a children's picture book, illustrated by Gaiman's longtime collaborator Dave McKean, which the New York Times named as one of the best illustrated books of the year; and the first Sandman graphic novel in seven years, Endless Nights, the first graphic novel to make the New York Times bestseller list.

In 2004, Gaiman published a new graphic novel for Marvel called 1602, which was the best-selling comic of 2004, and 2005 saw the Sundance Film Festival premier of MirrorMask, a Jim Henson Company Production, written by Gaiman and directed by McKean. A lavishly designed book containing the complete script, black-and-white storyboards, and full-color art from the film will be published by William Morrow in early 2005; a picture book for younger readers, also written by Gaiman and illustrated with art from the movie, will be published by HarperCollins Children's Books at a later date.

Gaiman's official Web site had 400,000 unique visitors per month in 2004; close to 600,000 per month are expected in 2005. His online journal is syndicated to thousands of blog readers every day.

Born and raised in England, Neil Gaiman now lives near Minneapolis, Minnesota, where he is currently at work on Anansi Boys, the long-awaited follow-up to American Gods.

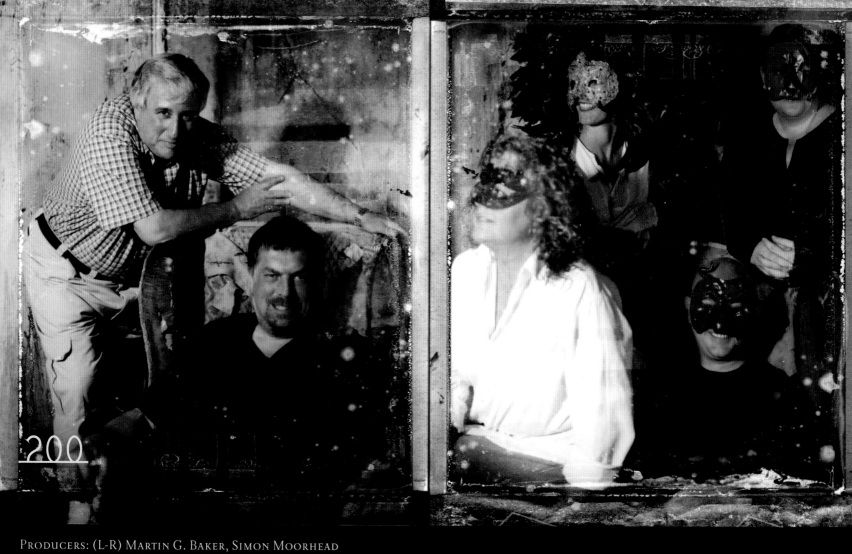

200

PRODUCERS: (L-R) MARTIN G. BAKER, SIMON MOORHEAD
COSTUME/MAKE-UP: (L-R) MICHELE DAVIDSON BELL, SAM SMART, ROBERT LEVER, JANE SPICER

END TITLE ROLLER.

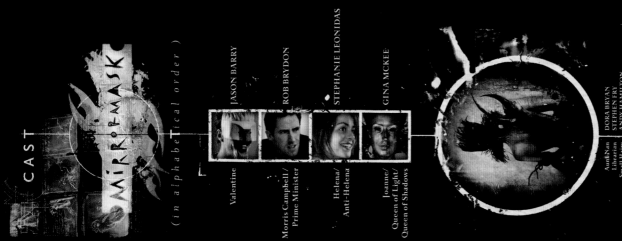

MIRRORMASK

(in alphabetical order)

CAST

JASON BARRY
ROB BRYDON
STEPHANIE LEONIDAS
GINA MCKEE

Valentine
Morris Campbell / Prime Minister
Helena / Anti-Helena
Joanne / Queen of Light / Queen of Shadows

DORA BRYAN
STEPHEN FRY
ANDY HAMILTON
SIMON HARVEY
LENNY HENRY
ROBERT LLEWELLYN
ERYL MAYNARD
EVE PEARCE
NIK ROBINSON
VICTORIA WILLIAMS

Aunt Nan
Librarian
Small Harry
Sphinx
Cops 1-4
Gryphon
Mrs. Bagwell
Future Fruit Lady
Pingo/Bing
Nurse

PERFORMERS

RICK ALLEN
GINA D'ANGELO
SIMON SCHOFIELD
SILVIA FRATELLI
LINA JOHANSSON
EMMA NORIN
PEACHI PANGEA
MARK TATE
RICHARD THOMPSON
ROBIN THOMPSON
SHAENA BRANDEL
NIKKI LUCAS
ANTON MACKMAN

Man In a Box
Heir of Insanity Woman
Heir of Insanity Man
Mimbre
Pyrotechnic Artist
Stilt Walker
Tat — The Strongman/Gorilla
Magician
Miss McKee's Spanish Web Double
Miss Leonidas' Juggling Double
Mr. Brydon's Juggling Double

CIRCUS Performers Co-ordinator : JANE BALLAMY

DIRECTOR OF PHOTOGRAPHY: ANTONY SHEARN; FIRST ASSISTANT CAMERA: MICHAEL GREEN;
BOOM OPERATOR: JOHN CROSSLAND; GRIP: JEM MORTON; FIRST ASSISTANT DIRECTOR: JO LEA

CIRCUS BAND

Band Leader and Soprano Sax	IAIN BALLAMY
Trumpet	CHRIS BATCHELOR
Button Accordion	STAN CARSTENSEN
Drum Kit	MARTIN FRANCE
Violin and Banjo	STUART HALL
Sousaphone	DAVE POWELL
Alto Sax	TRIFON TRIFONOV

Red Troll	PETER BORROUGHS
Yellow Gnome	RUSTY GOFFE
Music Box Dancer	KERRY JAY
Receptionist	FIONA REYNARD
Politician/Monkeybirds	NICK DAINTON
Mr. Snor-Thing, Monkeybirds	NICK JACKSON
Politician/Monkeybirds	MARK PERRY
Giant / Mrs. Sheething Chicken	KATIE ROBBINS

Production Manager	TESSA BEAZLEY
1st Assistant Director	JO LEA
Production Sound Mixer	IAN SANDS AMPS
Financial Controller	JOHN SARGENT
Costume Designer	ROBERT LEVER
Make-Up & Hair Design	MICHELE DAVIDSON-BELL
Supervising Art Director	ZOE TRODDEN
Production Co-ordinator	VALENTINA COCCIA
2nd Assistant Director	OLI BLANC
3rd Assistant Director	JANINE BEVAN
Floor Runner	MICHAEL SCANLON
First Assistant Camera	MICHAEL GREEN
	NATHAN MANN
Second Assistant Camera	COLLEEN WEBLEY
	KATE FILEY
2nd Second Assistant Camera	MARK NUTKINS
Video Assist Operator	SIGGI ROSEN-RAWLINGS
Grips	JEM MORTON
	BELINDA BICKERS
	JODY KNIGHT
	DAVE WELLS
Crane Operator	COLIN GINGER
Steadicam Operator	PETE MURRAY
Filmstream S-2 Storage Operator	JOHN O'QUIGLEY
Script Supervisors	HEATHER TAYLOR
	KATHY HUGHES
Boom Operators	JOHN CROSSLAND AMPS
	PAUL MILLER
	PETE FRESHNEY
Production Buyers	KATE WICKS
	PAUL FROST
Assistant Editor	RUTH COULSON
First Assistant Accountant	LARA SARGENT
Assistant Accountant	LOUISE GREEN
Make-Up & Hair Artist	SAM SMART
Tine's Mask created and supplied by	SHERMAN LABORATORIES
Lens supplied by	REEL EYE COMPANY
Costume Supervisor	JANE SPICER
Costume Assistants	DEBBIE O'BRIAN
	YVONNE DUCKETT
	REBECCA BROWN
Prop Master	NATHALIE PATEMAN
Standby Props	JASON WOOD
	STUART WALPOLE
Trainee Carpenter	JUSTIN HAVZELDEN
FT2 Art Department Trainee	GARY NUTKINS
Construction Manager	GUS MURRAY
Carpenters	GUY BERNARD
	ASHLEY MURRAY-FOWLER
	JAMES WRIGHT
Gaffer	GAVIN WALTERS
Best Boy	AARON WALTERS
Electricians	ANDY BELL
	GWILYM EDWARDS-OWEN
	MIKE GIANNOTTI
	AVALINO FERNANDEZ
Genny Operator / Electrician	ROB COLLINS
Rigger	STEVE BLYTHE
Unit Publicist	ROY ELSON
Stills Photographer	NICOLE GOLDMAN
	MARK SPENCER
	VANESSA KELLAS
Location Facility Drivers	MICKEY WEBB
	JOHN HOGBIN
	BILL LILBURN
	FRED RUSSELL
Mini Bus Driver	MICKEY ATKINS
Unit Nurses	BILL RIDDLAW
	MARTIN VANCE
	MARTIN WARNES
Stunt Co-ordinator	STUART ST. PAUL
Flying Assistant	LUKE ACKMAN
Stand-ins	VICTOR GALLUCCI
	ANDY MATTHEWS

DIGITAL ANIMATION AND EFFECTS by HOURGLASS STUDIO

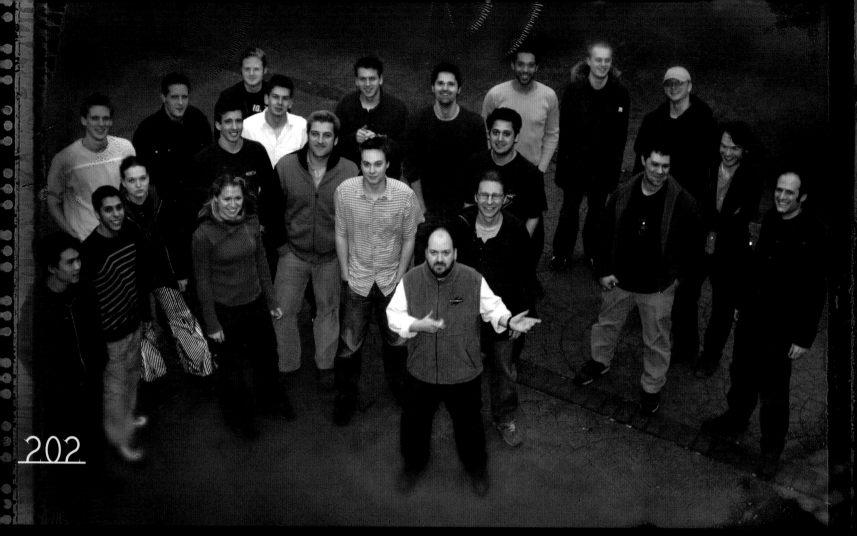

HOURGLASS TEAM PHOTO: (L-R) PAUL LEE, JORDAN KIRK, JAMIE NIMAN, EVELINA PERSSON, DAVE WALKER, ELLIE KOORLANDER, TOBY TAPLIN, ALEXIS HALL, MATT MIDDLETON, CHRISTIAN JELEN, ROSS STANSFIELD, MIKE NIXON, DAVE MCKEAN, PAWEL GROCHOLA, DANIEL GERHARDT, ARJUN GUPTE, JOCELYN DEBORNE, MARTIN LACEY, DAVE BARNARD, TREVOR HARVEY, KEITH MOTTRAM, MAX MCMULLIN

DIGITAL ANIMATION AND EFFECTS by HOURGLASS STUDIO

Storyboards, character and set design,
texture maps and compositing
Featured drawings and paintings by
Studio supervisor, animation
Studio manager
Editor, 2-d visual effects
Technical Supervisor
Systems Assistants

Render Management

DAVE McKEAN
IAN MILLER and DAVE McKEAN
SIMON MOORHEAD
MAX McMULLIN
KEITH MOTTRAM
DAVE BARNARD
JOCELYN DEBORNE
BOB LANGE
HENRIK NORIN

LEAD ANIMATORS AND EFFECTS ARTISTS

ALEXIS HALL
Title sequence, carbonising scene, Rooftop scenes, falling and 16-legged spider animation, motion tracking, general scene corrections

MATTHEW MIDDLETON
Giants animation and scene, gryphon scenes, sphinx street scene, gliding monkeybirds scene, water, spider model, gryphon model, politicians models, general scene corrections

MICHAEL NIXON
Music box doll scene, motion capture rigging, monkeybird model, Mrs. Bagwell interior scenes, schooling fish, flocking birds and ribbons, Prime Minister's story animation, black guard model, general scene corrections

TOBY TAPLIN
Library interior scenes, rabbit band animation, shoe-shining animation, black guard animation, spider out of goo animation

ANIMATORS AND EFFECTS ARTISTS

DANIEL GERHARDT
Dark palace exterior and interior, models and scenes, tree models

PAWEL GROCHOLA
Tendril model and animation, tower landing scene

ARJUN GUPTE
Spider animation, monkeybird animation, tower landing animation

CHRISTIAN JELEN
Library model and exterior scene, dream park model and scene, cops animation, future fruit scene

JORDAN KIRK
Giant Queens head model, animation and scene, street model and scene, tower interior model and scene, Small Harry model, rabbit band model

ELLIE KOORLANDER
City model and scenes, Mrs. Bagwell exterior model and scene, Anti-Helena's bedroom model and scene, bridge model and scene, playing with dolls montage models and scenes

PAUL LEE
Gryphon animation, sphinx animation, additional monkeybird animation

JAMIE NIMAN
Monkeybird animation, pedestrian models and animation, future fruit model, politician models, musical instrument models, Spiny Norman model

EVELINA PERSSON
Sphinx model, white palace model and scenes, abandoned hall scene, book models and animation, phonograph model

ROSS STANSFIELD
Cathedral street exterior and interior models and scenes

DAVE WALKER
Fog and water, tower model, minitramvnak model and scenes, crumpling landscape shots, motion tracking

TREVOR HARVEY
Keying

MARTIN STACEY
Keying and 2-d effects

Additional rendering by | **JIM HENSON'S CREATURE WORKSHOP**

Managing Director | PETE COOGAN
System Engineer | PETE GUYAN
Render Manager | JORJ ALEEM
Digital Co-ordinator | KEVIN BAGULEY
Render Wrangler | ELIOT HODDELL
| MARK J.G. SMITH

Motion Capture by | **ARTEM DIGITAL**
Commercial Director | NICK DOFF
Head of Motion Capture | RICHARD HINCE

Composer: Iain Ballamy; Music Producer: Ashley Slater

Original music composed and arranged by IAIN BALLAMY.
Produced by IAIN BALLAMY and ASHLEY SLATER.
Recorded and programmed by ASHLEY SLATER.
Mixed by ASHLEY SLATER and IAIN BALLAMY.

Music copyists TIM ADNITT and MARK WILLIAMS
Additional recording at BIG BOX STUDIOS, London by JEREMY COX.

MUSICIANS

Saxophones, Keyboards	IAIN BALLAMY
Cimbalom	KALMIN BALOGH
Trumpet	CHRIS BATCHELOR
Accordion, Banjo, Guitar	STAN CARSTENSEN
Drums, Percussion	MARTIN FRANCE
Violin, Banjo	STUART HALL
Trumpet, Voice	ARVE HENRIKSEN
Accordion	IGOR OUTKINE
Guitars	JOHN PARRICELLI
Percussion	NEIL PERCY
Tuba	DAVE POWELL
Cello	MATTHEW SHARP
Trombone, Voice	ASHLEY SLATER
Alto Saxophone	TRIFON TRIFANOV
Double Bass	STEVE WATTS
Voice	JOSEFINE CRONHOLM

'CLOSE TO YOU'
Written by Burt Bacharach & Hal David
Published by WINDSWEPT MUSIC (London) Ltd. (PRS)
on behalf of NEW HIDDEN VALLEY MUSIC (ASCAP)
Published by UNIVERSAL/MCA MUSIC Ltd.
On behalf of CASA DAVID MUSIC
Arranged by Iain Ballamy
Performed by Josefine Cronholm

'MY WALTZ FOR NEWK'
Written and arranged by Iain Ballamy
Published by PRS/MCPS
Licensed from CD 'The Little Radio'
Performed by Iain Ballamy and Stan Carstensen
Produced by Iain Ballamy

'IF I APOLOGISE'
Written by Dave McKean and Neil Gaiman
Published by FERAL MUSIC
Arranged by Iain Ballamy and Ashley Slater
Performed by Josefine Cronholm and Ashley Slater

Sound Effects Editor | DAVID HUNT
Dialogue Editor | STEFAN MONK
Re-Recording Mixer | HUGH JOHNSON
Assistant Re-Recording Mixer | GARETH LLEWELLYN
Foley Supervisor | BARNABY SMITH
Foley Artists | MELISSA LAKE
| JASON SWAN SCOTT

Sound Re-Recorded at
THE MAYFLOWER STUDIOS and
VIDEOSONICS, LONDON

THE JIM HENSON COMPANY

Head of Legal & Business Affairs | ANTONIA DOWNEY
| NATASHA REA
Assistant to Miss Downey | PENNY ROBERTS
Assistant to Mr. Baker | KAREN HARPER
Assistant to Mr. Polis | JIM FORMANEK

FACILITIES

Camera and Lens supplied by | ARRI MEDIA
Lighting Equipment | AFM LIGHTING
Grip Equipment supplied by | ARRI MEDIA
| TAKE 2 FILM SERVICES
HD Equipment | ON SIGHT

Circus | ANTONIOS AND PAULOS CIRCUS
Conveyor Belts | GUNNING CONVEYORS
Catering | HOLLYWOOD CATERING SERVICES
Courier Service | MASTER CARS
Facility Vehicles | MICKY WEBB TRANSPORT
| ON THE BUSES
| COLLINS COACHES
| IST VEHICLE HIRE

Film stock originated on | KODAK
motion picture film from | SOHO IMAGES
Laboratory | DIGITAL FILM LAB
Scanning & Recording | LIPSYNC POST
Tape Transfers | MIDNIGHT TRANSFER
Insurance | MEDIA INSURANCE BROKERS
Completion Guarantor | FILM FINANCE LTD
Payroll | SARGENT-DISC LIMITED
Legal Services for Hourglass Studio | TAYLOR WESSING
Security | PLACE INVADERS

Shot on location in LONDON, BRIGHTON,
and at BLACK ISLAND STUDIOS, LONDON, ENGLAND

The Producers wish to thank:
RESIDENTS OF EMBASSY COURT, BRIGHTON;
THE CAST AND CREW OF ARNETT & PAULO'S CIRCUS,
MEGA CITY, LONDON; DAVE COMICS, BRIGHTON;
QUEEN MARY'S HOSPITAL, ROEHAMPTON;
THE OLD SHIP, BRIGHTON; X-WEST, LONDON;
RUSSELL ALLEN; KATE MORRISON-LYONS; NIGEL HORN;
GREG BARRETT; EDDIE DIAS; STEVE GIUDICI;
NICK DOFF; ROBIN CONWAY

And many others too numerous to mention in this list.

The Director wishes to thank:
KEITH GRIFFITHS, TIM CURTIS,
CLARE, NORA, YOLANDA and LIAM

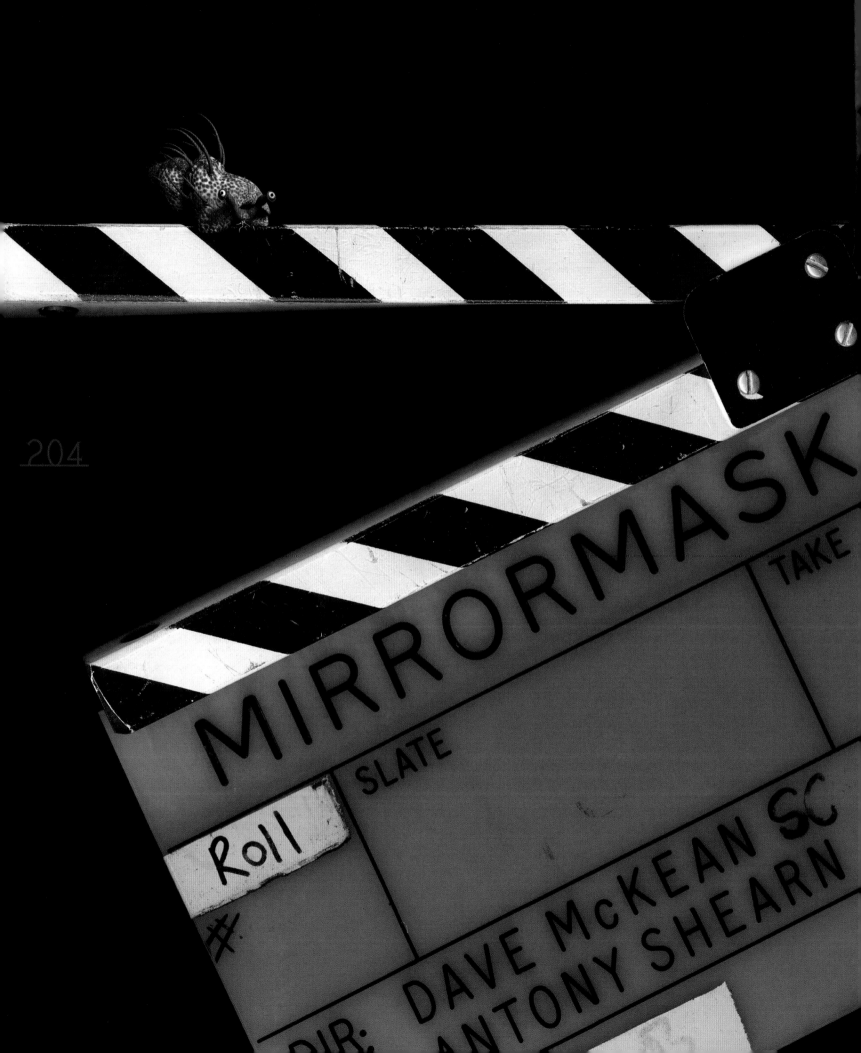

Behind the MirrorMask

MIRRORMASK

Famed comic-book artist DAVE McKEAN unveils his new fantasy movie, MIRRORMASK. Words: Joe Nazzaro

205

Not content with establishing himself as one of the world's greatest artists/illustrators, Dave McKean is exploring an even bigger creative arena. He's just finished principal photography on MirrorMask, a dark fantasy he created with Neil Gaiman, for Henson Films and Sony/TriStar for worldwide release in 2004.

"There's still far to go, but it's certainly encouraging," notes McKean, in a break from completing his editing work on the film. "I think it's coming together, I'm certainly happy with the performances, and the overall shade of the film is very close to what we originally had in mind."

MirrorMask began life when a Jim Henson story scout noticed that Jim Henson's fantasy epics The Dark Crystal (1982) and Labyrinth (1986) continued to generate impressive sales on video and DVD, and signed a deal with the Henson Company to make a new low-budget fantasy film. After securing a budget of just $4 million – roughly a tenth of the money The Dark Crystal cost to make two decades ago – producer Lisa Henson sought to bring McKean onboard as a director, on the strength of his work on such short films as The Week Before and Neon.) Before contacting McKean, however, Henson decided to discuss her plans with Neil Gaiman: "It was a conversation that was destined to shape the entire project. And independence to Lisa is an old friend of Neil, and he thought if I was going to direct it, he'd like to write it," McKean explains. "So we had one meeting about it in San Diego two years ago. They had a proposed title

called The Curse of the Goblin King, and we ended up writing something without any curses or goblins or kings in it, and it's been pretty smooth going since then."

The two longtime collaborators relocated to the Henson family house in England, around a year and a half ago, when they started hammering out a script together. Gaiman had the idea for a Prince and the Pauper-type story, while McKean was thinking about a circus girl whose mother falls ill, and a mirrored mask that had been lost for two weeks.

"We both came to the party with little ideas for scenes and characters, and books of reference material, and we sat down together for two weeks," McKean recalls. "I just wanted to be in the room

McKean is famous, the happy spoils of his other job as a comic book artist (he's worked with Gaiman, who wrote the script, on the likes of Sandman). And it was all done on the cheap: shot entirely on bluescreen, à la Sky Captain, and costing only $4 million. "This is very 'undergroundy'," says McKean. "I've used cheap techniques but they don't

"A dark and visually stunning tale, MirrorMask comes to life with the collage artwork for which McKean has become known"

The project has been backed financially by The Jim Henson Company, whose track record in this genre is something for which

aiming, with one exception, we are no Muppets!" laughs McKean. "But we definitely have the feel of the Labyrinth and The Dark Crystal era – that darkness."

The film centres on Helena, who ventures into a mysterious fantasy world to find the MirrorMask that will cure her sick mother. Along the way she meets sphinxes, monkeybirds, a mysterious Valentine and a menacing Dark Queen (all played by Gina McKee). A dark and visually stunning tale, the film confirms McKean as a master of the genre.

"Occasionally you go to a film knowing nothing about it, and when you discover something special, it's a more powerful experience"

IT'S BEEN A WHILE since we had a British fantasy film that tries to push the envelope. But if comic legends Neil Gaiman and Dave McKean have their way, they, like MirrorMask, and first foray into drama/moviemaking, will fill that void.

"she's not sure what's going on, but she strikes up a relationship with Valentine [played by Jason Barry], this character that guides her through the city.

"In many ways, Helena is still quite childish because she's lived in this little circus life cocoon. So in some ways, she's stretching her wings and pushing out a bit."

MirrorMask was shot over the course of six weeks earlier this year. The shoot encompassed a week on location in London, another in Brighton, and four weeks in a blue screen studio at Black Island. Due to the fact that so many of the sets, environments and secondary characters were going to be added by computer during post-production, McKean storyboarded the entire film from start to finish

In directing MirrorMask, artist Dave McKean is bringing his unique visual eye to film...

ETA Autumn 2005 Tbc
STARRING Gina McKee, Rob Brydon, Stephanie World Jr, Stephen Fry
DIRECTOR Dave McKean

MirrorMask

MirrorMask is a groundbreaking effort from McKean, Dave McKean and Neil Gaiman. Teaming cutting-edge, they combine live action with digital animation light and the other in constant darkness, that will dazzle children and adults alike.

MirrorMask is set in a magical world with the Light Queen is put under a spell and falls ill, queen, the Light Kingdom has no protection fate of the world soon rests on the shoulders herself on a fantastic journey to find the MirrorMask of power. Along the way, she encounters sphinxes, and otherworldly creatures that...

What is also impossible to describe are... at the film creates. The... s I have ever seen. The... not just to relate stor... MirrorMask is storytelling... is all about...

Kingdom, 2004, 101 min., color,
D Cam

ector: Dave McKean
eenwriter: Neil Gaiman,
om a story by Neil Gaiman
Dave McKean
ve Producers: Lisa Henson,
R. Polis, Martin G. Baker
roducer: Simon Moorhead
ucer: Dave McKean
pal Cast: Stephanie Leonidas,
Barry, Rob Brydon, Gina McKee

y, January 25, 6:45 p.m.
inemas V, SLC
9:45 p.m.
s V, SLC
p.m.

Saturday, January 29, 5:30 p.m.
ary Center Theatre

3-PIECE PVC SET

DAVE MCKEAN, NEIL GAIMAN AND THE JIM HENSON

FROM THE CREATIVE MINDS OF

MIRRORMASK

Deluxe

WARNING: CHOKING HAZARD
Small Parts. Not for children under 3 years.

FOR AGES 8 & UP

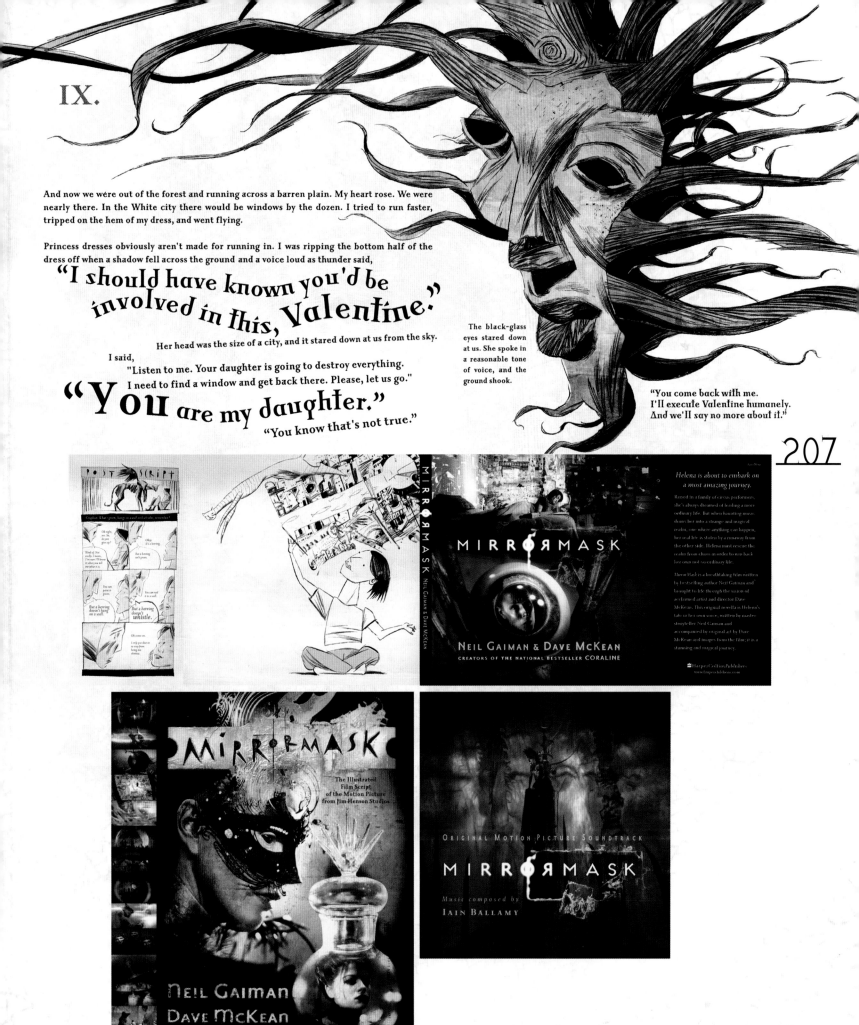

And now we were out of the forest and running across a barren plain. My heart rose. We were nearly there. In the White city there would be windows by the dozen. I tried to run faster, tripped on the hem of my dress, and went flying.

Princess dresses obviously aren't made for running in. I was ripping the bottom half of the dress off when a shadow fell across the ground and a voice loud as thunder said,

"I should have known you'd be involved in this, Valentine."

Her head was the size of a city, and it stared down at us from the sky.

I said,

"Listen to me. Your daughter is going to destroy everything. I need to find a window and get back there. Please, let us go."

"You are my daughter."

"You know that's not true."

The black-glass eyes stared down at us. She spoke in a reasonable tone of voice, and the ground shook.

"You come back with me. I'll execute Valentine humanely. And we'll say no more about it."

POST SCRIPT

MIRRORMASK

NEIL GAIMAN & DAVE McKEAN

Helena is about to embark on a most amazing journey.

Raised in a family of circus performers, she's always dreamed of leading a more ordinary life. But when haunting music draws her into a strange and magical realm, one where anything can happen, her real life is stolen by a runaway from the other side. Helena must rescue the realm from chaos in order to win back her own not-so-ordinary life.

MirrorMask is a breathtaking film written by bestselling author Neil Gaiman and brought to life through the vision of acclaimed artist and director Dave McKean. This original novella is Helena's tale in her own voice, written by master storyteller Neil Gaiman and accompanied by original art by Dave McKean and images from the film; it is a stunning and magical journey.

MIRRORMASK

NEIL GAIMAN & DAVE McKEAN

CREATORS OF THE NATIONAL BESTSELLER CORALINE

HarperCollinsPublishers
www.harperchildrens.com

MIRRORMASK

The Illustrated Film Script of the Motion Picture from Jim Henson Studios

NEIL GAIMAN
DAVE McKEAN

ORIGINAL MOTION PICTURE SOUNDTRACK

MIRRORMASK

Music composed by
IAIN BALLAMY